BRUCE SPRINGSTEEN

Editorial Director: Roland Hall
Designer: Russell Knowles and James Pople
Production Manager: Yael Steinitz
Photo Research: Steve Behan

Library of Congress Control Number: 2018936281

ISBN: 978-1-4197-3483-0

Text copyright © 2019 Brian Hiatt
Design copyright © 2019 Carlton Books Ltd

Printed and bound in Dubai
10 9 8 7 6 5 4 3 2

Abrams books are available at special discounts when purchased
in quantity for premiums and promotions as well as fundraising or
educational use. Special editions can also be created to specification. For
details, contact specialsales@abramsbooks.com or the address below.

Abrams® is a registered trademark of Harry N. Abrams, Inc.

ABRAMS The Art of Books
195 Broadway, New York, NY 10007
abramsbooks.com

BRUCE SPRINGSTEEN

THE STORIES BEHIND THE SONGS

BRIAN HIATT

ABRAMS, NEW YORK

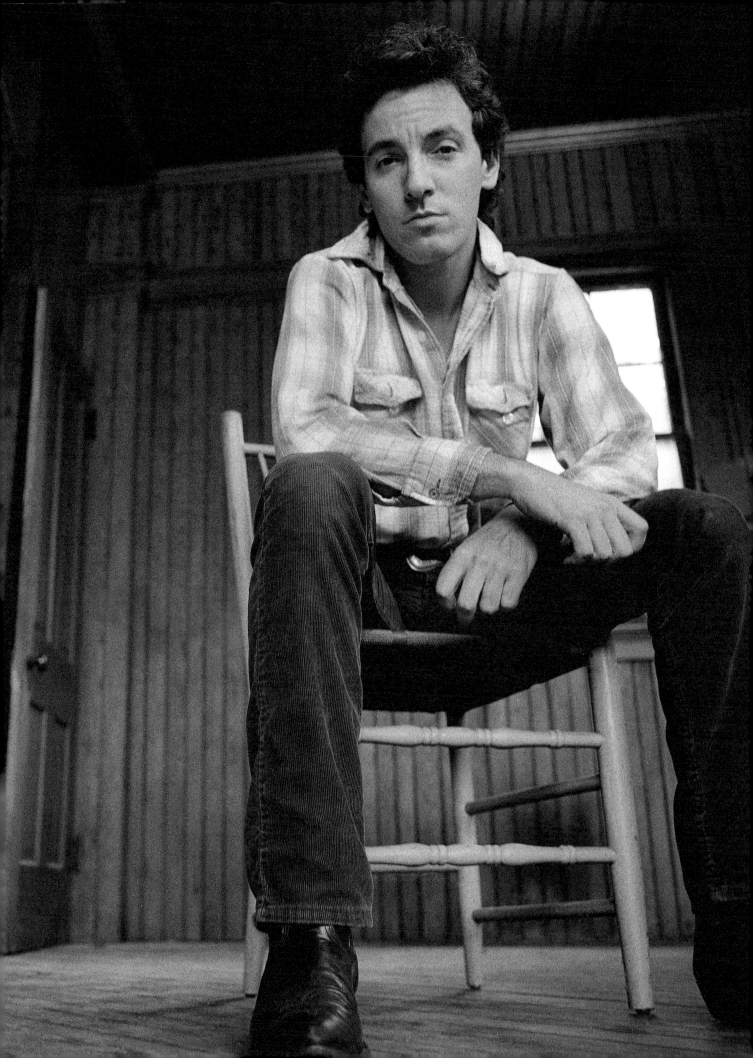

CONTENTS

•

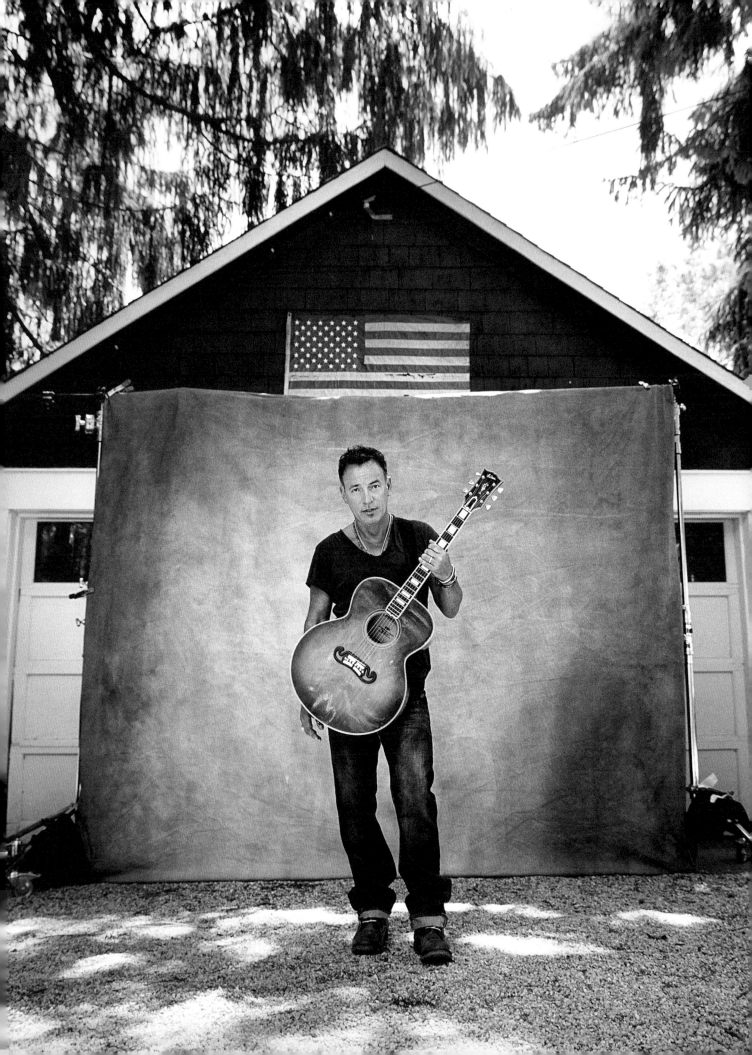

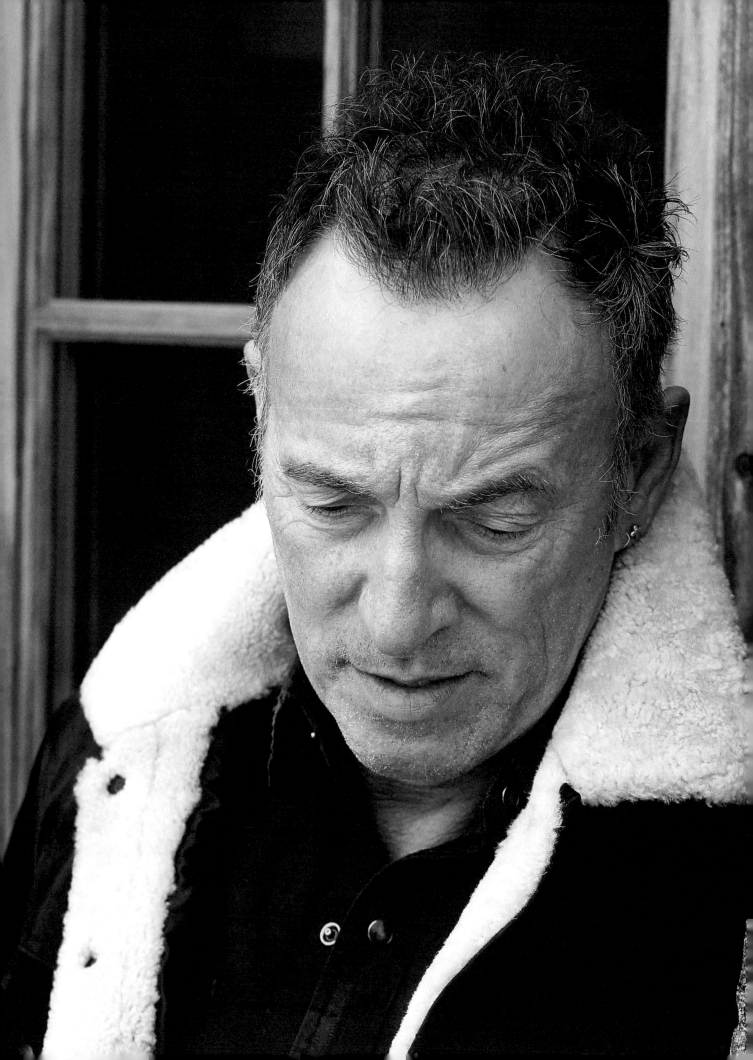

INTRODUCTION

You can try to explain it all. You can figure out the first two lines of "Badlands" probably came from the 1977 New York City blackout; you can prove there were no fireworks in Asbury Park the year "4th of July, Asbury Park (Sandy)" emerged; you can find the precise book and newspaper passages quoted on *The Ghost of Tom Joad*; you can trace songs from their earliest drafts; you can talk to people involved every step of the music-making and recording process. Nevertheless, the butterfly can't quite be pinned down. How *did* Bruce Springsteen write and record all those songs? Thankfully, that question can't be fully answered, even by Bruce Springsteen.

All that said, this book goes a long way towards unraveling the inspirations and creative process behind Springsteen's songs and recordings, with entries on every officially released studio track between 1973's *Greetings From Asbury Park, N.J.* and 2014's *High Hopes*. Among many other sources, it draws from 55-plus hours of new interviews I conducted with Springsteen's collaborators —musicians (E Street Band members Roy Bittan, Max Weinberg, Nils Lofgren and Soozie Tyrell, plus Tom Morello and many more) producers (Mike Appel, Chuck Plotkin, Brendan O'Brien and Ron Aniello) and engineers (Jimmy Iovine, Toby Scott and many others) from every phase of his career. Other key resources included my five interviews with Springsteen himself (all conducted between 2004 and 2016 for *Rolling Stone*) and raw transcripts of other Springsteen interviews, including many previously unpublished quotes, shared with me by incredibly generous colleagues. (All of my own fresh interview quotes are presented in present tense: "Roy Bittan says . . .") For a full list of interviewees and sources, see page 285.

The power of Springsteen's live performances, with or without the E Street Band (but especially with them) is such that they tend to overshadow the studio recordings—sometimes even in the mind of their creator. This book, however, is a chronicle of Bruce Springsteen as a recording artist, not just a songwriter, and digging in hard on the studio process provided some essential insights. (Springsteen's rhythm guitar is more of a driving force behind his recordings than most listeners might realize, for instance: the brilliant mix engineer Bob Clearmountain tells me that Springsteen refers to his electric rhythm parts as "the primal scrub.") The focus on Springsteen's own compositions and official

studio releases does mean there are a few omissions here: from great songs like "Seeds" and "Light of Day" that are as yet unheard in studio recordings, to the entire *Seeger Sessions* album, to the many bootlegged studio tracks that still haven't been released.

At the beginning of the book, we find Springsteen unburdened by doubt, a twenty-two-year-old laying down his first album without hesitation. Soon, his process grows as tortured as it is productive: the number of classic or near-classic songs he wrote, recorded and tossed away between 1977 and 1984 is astounding. (Thanks to his boxed set *Tracks*, and subsequent expanded album reissues, many of those songs have seen belated official release, and are included in this book.) By the 21st century, Springsteen recovers his initial nonchalance, writing with purpose and certainty, and recording quickly.

Many of the anecdotes in this book capture a vanished pre-digital era, when the record industry could allow a young artist to record for months on end, live in the studio with his road-tested band—when, as on "Something in the Night" and "Born in the U.S.A." a gesture from a frontman to his drummer could result in a spontaneous musical moment captured forever.

I was fortunate enough to spend many hours talking to Weinberg, the kind of drummer who remembers the exact details of those gestures—and just about everything else—forty years down the road. The importance of Springsteen's musicians, the E Street Band chief among them, comes through over and over here—Bittan, his keyboardist since 1974, had many revelations to offer on how he and the rest of the band helped the songs take shape.

Reevaluating Springsteen's catalog, song by song, offers a reminder of the essential seriousness of his project (producer Chuck Plotkin tells me that Springsteen approached it all with the gravity of a "brain surgeon"), and of the near-constant internal battles waged along the way. The moments of joy and triumph in his music are hard-fought, and oftentimes not what they seem. "White Americans seem to feel that happy songs are *happy* and sad songs are *sad*," James Baldwin once wrote, "and that, God help us, is exactly the way most white Americans sing them." For Springsteen, that was never a problem.

Brian Hiatt, New York, 2019

Previous spread: Frank Stefanko portrait of Bruce Springsteen, 2017.

Opposite: *Darkness on the Edge of Town*-era contact sheet, Frank Stefanko, 1978,

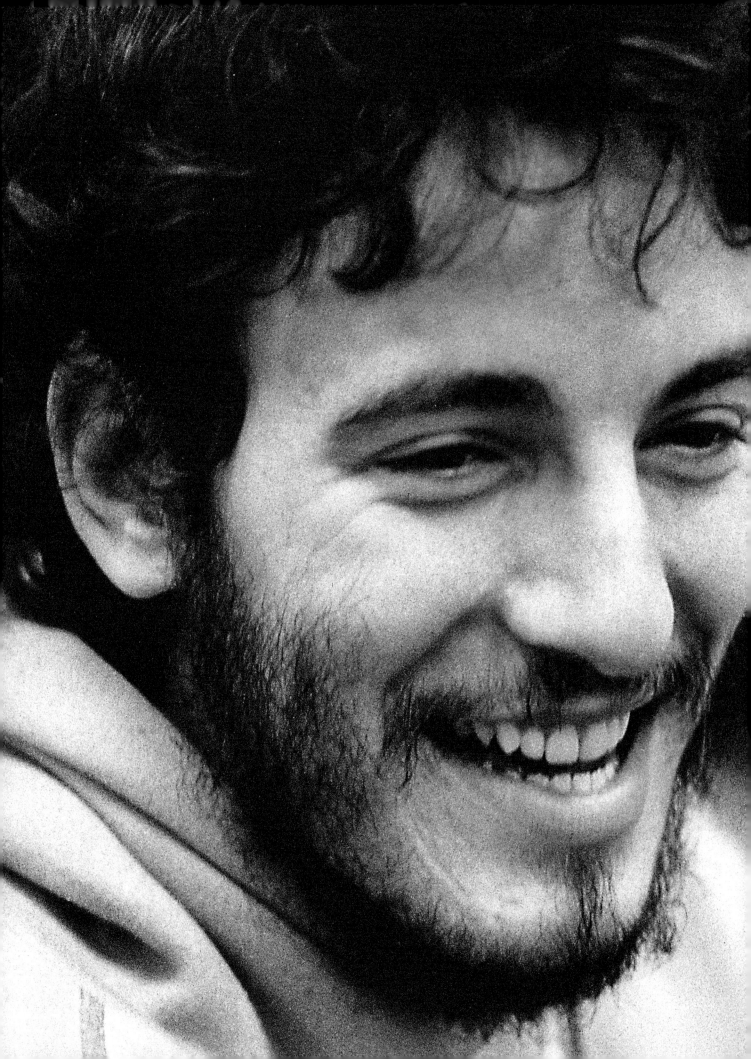

CHAPTER 1

•

1973
GREETINGS FROM ASBURY PARK, N.J.

•

BLINDED BY THE LIGHT

When Bruce Springsteen began working on his debut album, he was twenty-two years old, with an entire local career behind him in the shadowlands of New Jersey. "I had a lot of experience before that," he told me in 2016, "and I had a very clear idea of the kind of musician I wanted to be." His evolution was quick. His progressive hard rock band, Steel Mill, played its final shows in January 1971. By May 1972, he had grown a wispy beard and was auditioning at Columbia Records as a solo-acoustic singer/songwriter. In between, he crammed in an entire roots-and-soul phase back on his home turf of Asbury Park, mostly as frontman for the Bruce Springsteen Band, backed by the core of what would become the E Street Band.

He was Steel Mill's main songwriter, but those songs were, for the most part, vehicles for sludgy riffs and hippie-boogie jams of extraordinary length. One of their signature pieces, the multipart pseudo-rock opera "Garden State Parkway Blues," was the auditory equivalent of a drive down that highway's entire 171 miles. The band built itself around the formidable lead-guitar skills Springsteen first honed as a hard-gigging teenage frontman with his high school band, the Castiles. But Springsteen began to question whether he had a unique vision as a guitar player. "I said, 'Man, I can play the shit out of this thing, but I don't know if I have that,'" he told me in 2010. Along the way, Springsteen decided that his goal was to "summon up a world." "*Songwriters* do that," he told me. "There was a select group of guitarists that do it, and those are the very, very, very, very rare exceptions—Hendrix or the Edge. If I want to call up a world, that's songwriting, songwriting, songwriting, for me. If you're Frank Sinatra or Elvis, you can call it up with your voice. If you're not, you'd better think of something else, and I knew I wasn't."

"I felt I'd been gifted with a very, very high-octane journeyman's capabilities," he continued, "but I felt that that's what they were, and if I put those things together really, really thoughtfully and with enormous will and vitality, I can turn all of that into something that transcends what I felt my modest abilities were. The center of it was songwriting, so I delved into that with everything I had. I stopped playing in the band, I began to play just solo acoustically, and shortly thereafter is when I got signed for *Greetings From Asbury Park*." He found a producer/manager, Mike Appel, who, via sheer force of will, somehow got him in front of one of the greatest talent scouts in the history of the record business, Columbia's John Hammond. But in truth, Springsteen had parallel careers going until just a couple weeks before he met Hammond; when he wasn't recording solo demos in the city with Appel and then-partner Jim Cretecos, he was playing full-band concerts with the Bruce Springsteen Band in New Jersey and Virginia.

Appel and Hammond assumed Springsteen would make a solo acoustic album, but Springsteen himself wasn't so sure. Columbia Records president Clive Davis had his own doubts; the first draft of the album he heard included five songs with Springsteen backed by members of the Bruce Springsteen Band: Vini Lopez on drums, Garry Tallent on bass and David Sancious on keyboards (roadie Albee Tellone dubbed them the Pre-Street Band). There were also five acoustic tracks, including the seemingly endless (actually seven-minute-plus), entirely hookless, nearly melody-free, shaggy-dog acoustic tale "Visitation at Fort Horn." Davis informed Appel that they needed some songs that could, at least in theory, get radio play. "He said, 'ask Bruce to write two more, and make sure that they're with the band,'" says Appel. "'Let's take two out, put two in.'"

> **"I FELT I HAD BEEN GIFTED WITH A VERY, VERY HIGH-OCTANE JOURNEYMAN'S CAPABILITIES... AND AT THE CENTER OF IT WAS SONGWRITING."**
>
> **BRUCE SPRINGSTEEN**

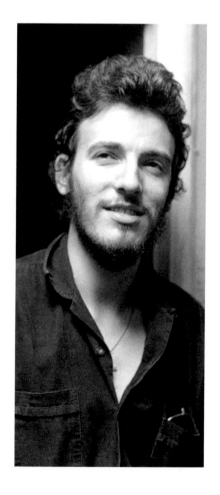

Unfazed, Springsteen went back to his rhyming dictionary and wrote "Blinded by the Light" and "Spirit in the Night"—reportedly alongside a third song, "The Chosen," which is still unreleased, even on bootleg. He also removed "Visitation" and two other acoustic songs from the album. "Clive made *Greetings from Asbury Park* a much better record by simply making that request," Springsteen told me in 2016. "He did me a great service." The two new tracks also gave Springsteen a chance to finally team up with a New Jersey saxophonist he'd gotten to know, Clarence Clemons, who had been "missing in action" when Springsteen initially tried to find him for the album. Over the years, Springsteen's use of Clemons in the studio would get increasingly more precise and controlled, but on "Blinded by the Light," he's let loose: Clemons plays R&B licks throughout the entire song.

Tallent and Sancious were in Richmond, Virginia, at the time "Blinded" was recorded, so Springsteen and drummer Vini Lopez were the only musicians around from the previous sessions. Springsteen overdubbed an assertive bass guitar part himself, while a skilled session player, Harold Wheeler, played some way-down-in-the-mix piano. "Blinded by the Light" is, incredibly, the only track on *Greetings from Asbury Park, N.J.* where Springsteen plays any electric guitar at all. In the earlier sessions, Appel banned the instrument, arguing that they were making a folk album. "I got signed in the pack of new Dylans," Springsteen told me, "but I could turn around, kick-start my Telecaster and burn the house down. It's an ace in the hole."

In the opening bars, Springsteen plays a clever little chordal lick that could have been emphasized more. "When the record came out," recalls Appel, "I said, 'You know what? We should have stopped the record and had a little break in it, and gotten that riff again.' I said, 'Hindsight, Mike. 20/20 hindsight.'" The electric rhythm guitar part that follows is strikingly similar to the intro of the Doobie Brothers' "Listen to the Music," which came out in September 1972, right around the time Springsteen recorded "Blinded." (Appel hears the resemblance but says that, to the best of his knowledge, it's a coincidence.)

As with other tracks on *Greetings*, "Blinded by the Light" was a coded autobiography, crammed with so many words and images that, as Springsteen later joked, his rhyming dictionary was "in flames, it's hot in my hands." The madman drummer in the first line is Lopez, whose temper earned him the nickname "Mad Dog." When Manfred Mann had a worldwide smash with the song in 1976, they were unwittingly singing about a guy from New Jersey who had been tossed out of Springsteen's band two years earlier. "Indians in the summer" is a reference to Springsteen's teenage Little League team, as confirmed in an August 31, 1961, edition of *The Freehold Transcript* newspaper that mentions Springsteen's name and the Indians' winning record. Even the line about catching the clap was based on "a little road experience, unfortunately," as Springsteen said in his 2005 *Storytellers* episode.

The song's best lyric, Springsteen said, arrives at the end, where he tries to justify staring at the sun: "That's where the fun is." "That was where I wanted to go," he said in 2005. "I wanted to get blinded by the light. I wanted to do things I hadn't done and see things I hadn't seen . . . So it was really a young musician's tale, kind of a litany of adventures." In Manfred Mann's hit cover, the word "deuce" in the chorus sounds an awful lot like "douche"; Springsteen's better-enunciated version didn't chart at all. "Maybe I should've changed that word," he said.

Previous spread: The journeyman, 1974.

Opposite: Portrait mode, 1973.

Below: Springsteen midway through a performance at the Schaefer Music Festival, New York City, August 3, 1974.

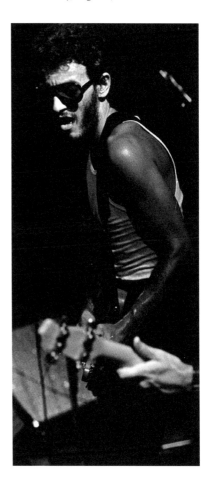

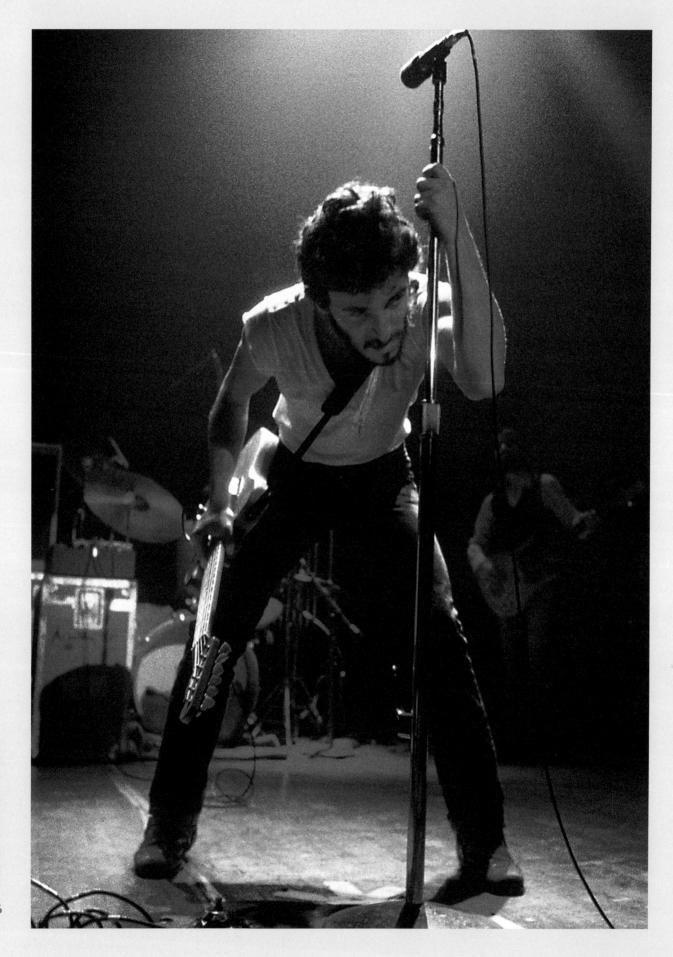

GROWIN' UP

By 1972, the Asbury Park music scene had largely imploded, and Springsteen was living among its ruins. The Upstage, the all-night club where he met many of his future collaborators, was no more. Even its bohemian founder, Tom Potter, a one-time hairdresser, had left town after a split with his wife. Springsteen and a couple of friends were paying sixty dollars a month for the Potters' bizarrely decorated former apartment, which looked like "the backseat of Tom Waits' Cadlllac," as he wrote in his memoir, with a red-on-black color palette and "thousands of bottle caps glued to the kitchen ceiling."

The apartment was on the third floor above the Potters' abandoned beauty parlor, complete with a row of hair-dryer chairs. Springsteen kept a piano in the back of the parlor, which connected to the apartment through a false wall. "I'd go down there at night when it was quiet," Springsteen told the writer Robert Santelli in 2017. "It was a little spooky, but I would start to work on these songs. At the time, I was very influenced by [Bob] Dylan and a lot of other writers, Tim Buckley . . . so I said, 'I'm going to be a poet'—I hadn't read any poetry, but I'm going to be a poet! . . . I was using this very intense poetic imagery, which now, looking back on it, doesn't feel like poetry but rather an insane, crazed sort of lyricism."

Springsteen told Appel that, because he wasn't playing out much, he'd try to go to sleep "at normal people hours" during this period, but found himself bolting awake around two or three o'clock in the morning. "He was writing his fool head off because he got jolted from his sleep," says Appel, "and propelled to write those lyrics. I'd say, 'God Almighty. It's hard to think that if you were in your waking state, and concentrating on what to write about, that you would write like that.'"

Springsteen appears to have taken the music for "Growin' Up" from a song he demoed in early 1972 called "Eloise," which had an identical guitar part and melody but far more forgettable lyrics. Early drafts of the "Growin' Up" lyrics show some changes along the way; he originally hid in the "mother breast" of the crowd rather than its "clouded wrath"; his companion was originally the graduate of a "sweet shop" rather than a jukebox; he cut some lines about getting busted in Tijuana, Mexico. Also, the lines about "a silicon sister" from "Blinded by the Light" were originally part of "Growin' Up," but he crossed them out.

The piano solo is the album's first spotlight on Sancious, then an eighteen-year-old musical prodigy who had been one of the few black faces at the Upstage. "Wow, I haven't heard that in years," says Sancious, listening to the solo in spring 2018. "We're on D minor and we're going to F, but there's a universe of possibilities in just that simple thing, and he just told me, 'play what you feel.'"

Again, Springsteen locates a single pivotal moment in the song, in this case when he finds the "key to the universe" in an old car. "That was important," he said onstage in 2003, "'cause that's what I was trying to do. I found so much in culture that was considered to be transient and trash. I felt that I heard a world of pain and pleasure and beauty and darkness, all coming out of those little records on the radio, and I knew that it was there. I wanted to find my key to that—the idea is that it's there, even in this town, if I look hard enough, you know?"

And as for that wrathful crowd: "I grew up feeling it was a hostile and pretty nasty world out there," he said. "And that I was broken, but that I was still magic, you know? And that's what you feel in this song, There's the insistence on a certain sort of magical fantasy, almost. Which can be, at a certain moment, when you're young, pretty life-sustaining."

> **"I GREW UP FEELING IT WAS A HOSTILE AND PRETTY NASTY WORLD OUT THERE. AND THAT I WAS BROKEN."**
>
> **BRUCE SPRINGSTEEN**

Opposite: Bathed in light, Bruce performs at the Trenton War Memorial, Trenton, New Jersey, November 29, 1974.

MARY QUEEN OF ARKANSAS

Of all the songs Springsteen played at his Columbia Records audition, Hammond was least impressed by "Mary Queen of Arkansas," which he found to be "pretentious." That's one of the nicer things people have said over the years about the song, one of the two solo tracks on the album; critic Robert Christgau called it a "turgid unaccompanied-acoustic horror." The version Springsteen demoed in a Columbia studio the day after he met Hammond is superior to the album cut, with a less agitated vocal and an amusing alternate lyric in which he's "a change man at your laundromat." When Springsteen sings that Mary is neither "man enough" nor "woman enough," his meaning should have been somewhat clear, but he didn't reveal until 2014 that he was writing about "a man in love with a transvestite." "Didn't think about that one before, did you?" he said onstage. "Go back and listen to those lyrics."

Springsteen recorded "Mary," and the rest of the album, with a brand-new Martin D-28 acoustic guitar borrowed from Larry Alexander, a young assistant engineer at 914 Studios. "Bruce didn't really have a great guitar," says Alexander, who still owns the instrument. "I drove home, got my guitar, let Bruce borrow it." They would record at 914, a budget studio next to a diner in Blauvelt, New York, until 1974.

DOES THIS BUS STOP AT 82ND STREET?

Partially dashed off on an actual New York City bus headed to 82nd street, where a friend of Springsteen lived, it's a more-or-less straightforward account of what the young singer saw through the window that day in

Below: Back to back with bandmate Clarence Clemons at the Trenton War Memorial, Trenton, New Jersey, November 29, 1974.

Opposite: Springsteen and the band pose for photos in Long Branch, New Jersey, August 29, 1973. (L–R: Clarence Clemons, Danny Federici, Bruce, Vini Lopez, Garry Tallent, David Sancious).

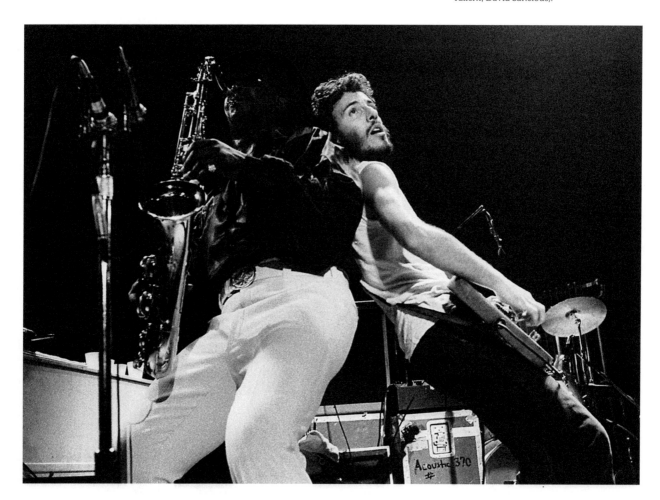

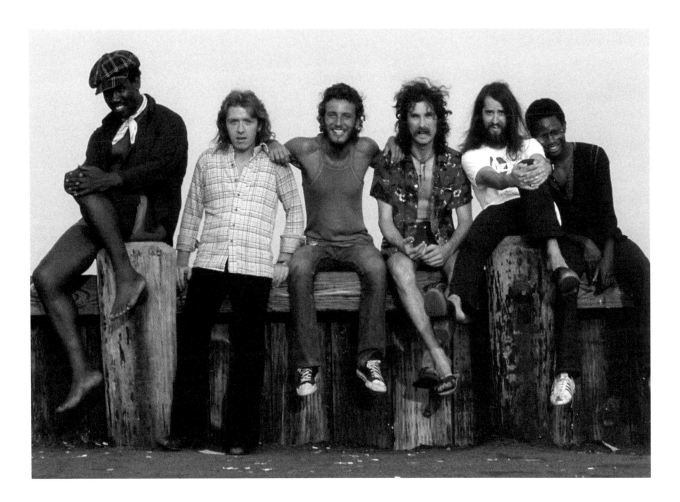

1972: pimps in their shorts and long sweat socks; marquees advertising porn movies; glamorous city women who reminded him of Joan Fontaine, a movie star from his childhood. The series of snapshots is beguiling enough to hide the fact that the song has no chorus and is barely more than two minutes long. It was perfectly satisfying in its solo acoustic version at the Columbia studio; the band adds so little that you can begin to understand why Hammond and Appel initially pushed for a solo acoustic album. "I said, 'Anybody who writes lyrics like this doesn't need a band,'" says Appel. "Especially on the first album, this should be just you, Bruce Springsteen.' And he said, 'Well, I agree with you partially, but I think I should try some with the band.' I said, 'You know what? Go ahead and try it.'"

Especially here and on "Blinded by the Light," Lopez's playing is highly idiosyncratic; instead of playing a steady beat, he smashes through nonstop fills, syncing with Springsteen's guitar, almost as if he's strumming one himself. "You almost forget about the fact that you're supposed to be playing drums," Appel recalls telling Lopez (as praise), "and you consider yourself like some guitar or a keyboard, and you're going to do whatever you feel like, and the strict rhythm be damned. Keith Moon, that's who you're closest to."

Springsteen said onstage in 2003 that "Does This Bus Stop" wouldn't have worked without one of its final lines, the one that promises that "there's still hope." "That's the song," he said. "Without that, the song doesn't get on the album. Somebody once said that you just need one good line that takes you where you want to go, and the other stuff is kinda getting there. And I think that's true."

LOST IN THE FLOOD

Aside from "Spirit in the Night," no song on *Greetings* feels more closely tied to the next four decades of Springsteen's writing than "Lost in the Flood." The first of the many Vietnam veterans Springsteen would write about appears here, as does the first hint of his arena-bound penchant for musical drama, storytelling lyrics and social commentary. The track is just voice and piano until Springsteen bites down on the line about Jimmy the Saint—and the band comes slamming in like an exclamation point. It's the first of many such moments in the catalog.

The song starts with an ominous rumble: Steve Van Zandt's only contribution to the album, man-handling Springsteen's guitar amplifier. "I punched the amp," Van Zandt told me. "In those days, they had a built-in reverb, and it made a sound like thunder or something. It was a cheap special effect." The effect was probably supposed to be an explosion, much like the one at the beginning of Tim Buckley's 1967 antiwar song "No Man Can Find the War," foreshadowing the similar subject matter.

An early handwritten draft of the lyrics sheds light on some of the song's foggier corners, although it fails to clarify whether the gunner in the first verse might be the same person as stock-racing Jimmy the Saint in the second. In the original first verse, our returning veteran realizes that "times have painfully changed," which makes it more clear that the "wolfman fairies" in drag (not to mention the fantasy images of pregnant nuns at the Vatican) are seen entirely through the character's eyes: the wolfmen are almost certainly just a bunch of hippies. There are also references in the draft to Noah and an ark parked on Main Street, just in case the apocalyptic nature of the flood imagery wasn't evident. In the finished song, the third verse is a mini movie, with the violence of a New York City gang shootout mimicking the war overseas.

It's one of Lopez's most forceful performances on record, but the arrangement doesn't have any acoustic guitar, let alone the electric punch it badly needs. "We wanted everything to be sparse even with the band," says Appel. "What happened is, that thinking still permeates those sessions, and permeated the final sounds and the mixes, and all the rest of it." It's almost certainly an uncredited Springsteen pounding out the simple piano chords at the song's spine, while Sancious unleashes doomy organ runs behind him. "You gotta feel like you're lost in the flood," says Sancious, "and you gotta express that musically. You have to take your feelings and you have to pretend. Its like acting. You're taking on a personality of someone in a story."

After sitting unplayed for twenty-two years, "Lost in the Flood" finally reached its full potential in 2000, when Springsteen broke out a gargantuan, hard rock arrangement with the latter-day E Street Band.

THE ANGEL

In a 1974 interview, Springsteen bragged of writing this acoustic vignette about a motorcyclist and a young girl in a mere fifteen minutes and called it "one of my favorites, because it's one of the most sophisticated things I've written." Even at the time, he was nearly alone in his admiration for the song, although it's aged a little better than "Mary Queen." There's a neat image of a highway jammed with clunky Volkswagen vans (filled, perhaps, with broken heroes) while the Angel zooms past them, nimble and free, on his motorcycle. Session musician Richard Davis, who also appeared on one of Springsteen's favorite albums of all time, Van Morrison's *Astral Weeks*, plays stand-up bass on this track, using a bow that creates a cello-like effect.

> ## "YOU GOTTA FEEL LIKE YOU'RE LOST IN THE FLOOD... AND YOU GOTTA EXPRESS THAT MUSICALLY."
>
> **DAVID SANCIOUS**

Opposite: A triumphant year: Bruce posing backstage, 1974.

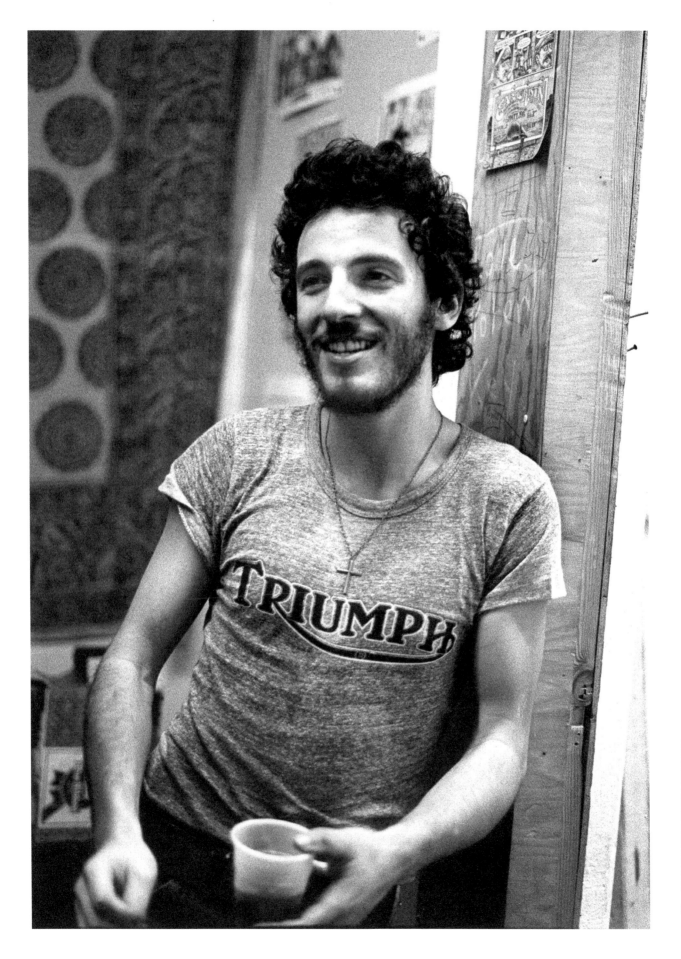

FOR YOU

Just before Christmas 1971, Springsteen had his heart broken by a troubled blonde "surfer girl." In his memoir, *Born to Run*, he called her "a drug-taking, hell-raising wild child . . . so alive, so funny and broken . . . She stirred up my Catholic school-bred messianic complex." Soon afterward, he wrote "For You," a story about trying to save a tormented girlfriend who has "barroom eyes." The song appears to end in his lover's death, while Springsteen's real relationship ended when he learned she was cheating with various out-of-town rock stars (probably the "carpetbaggers" he mentions in the song) and he took up with her roommate. The song feels inappropriately frantic on the album; the solo piano versions Springsteen would later play live better suit the anguish in the lyrics. (When Van Zandt visited 914 Studios, he recorded some slide guitar overdubs on "For You," but Appel rejected them as "too busy," Van Zandt told me.)

SPIRIT IN THE NIGHT

Before his adventure with his troubled blonde girlfriend, Springsteen had a memorable night in summer 1971 with a sixteen-year-old brunette named Diane Lozito, who would become his girlfriend the following year. She was dating a guy named Billy who liked to party; Springsteen nicknamed him Wild Billy. "One night at the beach, when Billy and the others were drinking, Bruce and I tucked around a rock and started kissing," Lozito told an interviewer in 2008. "Then I said, 'It's time to go,' because I was so scared of getting busted by Billy." The next day, Springsteen showed her a lyric he wrote about a "lonely angel."

Springsteen immortalized (and romanticized) every detail of that evening in "Spirit in the Night." Assuming that Lozito had her chronology correct, he had at least one line of the song completed a year before Clive Davis made his request for potential hits. Musically, the R&B of "Spirit" "pointed toward my next record already, toward the *Wild, the Innocent*," as Springsteen told me in 2016. The song has some faint, possibly coincidental similarities to Aretha Franklin's "Spirit in the Dark"—and Springsteen reportedly acknowledged taking some lyrical inspiration from the Band's 1971 song "The Moon Struck One," in which a character is "really hurt . . . lying in the dirt." Springsteen, who had been infatuated with the Joe Cocker-led *Mad Dogs and Englishmen* live album, also said that he wrote "Spirit" with Cocker's not entirely un-Springsteen-ian voice in mind.

The song was a showcase for Clemons, who carried the song's riff, Springsteen's first great one. Clemons often insisted that the first time he jammed with the Bruce Springsteen Band, in 1971, they were playing an "early version of 'Spirit in the Night.'" "The music brought us together so strongly," Clemons said in 2010 at a lunch with *Rolling Stone* editors. "It was so real, and it felt like everything I wanted to say and how I wanted to say it. We just fit like a hand in glove."

"Spirit in the Night" would become an E Street Band staple, but just as with "Blinded by the Light," Springsteen plays multiple instruments on the album version, backed by Lopez, Clemons and session pianist Wheeler. It's still the most realized production on the album, complete with Clemons's rich backing vocals on the chorus. For Appel, it was also the moment when he finally understood why Springsteen wanted to work with a band. "This saxophone player is playing these cool riffs, and Bruce is writing songs that capture those riffs in the right musical environment," he says. "I thought, oh, Mike Appel, you were wrong—this is gonna work out."

"THE MUSIC BROUGHT US TOGETHER SO STRONGLY. WE JUST FIT LIKE A HAND IN A GLOVE."

CLARENCE CLEMONS

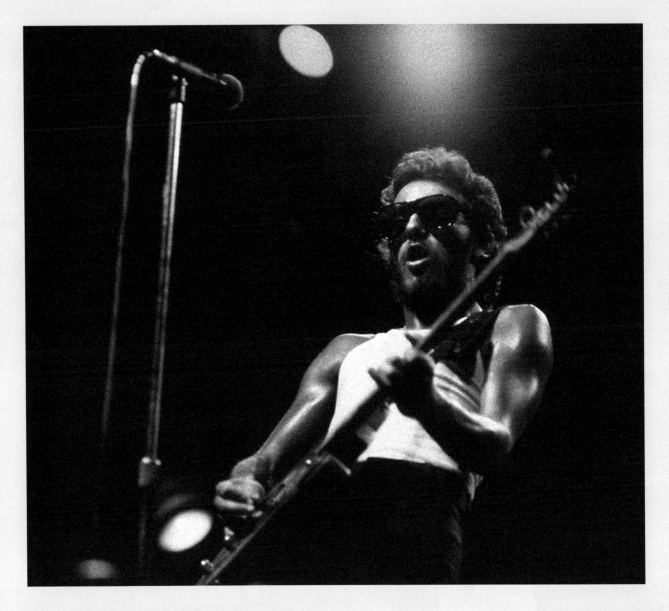

IT'S HARD TO BE A SAINT IN THE CITY

The swaggering imagery of this song had a mesmeric effect on listeners when Springsteen played it solo as an audition piece in 1972. "I was just so thunderstruck by the words," says Appel, who's particularly fond of the part about a "Harley in heat," saying, "I was transfixed." It was the first song Springsteen played for Hammond, and the moment he finished, the executive welcomed him to Columbia Records. "I just couldn't believe it," Hammond told a journalist in 1973.

"Saint in the City" is highly effective as a full-band rock song, driven by some inventive hi-hat work from Lopez. It's probably Sancious's strongest track on *Greetings*, beginning with a wild, bluesy solo in the intro that dips into full-on jazzy dissonance. "Wow, that's nuts," Sancious says in 2018, listening to the track, which he recorded at the age of eighteen. "That's pretty adventurous for us to do back then as teenagers."

The song's lyrics are pure braggadocious jive, a suburban kid's fantasy of conquering New York City, becoming the "pimp's main prophet" in the process. But the New Jersey in Springsteen inevitably comes out with an amusingly melodramatic account of what sounds like his first journey by subway.

Above: Enjoying the spotlight at the Schaefer Music Festival in New York City's Central Park, August 3, 1974.

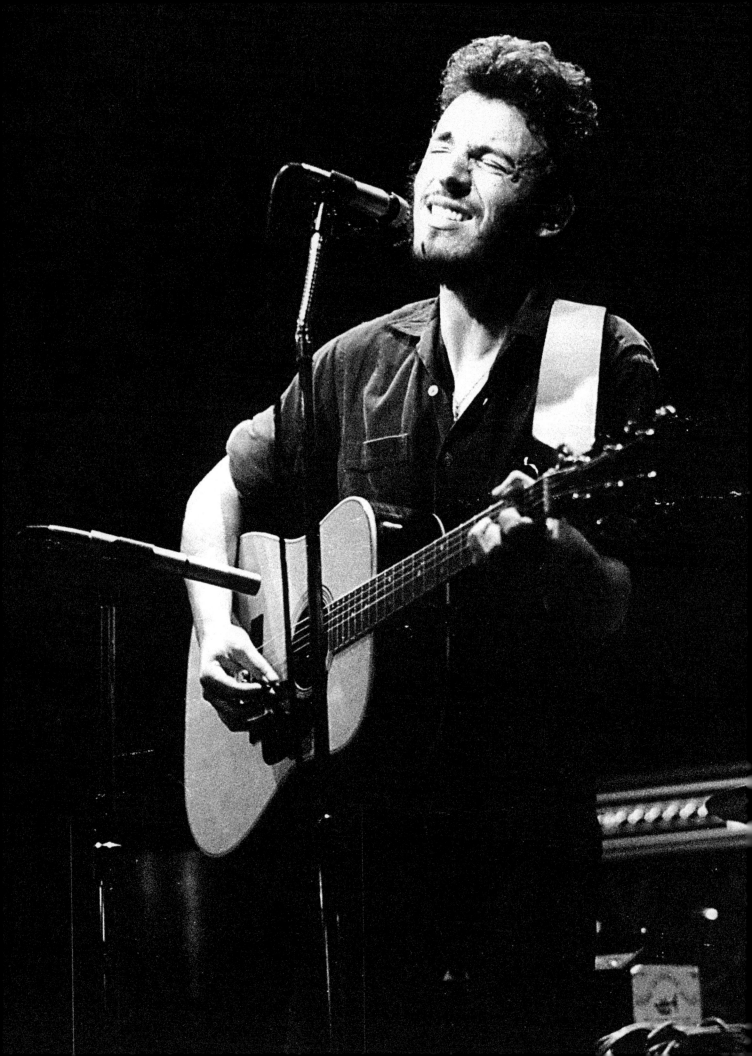

1973
THE WILD,
THE INNOCENT &
THE E STREET
SHUFFLE

THE E STREET SHUFFLE

In the beginning, there was the monkey. One of a series of post-twist sixties dance crazes, it reached the teenage masses in 1963 via one of the first true soul hits, "The Monkey Time," by the sweet-voiced Chicago singer Major Lance. Lance's childhood friend Curtis Mayfield wrote the song, playing guitar chords that bounce off a rumbling mix of bass trombone and baritone sax to create a junkyard-funk signature motif. A decade later, when Bruce Springsteen created a kind of existential dance-craze song of his own, he built it around a close approximation of that riff. Major Lance urged us to "do the monkey"; in Springsteen's song, we learn about an entire town worth of street kids "doin' the E Street shuffle."

"I wanted to describe a neighborhood, a way of life," Springsteen wrote in his book *Songs*, "and I wanted to invent a dance with no exact steps. It was just the dance you did every day and every night to get by." When roadie Albee Tellone first heard the song, played on piano and acoustic guitar in David Sancious's house on the actual E Street in Belmar, New Jersey, he instantly recognized the "Monkey Time" lift. "Don't worry about it," Springsteen told Tellone, according to the roadie's autobiography. Appel was also unconcerned: "You can't copyright a riff," he points out. "And it's entirely different rhythmically, with different chord changes and what have you." Years later, Springsteen would record a track for a Mayfield tribute album and honor him at the Grammys, before again nodding to "The Monkey Time" on 2002's "Mary's Place"—not to mention covering "It's Alright" onstage and incorporating "People Get Ready" into "Land of Hope and Dreams."

On "E Street Shuffle," Sancious bridged the gap between early-sixties R&B and the then-current model, playing a wildly syncopated part on a clavinet that growled through a wah-wah pedal, à la Stevie Wonder. "It was R&B for sure, but with Bruce's lyrics," says Appel. "No R&B song ever had lyrics like that." Springsteen played his funkiest-ever rhythm guitar, returning to his Bruce Springsteen Band sound, and at one point, somehow contorted his voice into an authentic James Brown shriek.

In all, the song announces an album that is a wild leap away from the austere *Greetings*, built around the idiosyncratic strengths of the *avant-la-lettre* E Street Band Springsteen had toured with since that album's release. Vini Lopez, Clarence Clemons, and Garry Tallent had been on board since the first album sessions, and former Steel Mill keyboardist Danny Federici joined as well, after receiving assurances that this band was not another passing phase. After playing on *Greetings*, Sancious went off to find work at a studio in Richmond, Virginia, but Springsteen finally convinced him to join the band in the middle of sessions for the second album. As a prodigally gifted, classically trained teenager, Sancious played in Asbury Park's jazz and R&B scenes before summoning the courage to cross racial lines and become one of the only black musicians at the Upstage. His unleashed chops became a linchpin of the second album's arrangements, and one of the reasons why it sounds like no other Springsteen music.

Springsteen wanted the album to wipe away any remaining conceptions of him as a mellow, solo singer/songwriter, although in 1973 that was a far more commercial proposition than a cosmic street-urchin, R&B poet. "I put my band together as soon as I had a little money, the ability to do it," Springsteen told an interviewer in 1974. "If I had guys behind me, I want each guy to be *happening*. It makes the whole difference. I got guys that play great—let 'em play!"

> **"IT WAS R&B FOR SURE, BUT WITH BRUCE'S LYRICS. NO R&B SONG EVER HAD LYRICS LIKE THAT"**
>
> **MIKE APPEL**

Previous spread: An early stage shot of Bruce with acoustic guitar, circa 1973.

Opposite: On the Jersey Shore, August 1973.

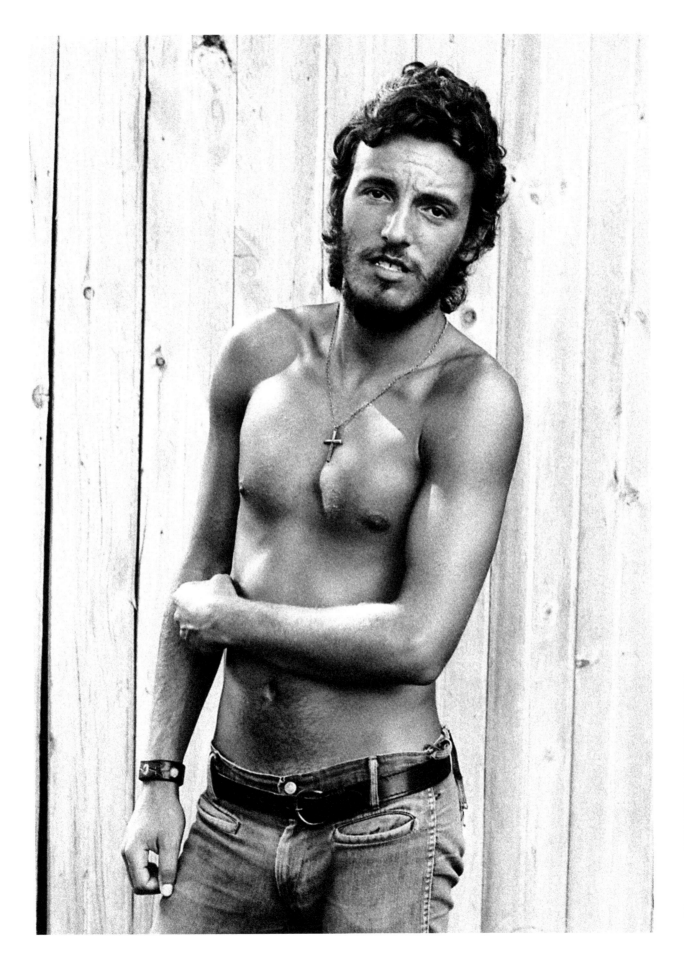

"The first album came out and a lot of wrong impressions were taken about, just, who I was," Springsteen continued. "The record company didn't know what I was, my own manager and producer didn't know who I was. So . . . I said I gotta straighten this out. So I rode the band heavy on the second album. I wrote songs and I arranged. I made sure there was a lot of music going on, and a lot of colors and different tonalities. Because I figured . . . I'd try to get it somehow so people would get a more clear picture of who I am and where I am."

"The E Street Shuffle" was Springsteen's first attempt at an elaborate studio creation—pretty much everything on *Greetings* had been recorded live, often in a single take, with minimal overdubs. They recorded a live basic track, and kept only Lopez's drums and Tallent's bass, overdubbing everything else, including horns, many layers of keyboards, several guitar parts and the fake street chatter buried in the background. Lopez remembered some tequila was involved as they gathered around a microphone, saying stuff like "What it is?" and "What are you looking at?" Appel wonders whether the track might be too dense, and wishes it built up more slowly to the full arrangement onslaught. "It's a busy, funky track," he says. "When I sometimes go back and listen to it, I say to myself, 'whoa, you got a lot of things going on here.'

The intro and coda were recorded separately from the rest of the song; in the latter section, Richard Blackwell, a guest musician from Asbury, overdubbed a rented Latin percussion kit, piece by piece. For the intro, the horn section was Clemons, Tallent on tuba, Lopez on cornet, and Tellone on baritone sax. Tellone was mostly a guitar player and hated playing saxophone—it was his high school instrument—but endured it for the chance to play on a Springsteen album. "We had to record a little prelude that Bruce called the tune-up," Tellone wrote in his entertaining book, *Upstage, Springsteen and Me.* "We played random notes to make it sound like an orchestra tuning up before the conductor raised the baton. Then we played what marching bands call a 'fanfare'—just a few measures as an introduction." Louis Lahav, who engineered the first album, remembers deliberately making the horns "very shrill and annoying, thin and bright."

"In that album, Bruce was feeling much more adventurous in terms of arrangements," says Sancious. "We had all kinds of energy, so we were trying all kinds of ideas. When it worked, we knew it, and we could move on. It wasn't like a torturous process. It was more like kids in a candy store, and that's the perfect thing for that song."

4TH OF JULY, ASBURY PARK (SANDY)

Fireworks blazed across the sky above the beach in Asbury Park on every Fourth of July since World War II, but not in 1973. "The fireworks company was unable to include Asbury Park in its bookings for tomorrow," the Asbury Park Press wrote on July 3, before quoting the troubled city's beach director on the situation: "It is not a happy thing," he said. That July, Springsteen was in the middle of on-and-off sessions for his second album, interspersed with tour dates, and living in a garage apartment in Bradley Beach, just south of Asbury, with his girlfriend Diane Lozito. He had the day off at home on July 4, and Bradley Beach did have fireworks that year.

Something about it all triggered a wave of nostalgia for Springsteen, who debuted a nearly completely formed version of a sublime new song in concert on July 21, 1973, and recorded it the following month. "Sandy" feels like it takes place a couple years after "The E Street Shuffle," with the party finally over. It's a love song of sorts—he promises to adore Sandy forever, and

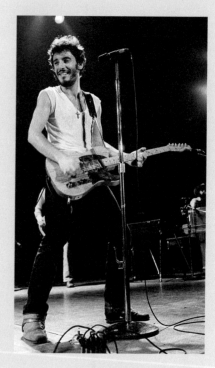

Above: Trenton War Memorial show, Trenton, New Jersey, November 11, 1974.

Opposite: Bruce Springsteen poses for a portrait in Long Branch, New Jersey, August 1973.

also warns that he might not ever see her again—but the narrator is really infatuated with its setting, the town Springsteen once called "dumpy." Yet he obviously adored it enough to immortalize the "carnival life" he had lived there, to send the name of the local fortune-teller, Madam Marie, around the world, to capture forever the moment when the breeze off the Atlantic grew chilly, with fall moving in. He drew all the right lessons from Van Morrison's use of real places and street names in his lyrics. That said, the idea of chasing lusty local girls "under the boardwalk" was probably more of a nod to the Drifters than anything Springsteen or his buddies ever attempted. "I never hung out under the boardwalk," Lopez told me in 2010. "There were *rats* under there! And near Convention Hall there was drunks and they would rob you under there."

The song's third verse was oddly mutable from the beginning. In the original live rendition, there were "North Side Angels" with waning desire, but in the final studio version it became a waitress who lost interest instead. (According to Peter Carlin's biography, Lozito became concerned that this was an actual confession.) In most subsequent live versions, the waitress is gone, replaced again by the motorcycle gang, minus the "North Side" part. For what it's worth, an unearthed, 1973 handwritten work sheet suggests that Springsteen considered The North Side Band, along with the North Ward Band and The Snakers Band—maybe he meant "sneakers"—as alternate names for the eventual E Street Band.

The live version of "Sandy" Springsteen played in July was just acoustic guitar and Federici's accordion (he was good enough on the instrument to have won talent shows in his youth), but Springsteen was wary of committing any more bare-bones tracks to record. "It's got to jump off the record player," Springsteen told an interviewer in 1974, explaining that fuller arrangements "make the song a little more alive. I don't want to be Mr. Esoteric: 'Let's do this song naked.'" (Too bad: "Mr. Esoteric and the Sneakers Band" has a ring to it.)

> **"THE RECORD COMPANY DIDN'T KNOW WHO I WAS...MY OWN MANAGER AND PRODUCER DIDN'T KNOW WHO I WAS."**
>
> **BRUCE SPRINGSTEEN**

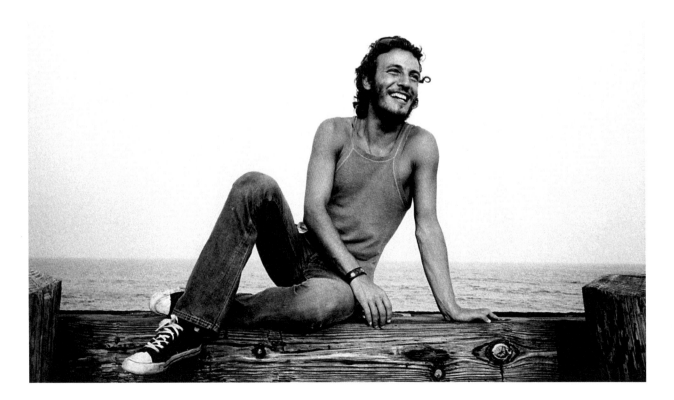

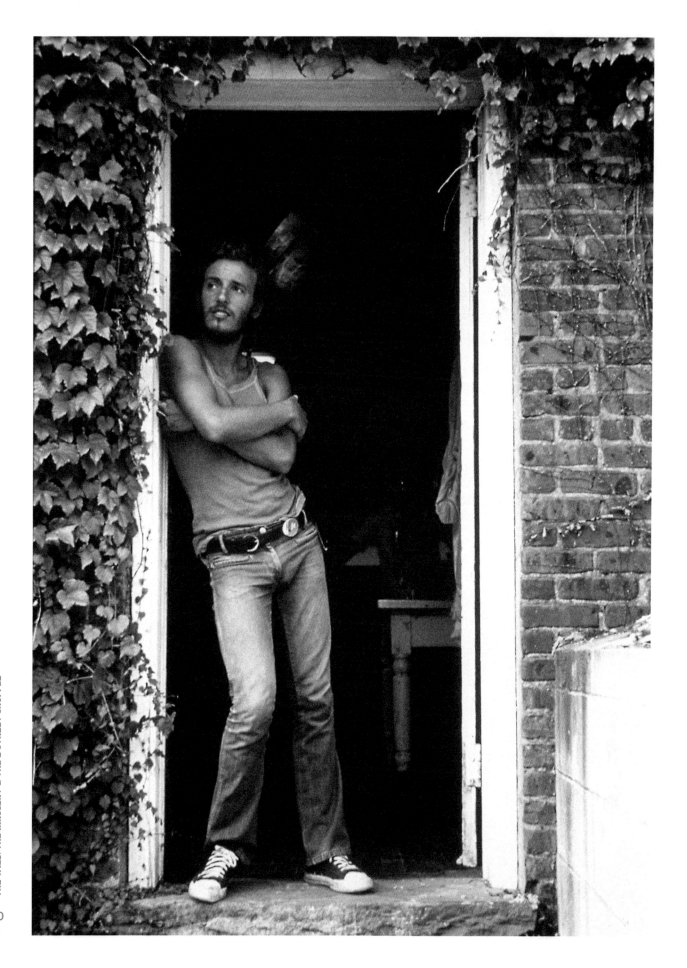

"Sandy" was the only song on the album that the band hadn't rehearsed in advance. "Bruce came into the studio and said 'try this,'" Lopez told me in 2010. Later, Springsteen dubbed four separate electric guitar parts over the intro, and even played a part on the recorder towards the end. Appel confirms the legend that a children's choir was supposed to come in to record angelic background vocals on the song. When they didn't show up, Springsteen enlisted recording engineer Louis Lahav's wife, Suki, in their stead. Lahav swears that while his wife leaned into a microphone and sang layer upon layer of harmonies, she was also breastfeeding their infant daughter.

KITTY'S BACK

Depending on which story you believe, Springsteen saw the sign either at a strip club somewhere on tour or at a go-go dancing spot called the Sportsman's Club on Route 33 in New Jersey. Either way, its message welcomed a dancer who had been away: "Kitty's Back," it said. The seven-minute-long song he attached to those words illustrates his "let-'em-play" philosophy of the moment, owing a fair amount to both Van Morrison (in concert, they would stick in actual chunks of Morrison's song "Moondance") and some of Springsteen's lengthy Steel Mill improv pieces. It sounds like something the characters in "Sandy" would hear blasting out of a boardwalk bar, and the lyrics, for once, are secondary; it's a simple tale of a guy who can't help forgiving his unfaithful girlfriend.

The solo over the opening bars is something of a coming-out party for Springsteen's guitar playing (although early live versions suggest that an alternate idea was to have Springsteen and Clemons soloing at once, which blunted the guitar's impact). Years later, in an interview with the Rock and Roll Hall of Fame's Jim Henke, Springsteen cited the solo as one of the best examples of the sound of his signature Fender Esquire (which is actually a hybrid—someone stuck a Telecaster body on an Esquire neck). Sancious also takes a lengthy organ solo. "That's what happens when he gives you space," Sancious says. "It's not something I asked for. When he gives you that much trust and opportunity to do it, it just comes out."

Springsteen has never mentioned the connection, but he began recording "Kitty's Back" in late June 1973, just two weeks after getting home from a disastrous series of arena concerts opening for Chicago. It is, at the least, a remarkable coincidence that he would turn his attention to a jazzy, twisty composition of his own after thirteen nights of watching crowds groove to that band's slick, horn-driven jazz-pop sound while largely rejecting his music. However, in a circa 1974 interview with a European journalist, he offered an even more unlikely possible influence: "It's a striptease number, that's what that is," he said, laughing. "A follow-up to the David Rose Orchestra." (He was referring to "The Stripper," a goofy 1961 big band instrumental that evokes its title—with horns that actually do bear a passing resemblance to "Kitty's Back.") "Kitty's Back," Springsteen explained, "is a strange song. Sort of big-band-y. I like it because it communicates the heat."

The dissonant horn breakdown in the middle and the relatively complex chords all come from the songwriter himself—in a leaked early studio version, you can hear Springsteen playing the entire thing on guitar in place of the horns. "It was him having fun experimenting with chord changes," says Sancious. "I'm sure Clarence had something to say about what notes we were going to use and all that. It's basically like a chromatic movement back and

"IT'S A STRIPTEASE NUMBER, THAT'S WHAT IT IS."

BRUCE SPRINGSTEEN

Opposite: Long Branch, New Jersey, August 1973.

forth and then it goes crazy." That part anticipates a similar moment in "Born to Run," where the chords descend all the way down, just before that song pauses and kicks back in with a "one, two, three, four" count.

WILD BILLY'S CIRCUS STORY

As a small boy, Springsteen was enthralled by the circus. He would go with his mother, who paid fifty cents on one visit so he could meet a "giant" in the sideshow. "He had this huge hand and you could take the ring off his finger and put it back on," Springsteen told Elvis Costello on his TV show *Spectacle* in 2009. "I was both thrilled and frightened by the sideshow." But he was even more interested in the glimpses he got of the performers' backstage lives; surrounded as he was by working-class suburban normality, the weirdness was intoxicating. "It all felt frightening, uneasy, and secretly sexual," he wrote.

"I was always interested in what's going on down that side alley back by that trailer," Springsteen told Costello, adding, oddly, "if you happened to be stranded there at 11:30, midnight, after it had shut down, it was a province of local hoodlums at the time and it was really scary for a little boy." Although this account matches early stage banter introducing the song, it seems unlikely that Springsteen's mother left him at the circus at midnight when he was a "little boy," so he may be inserting a teenage experience here, or spinning myths.

"Circus Story" is one of the older songs on the second album; he was playing it live under the name "Circus Song" in 1972. Tallent played the tuba in high school, and Springsteen called upon those skills for the song, along with Federici's accordion. "I remember sitting in a living room with a tuba learning it," Tallent told *Rolling Stone*'s David Browne. "I guess Bruce wanted it to sound cheesy, and what's cheesier than accordion and tuba? The idea was to sound like a circus." Lopez had trouble doing the press roll called for in the song, and an uncredited session drummer was called in, according to Appel.

The earliest versions of "Circus Story" are similar to the released song, complete with ample homoeroticism. In one draft, a "leather boy" handles the "sword swallower's blade," making the innuendo considerably less subtle. One of its greatest lyrics, the clown's poetic lament in the third verse, arrived late, as did the ending, which feels like the entire point of the song. It's hinted that everything we have seen has been through the eyes of a "little boy," who gets an enticing offer to try out the circus life for himself.

INCIDENT ON 57TH STREET

The first side of *The Wild, The Innocent* takes place in a fairly realistic New Jersey; the second side is dominated by two sagas set in a cinematic version of New York City. Springsteen has never had much to say about "Incident on 57th Street." In 1974, he was still resisting such questions, telling journalist Jeff Burger, "I really don't want to touch on the songs at all, because I'll screw them up. As soon as you start talking about it, you're messing with the magic." But he did once call it a "secret love song" onstage, while also making it clear that it's one of his first songs to tackle a central theme, the quest for redemption.

In an interview with a European journalist circa 1974, he allowed that "Incident" is about "decisions and escapes and taking stands and doin' everything that people gotta do, day to day. There's never any solutions, there's never any answers, because there's never any in real life. That's why the songs go on forever. They don't begin and they don't end because that's the way life is. It's just day-to-day, moments, *incidents*." Spanish Johnny's fate

> ❝ AS SOON AS YOU START TALKING ABOUT IT, YOU'RE MESSING UP THE MAGIC. ❞
>
> **BRUCE SPRINGSTEEN**

after he heads back into the night with his gang is left deliberately open-ended, he hinted. "It's not like, 'then he died.' It always goes on. All of the songs should just fade out as a matter of fact—should never end."

With its operatic scope, "Incident" anticipates *Born to Run*, even introducing the piano style that would define that album. While Federici and Sancious both play piano on the track (each taking a side of the stereo spectrum), they are drawing on a part written by Springsteen himself, in a vein that keyboardist Roy Bittan would expand into an E Street signature. The rise and fall of the arrangement crackles with magic, and the "good night, it's all right" chorus is almost painfully tender; there is a hushed beauty to the section where the band drops out, leaving Springsteen's voice, Tallent's bass, and Lopez's delicate taps on a cymbal. The concluding piano outro, which lends the song a musical connection to "Rosalita" and gives the side a song-suite feel, was clearly a late addition, recorded separately.

With its tale of Puerto Rican Jane and Spanish Johnny, and an explicit nod to "Romeo and Juliet," listeners have long assumed that this track (and later, "Jungleland") was a take on *West Side Story*. Springsteen must have been aware of those frequent, sometimes disparaging comparisons, and in an interview circa 1975, he made a point of claiming to have never seen the movie. Still, even if you take him at his word, he may have absorbed its themes through cultural osmosis, or heard the cast album somewhere. At the same time, there is always an element of "emotional autobiography" to his songs, Springsteen has said. On top of its ostensible subject matter, "Incident" also seems to capture what it feels like to be a young rock musician leaving a girlfriend to head out on the road—or perhaps more accurately, given the song's focus on Jane, what it feels like to be the girlfriend.

ROSALITA (COME OUT TONIGHT)

In mid-1972, Springsteen got evicted from his apartment over the old beauty parlor and ended up crashing in the apartment of Big Danny Gallagher, a bearded, four-hundred-pound-plus Asbury fixture who would become, for a time, Springsteen's questionably competent road manager (his typical response to requests for help from the band was "fuck you, do it yourself"). In a 1989 interview with *Backstreets* magazine, Gallagher recalled Springsteen "spending a long time" writing "Rosalita" in his apartment: "He kept on complaining he had the beginning and ending of 'Rosalita' finished but couldn't quite figure out how to bridge the two parts." It would become his first great rock song.

Springsteen used some of the melody of "Rosalita" in the 1972 song "Henry Boy" and introduced the song's guitar-and-organ intro onstage as part of a rearrangement of "Does This Bus Stop at 82nd Street." The song owes an obvious musical debt to Van Morrison's "Domino," from his 1970 LP *His Band and the Street Choir* (just listen to the rhythm guitar on both songs), and it probably got its "come out tonight" refrain from "Sweet Jannie," another track on the same album. Springsteen has also introduced the song periodically over the years with some of Jay and the Americans' "Come a Little Bit Closer," which may have been a source for the song's Latin lilt, not to mention the line about the café. In the first live performance of "Rosalita," in February 1973, captured on a muddy audience tape, Springsteen somewhat mysteriously embedded a chunk of the Beach Boys' "Fun, Fun, Fun," as well as James Brown and Wilson Pickett tributes. The song was completely formed in its early live performances, albeit with a guitar-saxophone duel cut from the recorded version and a few other

differences. The "hey, hey, hey" part—which Lopez said was inspired by the 1963 instrumental "Wild Weekend"—was a late arrival.

The version caught on record is "largely live," Lahav recalls. "It was smoking. The control room was playing the music so loud. I remember that." Appel has the same recollection. "We were very lucky on that one," he says. "There's a lot going on there, and there's a lot of personality in that record, especially from Bruce's vocals. We were very lucky to get it very quickly. I'm not a believer in getting things too quick. Whether you're writing it, or whether you're recording it. I'm used to the struggle . . . We stood there in the studio and said, 'I think that's it. I mean, that's it.'" Lopez remembers Appel urging him on as they recorded: "I could see him back there shaking his hands like he really wanted me to play," he told Browne. "He was back there like, 'Hit those goddamn drums!'"

Diane Lozito has insisted she is the inspiration for the song, pointing out that Springsteen wrote it after meeting her grandmother, Rose Lozito, and that her father had objected to her shacking up with a musician. But in 1974 interviews and in his memoir decades later, Springsteen pointed to an earlier relationship. In high school, he dated a "sweet blonde" whose mother "threatened to get a court injunction" to keep him away, he wrote. In earlier tellings, she actually got the injunction, and Springsteen recalled standing under the window of her parents' house and calling up to her. In any case, the song ends with what Springsteen called "one of the most useful lines I've ever written." One day, he promises, the dramas of the moment "will all seem funny."

NEW YORK CITY SERENADE

Springsteen built the nearly ten-minute-long "New York City Serenade" out of a combination of two discarded songs, "Vibes Man" and "New York City Song." But its larger inspiration was his longtime obsession with Van Morrison's transcendent album *Astral Weeks*. "The divine just seems to run through the veins of that entire album," Springsteen said in 2016. "It was trance music. It was repetitive. It was the same chord progression over and over again. But it showed how expansive something with very basic underpinning could be. There'd be no 'New York City Serenade' if there hadn't been *Astral Weeks*." In a nod to that album's gentle touch, Lopez doesn't play drums on the track, other than a single conga to keep time, otherwise leaving the percussion to Richard Blackwell—and, in the "she don't take the train" section, handclaps.

The track opens with a dazzling piano piece by Sancious, a song in its own right, cross-cutting between classical, jazz, and R&B. The first sound we hear is Sancious strumming the strings of the piano with a finger while holding down one of its pedals, creating a harplike effect. "It's a neat thing," says Sancious, who says he got the idea from jazz pianist Keith Jarrett, among others. From there, he simply played—there were a couple of rehearsals beforehand, but the piece is largely an improvisation. (You can hear the piano pedals creaking throughout the intro, which is one of the problems that led Springsteen to eventually abandon 914 Studios on his next album.) "I don't know how we arrived at it," Sancious says. "He showed me the song originally, and it was his idea to have some piano introduction. He wanted me to improvise something and said, 'When you're done, give me a look and then the song will start,' and he'd start playing guitar. He said, 'Do what you want, as long as you want.'" Sancious also wrote a string arrangement for the song, which he played on a Mellotron, the tape-loop synthesizer.

The song doesn't have much to do with the actual New York City; it feels more mystical than that, as if its real subject is the spiritual possibilities Springsteen sensed within music itself. "It's one of those songs that hooks up with a rhythm and goes on and on and on into the night," Springsteen told a European interviewer around 1974. "The whole rhythm of the whole street thing runs right through that song. That song's really special to me."

THE FEVER (OUTTAKE, *18 TRACKS*)

This was the first on a long list of potential hits that Springsteen would jettison from his albums without a second thought. Springsteen told disc jockey Ed Sciaky in 1974 that he recorded the sexy retro-R&B slow jam in one take and never even thought about using it on the album, intending

Below: Bruce and his band in Long Branch, New Jersey, 1973.

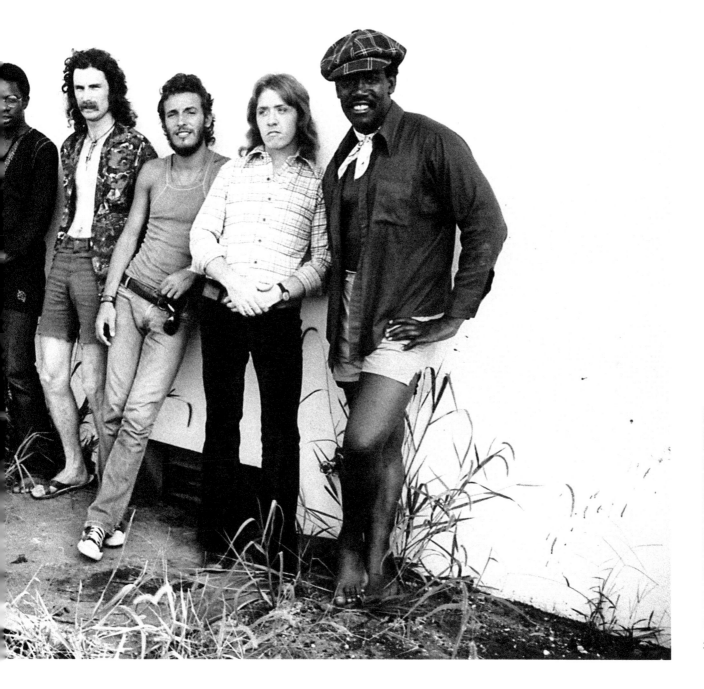

it only as a demo for other artists. (Southside Johnny ultimately recorded it on his debut album.) Although he would play it regularly in concert, Springsteen seemed mildly annoyed that the public had heard the recording (which Appel leaked to friendly radio stations) and other outtakes. "It's things that aren't really indicative of where I want to be or where I'm trying to go," he told Sciaky.

SEASIDE BAR SONG (OUTTAKE, *TRACKS*)

"Seaside Bar Song" is Springsteen's first attempt at the kind of basic rock 'n' roll song he would master years later with tracks such as "Cadillac Ranch," and also something of a dry run for "Born to Run." But Lopez doesn't sound comfortable—or particularly powerful—playing the straight-ahead, Max Weinberg-like beat, and the song as a whole never quite congeals. "It wasn't quite there," Tallent told Browne. "We didn't really nail it. it was a cool song that wasn't fully realized." The chorus lyric—"the highway is alive tonight"— would make an ominous return decades later on "The Ghost of Tom Joad."

THUNDERCRACK (OUTTAKE, *TRACKS*)

One of Springsteen's live showstoppers, "the thing you pull out at the end of the night," it was meant to stun and dazzle audiences. "We weren't satisfied until there were two or three endings," Springsteen told *Rolling Stone*'s Anthony DeCurtis in 1998. "I had them all. I thought they were all good, and I wanted to use them all. I got a big kick out of hearing 'Thundercrack,' where we had all these crazy arrangements—there are parts of it that are a little

Below: Bruce and the band lounge in the tall grass, Long Branch, New Jersey, 1973.

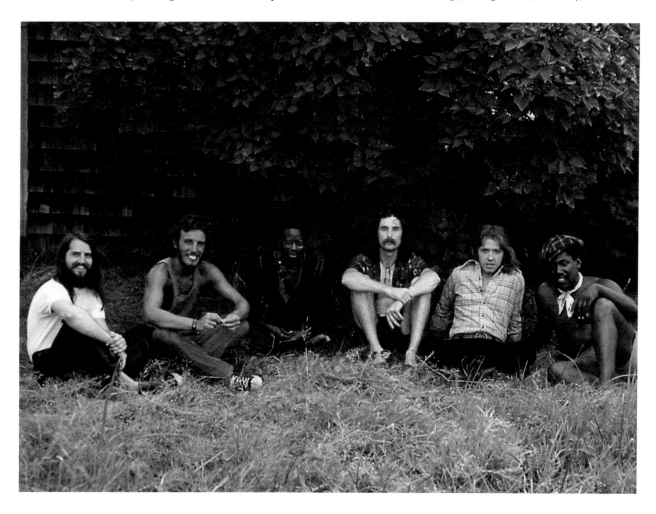

bit like the Beach Boys. It was just fun hearing the freeness and the lack of preconception that you brought into the studio. Mad Dog [Vini Lopez] had a style that was completely his own. I've never heard anyone else play like that. He's playing constantly, these little foot things, drum fills, but yet, he is very in tune and responding to everything else that was happening around him."

In 1973, Springsteen abandoned the studio version of "Thundercrack" after playing maybe a single take. "I remember listening to it and saying, 'This is too much work,'" he told DeCurtis. "And we put it away and never went back to it." But he wanted to put it on 1998's *Tracks* boxed set, which meant filling in the vocal overdubs. "So I called up Vini and I said, 'Vini, I got some singing for you to do. It's about twenty-three years later. We're going to finish one of these.' And so he comes in and the amazing thing was, of course, he remembers his part exactly with no coaching whatsoever. He just steps up and sings all those high notes that he sang and knew exactly what it was, and says, 'Hey, thanks, that was fun,' and then walks out."

SANTA ANA (OUTTAKE, *TRACKS*)

An enchanting little song that is very much of an extension of the second album's sound, "Santa Ana" was built out of what Springsteen described in 1998 to *Mojo* magazine as "just a series of images." "It could have had a place on the album," says Appel. The main character is a gunslinger-type hero, "a punk god risen from the canyons," as Springsteen calls him in discarded lyrics from an early draft. It's also about his own life, given the line about "matching braces" with a Spanish girl, which matches Springsteen's stories of his first kiss at a junior-high dance.

In a 1973 stage rap, Springsteen said he was inspired to write "Santa Ana" during a trip to Mexico with his father. "I was able to shrug off the reality of the situation as usual," he said, "and I romanticized myself into writing a tune down there." Springsteen would repurpose the line about French cream and French kisses for "She's the One."

ZERO AND BLIND TERRY

A cousin of "Incident at 57th Street," this tale of gangs and forbidden love began life as "Phantoms," an all-but-identical song with inferior lyrics built around an image of planes flying in "strict formation over the hills of Saint George." The "Mongolian gangs" who supposedly prowl Route 9 in "Zero and Blind Terry" sound like one of Springsteen's wilder lyrical indulgences, but they were very real; in his autobiography, Springsteen explains that a number of families of Mongolian descent moved to a subdivision called Freewood Acres. "Those guys had great-great-granddaddies who rode hard and conquered the world, and their New Jersey offspring looked like they could do it again if pressed." Springsteen would use the choose-your-own-adventure ending of "Zero"—some say the lovers got away, others that they got caught—once again on "Outlaw Pete."

> **"IT'S ONE OF THOSE SONGS THAT HOOKS UP WITH A RHYTHM AND GOES ON AND ON AND ON INTO THE NIGHT."**
>
> BRUCE SPRINGSTEEN

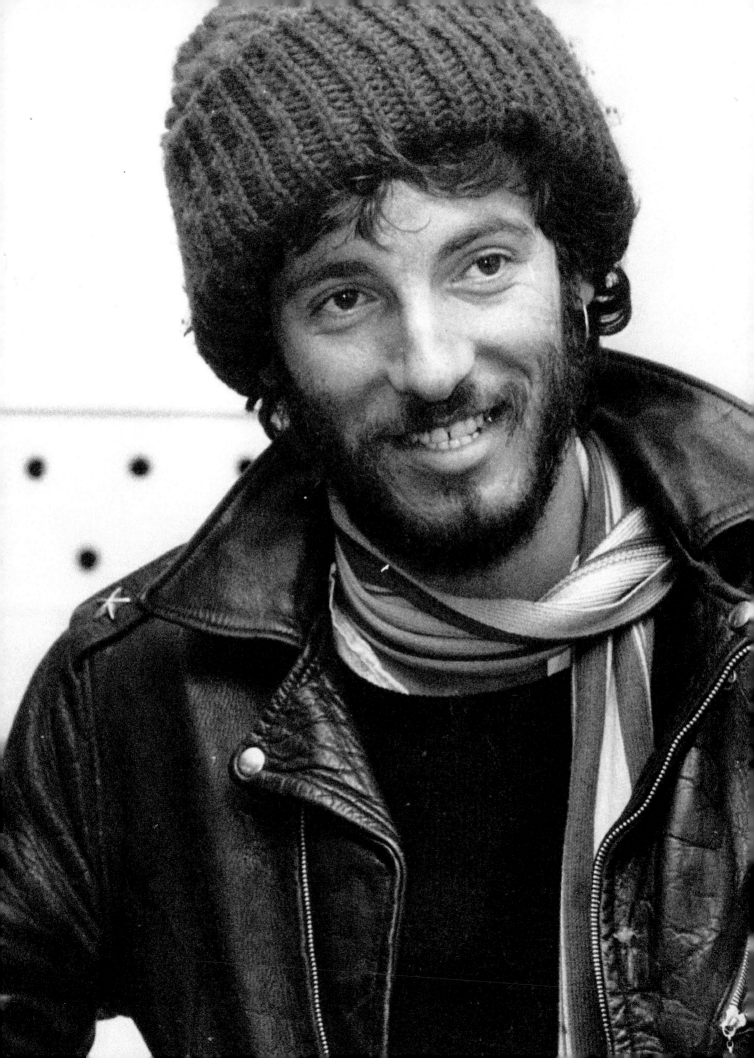

1975

BORN
TO RUN

THUNDER ROAD

A funny thing happened the first time Bruce Springsteen and the E Street Band played an embryonic version of "Thunder Road" back in February of 1975: the crowd cheered the delicate opening riff as if they had known the song for years. It was an encouraging sign, but what Springsteen performed that night was something of a mess, with a bunch of undercooked lyrics ("baby, you know that's just jive"), and an ill-placed, vaguely "Rosalita"-like, Latin-tinged, double-time sax break. The eventual chorus melody was in there, albeit played by Clarence Clemons's sax; the phrase "thunder road," which Springsteen would pinch from an old movie poster, was absent. In all, it was emblematic of a songwriter caught between styles and eras, trying to find the right exit on his musical turnpike. (It's widely assumed that this early version was called "Wings for Wheels"—also the name of Thom Zimny's excellent 2005 *Born to Run* documentary—but Max Weinberg says that was actually a working title for the entire album, and that they referred to the song as "Angelina" or "Angelina's Dress Sways.")

Springsteen had a new band, but he wasn't sure what to do with it. In summer 1974, after finishing just one song, "Born to Run," for Springsteen's third album, David Sancious and drummer Ernest "Boom" Carter (who had just joined in February as Vini Lopez's replacement), bolted the E Street Band together to start a jazz-fusion act, Tone. Producer/manager Mike Appel was understandably horrified, especially given Sancious's considerable influence on *The Wild, the Innocent & the E Street Shuffle*. Springsteen was stoic; he'd

Previous spread: Backstage at the Hammersmith Odeon, London, moments before Bruce's first UK show, November 18, 1975.

Opposite: Born To Run Tour, Amsterdam, Holland, November 23, 1975.

Below: Alex Cooley's Electric Ballroom, Atlanta, 1975.

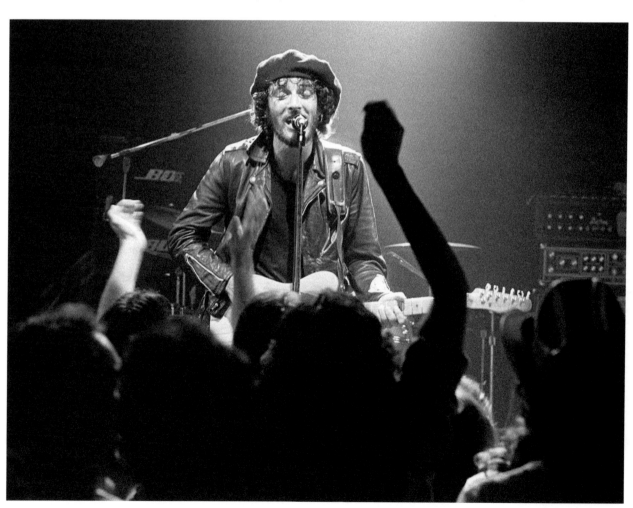

figure it out. Enter the new guys. Max Weinberg and Roy Bittan would stick around for forty years and counting, forming the core of what would turn out to be the defining version of the E Street Band.

Like Danny Federici, Bittan grew up playing the accordion, but he was a more disciplined and intellectual musician. He absorbed the full breadth of American popular music, "from Al Jolson forward," Bittan says. "I was playing for fiftieth anniversary parties when I was fourteen years old, because I had a repertoire of all those songs." Weinberg, a native of Newark, New Jersey, played professionally starting at the age of seven, when he first sat in with a wedding band. By the time he auditioned for Springsteen, he was attending Seton Hall University in South Orange, New Jersey, with thoughts of law school. His heart was in soul music and pre-1967 rock, and he felt like "an anomaly, a little out of the time." "I never really thought that I'd end up playing drums for my whole life, which is really odd," Weinberg says. "I love playing the drums, but if I couldn't play them the way that I wanted to, I didn't want to do it." With Springsteen, he saw his chance, dropping out of college to jump on board.

Another new figure in Springsteen's orbit was Jon Landau, a prominent rock critic who had a past as a record producer, having hopped onto a Detroit-bound plane straight from his college graduation in 1969 to produce the MC5's second album, *Back in the U.S.A.* In early spring 1975, with sessions for his third album stalling, Springsteen invited Landau to the empty Neptune, New Jersey warehouse where the E Street Band was rehearsing. It would be one of the most important rehearsals of Springsteen's career. "Jon immediately started making tremendously spot-on musical suggestions," says Weinberg, "particularly rhythmically. It was amazing. Within a couple of hours, he had turned the rhythmic thrust of the band away from that kind of charming but scattershot approach that was on the first two records. Very charming, but very busy drumming, certainly not what Jon wanted to hear."

"Thunder Road," in particular, "was fantastic, but it was a little unwieldy, a little unfocused, a little more like a jam piece," Landau told me in 2005. "I remember talking with Bruce about a few ideas about how to just reshuffle the deck a little bit, and keep the song building from the very beginning right through the end." As Springsteen adopted Landau's suggested shifts and edits, the song started to take shape and with it, a new, streamlined, harder-rocking sound for the E Street Band. From there, Jon Landau was on the production team for the third album, beginning a lifelong professional relationship.

"Thunder Road" was the world's introduction to Bittan's architectural piano style, enhanced by glockenspiel parts an octave up. "Roy had the ability to take the basic parts that Bruce created when he would write the song," Landau told me, "and expand on them just the right amount and give them a little more structure, and really wound up anchoring the arrangements on most of that record." Engineer Jimmy Iovine relied heavily on Bittan when he was mixing the album, "I always had Roy's piano in my hand," he says, "And whenever I would get in trouble I'd push Roy out. It's the truth—he was always doing something interesting."

Springsteen wrote nearly all of *Born to Run* on piano. "'Thunder Road' was just so obviously an opening, due to its intro." Springsteen told me in 2005. "There is something about the melody that just suggests 'new day,' it suggests morning . . . That's why that song ended up first on the record, instead of 'Born to Run.' Which would've made sense, to put 'Born to Run' first on the album—[and we] still put it on the top of the second side."

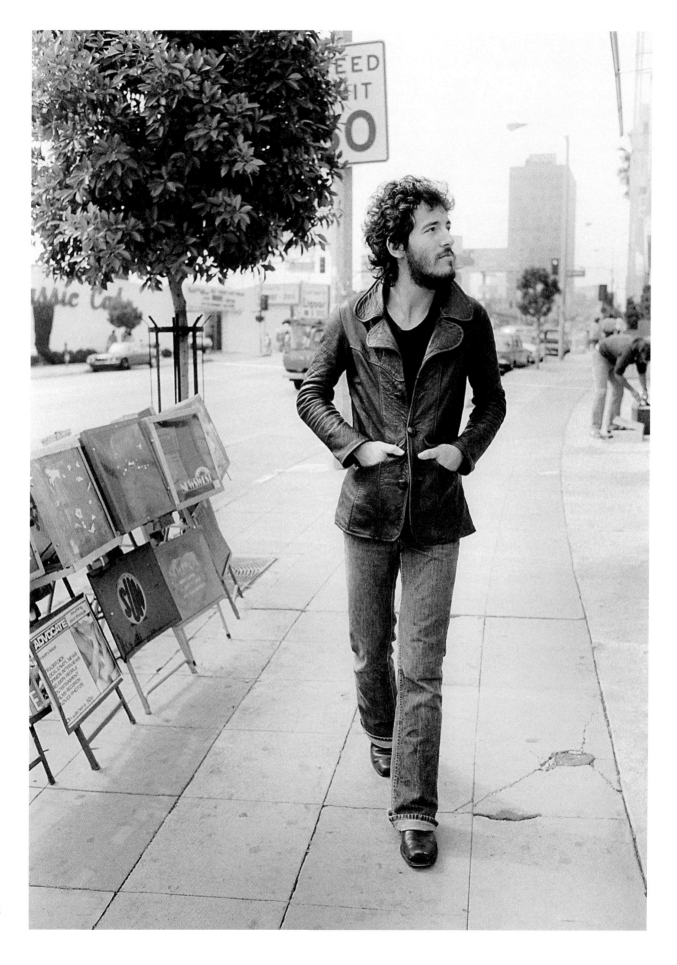

"That song was interesting for me," says Bittan, "because I created a piano part that moves—it was like staircases to me. I would move up to a section, then down. When the chords change, I would sort of step up to it musically and then I would come down from it and move around all different ways." He recalls the instrumental coda as a collaboration with Springsteen. "When we got to the end," Bittan says, "it seemed like it needed something. So I said, 'well, what if we do a little instrumental?' I'd play a little something, and then Bruce would play something, so it kind of came about in a very beautiful way."

There were many revisions, including an amusing array of women's names—Angelina, Anne, Chrissie and Christina all got a ride before Mary won out. The harmonica part in the intro was, at one point, played on sax instead. A handwritten work sheet from the sessions shows Springsteen's focus on details, such as the fill Weinberg plays at the song's "pulling here to win" climax—he wanted to try something à la the Dave Clark Five. Appel, whose relationship with Springsteen began to fray during the making of *Born to Run*, recalls a moment when the artist and Landau wanted to build "Thunder Road" more gradually, and replace the electric guitars that come in close to the two-minute-mark with acoustics—in Appel's telling, he talked them out of it. As it was, Springsteen spent thirteen hours straight overdubbing electric guitar, Iovine recalls. And at some point in 1975, Springsteen also recorded an eerie alternate version, a solo acoustic take that feels like a ghostly reflection of the released song, as if it's being sung by a heartbroken narrator decades after its events.

As Springsteen wrote in his book *Songs*, "Thunder Road" offered a proposition: "Do you want to take a chance? On us? On life?" There was, however, an undercurrent of dread, as there almost always would be going forward. Springsteen was only twenty-four when he recorded "Thunder Road," which makes the line "maybe we ain't that young anymore" all the more striking. "The songs were written immediately after the Vietnam War," Springsteen told me in 2005. "And you forget, everybody felt like that then. It didn't matter how old you were, everybody experienced a radical change in the image they had of their country *and* of themselves. The reason was, you were changed. You were going to be a radically different type of American than the generation that immediately preceded you, so that line was just recognizing that fact. The influences of a lot of my heroes from the sixties and fifties ended up on that record, but I realized that I was not them. I was someone else. So it wasn't just a mishmash of previous styles. There was a lot of stuff we loved in it from the music we loved, but there was something else, too—quite a sense of dread and uncertainty about the future and who you were, where you were going, where the whole country was going, so that found its way into the record."

TENTH AVENUE FREEZE-OUT

The house where David Sancious's parents lived on E Street was one block away from an intersection with 10th Avenue, and Springsteen recorded almost all of *Born to Run* at the Record Plant in Manhattan, a block and a half away from that city's own 10th Avenue. Whatever the geographic inspiration, Springsteen admitted to having no idea what a "Tenth Avenue Freeze-Out" actually might be beyond a cool-sounding phrase. The song's narrative, however, is clear: It's an origin story of sorts for the E Street Band, or an idealized version thereof.

Appropriately enough, it also marked the official entrance of Steve Van Zandt as a band member. The story of Van Zandt schooling the horn-playing session men brought in for the song by simply singing them their parts has

> **"IT DIDN'T MATTER HOW OLD YOU WERE, EVERYBODY EXPERIENCED A RADICAL CHANGE IN THE IMAGE THEY HAD OF THEIR COUNTRY AND OF THEMSELVES."**
>
> BRUCE SPRINGSTEEN

Opposite: In town to promote *Born to Run*. Sunset Strip, Los Angeles, 1975.

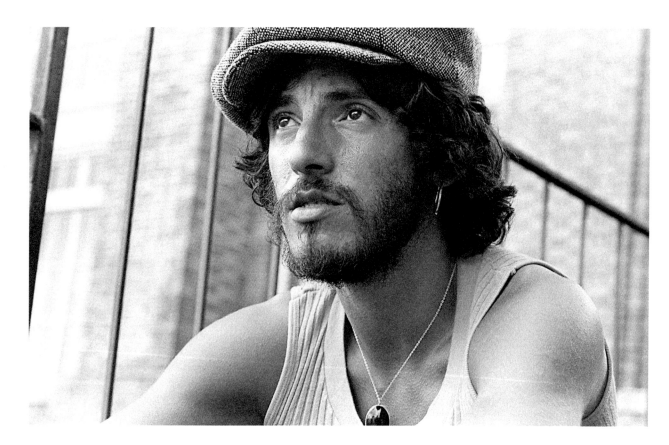

long since entered into legend, but he told it to me one more time in 2005. "So I'm sitting on the floor," he said, "and I didn't know anything about diplomacy or knowing one's place or anything. I never knew what a session guy was. I didn't get any of it. All I knew, is the song ain't workin', man. And Bruce looked down, and I remember him saying, 'This isn't working, is it?' and I'm just like, 'No.' And he goes, 'Well what do you think,' and I go, 'Want me to fix it?' and he goes, 'All right, go fix it.' So I went in, and I was already working with Southside Johnny and the Asbury Jukes by then, so I was already quite conversant with horns, and that's how I arranged all those horns." (Still, he's not sure that Springsteen really invited him into the band at that very moment, as reported in Dave Marsh's classic biography *Born to Run*.)

Cleverly, the bridge ("I'm all alone . . . ") reprises the music from the song's intro. As Bittan recalls, Springsteen "left the room. Steve looks at me, and goes, you know, what are we going to do in the middle? I said, why don't we use the intro chords. Bruce comes back in. 'Hey, what do you think about the intro chords played with the whole band?' And then he sang that over that, and that was it."

Early lyrics for the song mentioned Van Zandt (by his then-nickname "Miami"), and had even more nods to Clemons, a.k.a. the Big Man. In the final version, the narrator declares himself all alone, with home nowhere in sight, only to be saved when "the Big Man joins the band." Springsteen was not mythologizing the depth of their bond. "We looked at each other and I just knew it," Clemons said at a 2010 lunch with *Rolling Stone* editors, describing his first meeting with Springsteen. "This is what I was looking for. And he looked at me the same way. And we never separated for two weeks—we were inseparable. My girlfriend called me gay; his girlfriend called him gay!" He laughed hard. "The music brought us together so strong. It was so real. It felt like everything I wanted to say and the way I wanted to say it. We fit like a hand in glove."

> **"WE LOOKED AT EACH OTHER AND I JUST KNEW IT. THIS IS WHAT I WAS LOOKING FOR."**
>
> CLARENCE CLEMONS

NIGHT

Unlike almost everything else on the album, "Night" was easy to record. "That song just seems to play itself all the way through," says Bittan, who recalls playing a Baldwin electric harpsichord (also heard on the Beatles' "Because"), along with another precisely crafted piano part. "That was another song where the way I connected the chord changes, you could see the shape to the piano part. It was always rising and falling or had percussive elements to it."

Appel remembers "Night" as the first song where he noticed Springsteen singing from deep in his chest in an attempt to approximate the nearly operatic sound of Roy Orbison. The key, Appel says, was that Springsteen was double-tracking his voice in harmony. "When he listened back to it he said, 'oh wow, see, that really works!' I was like, 'okay, it sounds like Roy!' It was great."

"Night" is notable for being one of the first Springsteen songs to mention the reality of nine-to-five jobs, not to mention summing up many of the themes on his next album in one line: You work all day, he sings, and push to survive "'till the night."

BACKSTREETS

Springsteen told me in 2016 that one of his most evocative songs and monumental recordings was inspired by "just youth, the beach, the night, friendships, the feeling of being an outcast and kind of living far away from things in this little outpost in New Jersey. It's also about a place of personal refuge. It wasn't a specific relationship or anything that brought the song into being." It was, in other words, written in part about the seductive safety of hiding out in New Jersey obscurity, an option that Springsteen was about to lose forever, thanks to the galvanic power of songs like "Backstreets."

Opposite: Taking a break from the soundcheck for an August 22, 1975 concert at the Electric Ballroom, Atlanta, GA.

Below: Springsteen and the E Street Band, Born to Run Tour, 1975.

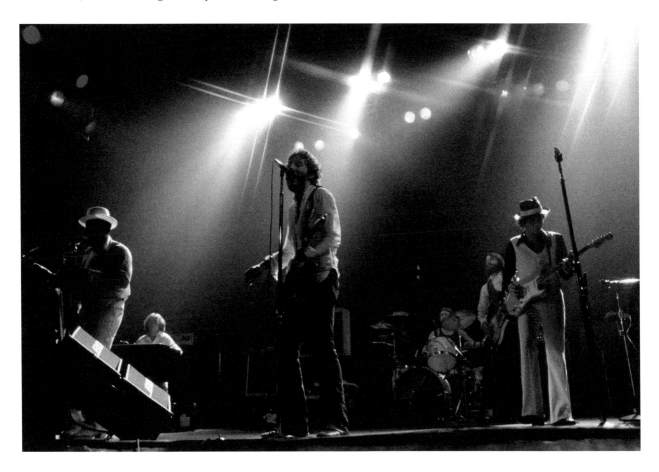

From its earliest origins, the song erased the line between friendship and romance—in an early draft, instead of "me and Terry" becoming friends, it was "Wild Billy and Joe" (with a Chrissie showing up in the next verse). There was also a nice, ultimately unused line about "the truth we were too young to see."

"That's my favorite recording on the album," says Iovine. "We nailed that. It was going for the impact of a Phil Spector record, but with the presence of a modern-day rock record. That's not easy to do." In Spector's Wall of Sound approach, individual instruments blended together, but Springsteen wanted to keep everyone's playing distinct. "At any given moment, you can hear what everyone is playing," Iovine says. "You really hear it on 'Backstreets'— all of a sudden Roy's piano will be as clear as anything over this incredible hurricane of music underneath it." The song is enveloped in echo, thanks to tape-delay techniques that Iovine had perfected when working with John Lennon, but nothing could blunt the impact of Springsteen's wildly impassioned vocal, his most committed performance on record up to that point. "He was *howling*," Appel recalls. "I get chills just talking about it."

"Backstreets" was another song that Landau ironed out in rehearsals. "We had been playing it completely differently," says Weinberg, "and Jon suggested, and Bruce immediately went there with him, that the drum beat should evoke the Roy Orbison record, 'Running Scared.' Just building a lot of tension and release." He recalls Springsteen coming up with the actual beats, something he'd do often, communicating them by the simplest means imaginable; he'd sing the drum part to Weinberg. Later, Appel remembers working closely, note by note, with Springsteen on his melodic guitar solo, even playing him James Burton's famous lead on Ricky Nelson's "Hello Mary Lou" for inspiration.

Bittan played both piano and organ on "Backstreets," and Springsteen specifically requested an organ part that evoked Bob Dylan's *Blonde on Blonde*. "If you listen to the organ in that second half of the intro," says Bittan, "It's totally *Blonde on Blonde* notes. I was channeling Al Kooper." Official E Street organist Danny Federici kept away from the album sessions, playing only on the title track. They tracked the songs with piano, bass and drums, plus guitar and vocals that Springsteen would usually replace. "I had all the freedom in the world to create whatever I was creating," says Bittan. "And orchestrate it. Danny at one point came in, and I think he was a little overwhelmed by the fact that the songs had a structure already. He came in and he had a tough time. It was not his strong suit, necessarily, to play structured parts. And that was one of the reasons he and I developed a playing style eventually; I was all about structure and he wanted to jam, so he would fill the air behind me, and it was a really fabulous synergy."

Springsteen also drew from one of his favorite wellsprings in this song. There is a repeated chant of "in the backstreet" in Van Morrison's "Madame George" on *Astral Weeks*, right before strings enter playing a melody that anticipates the whoa-whoas in "Thunder Road."

BORN TO RUN

By 1974, Columbia Records had lost faith in Bruce Springsteen. "The Columbia people won't let us cut the next album," Springsteen told *The Boston Globe* in April of that year. "At least not until we deliver a single. Imagine that! It's like a publisher demanding a middle chapter before agreeing to accept a novel." It would take him six months of obsessive on-and-off recording, but he would deliver that single, after setting out to make it nothing less than "the greatest rock record I'd ever heard." As he told me in 2005, he wanted

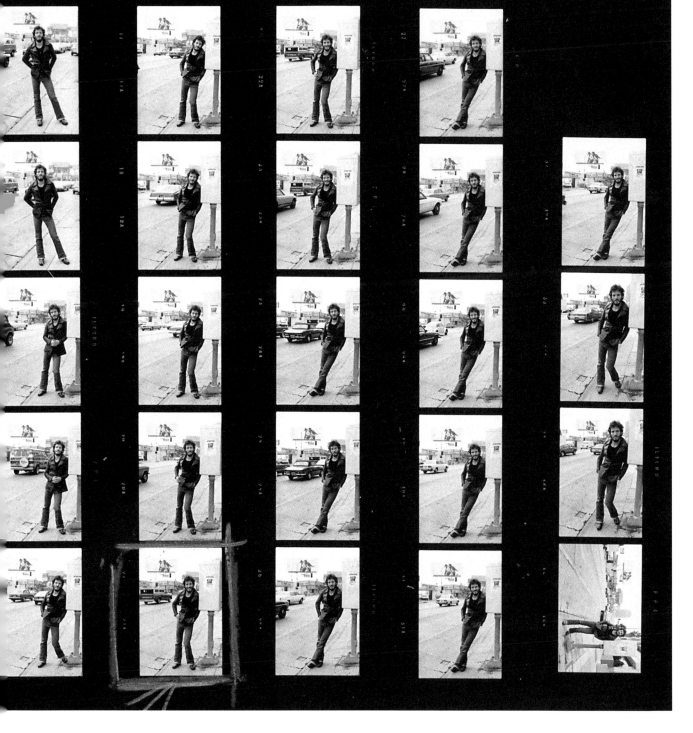

it to be "exhilarating, orgasmic . . . to sound enormous, to grab you by your throat and insist that you take that ride, insist that you pay attention—not just to the music, but to life, to being alive."

To that end, Springsteen would marshal the ghosts of early sixties AM radio—Duane Eddy's "Because They're Young" (the wide-screen twang of the guitar riff), Little Eva's "Loco-Motion" (the snare-punishing drum intro and the sax-bolstered opening chords), the Ronettes' "Be My Baby" (the whoa-oh-ohs) and countless others—into an army. To get there, he had to battle

Above: A contact sheet of Bruce walking down Sunset Strip, Los Angeles, 1975.

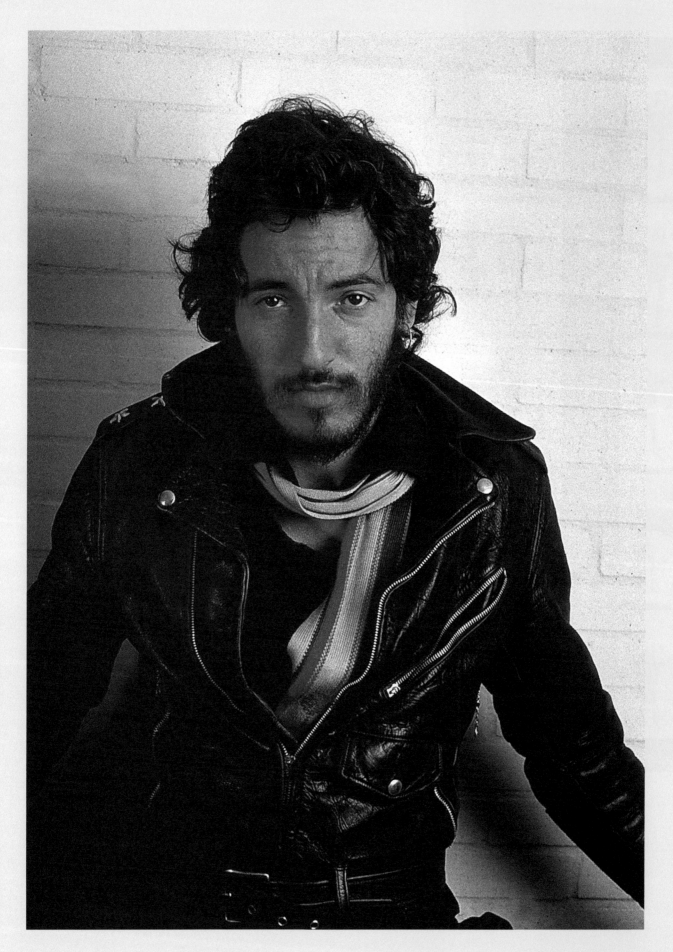

himself, to move away from the bleak side of his nature. Early alternate lyrics to the song are almost comically dark, with a reference to "murder in our dreams" and, from another draft, the "Something in the Night"-like "they crushed my heroes . . . beneath the wheels of a Chevy 6." In the final draft, the darkness is only on the edge of the narrative. "The record felt just wide open, full of possibilities," Springsteen told me, adding, "full of fear, you know, but that's life." The "death trap" imagery plays against the fairy tale of the rest of the story; the reference to Wendy is a deliberate nod to *Peter Pan* (a journalist spotted a poster of the character above his bed circa 1975)."He wrote five different lyrics," Appel recalls. "I finally had to stop him."

It took six months of experimentation at 914 Studios to find a version of the song Springsteen could live with, driving the E Street Band slightly mad in the process. Carter, who began and ended his recording career with Springsteen on that record, told me he "became a pretty good dart player, pool player, hanging out in that studio," To try to record the main guitar riff, "we put the amp in a bathroom, we put in the football field in the back, we put it everywhere we could think of," says assistant engineer Larry Alexander. Creating the Wall of Sound effect they wanted was laborious. "The acoustic guitar? He had twelve of them," says Appel. "And I don't know how many times we had Clarence play saxophones." They overdubbed a synthesizer, too, to bolster the baritone hum of the sax in the rhythm track.

The sax solo, meanwhile, was a pure studio creation, put together from numerous takes. They decided they were done, Appel says, only when they ran out of things to overdub and Springsteen hit a wall of exhaustion. He would spend decades shying away from elaborate productions, perhaps because he got it all out of his system on this song. Discarded elements included massed female backing vocals, a string arrangement by Sancious and even actual engine noises. As revealed in Thom Zimny's documentary, Van Zandt realized that amid all the overdubs and echo, the guitar riff had gotten buried. Springsteen was bending up to it, and all that was audible was a minor note. In 2005, Van Zandt half-joked that he wished Springsteen hadn't fixed it. "I have mixed feelings about it," he told me. "I think I liked the other riff better. It was a little more Roy Orbison."

Van Zandt instantly understood what was revolutionary, or maybe counterrevolutionary, about "Born to Run." Rock, at the time, was "looking to the future and being as rootless as they possibly could be, that's what was fashionable," he told me. "And so it was a strange move for him to very consciously acknowledge the past, and have that reflected in the style and arrangement of the song. It was wonderful, as far as I was concerned, of course, to use the whole Spector thing obviously, and those basic 'Twist and Shout' chords, and basically a Dick Dale surf riff. You put that together and you got a fucking pretty weird record in 1974. It was *not* what was going on. It was a strange, strange move at that time, and one that separated him from the pack immediately. I think it was one of these things that actually helped lead to that whole punk movement to follow, actually. That and a leather jacket."

For decades to come, the song was the climax of Springsteen's shows, with fans whose running days were far behind them shouting along with as much fervor as ever. Springsteen told me he understood why. "Those emotions and those desires—and it was a record of tremendous longing—never leave you," he said. "You're dead when that leaves you. It transcends your age and continues to speak to that part of you that is both exhilarated and frightened about what tomorrow brings. It'll always do that, that's how it was built."

> **"IT WAS A STRANGE MOVE AT THAT TIME AND ONE THAT SEPARATED HIM FROM THE PACK IMMEDIATELY."**
>
> STEVE VAN ZANDT

Opposite: Backstage at London's Hammersmith Odeon, November 18, 1975.

SHE'S THE ONE

"I wrote 'She's The One' because I wanted to hear Clarence play the sax in that solo," Springsteen told author Bill Flanagan in 1987. "I sort of went back and wrote the words to it just 'cause I wanted to hear that beat and hear Clarence play that. That's kind of a reverse way of doing it." The pre-Bittan-and-Weinberg incarnation of the E Street Band never played the song live, but Springsteen had the song ready before the lineup changed; Bittan instinctually came up with the song's signature, much-imitated piano arpeggio when he played the song in his audition for the E Street Band.

Weinberg remembers hearing a demo version by the old band in which the song had yet to acquire its Bo Diddley-ish beat; while Springsteen was strumming a Bo Diddley rhythm on guitar, Carter was playing something more like the Band's funky "Up on Cripple Creek." Weinberg was in the E Street Band for all of a week when he made a suggestion: "What if I tried just playing the 'I Want Candy' beat?," he asked, referring to the slightly modified Diddley pattern of the 1965 Strangeloves hit. Springsteen agreed, and the song started to take shape, although it initially had some lyrics that ended up in "Backstreets."

Weinberg told Springsteen about the Cuban-derived clave beat that underpins the Diddley rhythm, explaining that "it's known as the universal beat, and it's found in almost every culture on the planet." Springsteen took it to heart, kind of, and began to introduce "She's the One" with a rap about Diddley, who was born Ellas McDaniel. "About twenty years ago a cat named McDaniels [sic] discovered the beat of the universe," he would say. "Every time he played this beat . . . good girls would go bad, and the bad girls would get worse."

MEETING ACROSS THE RIVER

One day in 1975, Bittan was visiting Springsteen at his house in Long Branch, New Jersey, when the keyboardist sat down at Springsteen's piano and started playing some music inspired by a recent trip to a jazz club in the city, where Bittan had seen the saxophonist Pharoah Sanders. When Bittan came back to Springsteen's house the next day, he heard him experimenting with chords that he thought might have been influenced by what Bittan played the day before, which would become the skeleton of "Meeting Across the River." Bittan is convinced Springsteen had it in mind as a prelude to "Jungleland" from the beginning.

The lyric is a kind of dramatic monologue from a small-time gangster, with more grounded detail than anything Springsteen had written before, anticipating decades of story-songs to come. Appel was crazy about the song, but Springsteen was dubious, at least until *Astral Weeks* bassist Richard Davis (who had previously played on "The Angel") came in, and Randy Brecker played post-bop counterpoint to Springsteen's vocal on his trumpet, blowing through the song in a single take.

"I had that little piano riff," Springsteen told me in 2005, "and I'm not exactly sure where the lyric came from. There was that New York, New Jersey, big-time, small-time thing, you know? Back then, when you lived in New Jersey, you could've been a million miles from New York City and yet it was always there . . . By that time, I think we'd been counted out, and it probably had something to do with that, a feeling I had about myself, maybe, that I'd been underestimated . . . Most of the folks that go into my business have had the experience of someone counting them out, of someone judging your life as being without great value. So that song grew out of, 'Hey, that guy's sort of a small-time player, but he's still got his sights set on what's across that river.' I suppose that was where the emotions of it came from."

> **"BACK THEN, WHEN YOU LIVED IN NEW JERSEY, YOU COULD'VE BEEN A MILLION MILES FROM NEW YORK CITY...BUT IT WAS ALWAYS THERE. "**
>
> **BRUCE SPRINGSTEEN**

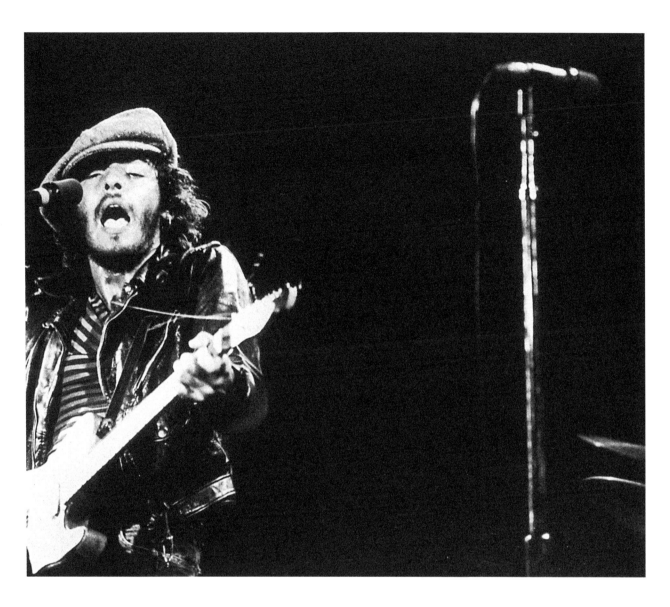

JUNGLELAND

A very early lyric sheet for "Jungleland" bears the title "Calvin (little Jesus) Jones and the 13th Apostle," which only underscores the tortuous journey this song took to reach its final form. "That was a tough one," Landau told me. Springsteen was already trying to record "Jungleland" in 914 Studios by mid-1974, but it was a different song at that point. In live performances with Carter and Sancious on board, the song sounds familiar at first, with the piano intro and first verse in place, but it leaps midway through into a full-on jazz odyssey, a shuffling "Kitty's Back"-like electric piano excursion that sounds alternate-universe bizarre to anyone familiar with the finished product. Both Sancious and Carter had a particular fondness for "Jungleland." "It kind of had a harmonic resemblance to what Ernest and I were listening to," says Sancious, "like British progressive rock. Those big chords are gorgeous." Springsteen was a closet King Crimson fan, but the only British influence he ever acknowledged on "Jungleland" was The Who, for the crashing power chords in the song's eventual, and final, hard-rock incarnation.

Springsteen plunged on with "Jungleland" at 914 with the new E Street lineup, but the studio itself seemed to be fighting him. The same piano that has its noisy pedals immortalized on "New York City Serenade" wouldn't

Above: At The Bottom Line, New York, 1975.

Opposite: Bruce and then-girlfriend Karen Darvin.

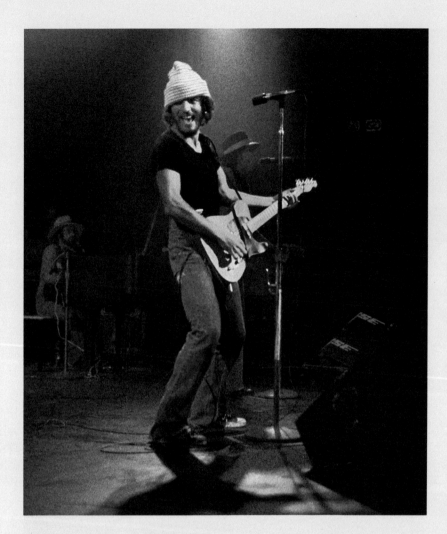

stay in tune, for one thing. It was Landau who pushed for a move to a better studio, pointing out that 914 "had seen better days," and they ended up at the far more upscale Record Plant. The song kept evolving, but every version of "Jungleland" had a line about "flesh and fantasy," and at one point Springsteen wanted to call the whole album *Between Flesh and Fantasy*.

Bittan saw "Jungleland" as an "orchestral piece," an anomaly on what was otherwise Springsteen's most rock 'n' roll album to date. "I needed to sort of summon my semiclassical memories to try and make that all happen," he says. "It was always about the transitions, that song, for me. How do I connect the sections so that they flowed from one to the other, because they were somewhat disjointed." Once the "jazz break" came out, they had to figure out how to move into and out of the sax solo. "He had some strange chords that he was trying to figure out how to make work, and there was no ending, really," Bittan says. "The piece at the end did not exist. He had an idea for the end, and I started working on it. I developed a little repetitive pattern in my right hand, and then we had the first chord. The end of 'Jungleland' was collaborative, I'd have to say."

The sax solo was its own kind of collaboration, with Springsteen guiding Clemons. "It was sixteen hours to do that solo," Clemons said in 2010. "Bruce and I hammered that thing out. I don't think I even went to the bathroom. After we got it done, he said 'Do you know how long we've been standing here?' It was like we were in this tent. It was one of the best experiences I ever had with him. We just bared our souls, opened our hearts and that solo came out. It's a real statement of our friendship and our love."

Above: Anticipating Devo, 1975.

Opposite: Clarence Clemons, Bruce Springsteen and Steve Van Zandt stay close to the crowd on the Born to Run Tour, 1975.

Overleaf: Springsteen before his first concert in London, November 18, 1975.

After the months of torture, Springsteen solved the song's final aesthetic problem in moments. He needed something to go over Bittan's piano coda. "We were trying some different ideas," Landau told me. "Ending with some kind of guitar thing, some kind of this or that, and finally Bruce just sort of looked up and said 'Okay, just set up a vocal mic.' And he just went out and boom, he just came up with those incredible howls. I remember Mike Appel and me turning to each other—we couldn't believe this, because it was so fabulous. He did it three or four times and that was it." They hadn't sequenced the album yet, but it all fell into place in that moment. "I just said, 'well, that certainly has to be the last thing that you hear on this album.' And that was really thrilling. It was something that I'll never forget."

LINDA LET ME BE THE ONE (OUTTAKE, *TRACKS*)

As Springsteen noted onstage when he brought this song out for a rare live performance, "Linda Let Me Be the One" bears a distinct musical resemblance to "Hungry Heart," mostly thanks to Bittan's piano part. Springsteen and Landau supposedly wanted to include "Linda" in place of "Meeting Across the River," but Appel was violently opposed. Appel calls the song "fucking turgid," and he's not altogether wrong. It's far too slow and feels unfinished—in all, it's entirely disposable compared to anything that actually made it onto *Born to Run*.

SO YOUNG AND IN LOVE (OUTTAKE, *TRACKS*)

A thoroughly charming, exuberant pop/R&B song that sounds like it would have belonged on a nonexistent album between *The Wild, The Innocent* and *Born to Run*, perhaps the one Springsteen might have recorded if the record company had not made him lay down that single first. It's similar to Springsteen's later instrumental "Paradise By the 'C,'" and shares a couple of lyrics with "Night." The band mentioned in the lyrics, Little Melvin and the Invaders, was real; it was an Asbury Park soul act that had once counted both Clemons and Garry Tallent as members.

> **" WE JUST BARED OUR SOULS, OPENED OUR HEARTS, AND THAT SOLO CAME OUT. "**
>
> CLARENCE CLEMONS

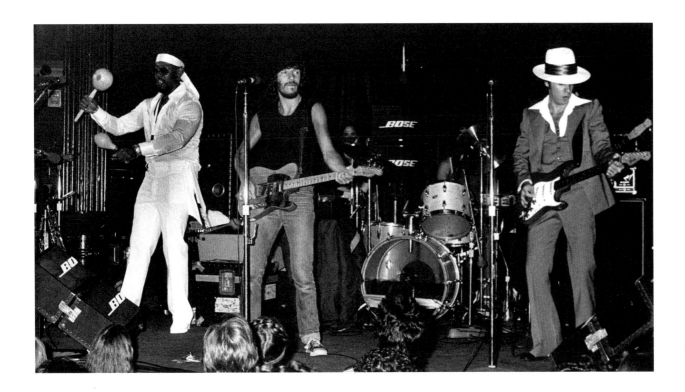

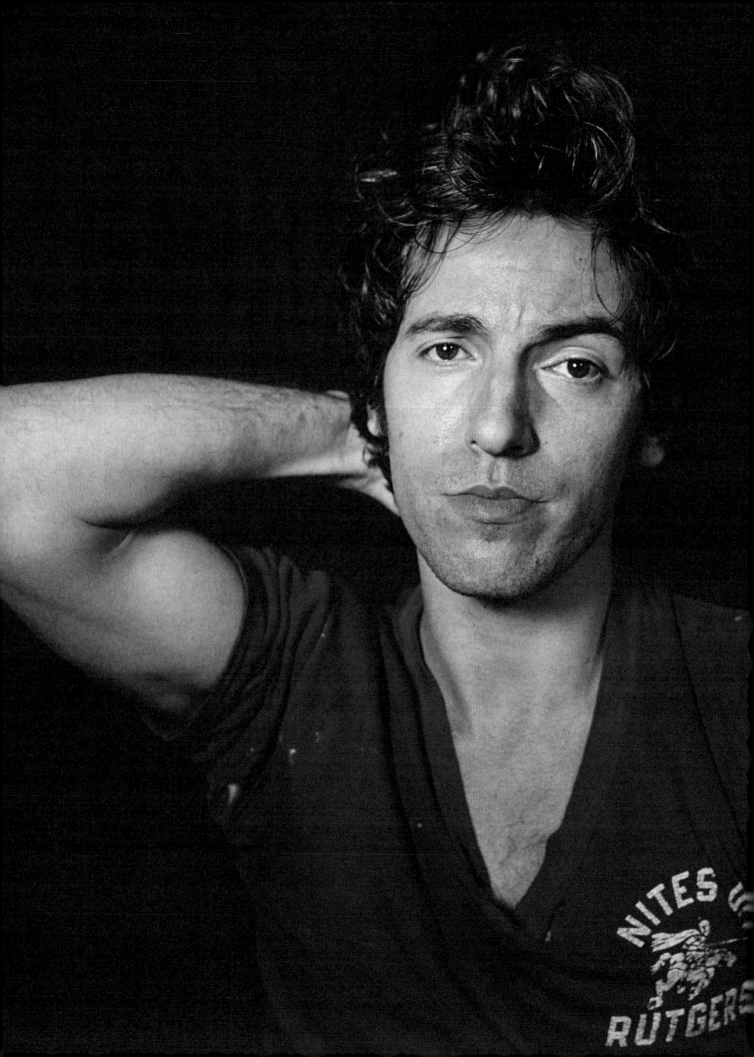

CHAPTER 4

•

——————

1978
DARKNESS
ON THE EDGE
OF TOWN

——————

•

BADLANDS

He had a title, and some anthemic music to go with it. All he needed was something worth singing about. "I said, 'Now I have to write something to make this real,'" Springsteen told me in 2010. "'I've got to find something in me that gives the character in this song life, breath, heart, soul, spirit, experience.' 'Badlands,' that's a great title, but it would be easy to blow it. But I kept writing and writing until I had a song that I felt deserved that title. I didn't have any problem thinking really hard about what I was doing. I didn't have any problem spending hours and hours in pursuit of what I was after. I honored, I believed, I respected the characters in my songs to the place where I felt they deserve my time, they deserve my greatest effort, and I will do honor by them and by myself if I do this right."

When Springsteen and the E Street Band walked into Manhattan's Atlantic Studios to start his fourth album on June 1, 1977, they were many months behind schedule. (Dissatisfied with the sound, they would soon move back to the Record Plant, where they recorded *Born to Run*.) An ugly, emotionally wrenching, year-long legal battle with Mike Appel, his former producer and manager, had left Springsteen, in essence, barred from recording—so when he settled the lawsuit on May 28, he wasted little time. He and the band were as ready to record as they would ever be, after months of scattershot touring and relentless rehearsals of new songs in Springsteen's house in Holmdel, New Jersey—Max Weinberg still has seventy hours' worth of lo-fi recordings from those practice sessions.

By late June, they had a rough attempt at "Badlands," minus anything like final vocals. The martial music crystallized early on, down to Weinberg's opening drum fill (which the drummer says was suggested by Steve Van Zandt and faintly inspired by the lead-ins of Motown songs, such as "Tracks of My Tears"). Springsteen would take an instrumental recording home and write lyrics over it, a process that led to a song that has never been easy to perform. "I'd go home and I'd play the tape and write the words, but I wouldn't do it out loud," he told DJ Dave Herman in 1978. "I'd write 'em in my head. So I'd go in the studio and I'd try to sing and I'd realize it was hard to breathe and sing it all at once."

An early take seems to (mis)direct its shouted fury at some unfortunate woman ("I'm talking to you, baby!"). In one draft, Springsteen painted a world where "no God smiles down," where fate might tear out your eyes. Another early set of lyrics has what would have been his most explicitly political line to that point, with a man on television making false promises of peace—probably a reference to Richard Nixon, who resigned three years earlier. In yet another version, it's a singer on the radio making questionable promises about dreams— now even Roy Orbison and/or Elvis could not be trusted.

The song's opening riff, Springsteen revealed years later, is a major-key twist on the minor-key intro to the Animals' 1965 hit "Don't Let Me Be Misunderstood." (The Animals, in turn, built their riff on a string part from Nina Simone's earlier version of the song.) The vibe of "Badlands" also reminded Weinberg of Paul Revere and the Raiders' 1966 garage-rock burner "Hungry," and his snare-heavy drum part recalls both "Hungry" and "(I Can't Get No) Satisfaction." On tour during the lawsuit, Springsteen would frequently sing a roaring version of another Animals hit, "It's My Life." That song—class conscious, with a highly particular tone of furious, defiant triumph—seemed to be a model for what he was trying to capture with "Badlands" and the fourth album as a whole.

> **"I KEPT WRITING AND WRITING UNTIL I HAD A SONG THAT I FELT DESERVED THAT TITLE."**
>
> BRUCE SPRINGSTEEN

Previous spread: Pretty in pink, Springsteen pictured in 1978.

Opposite: A Lynn Goldsmith portrait of Springsteen, 1978.

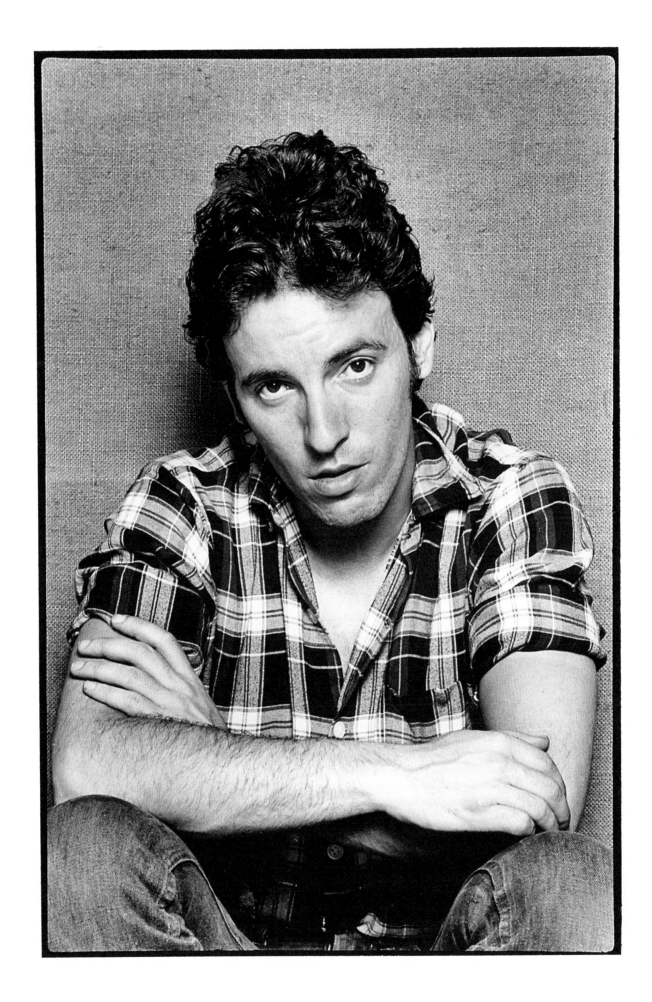

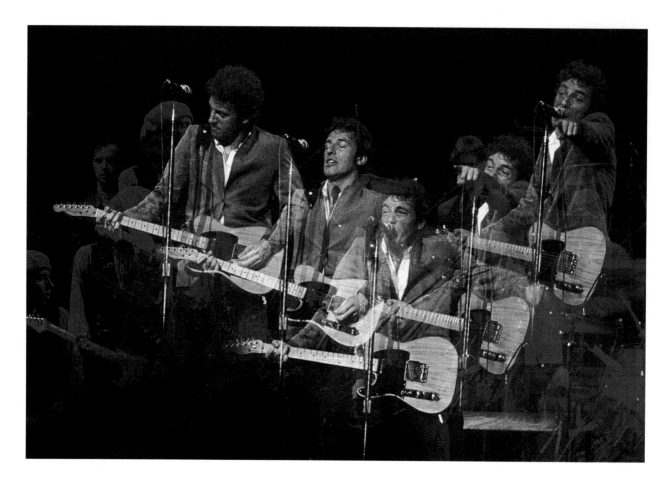

"Badlands" was among the songs Springsteen was working on in sessions on July 13, 1977, when the infamous, twenty-five-hour-long New York City blackout began. Assistant engineer Thom Panunzio remembers Springsteen recording a twelve-string-guitar overdub at the moment the lights went out (9:27 p.m., to be exact). First, Springsteen couldn't hear his guitar in his headphones; then everything went black. Everyone followed the glowing exit signs and walked out onto 57th Street, where they saw block after block swathed in darkness. "Badlands" may well have acquired its opening line, "lights out tonight," after that evening. A discarded draft strongly backs up that theory, continuing the narrative with another line about a "city in the dark" that "suddenly has new owners."

As on "Born to Run," Springsteen found the heart of "Badlands" by moving past gloomy drafts that flirted with despair. The finished first verse lays out the narrator's essential dilemma in a more sophisticated fashion than Springsteen had managed before, acknowledging larger forces at work. He is "caught in a crossfire," buffeted by historical and societal forces he does not comprehend. (The lines about poor men wanting to be rich and rich men aspiring to royalty came from a 1962 Elvis Presley obscurity, "King of the Whole Wide World.")

"You got to have friction and tension, something to push up against," Springsteen told me in 2016. We were discussing one of the essential revelations of his memoir, *Born to Run*: His lifelong struggle with depression and how it manifested itself in his music. It was undiagnosed during the *Darkness* era, but lurking nonetheless. I suggested that we believe him when he sings about being saved by faith because he sounds like he was overcome with doubt the day before. "Yeah," he said. "Or maybe barely

Above: Performing at the Palladium, New York, September 16, 1978.

Opposite: The Big Man and Springsteen, Fox Theater, Atlanta, Georgia. November 1, 1978.

believing right now, you know? . . . If the triumphant part of the song was going to feel real and not just hacked out, I had to have something I was pushing up against. I just understood that balance. It comes out of gospel music, which is the music of transcendence. I wanted my music to be a music of transcendence."

"All power starts with the music," Steve Van Zandt told *Rolling Stone*'s Andy Greene in 2013. "It's a powerful song, wonderfully positive and optimistic in its own negative sort of atmosphere. A warrior sort of heroism really is present in that opening salvo—you know that it's not gonna get better. Life is gonna be tough and then it's gonna stay tough. And you better adjust to that really quickly, because the good times that you've heard about or saw in the movies or read about, they're probably not coming back, if they ever happened. And life's gonna be a struggle every day. So I think it has that recognition in it."

The song's call-to-arms saxophone solo was nearly left off; Springsteen believed the instrument evoked the city, leaving it out of place on an album set in something more like "the heartland." But Springsteen restored the solo in the last minute, correcting what he later admitted would have been a major error. "That solo was very strong," Clarence Clemons said in 2010. "The limited sax on that album—he used it as a tool to hammer in what he was saying. You could say it's not enough sax." He smiled and used what must have been a favorite line: "But too much sax ain't good for you. You'll become a sax maniac!"

ADAM RAISED A CAIN

Steve Van Zandt was credited for "production assistance" on *Darkness*, his first full album as a member of the E Street Band. "I was helping arrange all those songs," Van Zandt told me in 2017. "I was intimately engaged in that stuff." Springsteen has made it clear that he was playing Van Zandt and Jon Landau off each other, with Van Zandt cast as the voice for rock 'n' roll fury and Landau as the "formalist" who wanted clean, tight recordings. Still, both Landau and Van Zandt encouraged Springsteen's move away from the eccentricity and sprawling structures of his earlier music. "I think in more conventional terms, for the most part," Van Zandt told me in 2017, "when it comes to arranging and configuration of a song, structure of a song, I tend to know what is the best, most effective way of producing something. [Springsteen] was a bit less conventional and I was a bit more, and the two of us together helped those records become what they were."

Van Zandt helped push the sound in a particular direction. "Steven came on board and it seemed like together, they wanted to go more guitar heavy," says *Darkness* engineer Jimmy Iovine. "Steve kept pushing the guitars." Roy Bittan remembers there was "some friction" over the idea. *Born to Run* had "really defined the sound of the band," he says. "And now all of a sudden you go in and now you're tinkering with essential elements of it. But it all worked out."

It certainly did on "Adam Raised a Cain," one of the fiercest songs Springsteen would ever record. Even here, though, despite Springsteen's unleashed, fire-breathing lead guitar, the verses are underscored more by Danny Federici's roiling organ than any rhythm-guitar crunch. It's the group shouting—which Dave Marsh, years ago, astutely compared to the MC5—that lends the song its un-Bruce-y raucousness, one of the most overt signs that Springsteen had been listening to 1977's stream of punk singles.

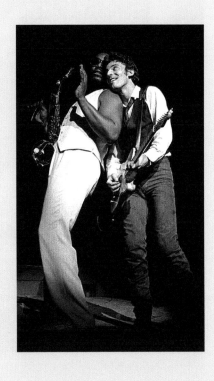

It's easy to forget that many of the subjects assumed to be Springsteen perennials—his father and the blue-collar life, most significantly—didn't fully surface until *Darkness*. "Adam" was Springsteen's first father song, with a lot of *East of Eden* (the movie, not the book) mixed in. The father in the song toiled away for "nothin' but the pain" and stalks his house looking for a target (in an earlier draft, he walks around "rattling his chains"). It was an oversimplification of his father's situation—his real-life dad was more than a hard-hat hardass, suffering from mental illness and an unhappy childhood of his own. "I was a little unfair to my dad," Springsteen told me in 2016.

In the wake of his success, Springsteen was determined to remain connected to the emotional currents that fueled his art. As he told me in 2010, he decided to head off "in deep pursuit of the mysteries of the past in order to find out, 'Who am I, who am I going to be, where's my future?' I was beginning to realize a part of me was going to keep a leg in in my history, and that my history was tied to my parents' experience, and my experience growing up, and so that was a mystery to me, and I was very interested in beginning to investigate that mystery. Suddenly, I recognized there was a life lived here when I was a child. There were several lives lived here, that seem to have impacted on my life tremendously. And yet I've also had the unusual experience of escaping the tethers of the hardest of their circumstances— so that should give me a position to reflect and observe from. Artists are psychologically and emotionally driven to tell their stories. I'm not so sure we choose them, they choose you."

Springsteen wanted a truly brutal sound for "Adam," telling mixer Chuck Plotkin he wanted it to feel like a cinematic shock cut from "a couple having a picnic to a mutilated dead body under a tree." "I said, what the fuck?," recalls Plotkin, a cerebral, bearded record producer with a law degree. He was enlisted

Opposite: Making contact. Springsteen takes the Darkness on the Edge of Town Tour across the west coast of the USA.

Below: Springsteen performs at a concert in Los Angeles in 1978.

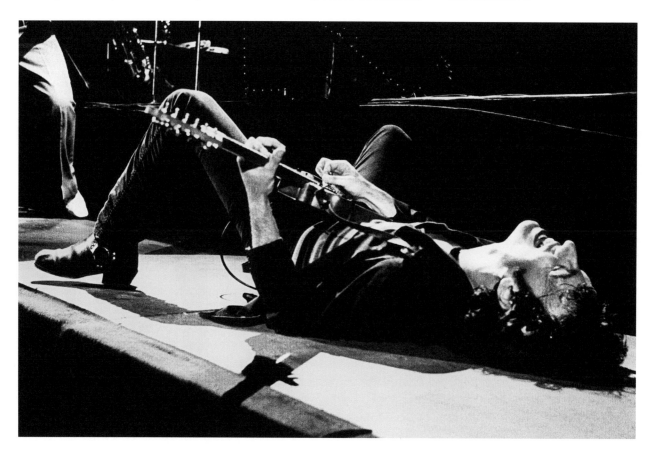

by Landau to help mix *Darkness* at the end of the process (despite a complete lack of mixing experience) and subsequently joined the production team.

Plotkin took Springsteen at his word, deciding that something in "Adam" "had to sound off." He zeroed in on Bittan's piano part, which the pianist describes as "rock piano 101, bang away as hard as you can, with giant chords." Plotkin decided to knock it slightly out of tune, "just try to make something happen that takes away the formal sort of grandeur and polish of the sound of the instrument." To do so, he apparently used an early piece of digital equipment, the Eventide Harmonizer. He was pretty sure Springsteen and Landau would recoil at that point and realize they needed a real mixer, but instead, he says, "They went, 'Sounds great!'"

SOMETHING IN THE NIGHT

Something dark and powerful lurks within this underrated track, one of Springsteen and the band's most indelible studio performances. The take on the album dates back to the first night of recording, June 1, when they blasted through ten songs they had been rehearsing. What they laid down that night could have been the core of a very different album, packed with pop songs: "Rendezvous," "Because the Night," "I Wanna Be with You." They called the cassette from the sessions "the *Star Wars* demo tape," according to Panunzio, because the movie had come just a few days earlier. "That was an album, in my opinion, that was great from beginning to end," Panunzio says. "If that would've been the album, I think commercially, it would've been a lot more successful, because he gave away the hits."

Springsteen had been playing "Something in the Night" live since August of 1976, and the song had already gone through several evolutions, including the loss of a lovely, melancholic horn intro, along with the usual lyrical shifts (at one point it included the striking, Robert Johnson-like image of Satan himself, strolling along "these streets like a man.") The finished lyrics are among Springsteen's bleakest, the kind he would often discard up to that point, single-handedly backing up what Springsteen told me in 2016—that there's "plenty of" evidence of his depression on *Darkness*. He was also consciously presenting a dark flipside to "Born to Run"; here, as soon as he hits the accelerator, he runs something over. By the final verse, everything he loves is "crushed and dying" on the ground and he ends up "running burned and blind." Springsteen has often maintained that the album has little to do with his lawsuit experience, but he does acknowledge one line—where he sings that as soon as you build something, the world tries to "to take it away"—was inspired by his own life. "That was the situation I was in at the time," he said in 2016.

Darkness was, from the beginning, cut live with the full band, and "Something in the Night" is unmistakably a live performance, albeit with at least some overdubbed vocals. Bittan remembers the slow pace as a challenge. "It always felt like there was so much dead air. Very slow. I always felt like I tried really hard to put stuff in it, and I never thought it was one of my most successful songs. The intro is great." At the top of an early draft of the lyrics, Springsteen wrote that the song should have a "slow build from 0 to 1,000," which it certainly does, starting with Weinberg's thunderous tom-tom bashing at the beginning. In the final verse, when the song breaks down to just drums and voice, you can hear Weinberg suddenly stop his beat after two hits of the bass drum, a move directed in the moment by Springsteen. "He threw up his arm to stop me," Weinberg recalls. "Like a stage cue. That was very spontaneous."

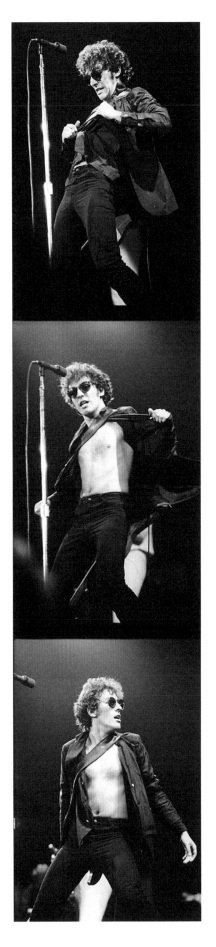

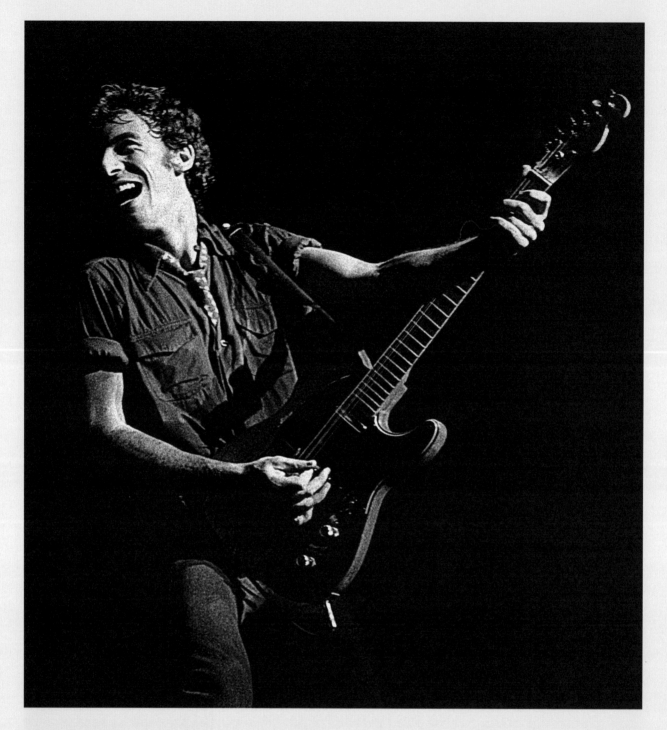

CANDY'S ROOM

A ruminative, modular creative process meant a lot of Springsteen's lyrics kept jumping from song to song, a procedure he compared to swapping parts between cars. "Candy's Room" was an extreme example, created by cannibalizing most of the lyrics of the sweet, organ-led midtempo tune "Candy's Boy" and grafting them onto a hard-rock song known only as "Fast Song # 2," which previously had some nasty, Rolling Stones-like lyrics about a rich girl who can't understand the street life, along with a second verse more or less like "Candy's Room." "Fast Song," which is just about musically identical to "Candy's Room," also included a line he kept trying to jam into various songs, where he hoped for his whole town to "blow into the sea."

Both "Fast Song" and "Candy's Boy" were creations of the rehearsal room in Springsteen's house on Telegraph Hill in Holmdel. "The band would play what we heard in our heads," Bittan says. "Bruce had the songs, the chords, the ideas. But he didn't have a lot of details that were created by the guys." Weinberg's drum part is particularly radical on "Candy's Room," beginning with a rapid-fire hi-hat part that he says was inspired by various Barry White records—apparently because the spoken-word thing Springsteen does at the beginning of the song reminded him of Barry's lover-man monologues. "He kinda had this rapped intro," says Weinberg. From there, Weinberg switches to playing a drum rudiment called a single-stroke roll on the snare, which continues through much of the song. "It was cool, because it was really different," he says. "I can't think of another song where that is specifically done that way." Many signature parts were dictated by Springsteen or Van Zandt; with others, such as this one, the strategy was "do it until someone tells you don't do it," Weinberg says.

"It was a hard song to record, because it's so busy," says Iovine. "When you want real power and space on a record, it's really hard to do when the record's busy." Plotkin found it equally challenging to mix; whenever he put the vocals up too loud, it ruined the song's entire effect. "You have to feel the voice struggling to be heard but able to be heard," he says.

At least two of Springsteen's ex-girlfriends are convinced they're the subject of "Candy's Room." One of them, Karon Bihari, told her story to the *National Enquirer*, which doesn't help her credibility; on the other hand, the fact that she was a singer of some success at the time might explain the line about "strangers from the city" calling Candy. That same line has long convinced some listeners that the song is actually a fictional account of dating a prostitute. When I pressed Springsteen on the issue in 2010, he laughed. "Does it matter, does it really matter? I'll never tell!"

Opposite: Springsteen looks to the E Street Band, Fox Theater, Atlanta, Georgia, November 1, 1978.

Below: Bruce Springsteen and Clarence Clemons, 1978.

RACING IN THE STREET

"'Racing in the Street,' I always thought was like a sequel to 'Don't Worry Baby,'" Springsteen told the Rock and Roll Hall of Fame's Jim Henke in 2009, referring to the 1964 Beach Boys ballad about a street-racing kid buoyed by his girlfriend. "You put ten to fifteen years on the guy in 'Don't Worry Baby,' and he's the guy in 'Racing in the Street.'" Springsteen was also "in love with the local culture of Asbury in the seventies, which was still deeply enmeshed in car culture," he told me in 2010. "If you went to the Stone Pony, it was a constant circle of souped-up muscle cars on Saturday and Sunday, and, once again, I sort of stood outside of it. I didn't have a car, but I wanted one real bad. I was hitchhiking. So it's the things you're drawn to."

In a bar one night in Asbury, Springsteen met one of those drivers and talked to him about his life, which led directly to the song. In this world, street racing is a way to stay spiritually alive, a reason to exist beyond dragging yourself to work each day. In one alternate set of lyrics, class comes more explicitly to the forefront: The narrator races because he's sick of "a world that somebody else owns."

Springsteen did his research. When Panunzio stopped by Springsteen's hotel room in the city, "he had car magazines just all over the place," he says. "It looked like a newsstand had been dumped in his room, you know. He was researching and reading and all that." Despite his best efforts, he starts "Racing in the Street" by describing a car that could not exist—fuelie heads do not fit on a 396. Springsteen didn't learn of his mistake until after the album came out. "This depresses me," Springsteen told a DJ in 1978, promising to sing the more accurate "283" going forward, though he didn't. In the end, he shrugged it off. "I write about 'em and ride 'em," he said. "I don't have to fix 'em."

Bittan's piano and Federici's organ entwine for the lengthy coda, which ranks with the end of Eric Clapton's "Layla" as one of the most beautiful instrumental passages in seventies rock. "That felt like a holdover from *Born to Run*, really," says Bittan, who thinks the melodies came from Springsteen. "I don't have much memory of that," he says, "other than 'Let's just get the right take.'"

THE PROMISED LAND

In August 1977, just after the death of Elvis Presley, Springsteen and Van Zandt took a break from recording to join photographer Eric Meola on a road trip through the Southwest, starting in Salt Lake City, Utah. One day, they watched the sky turn black as a powerful storm blew over. "It was like a Biblical storm," Meola told Peter Carlin in his biography *Bruce*. Later, they heard dogs howling on what used to be the main street of a small town, according to Carlin. In a 2010 conversation with the actor Ed Norton, Springsteen recalled seeing an actual "Rattlesnake Speedway" in the Utah desert; however, what he almost certainly encountered was the Rattlesnake Raceway, a dirt-road racing track in Nevada. Close enough. Meola came back from the trip with some spectacular photographs; Springsteen packed the images he saw (or in the case of the Speedway, what he *thought* he saw) into "The Promised Land," which also happens to be the name of one of Presley's final studio albums—the title track was a cover of the Chuck Berry song.

"The Promised Land" is a radical departure from anything on *Born to Run*. For Springsteen, this song and other *Darkness* tracks "really begins our folk-based rock," he told me in 2010. "It goes back to blues and folk structures, I was not trying to be really melodic, because that immediately pulls you into

> **"I WAS NOT TRYING TO BE MELODIC, BECAUSE THAT IMMEDIATELY PULLS YOU INTO THE POP WORLD."**
>
> **BRUCE SPRINGSTEEN**

Opposite: Springsteen backstage at the Fox Theater, Atlanta, Georgia, October 10, 1978.

the pop world, so I was distancing myself from that, and I was trying to create this mixture, this sort of rock/folk music that stretches back all the way, in some ways, to the Woody Guthrie and country music and up through the Animals. And it was thematically influenced by punk music and the times. It was 1977, there was a recession going on, so there were tough times."

Thanks to its distillation of so many of Springsteen's central themes into four minutes and thirty-three seconds' worth of vivid, precise desert imagery and gritted-teeth declarations, "Promised Land" is, in its own way, as dazzling as any of Springsteen's old epics. Some dreams are lies that "tear you apart," Springsteen sings, but nevertheless, even as a grown man, he believes in that promised land.

Drum sounds were famously an issue on *Darkness*, and "Promised Land" is a good example of the maddeningly muffled snare sound they often got. The initial mix of the song left out the lead-guitar part that leads into a sax solo; Springsteen delayed the album release so he could go back in and restore it. The sax solo, in turn, segues into a harmonica riff by Springsteen, a wildly unusual pairing of instruments that somehow works.

Below: Springsteen receives the audience's full approval, 1978.

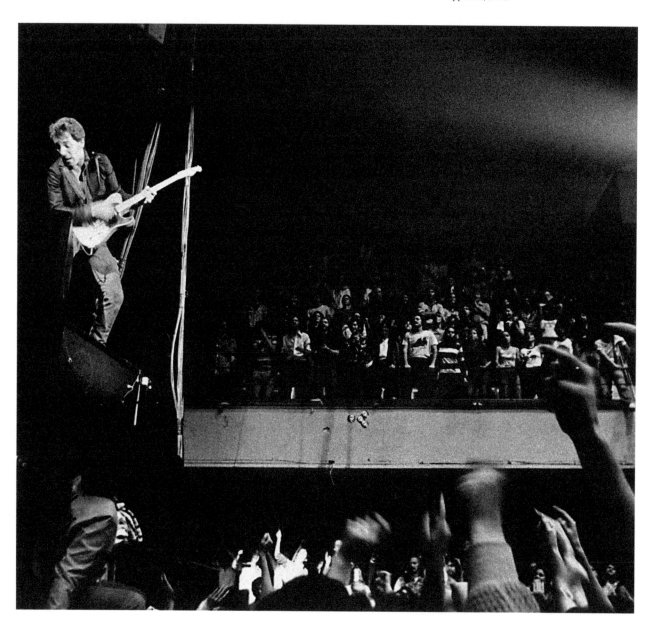

FACTORY

Another song about his father, and about the life Springsteen successfully escaped, "Factory" is a lyrical leap for Springsteen into quotidian reality. The detail of his father losing his hearing to his job is true to life. "I guess there's two kinds of people," Springsteen said onstage in various 1980 stage raps. "There's people that get a chance . . . to live the kind of life they wanted, get a chance to change the world they're living in, and then there's people . . . that do what they have to every day to make sure that the world that they live in doesn't fall apart. When I was sixteen, I couldn't figure out that what my old man was doing, laying on the cold ground at six in the morning, trying to get one of the junk cars to start so he could get to work. He was doing that for me."

"Those songs were ways that I spoke to my father at the time," Springsteen told me in 2010. "Because he didn't speak and we didn't talk very much. It was kind of a way out . . . not the best way, but it was what was available to me, and it worked out for us. I think if you weren't really close with someone, particularly children, the way they become close with that person is you take on their personality, you take on an imitation. The subjects I was drawn to, the issues I was moved to investigate, the clothes I wore—when I went to work, I really went to work in my dad's clothes. It became a way, I suppose, that I honored him and my parents' lives, and a part of my own young life, and then it just became who I was."

STREETS OF FIRE

For once, the performance is far better than the composition itself—a spectacular take, complete with monster guitar solo, of a song so skeletal it barely exists. "You know what was really something else?," Iovine says. "Witnessing Bruce sing 'Streets of Fire' live in the studio. It's still one of the most incredible things I've ever seen. How his voice did that I will never understand." Again, what's on the record is a live early take, with some overdubs.

PROVE IT ALL NIGHT

Springsteen spent enough time in the city recording *Darkness* that his tale of this song's inspiration is probably true: "I got into a cab," he said onstage in 1978, "and a lot of cabbies that are in the city, they got a running monologue that don't stop whether somebody's in there or whether they're not. I only knew this guy was about forty-five years old, and he was just raving about how all day long you gotta prove it to your boss driving around in a cab, and all night you gotta go home and prove it to your wife. On the weekends, you gotta prove it to your kids. It never lets up, you know. Anyway, I wrote this song. Sometimes you gotta prove it all night."

The riff came from the lighter-hearted outtake "It's a Shame"; in one of Springsteen's first attempts at "Prove It," he tried singing lyrics adapted from "Something in the Night," which fit surprisingly well over the song's finished arrangement (and suggested that he was briefly ready to abandon "Something" and scavenge it for parts). Another version had a line that sounded like Springsteen refrigerator poetry, complete with references to a little girl, a mansion, and the edge of town. "Prove It" was the first single from *Darkness*, but the studio recording always paled besides live performances, especially with the lengthy instrumental intro the song acquired on the 1978 tour.

> **"WHEN I WENT TO WORK, I REALLY WENT TO WORK IN MY DAD'S CLOTHES. IT BECAME A WAY TO HONOR HIM."**
>
> **BRUCE SPRINGSTEEN**

DARKNESS ON THE EDGE OF TOWN

Some of the other characters on *Darkness* fear the prospect of losing everything, but the guy on the title track almost welcomes it, as a proving ground. If, as Springsteen has said, *Darkness* was his "samurai record," here is his samurai. The song, at once stately and anthemic, was once subtitled "The Racer," which, along with the mention of "Sonny" from "Racing in the Street," suggests that it was meant to be the same narrator at a darker point in his journey. He is alone now, battered by fate, but unwilling to surrender. "Here's a song I wrote a long time ago," Springsteen said onstage in 1992, "I guess when I was going through a tough time in the late seventies. It's kind of a song about stripping everything away from yourself, so that you can find yourself again, and find something new and meaningful in yourself. A little bit of a test of heart."

The song was one of the ten tracks on the "Star Wars" demo from the first night in the studio, and Springsteen started writing it as early as 1975. The version on the album was re-recorded from scratch in March 1978 in the final days of the album sessions. They went into Record Plant's Studio B while it was under renovations, with all of the sound-absorbing carpeting and insulation stripped away, leaving resonant concrete walls. The moment they started playing, the drum sound they sought for the entire album bounced back at them.

Weinberg is proud of the fill he played at the end, as Springsteen's vocals dissolve into wordless moans and the song's beat stops for a moment. "I hesitate to characterize it myself," he says, "but it was perfect. And it ends the album. And then it goes back into the riff; it's this dignified fade-into-the-sunset kind of thing."

Below: The band at Shellow's luncheonette in East Camden, N.J., 1978. "You don't get seven people in a booth like that; it's just not done. And Bruce is smiling," recalled photographer Frank Stefanko.

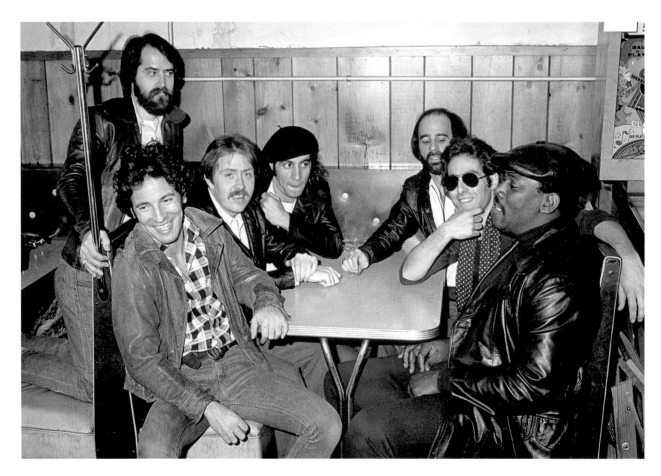

RACING IN THE STREET ('78) (OUTTAKE, *TRACKS*)

"Racing" went through many mutations; former archivist Toby Scott thinks there are about six musically distinct versions in Springsteen's archives. True to the song's origins, Weinberg remembers a "real Beach Boys version" that's never leaked. This one becomes more of a rousing rock song, with an alternate harmonica-and-piano opening, a violin part and even a different car—a '32 Ford with a 318 and fuelie heads, which again, according to one expert, could not actually exist: "they didn't make fuelie heads for 318s!" This version otherwise has similar lyrics, down to the girlfriend—other drafts didn't have a woman in it, and Springsteen consulted friends about whether to include her. "It was more about being a loser hot rodder, and then it morphed into a love song," Panunzio says. Bittan, for one, had entirely forgotten about this incarnation of the song. "As soon as I heard the first couple of chords, I went, 'Oh my god.' It's a great version. I love it." Springsteen even played it live a few times, which was a brain-bending experience for the band members, who had to make sure they were playing the right version. "It was my nightmare," says Bittan. "For many years I had so many piano intros that there were nights he would call a song, and I would go, 'Oh shit, which intro? Wait a second, where do I put my hands?' And by the time he hits four, hopefully you're there."

GOTTA GET THAT FEELING (OUTTAKE, *THE PROMISE*)

Springsteen recorded at least two albums' worth of outtakes for *Darkness*, many of them entirely incongruous with the finished album. "You're throwing the paint on the canvas," Springsteen told me in 2010, "and you haven't started to chop it down. I couldn't compare it with something I didn't have, so I was doing what I wanted to do internally and letting it come out to see what I didn't want to do, but to *see* what I didn't want to do, I had to do it." He laughed. "I had to make the albums I didn't want to put out."

Most of that material came out either on the 1998 outtakes boxed set *Tracks* or on the 2010 boxed set *The Promise*. For the latter release, in particular, Springsteen did extensive overdubs to either fix or finish the old recordings. It's not hard to hear, for instance, that he recorded an entirely new twenty-first-century vocal for the Phil Spector-ish outtake "Gotta Get That Feeling."

Springsteen is capable of emulating his voice at various eras when he's doing partial fixes on old outtakes, but when he re-records old vocals entirely, he tends to slip away from that approach, says longtime engineer Toby Scott. "When he's singing it new and he knows that he doesn't have to punch into anything, his projection and his singing is going to sound more like Bruce in 2010," he says. "And not Bruce in '78, because he had different styles of singing back then, and even though he can imitate it or emulate it, if he's not concentrating on trying to be Bruce in 1978, then it will evolve into a little bit later in time. Then I'm sure that Bruce fanatics could go through and go, 'Oh, well, he obviously . . . this is a new vocal on this song or that song.'"

OUTSIDE LOOKING IN (OUTTAKE, *THE PROMISE*)

A tossed-off but enjoyable Buddy Holly homage, another one of the songs on the "Star Wars" tape. "It's totally 'Peggy Sue' in the drum part," says Weinberg. "Or 'Sheila' by Tommy Roe." "I didn't want to be pegged as a revivalist," Springsteen told me. "So I was hesitant to wear my influences too clearly on my sleeve at the moment."

> **"IT'S A SONG ABOUT STRIPPING EVERYTHING AWAY FROM YOURSELF, SO THAT YOU CAN FIND YOURSELF AGAIN."**
>
> BRUCE SPRINGSTEEN

SOMEDAY (WE'LL BE TOGETHER)

Another Brill Building/Spector-ish lush pop song, heavily reworked circa 2010, down to the backup vocals from Patti Scialfa. Musically, it bears some resemblance to "Linda Let Me Be the One." "On the love songs," Springsteen told me in 2010, "it's a funny thing—if you sing and write those lyrics well enough, something like 'Someday (We'll Be Together)' takes on a universal element that sort of transcends its genre. I was having an enormous amount of fun with the toolbox of rock 'n' roll, all the things that were already sort of in there, and I was like, 'Oh, let me use this. Wait a minute, there's that big, thick sound with the girl singers, I'm going to try to write something that sounds great . . . ' I'd write something to hear Clarence play the sax or for the keys, and if you write well enough, what you end up with has nothing to do with whatever its initial spark was. You don't know what's going to come out. I still enjoy writing that way—it's like flexing all the muscles of the craft you studied and the deep emotions of all those great singers, so it's fun to do."

ONE WAY STREET (OUTTAKE. *THE PROMISE*)

Springsteen spent one day in June 1977 on this slow burner and then seems to have overdubbed a vocal and horns decades later. The song's melody is superior to its lyrics—usually a good excuse for Springsteen to vault a song.

BECAUSE THE NIGHT (OUTTAKE. *THE PROMISE*)

"Because The Night" was another song Springsteen had ready on day one, albeit with unfinished lyrics; it's on the "Star Wars" tape. "We cut that and we all looked at each other and said, 'That's a hit record,' says Bittan. "We said that many times on many outtakes on many albums." Springsteen quickly realized he had little interest in finishing the song, and was frustrated with those initial ten songs as a whole. "We had great arrangements," he told *Rolling Stone*'s Mark Binelli in 2002. "The band sounded really good. We recorded about ten or twelve songs in one night, and I realized they weren't any good. It was terribly disappointing. I didn't hang them on anything. They were centerless. They were coreless. So I went back to the drawing board and went from the inside out."

Darkness engineer Jimmy Iovine was simultaneously producing an album for the Patti Smith Group, and he convinced Springsteen to send over a cassette for Smith to hear. After some initial reluctance, she finished the lyrics in a single night and recorded the song, which became her only hit single. Landing at No. 13 in the United States, it outperformed anything on the actual *Darkness* album, but Springsteen was nothing but pleased about it. When he heard it on pop radio in 1978, he was "really excited," he told a DJ that year. "I said, is that AM radio? Turn it up!"

Springsteen eventually finished his own set of lyrics to the song, which he used when he performed it live. For *The Promise*, he reverted to Smith's words, overdubbing them onto a *Darkness*-era E Street take.

WRONG SIDE OF THE STREET (OUTTAKE. *THE PROMISE*)

For his next album, Springsteen would write a burst of tight, British Invasion-influenced pop-rock songs, and he was already leaning in that direction during the *Darkness* era, judging by the crashing power chords of "Wrong Side of the Street" (a working title, "English Sons," seemed to be a nod to its influences rather than any actual content of the song). These kinds of songs were always Van Zandt's favorites, and they were often the first to be

tossed. "There are bands that would have whole careers with those songs," Van Zandt told me in 2017.

THE BROKENHEARTED (OUTTAKE, *THE PROMISE*)

This lovely, lilting, Latin-tinged ballad anticipates "Fade Away" from *The River*. It's impossible to imagine a song like this fitting on any incarnation of *Darkness on the Edge of Town*, but again, in November 1977, when he took a brief stab at the track, Springsteen wasn't sure what album he was making. "There *was* no *Darkness* stuff," he told me in 2010. "I didn't worry that it was going to belong to something I didn't have."

RENDEZVOUS (OUTTAKE, *THE PROMISE*)

A power-pop classic that made the "Star Wars" tape, "Rendezvous" is light, fun, and glossy—it bore, in other words, the precise virtues that Springsteen was most suspicious of at the time. He gave it to the retro-pop singer Greg Kihn, who recorded an unspectacular rendition.

CANDY'S BOY (OUTTAKE, *THE PROMISE*)

More than an ancestor to "Candy's Room," the boardwalk groove and romantic imagery of "Candy's Boy" seems to hint at the kind of album that Springsteen might have recorded in 1976. There is a line about machines and fire "at the edge of town" that Springsteen could not let go of, sticking it in "Frankie" and "Drive All Night" as well. But mostly, with its long Federici organ solo and relaxed vibe, the song feels like Springsteen's rehearsal room in his Holmdel house, where the band would play all day, without the weight of budgets or deadlines. "We had a routine of five days a week, two o'clock in the afternoon to seven o'clock," says Weinberg. "Bruce would get out of bed when we were all there. He had a roommate, a housemate, who was also our road manager at the time, who would wake him up when we were all there. Bruce would come down, he'd take a big salad bowl, and fill it with Sugar Pops and then take a diner glass container of sugar and practically empty it on it. And then we'd play."

SAVE MY LOVE (OUTTAKE, *THE PROMISE*)

"Save My Love" was one of the many, many songs Springsteen and the band tried out at his house, but this one seems to have never made it to a studio at all. However, Barry Rebo, a moviemaker who trailed Springsteen extensively in the seventies, capturing some of the only footage of those years, happened to be shooting while they played it at the house one day in 1976. Years later, when director Thom Zimny was going through Rebo's footage for use in his *Darkness* documentary *The Promise*, he was captivated by the song, playing it over and over. "Jon suggested I show it to Bruce," Zimny says. "Bruce liked it a lot." Later, Zimny got a call to come to Springsteen's home studio, where he and the band were preparing to re-record the song from scratch after learning it from the video.

In a 2014 concert, Springsteen explained that "Save My Love" was inspired by the magic of radio. Referring to the time he first heard one of his songs, "Spirit in the Night," on the air, he recalled, it was "one of the top ten moments of my life. I stood there and I remember thinking about all the people who were listening to that song at that moment. When radio is great, something happens in the air from all those souls converging around one idea at one moment. I think that's what I wrote about in this song."

Above: The Darkness Tour of 1978 saw Springsteen and the band play 115 shows across the U.S.A.

AIN'T GOOD ENOUGH FOR YOU (OUTTAKE, *THE PROMISE*)

This appealingly goofy frat-rock track had little chance of making any Springsteen album—the fact that he actually mentions Iovine by name in the lyrics, apparently praising his fashion sense, makes that clear. Iovine says the nod was inspired by his habit of visiting Bloomingdale's, the upscale department store, before the day's sessions. "I'd go with a friend of mine and we'd look at the girls in the makeup section, you know," he says. "Bruce would say, 'Where ya been?' I got a bag in my hand the whole time, right? I said, 'I went to Bloomingdale's.' He said, 'What's Bloomingdale's?' I said, 'It's a shop, Bruce, they got all this stuff. I bought this shirt today.' And he just put it in his song."

FIRE (OUTTAKE, *THE PROMISE*)

"Elvis needs a hit," Springsteen declared in June 1977, as Weinberg recalls it. "I'm going to write Elvis a hit." True to his word, Springsteen sat down and wrote "Fire." He and the band laid it down on June 17, but the song never made it to Presley, who died two months later. They never revisited it in the studio, and Springsteen gave "Fire" to the neo-rockabilly singer Robert Gordon. Its first real success, however, came from the Pointer Sisters, who took it to No. 2 in early 1979—another case of a *Darkness* outtake outperforming the actual album.

"I'M GOING TO WRITE ELVIS A HIT."

BRUCE SPRINGSTEEN

Left: Bloomington Metropolitan Sports Center, Minnesota, June 10, 1978. 6,000 fans turned up.

SPANISH EYES (OUTTAKE. *THE PROMISE*)

Panunzio had always loved this ballad, but when he heard its "hey little girl" lines reused in "I'm On Fire," he figured the world would never hear it. Later, the engineer did elaborate digital surgery on a half-finished vocal to try to ready the song for *Tracks*, but it didn't come out until *The Promise*, by which time Springsteen had resung it.

IT'S A SHAME (OUTTAKE. *THE PROMISE*)

Notable mainly for an early use of the "Prove it All Night" riff and a (solid) performance by Landau on drums, this soul-rock song would have worked nicely as a Southside Johnny track.

COME ON (LET'S GO TONIGHT) (OUTTAKE. *THE PROMISE*)

A mood piece about the crowds that gathered in Memphis, Tennessee, upon Elvis Presley's death, set to what became the music for "Factory." It's mildly intriguing that Springsteen turned a song about the death of his fantasy father into one about the soul-killing life of his real dad. A couple lines turned up in "Johnny Bye Bye," another meditation on Presley.

TALK TO ME (OUTTAKE. *THE PROMISE*)

"It was a genre exercise," Springsteen says. "Those are just the kind of songs guys wrote, at the time, about women. Most of them were done with a wink. A lot of it was just trying to write a clever lyric, because I liked how the idea of the Brill Building was, 'OK, we're going to write a song about . . . it's a breakup song, or the girl, she won't talk to the guy. You can't satisfy her.'" During the recording of "Talk to Me," Panunzio accidentally put the guitar on the same track as the vocal, so he was highly relieved when he learned that Springsteen would only be using it as a demo for Southside Johnny.

HEARTS OF STONE (OUTTAKE. *THE PROMISE*)

An exquisite soul ballad that became the title track of Southside Johnny and the Asbury Jukes' best album (produced by Van Zandt) with Southside simply replacing Springsteen's vocal on the E Street recording. "Hearts of Stone" is one of multiple songs in this era that sympathetically mentions "wrinkles" or "lines in your face" (at this particular point in Springsteen's songwriting, women fell into two categories: "little girl" or incipiently middle aged.)

THE LITTLE THINGS (MY BABY DOES) (OUTTAKE. *THE PROMISE*)

Of a piece with "Gotta Get That Feeling" and "Someday (We'll Be Together)," this retro-pop song—banged out in a single take in 1977 but released in 2010 with modern vocals—continues a musical thread from the previous album. "The stuff is melodic, the arrangements are changing keys and moving," Springsteen told me, "and in that way, it really slid out of *Born to Run*, but on *Born to Run*, I had a theme that tied it together."

BREAKAWAY (OUTTAKE. *THE PROMISE*)

One of the "Star Wars" songs, released in its original take with latter-day overdubs. Thematically and sonically, it anticipated the *Darkness* album, but it wasn't distinct or powerful enough to earn an actual place on it. One line, about broken hearts and prices paid, ended up in cleaned-up form on "Badlands."

THE PROMISE (OUTTAKE. *THE PROMISE*)

Springsteen always seemed somewhat uncomfortable with the "pulling out of here to win" conclusion of "Thunder Road," and he added a muted note of doubt to that part when he performed the song in a piano-and-voice arrangement the year of its release. He made that discomfort explicit in "The Promise," which originally bore the subtitle "Return to Thunder Road." In "The Promise," winning means "carrying the broken spirits" of everyone who couldn't help losing, and given the future direction of Springsteen's songwriting, that may be the single most telling line he ever wrote.

Springsteen debuted "The Promise" live in August of 1976, just as his legal battle with Appel was heating up, and the song's tales of broken promises and shattered dreams (he sings the words "Thunder Road" again, only to note that "something's dying" on it) inevitably led to assumptions he was singing about the lawsuit. He furiously denied it, but later came close to admitting the connection. "At the time," Springsteen told me in 2010, "I felt this sounds a little bit like maybe it's too close to my story at the moment, and that's not a story I'm so interested in telling, I'm interested in telling *your* story, or our story . . . If I'm not telling our story, I don't put that song on the album, or if I do, it was a mistake. So I'm aware when I'm making a record that I have this stuff going on, but it's not relevant to most people's lives." Still, he worked hard on "The Promise" in the studio, and it was long in competition with "Racing in the Street" to make the album. "We probably spent three months on 'The Promise,'" says Panunzio. "I mean, there's every possible version of that song—Bruce with the piano, Bruce without piano. Roy with piano, harmonica starting the song, acoustic guitar starting the song. I mean, every way man could've recorded that record, I think we did." Thanks to live performances, the song was a fan obsession from the beginning. The *Asbury Park Press* bemoaned its absence from the album in an article written the week of its release.

CITY OF NIGHT (OUTTAKE. *THE PROMISE*)

This lost soul-pop treasure, perfected in a single day in October of 1977, captures a languid, carefree late-night cab ride. Its slow, mildly funky groove has little counterpart in Springsteen's catalog; the arrangement he often used for "E Street Shuffle" in concert might be closest.

THE WAY (OUTTAKE. *THE PROMISE*)

Iovine has loved this impassioned love ballad for decades. "I just think that song will be recorded by somebody and be a gigantic hit," says Iovine, who went on to co-found Interscope Records and Beats Electronics. After working hard to perfect "The Way" in the studio, Springsteen didn't release it until *The Promise*, as a hidden track at the end—perhaps in part just to tease Iovine. "Bruce called me," says Iovine, "and I said, 'Why did you leave this song off the fucking record? What the fuck is wrong with you?' He said, 'You didn't listen to the record till the very end.'"

GIVE THE GIRL A KISS (OUTTAKE. *TRACKS*)

An up-tempo R&B blast (with a title inspired by the Shangri-La's "Give Him a Great Big Kiss") that sounds like it should date from 1973 or 1974, this song again demonstrates how Springsteen's stylistic shifts between albums were not as linear as they seem. In a 1998 interview with *Rolling Stone*'s Anthony DeCurtis, Springsteen recalled the song as the kind of thing that "comes up on its own. It's just, 'hey, we're in the studio and we're having a great time.'

> "I WAS HESITANT TO WEAR MY INFLUENCES TOO CLEARLY ON MY SLEEVE AT THIS MOMENT."
>
> BRUCE SPRINGSTEEN

On certain nights, you would just release. You wrote this particular type of song, you went in, you played it, and maybe you only played it once and got it out of your system—and either it was going to stand, or it was going to fall and you put it away."

ICE MAN (OUTTAKE, *TRACKS*)

A spare, spooky track, featuring one of Garry Tallent's greatest bass lines and some unsettling lyrics ("I was born dead"), it was easily strong enough to have made the album. Springsteen forgot entirely about the song for decades, perhaps because he worked on it on a single day in October 1977 (and Panunzio, for one, has no memory of recording it). A line about heading out to "find out what I got" reappeared on *Badlands*.

DON'T LOOK BACK (OUTTAKE, *TRACKS*)

The final song to be cut from *Darkness*, at the absolute last minute, "Don't Look Back" is an exciting rock track that may have suffered for being off message: the narrator and his girlfriend Angel are ready to blaze off into the distance together, "Born to Run"-style, and no dark consequences loom.

Above: The Darkness Tour saw Springsteen and the E Street Band perform more than 25 songs per night—their longest sets to date.

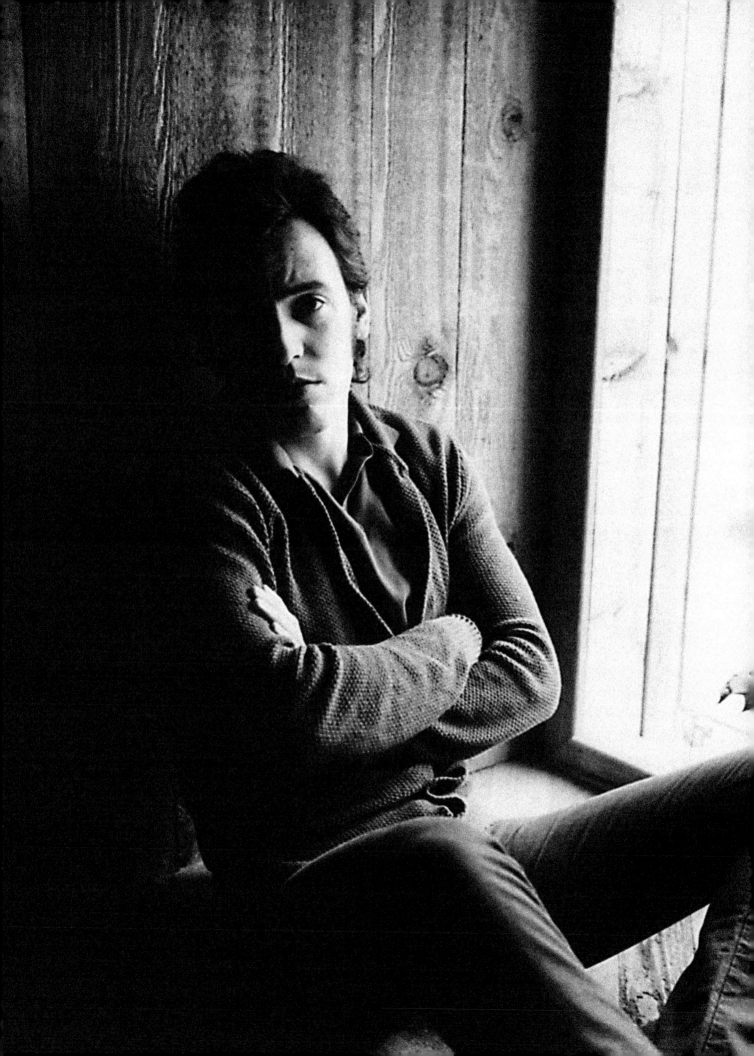

CHAPTER 5

•

1980
THE
RIVER

•

THE TIES THAT BIND

"Because of the lawsuit, I'm a little behind," Springsteen said in an August 1978 radio interview, three months after the release of *Darkness on the Edge of Town.* "I got records to make . . . and I have a lot of catching up to do." He may have convinced himself that his next album could arrive quickly this time; he had all those outtakes ready, and had already written a major new song, "Point Blank," since finishing *Darkness.* Another one was on the way. In a September 1978 soundcheck, he tried out a galloping, melodramatic, minor-key tune called "The Ties That Bind," presumably named after a line in Johnny Cash's "Ring of Fire." The music bore zero resemblance to its final incarnation, and the lyrics still attached some romance to the image of barreling down some lonely highway with "no one at my side," an idea that the song would soon flip on its head.

He soon scrapped that iteration, working with the E Street Band on a new, major-key "Ties That Bind" in rehearsals during a tour break the following month. The song was slow and heavy on its feet, and the bridge proved tricky—at one point, he tried to wedge in the one from the abandoned *Darkness* track "The Brokenhearted," which almost worked. They ended up speeding up the song and pushing the key up toward the top of Springsteen's range, which automatically pulled him into poppier territory. "Wow, that's high," he said, at the end of one rehearsal take. They performed a close-to-perfected "Ties That Bind" onstage for the rest of the Darkness Tour.

Even in its clunkiest stages, you could see what Springsteen liked about the song. It combined the musical sprightliness of something like "Rendezvous" with a lyric that moved his central themes forward. It was the sound of the guy standing alone at the hill at the end of "Darkness" getting yanked back into society; Springsteen always enjoyed writing songs that put the lie to the albums he had just finished.

In March 1979, Springsteen and the E Street Band walked into the Power Station's Studio A, a huge, wood-paneled, high-ceilinged room. Max Weinberg, Roy Bittan, and Garry Tallent had come back raving about its sound after recording there with Mott the Hoople's Ian Hunter. They were quickly proven correct: Famed mixer Bob Clearmountain, who engineered the first two songs recorded for *The River,* says that after the torture of the *Darkness* sessions, they got a drum sound in all of twenty minutes—complete with the cracking, "Hound Dog"-style gunshot snare they had chased in vain. Perhaps in tribute to that achievement, the studio incarnation of "The Ties That Bind" famously opens with a single snare shot, played with two sticks slamming down at once. It was also, Weinberg says, "probably" a conscious reference to the beginning of "Like a Rolling Stone," while his dramatic part in the bridge is a nod to The Who's "The Kids Are Alright." Springsteen and Steve Van Zandt, who was on board as a full co-producer, pushed Weinberg to play with Keith Moon's flamboyance on *The River,* even as producer Jon Landau continued to prefer less obtrusive timekeeping.

A Clearmountain-mixed "The Ties That Bind" was the title track of an album Springsteen nearly put out in late 1979. He soon decided the LP felt too lightweight—and had come too easily—so he yanked it, embarking on another six months of recording that would yield a double album, *The River.* The "Ties That Bind" that Springsteen ultimately released appears to be the same take with a different, superior vocal performance.

Previous spread: Springsteen at the Power Station recording studio during sessions for *The River,* March 25, 1980.

Right: On the roof of the Power Station studio, New York, New York in March 1980.

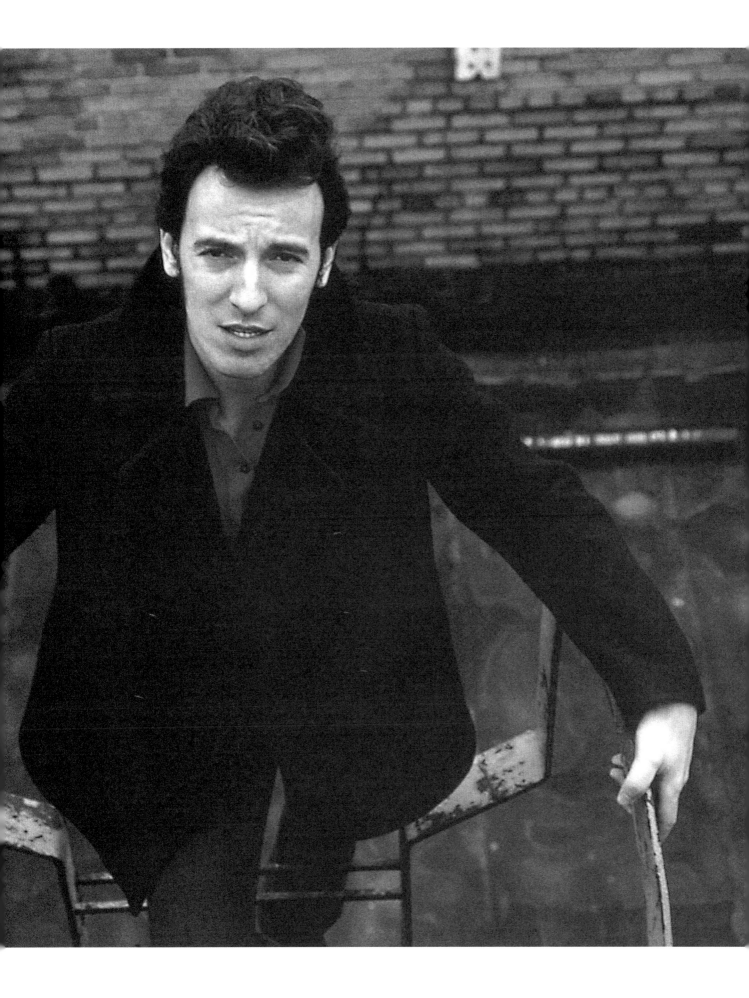

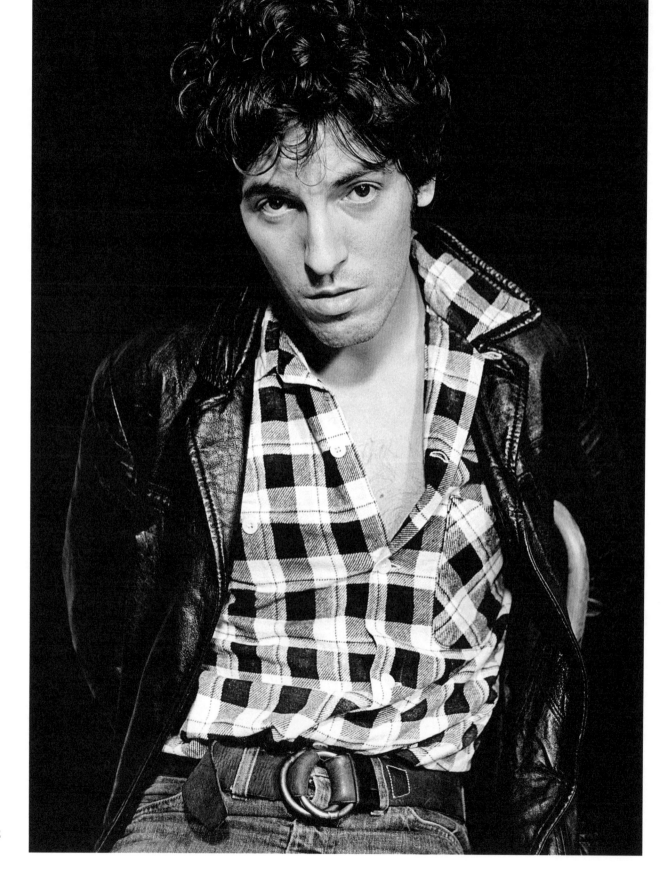

SHERRY DARLING

After spending most of the summer of 1977 holed up in the studio and a midtown Manhattan hotel room, Springsteen missed the beach. So he recorded his first song about wanting to run *back* to New Jersey, albeit in the form of a joyously trashy take on sixties frat-rock, complete with party noises and handclaps straight out of the Swingin' Medallions' "Double Shot (of My Baby's Love)." With its off-kilter lyrics about forcing a girlfriend's mother to take public transit back "to the ghetto tonight," it seemed like one of the song's main goals was to make Van Zandt laugh. Although they first recorded it during the *Darkness* sessions, "Sherry Darling" had zero chance of making that album. It popped up on that tour ("throwing up in your girlfriend's purse is allowed on this next number"), sometimes introduced with an exegesis on the history of frat-rock. Slotting a 1979 re-recording (with a couple lyrical alterations, including the tragic loss of the self-descriptor "low-class, punk-ass boy like me") as the second song on *The River* sent a message: It was the first time in years he had made room for such a purely fun song, and he had finally figured out how to make an album that would come closer to capturing the emotional range of his live shows. "I never thought it would make it to the record," says Neil Dorfsman, who took over as engineer after Clearmountain's departure. "It's such a party song. I didn't get a good sound on it, and it just felt chaotic, which I guess was the point, you know? It's just trashy as hell, which I think is exactly what they liked."

JACKSON CAGE

As he wrote songs for his fifth album, Springsteen kept drifting back to the image of a woman driving home from work and disappearing into a row of anonymous houses. Variations of the idea popped up in a demo of the outtake "Whitetown" and in another outtake, "Where the Bands Are," before

Opposite: Frank Stefanko shot the album cover photographs for *The River* and *Darkness on the Edge of Town.*

Below: Bruce Springsteen with the E Street Band (L–R): Clarence Clemons, Danny Federici, Steve Van Zandt, Max Weinberg, Roy Bittan, and Garry Tallent; October 9, 1980.

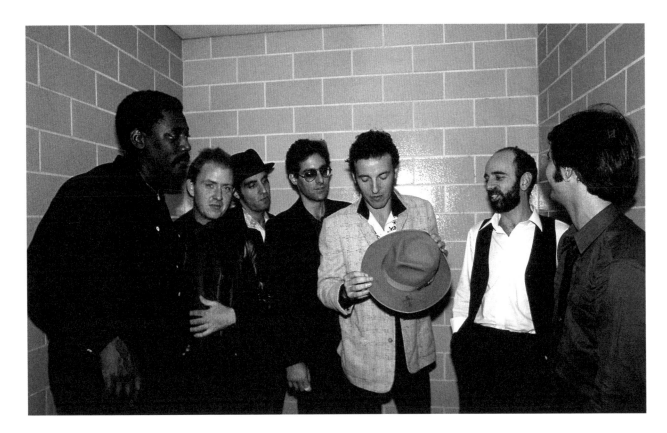

finding a home in "Jackson Cage." He may well have been thinking of his sister, Virginia, a young mother who worked at a K-Mart department store and lived in Lakewood, New Jersey, a town bordering Jackson Township (which, in turn, includes a section called Whitesville.) It was a song about powerlessness, about becoming "scenery in another man's play," and it was, of course, about his father's life as well. "I never knew anybody who was unhappy with their job and was happy with their life," Springsteen told the music critic Dave Marsh in 1981. "It's your sense of purpose." He tried at least two alternate musical settings for the song: one with an insistent organ riff and another in which he attempted to sing the "Point Blank" lyrics to the tune of "Restless Nights," over that song's full arrangement.

TWO HEARTS

In a sermon at the 1979 wedding of Springsteen's then-lighting director Marc Brickman, a rabbi told the attendees that getting married was the first step toward making "dreams and hopes a reality." "That really got to me," Springsteen told the *Boston Phoenix*'s Kit Rachlis in 1980. "I wrote a lot of songs after that." "Two Hearts" combines that idea (as also expressed in Marvin Gaye and Kim Weston's "It Takes Two") with some of the E Street Band's most unadorned guitar rock. Van Zandt steps up with tight harmony vocals (perfected in a long series of rehearsals at Springsteen's house), the first time a non-Bruce voice is allowed such a prominent spot on one of his records. The blend is seamless to the point that some early listeners may have assumed it was just Springsteen overdubbing his own harmonies again. "I know what you mean," Van Zandt told me in 2017, reflecting on their vocal similarity. "We grew up listening to the same stuff. We just kind of blended together through the years, maybe."

Judging by an early acoustic demo, the song began as a "I Wanna Marry You"-type scenario, a fantasy monologue addressed to a pretty woman the narrator spots in a department store. Despite failed attempts at wedging in an incongruous guitar solo, the boom-box recordings of the early Telegraph Hill rehearsals of the song are more exciting than the studio version, which lost some of its frantic edge at the Power Station. Getting the song right must have been daunting: "It's a great melody, but it's . . . " Springsteen says on one tape, right before it shuts off.

INDEPENDENCE DAY

Written as early as 1976, "Independence Day" was another *Darkness* leftover, re-recorded for *The River*. If "Adam Raised a Cain" was a screaming argument, "Independence Day" is the resigned tenderness that follows, with a Clarence Clemons solo that feels like grace incarnate. It's Springsteen's best song about fathers and sons, built on forgiveness and understanding: He knows by now that his dad had his own unfulfilled dreams, even if it took a while to come to that realization. "I don't know if kids care as much as they should about their parents as people until they're in their late twenties, at best," Springsteen told me in 2010.

HUNGRY HEART

In March 1979, Springsteen saw the Ramones play at the Fast Lane, a club in Asbury Park, and he met them backstage afterward, taking in the sight of four kindred spirits dressed permanently in his outfit from the cover of

"WE GREW UP LISTENING TO THE SAME STUFF. WE JUST KIND OF BLENDED TOGETHER THROUGH THE YEARS."

STEVE VAN ZANDT

Opposite: Bruce Springsteen and Clarence Clemons at the Oakland Coliseum, October 28, 1980.

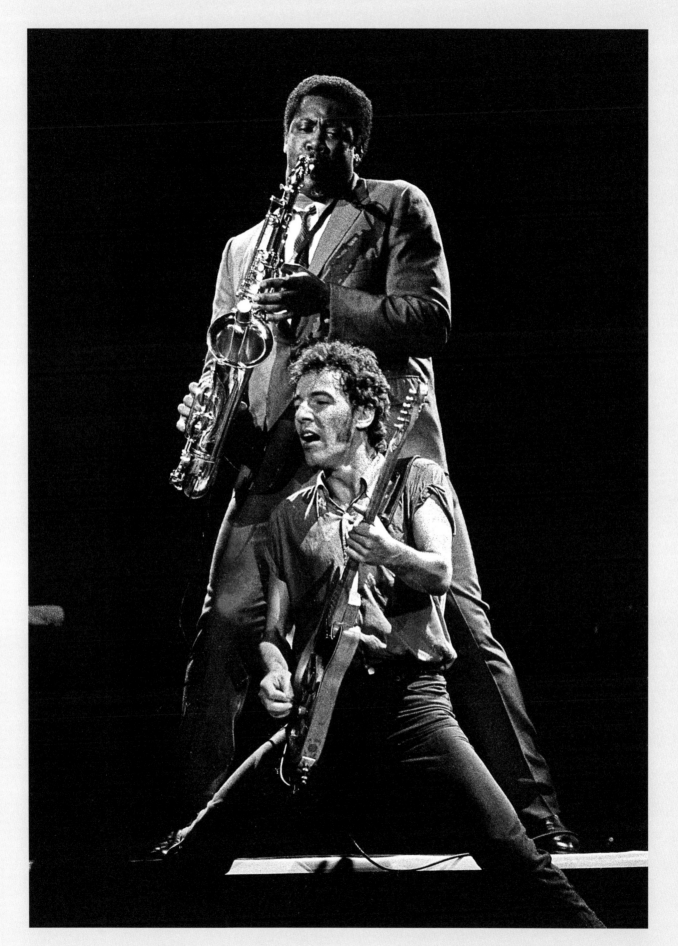

Born to Run. Joey Ramone asked Springsteen if he would write a song for them, a request that would yield "Hungry Heart," recorded with the E Street Band three months later. At some point in the process, possibly well before the band ever got to it, Landau urged Springsteen not to give away yet another obvious hit.

The band nailed the track quickly in the studio (Bittan thinks they may have used the second take), and everyone but Springsteen himself was visibly excited about its potential. "It just sounded different from everything we had been doing," says Dorfsman. "I remember feeling from Jon that this is a legitimate hit record. I remember the band loving it. Bruce was pretty close to the vest. You'd always know there was a process. The 'yes' would be a very slow and contemplative 'yes.' And when it was a 'yes,' it was still subject to change."

Van Zandt had used Mark Volman and Howard Kaylan, aka Flo & Eddie—the voices of The Turtles ("Happy Together")—on songs he produced for Southside Johnny and Ronnie Spector, and he suggested bringing them to sing backgrounds on "Hungry Heart." The idea was to do a "Beach Boys-type thing without getting the Beach Boys," Kaylan told the *Argus Leader* in 2014. Springsteen was initially uncomfortable with outsiders in the studio, and they struggled to find "the right blend between Steve, Bruce, me, and Howard . . . that would create the oohs and ahhs of 'Don't Worry, Baby,' but in the long run it ended up being successful."

When Clearmountain mixed "Hungry Heart" for the discarded *Ties That Bind* album, he slightly sped up the recording. In the comically protracted six-month mixing process for the double album, Chuck Plotkin (who worked

Above: Springsteen greeted by enthusiastic fans in Red Bank, New Jersey, circa 1980.

Opposite: Springsteen leaves the stage during a performance.

with Toby Scott on the final mixes), could not replicate the sophistication of Clearmountain's work on the track. He also found the song's pace plodding and sped up his own mix, which Springsteen hated early on. But six months later, apparently after listening to rough mixes on a cassette player that was running too fast, Springsteen told Plotkin that "Hungry Heart" felt too slow. They returned to Clearmountain's version, which ended up as the only *Ties That Bind* mix on the final album, and sped the hell out of it. "I got it all the way up until the voice started to just Mickey Mouse out on you," Plotkin says. "We found it couldn't go even a smidge faster than it ended up. Let me tell you, it was the single most important thing I did in those six months."

OUT IN THE STREET

Springsteen had the music and arrangement to "Out in the Street" nailed well before he got the words right, judging by a rehearsal tape of a musically identical song that bootleggers dubbed "I'm Gonna Be There Tonight." The final song, obviously inspired by the Easybeats' "Friday on My Mind," was a nightmare to record, and Weinberg thinks it almost got him fired. After as many as thirty or forty full takes of the song—they had to start over every time Springsteen tweaked a lyric—the drummer was "frankly, getting tired."

Weinberg's sense of time, too, had become excessively flexible after a few years on the road, which suited the live shows, but not the metronomic requirements of modern recording:

"When I first got in the band," Weinberg says, "Bruce said, 'Look, you watch my foot. If I speed up, you speed up. If I slow down, you slow down.' I said, 'Fine.' But at a time when 50 percent of the records were being made with click tracks, suddenly the live excitement of our shows didn't work in the studio."

> **"IT COULDN'T GO EVEN A SMIDGE FASTER THAN IT ENDED UP. LET ME TELL YOU. IT WAS THE SINGLE MOST IMPORTANT THING I DID IN THOSE SIX MONTHS."**
>
> CHUCK PLOTKIN ON "HUNGRY HEART"

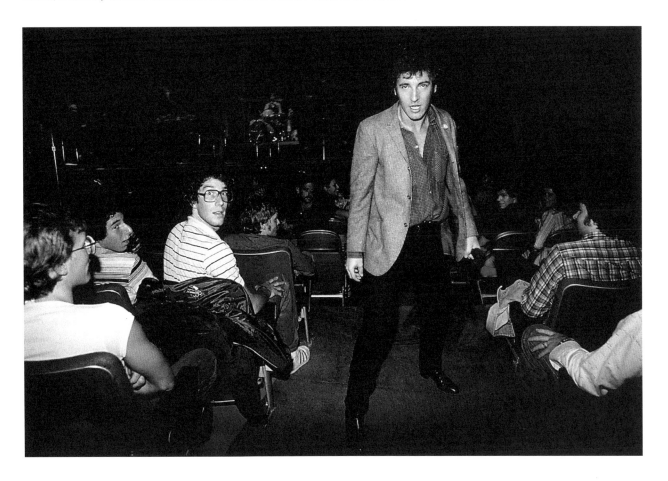

They ultimately spliced together several takes to create a workable version of "Out in the Street," but with Landau starting to talk about getting session drummer Russ Kunkel to come in and play, Springsteen took Weinberg aside in the studio lounge. "He was very, very kind, but very clear," Weinberg recalls. "The message was, 'Get it together, or else.' And this was my rock 'n' roll bar mitzvah. That was the day that I became a man." It was the beginning of a long journey of musical self-improvement for Weinberg, but it also had an immediate effect. "What comes to mind is the prison movie *Scared Straight*. Because, right away, from that moment on I played 50 percent better. "

CRUSH ON YOU

"We firmly believe this is the worst song we ever put on a record," Springsteen said in 2008, before a rare live performance of this endearingly trashy tune. Springsteen also claimed to have taken the intro riff from the theme to the early-sixties TV show *Car 54, Where Are You?*, though it sounds a whole lot more like he got it from Keith Richards. He also took obvious inspiration from the 1978 Clash B-side "1–2 Crush On You."

YOU CAN LOOK (BUT YOU BETTER NOT TOUCH)

On the abortive *Ties That Bind* album, "You Can Look" was straight-up rockabilly, with a nearly rapped vocal that recalled Chuck Berry's "No Money Down." It had a deliberately silly ending (multiple upward key changes in a row) that emphasized the comic nature of the song's tales of dissatisfaction. *The River*'s version was less distinctive four-chord rock, while a leaked early acoustic demo has a slight reggae lilt, raising the specter of infinite versions in infinite genres of this relatively slight song.

I WANNA MARRY YOU

With its distinct Drifters-like lilt, this is one of the loveliest pop tunes Springsteen had recorded up to this point. "I wrote this song as a daydream," Springsteen said onstage in 2016, "like you're standing on a corner watching someone you'll never meet walk by, and you imagine an entire life with this person, where you're gonna live, what kind of kids you're gonna have. Of course, it's the easiest kind of life, the one without the consequences. But hey, it's a young man's song. It's imagining love and all of its glory. It's not the real thing. But you gotta start someplace, so this is where I started."

THE RIVER

In his book *Born to Run*, Springsteen insists that the chorus of "The River" was inspired by Hank Williams's "My Bucket's Got a Hole in It," an assertion he has made multiple times over the years. However, it's *another* Williams tune, "Long Gone Lonesome Blues," that has its narrator going "down to the river," only to find it's dry. It doesn't matter: Springsteen certainly knew both songs. Hanging in the studio with Plotkin one night in 1980, Springsteen started singing and playing "every goddamn Hank Williams song ever," Plotkin says. "Just one after the other." Plotkin was deeply impressed, realizing that Springsteen approached the craft of songwriting with the seriousness of a "brain surgeon."

Springsteen appears to have grafted the "down to the river" idea onto a song well in progress, "Angelyne," which already had many of the final song's lyrics and even its chorus melody in place. Applying taut literary detail to a

> "THE MESSAGE WAS 'GET IT TOGETHER, OR ELSE'. AND THIS WAS MY ROCK 'N' ROLL BAR MITZVAH. THAT WAS THE DAY I BECAME A MAN."
>
> MAX WEINBERG

tale of a teenage pregnancy, drawn from his sister's life, "The River" was a clear step forward.

"We tortured ourselves on it, man," says Dorfsman, who remembers recording take after take. "I'm pretty sure we did more and less stripped down versions, more and less folk-y versions." Clearmountain mixed a version of "The River" for *The Ties That Bind*, and what appears on the eventual double album sounds like the same take with some fresh overdubs, including a wordless, spectral vocal coda that hovers over the end of the song.

POINT BLANK

Springsteen started writing "Point Blank" during a soundcheck a couple days before *Darkness* hit stores, with eerie music that would soon underscore a story meant to illustrate just how dangerous the isolation lurking in that album could be. The ex-girlfriend in "Point Blank" has experienced a spiritual death. In early versions, she was a drug addict, seeking her "usual fix," but either way, she has surrendered to the disappointments of adulthood, forgotten "how to fight."

By the time Springsteen recorded the song for *The River*, after playing it throughout the Darkness Tour, it was more than nine minutes long, as Plotkin recalls, thanks to a lengthy bridge section that recurred three times. While Springsteen and Landau were out at dinner, Plotkin took the liberty of editing out those bridges entirely. "And Bruce, he said, 'Charlie. I wrote them months after I wrote this song, because I felt like this song was not finished, and that it needed this to finish itself,'" Plotkin recalls. "And I said, 'I'm not surprised, because it sounds like an add-on rather than an organic part of the song that you've written.'" In the end, Springsteen agreed, and Plotkin was soon the latest member of his production team.

CADILLAC RANCH

A great, gleeful rock 'n' roll song about mortality, the whole thing is a dark joke, packed with skull-faced double entendres (the first line's reference to "when his day is done," for example, is not really about a hard day's work). Springsteen spent an unusual amount of time overdubbing the vocals. "I think it was a bit of an attitude thing," says Dorfsman. "Getting the exact right sort of Elvis-ian, rockabilly, full-on rocker guy persona." Springsteen did the final verse so many times that he got loopy and started singing it in a Richard Nixon imitation. "Everybody was just dying," Dorfsman says. "It was hilarious. He did a *lot* of takes as Richard Nixon singing that verse."

I'M A ROCKER

Dorfsman thinks there may have been talk of giving this cartoonish tune, known as "She's a Rocker" until the final vocal overdubs, to the Ramones in lieu of "Hungry Heart." As Weinberg recalls, Springsteen wanted the song to have the dense, echoey sound of the Dave Clark Five's "Anyway You Want It," which it somewhat resembles. In general, however, Dorfsman had little chance to tweak the sound of any song: "It was unlike any record I have ever worked on before or since in the sense that it was kind of throw and go," he says. "They expected the sounds to be up and ready when they started playing. And, as an engineer, I was always wanting to go, 'can we just spend two minutes on this and let's try a different amp, or a different guitar?' That wasn't even a consideration, man. It was about generating audio data as fast as possible. It was more about the performance than it was about anything else."

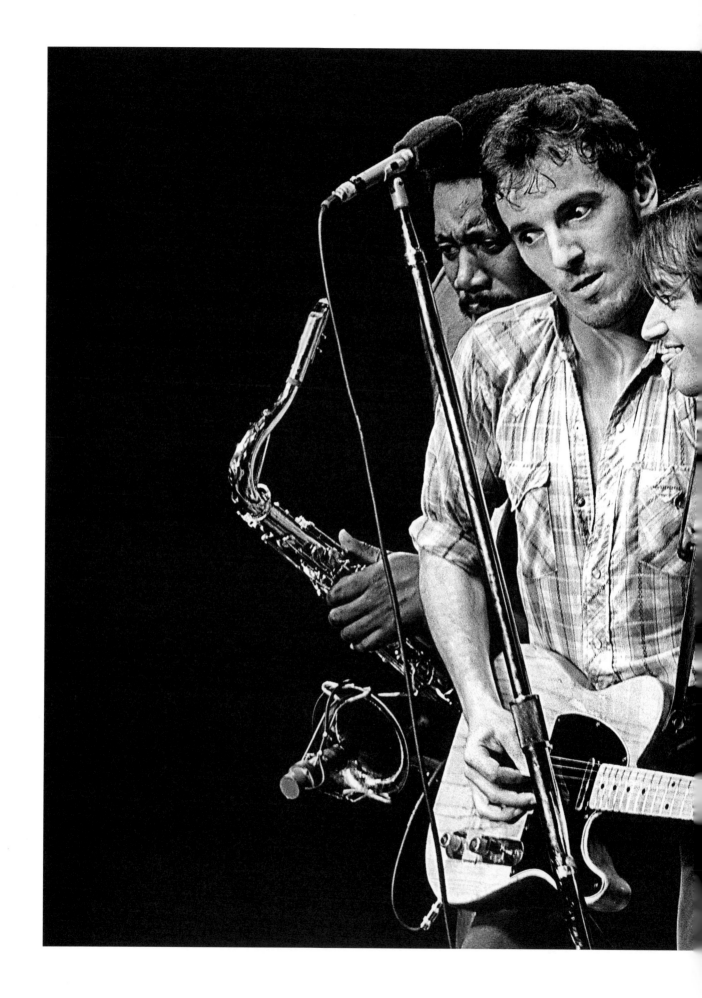

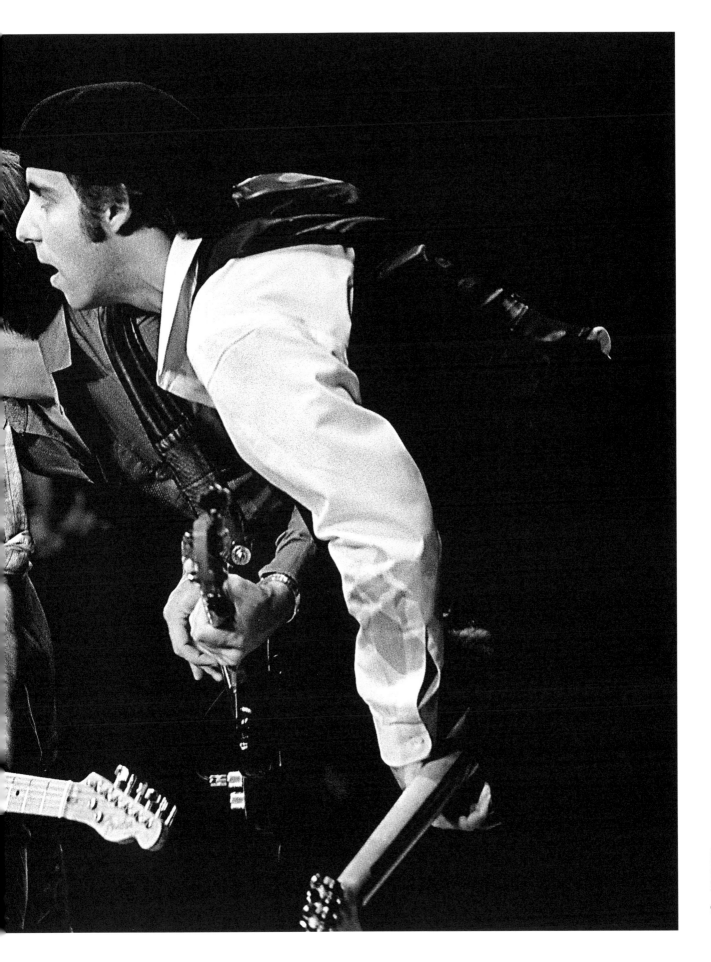

FADE AWAY

Springsteen was especially conscious of trying to incorporate the power of pure pop onto *The River*, as on "Fade Away," a somewhat generic soul ballad with a strong hook—again, the kind of thing he had usually been inclined to give away. Late in the process, Plotkin remembers "Stand By Me" coming on the radio. "That right there, that is all I'm trying to do," Springsteen said. "Just make something as beautiful, and righteous, and powerful, and sweet as that. That's our job."

STOLEN CAR

Springsteen fans always worshipped the (widely bootlegged) *Ties That Bind* version of "Stolen Car," with its lush E Street arrangement—and a striking section where the narrator claims that his marriage was doomed from the moment the preacher said "son, you may kiss the bride." Cutting that part was indeed a mistake, but the double-album version, recorded months afterward, is otherwise a more interesting piece of music, with Springsteen's voice initially backed by just droning electric guitar and Bittan's stately piano. Dorfsman felt it was the most modern thing Springsteen had recorded for the album, and he presciently compared it to the doomy New York synth-punk duo Suicide, who would be a major influence on *Nebraska*.

For Springsteen, the plainspoken lyrics of "Stolen Car," which owe a distant debt to Hank Williams's "Wedding Bells," pointed toward a new style of writing, one where characters essentially pull up to the barstool next to you and tell their story. (It's also the same narrative as "Hungry Heart," with its darkness laid bare.) "Those particularly colloquial kinds of narrative writing, I started with 'Stolen Car' and 'The River,'" Springsteen told *Rolling Stone*'s Joe Levy in 2008. "I like completely moving into another world and getting people to walk in somebody else's shoes."

RAMROD

Springsteen wrote "Ramrod" for *Darkness on the Edge of Town*, but he tossed it from the album because it was "anachronistic . . . a celebration of all that stuff that's gonna be gone," he told Marsh in 1981. "That song is a goddamn gas guzzler." The guy in "Ramrod" wants to go racing in the streets *forever*, a desire Springsteen finds both tragic and impossible; he also hinted to Marsh that the character could be an actual ghost: "he's not *there* any more." (Stephen King's *Christine*, a 1993 novel about a car haunted by the spirit of a fifties greaser, quotes multiple Springsteen songs, "Ramrod" inevitably among them.)

THE PRICE YOU PAY

With its Byrds-y riff (emphasized even more on an alternate take that used a twelve string), and lyrics about consequences and adult choices, "The Price You Pay" sums up the sounds and themes of *The River* without necessarily pushing them forward. Dorfsman, for one, was surprised it made the album, although it also appeared on *The Ties That Bind*.

Previous spread: Clemons, Springsteen, Tallent, and Van Zandt at The Spectrum, Philadelphia, on December 8, 1980

Right: Springsteen in October 1979 in Holmdel, New Jersey.

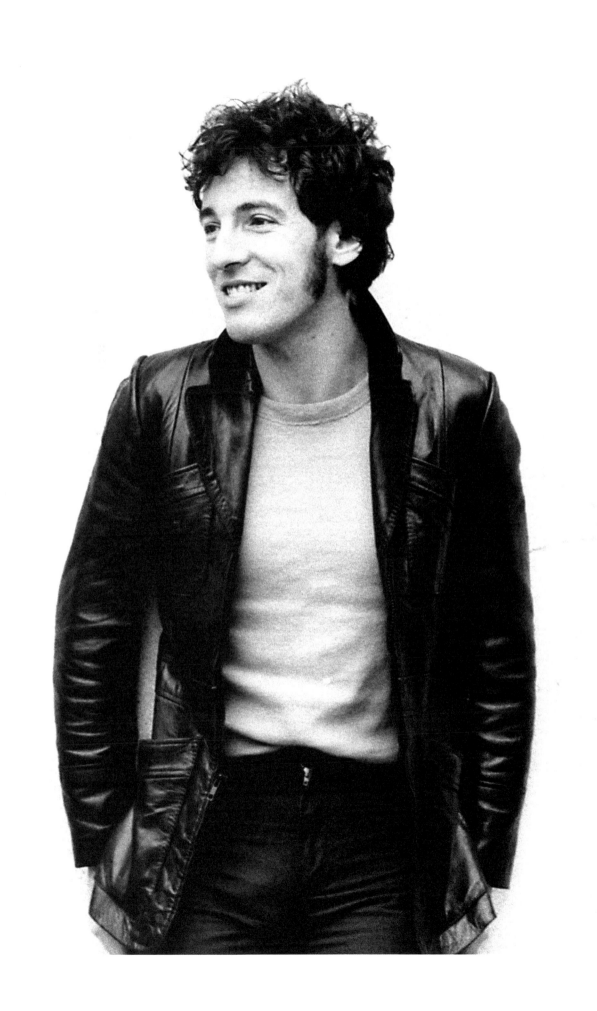

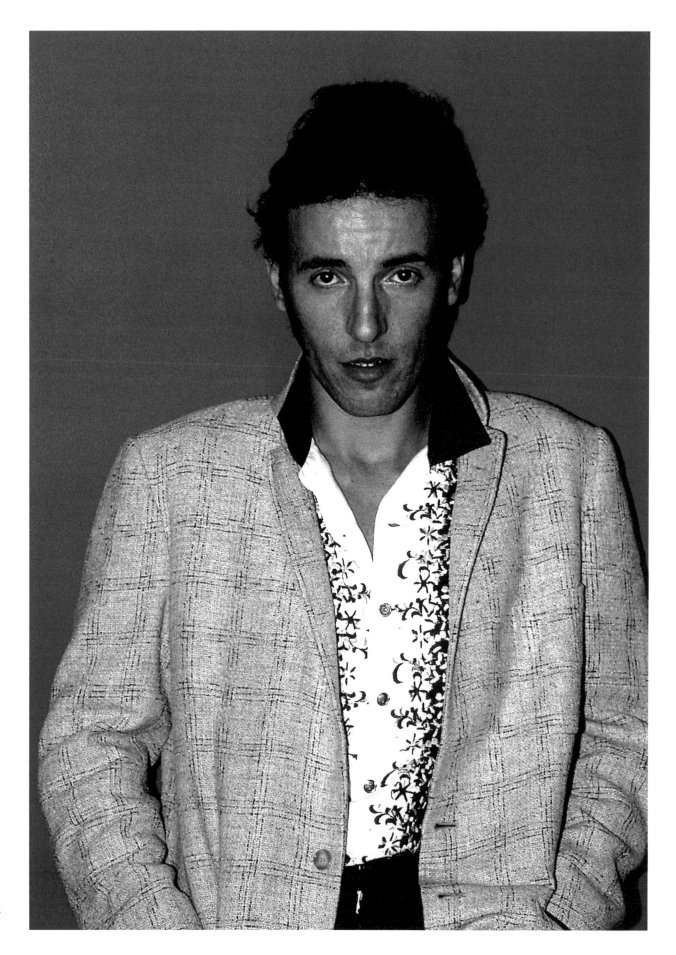

DRIVE ALL NIGHT

Springsteen recorded this hypnotic, Van Morrison-influenced ballad for *Darkness* in what appears to have been a first take, playing piano himself. "It sounds like Bruce is playing the song for the band so that they could hear the song," says Plotkin. "Max, for instance, just keeps the pulse because he knows he doesn't know what's coming next. He's playing with his ears, not his hands and feet . . . It has that strange organic perfection to it."

They intended to re-record it for *The River*, but everyone was so impressed with the original 1977 track that they kept it, with a few overdubs, including the lead vocal (Springsteen changed the very *Darkness*-era "when I lost my money" to "when I lost you, honey"). Says Dorsfman, "I remember Roy saying, 'This is fucking amazing. Why would we redo this?'"

WRECK ON THE HIGHWAY

The title and some imagery were borrowed from the country music singer Roy Acuff, an influence Springsteen and the band nodded to when they tried a more up-tempo, country-ish arrangement. The song's fatal crash, of course, could have been the fate of the guy from "Ramrod" or any number of Springsteen protagonists. "'Wreck on the Highway' is about confronting one's own death and stepping into the adult world, where time is finite," Springsteen wrote in *Songs*. "On a rainy highway, the character witnesses a fatal accident. He drives home, and lying awake that night next to his lover, he realizes that you have a limited number of opportunities to love someone, to do your work, to be part of something, to parent your children, to do something good."

CINDY (OUTTAKE, *THE TIES THAT BIND: THE RIVER COLLECTION*)

Slotted as the second track on *The Ties That Bind*, and then left unreleased for 26 years, "Cindy" is a sweet, Buddy Holly-like pop tune that takes on a slightly twisted edge as it becomes clear that Cindy wants nothing to do with the narrator.

BE TRUE (B-SIDE)

This arena-sized love song—with a chorus that may have been addressed as much to Springsteen's audience as to any actual lover—was slotted for *The Ties That Bind*, only to become one of way too many great songs left off of *The River* for thematic rather than musical reasons.

LOOSE ENDS (OUTTAKE, *TRACKS*)

A torrid, wildly catchy break-up song that was a longtime fan favorite on bootlegs—and the focus of considerable attention during the recording sessions. "That was a big one," says Dorfsman, who assumed it would make *The River*. "We did a lot of work on it. I would say at least 30 takes, maybe more."

MEET ME IN THE CITY
(OUTTAKE, *THE TIES THAT BIND: THE RIVER COLLECTION*)

Apparently left unfinished in the *River* sessions (when it may have been recorded under the title "Do You Want Me to Say Alright"). Springsteen recorded a new vocal part for this song's 2016 release.

> **"IT SOUNDS LIKE BRUCE IS PLAYING THE SONG FOR THE BAND SO THAT THEY COULD HEAR THE SONG."**
>
> CHUCK PLOTKIN

Opposite: Springsteen in Detroit, Michigan shortly before a performance at Cobo Hall, October 9, 1980.

THE MAN WHO GOT AWAY
(OUTTAKE, *THE TIES THAT BIND: THE RIVER COLLECTION*)

With a riff that's very "Glory Days," this careening garage-rocker features strong playing from the E Street Band (it's a favorite of Weinberg, who labeled it "super-fast roll song" on an early cassette), without ever turning into much of a song.

LITTLE WHITE LIES
(OUTTAKE, *THE TIES THAT BIND: THE RIVER COLLECTION*)

Most of the lyrics of "Loose End" are squeezed here into a "Paint It Black"-like arrangement. A bootlegged alternate version used the lyrics of "Be True" instead. "Bruce would have lyrics," says Weinberg, "and fifteen different musical motifs to try them with."

THE TIME THAT NEVER WAS
(OUTTAKE, *THE TIES THAT BIND: THE RIVER COLLECTION*)

A Phil Spector-meets-Four Seasons ballad that seems to be about aching nostalgia for an idealized past that never existed. It resembles some of the more retro-leaning *Darkness* outtakes.

NIGHT FIRE (OUTTAKE, *THE TIES THAT BIND: THE RIVER COLLECTION*)

The dramatic but overwrought arrangement bears some resemblance to the original minor-key "Ties That Bind," with a baffling line about people "staring down your throat" that Springsteen retained even when he sang new vocals circa 2016. A lyric mentioning "broken glass and running feet" also appears in "Whitetown."

WHITETOWN (OUTTAKE, *THE TIES THAT BIND: THE RIVER COLLECTION*)

The acoustic demos for this song suggested the influence of Jimmy Cliff's "The Harder They Come," and at one point it shared lyrics with "Jackson Cage." The studio version sheds all of that, becoming an uncommonly melodic power-pop song, with a unique, wall-of-Bruce multi-tracked lead vocal.

CHAIN LIGHTNING
(OUTTAKE, *THE TIES THAT BIND: THE RIVER COLLECTION*)

This Link Wray-like rocker somehow manages to anticipate both "Pink Cadillac" and "State Trooper."

PARTY LIGHTS (OUTTAKE, *THE TIES THAT BIND: THE RIVER COLLECTION*)

An intriguing mash-up of lyrics from "Point Blank" with lines that Springsteen would insert into his version of Tom Waits's "Jersey Girl," plus a title and chorus that nod to Claudine Clark's 1962 hit of the same name.

PARADISE BY THE 'C'
(OUTTAKE, *THE TIES THAT BIND: THE RIVER COLLECTION*)

A concert-favorite instrumental built on the same bones as "So Young and In Love" (as well as the never officially released "A Love So Fine"). All three, according to Weinberg, are loosely inspired by Dion's 1962 song "Love Came to Me."

STRAY BULLET (OUTTAKE, *THE TIES THAT BIND: THE RIVER COLLECTION*)

In a singularly moody ballad recorded in 1980 but unheard, even on bootleg, until 2016, Clarence Clemons plays plaintive soprano sax, while Springsteen seems to be trying his best to sing like Neil Young, before playing a very

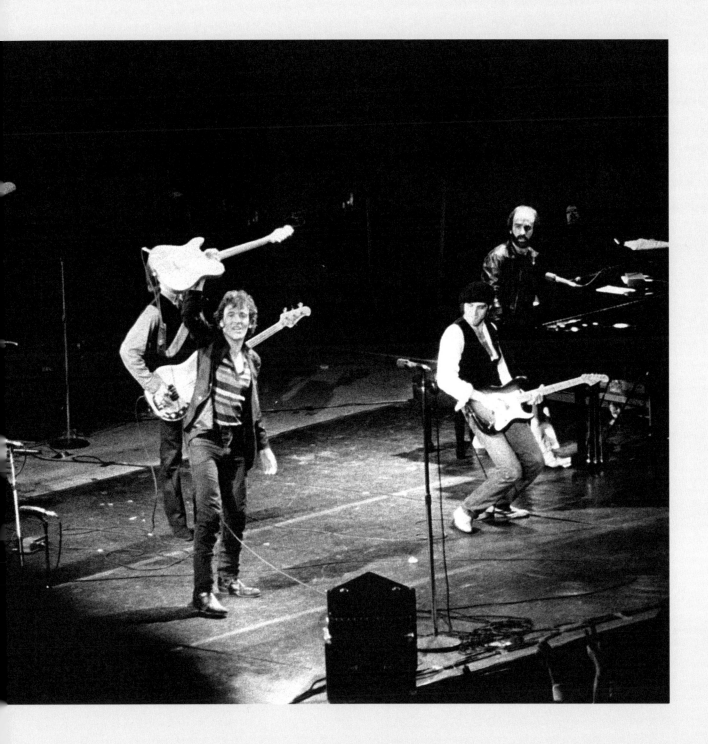

Young-like, fuzzy guitar solo. "It's got a 'Point Blank' vibe to me a little bit," says Dorfsman, who remembers being intrigued by the song's oddness back in 1980. "Just that sort of dark, midnight kind of vibe. It doesn't sound like a Bruce song. It's got a different kind of melodic approach. It sounds like he's covering someone else's tune."

MR. OUTSIDE (OUTTAKE, *THE TIES THAT BIND: THE RIVER COLLECTION*)

With no copies of this song in the official archives, Toby Scott downloaded a bootlegged solo-acoustic demo tape online and slightly tweaked it for official release. "Mr. Outside" seems to have been an offshoot of early versions of "Whitetown," or vice versa.

Above: Springsteen and the E Street Band at the LA Sports Arena in Los Angeles, California, November 3, 1980.

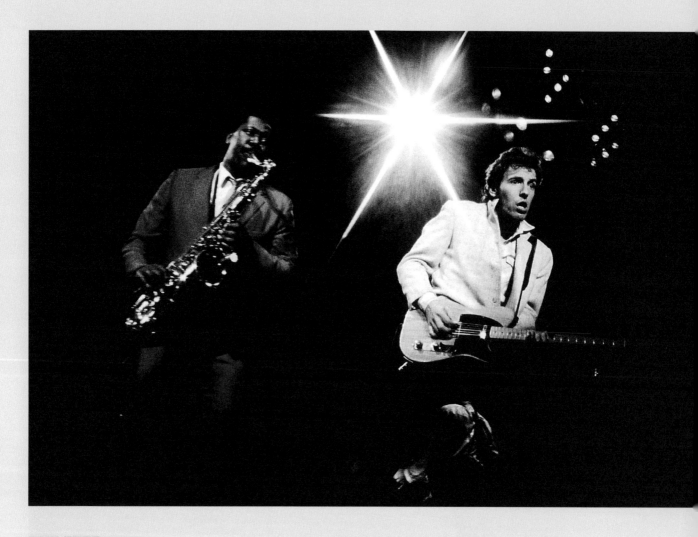

ROULETTE (B-SIDE)

Six days after the March 1979 partial meltdown of the Three Mile Island nuclear reactor, Springsteen had the E Street Band in the Power Station, recording a protest song he'd written in a furious burst. For Springsteen, the incident was an extreme real-life example of a theme that captivated him: ordinary men and women at the mercy of a society indifferent to their fates. The explosive "Roulette" was the first song recorded for *The River*, and their introduction to Studio A. "Suddenly that elusive sound that we'd all been looking for, was there in that room," says Weinberg, who remembers Springsteen singing him his furious, tom-tom-driven drum pattern for the "Roulette" intro: "Diggadigga, dum, dum."

The downright frantic "Roulette" rocked harder than even "Adam Raised A Cain," directly drawing on punk rock, complete with a spy-movie guitar intro borrowed from one of Springsteen's favorite 1978 singles, Magazine's "Shot By Both Sides." Within two days, Clearmountain had a finished mix. "I remember Bruce standing there in the control room, and Landau was behind him," says Clearmountain, "and I said to him, 'This is fantastic. Are you gonna just release this as a single? Because it's so topical." Springsteen winced at what he perceived as a crass suggestion, and "Landau was like, 'No! No! Don't say that,'" Clearmountain recalls. "And then it didn't even end up being on the album." It may have been a few years too soon for Springsteen, but "Roulette" was a sneak preview of the big noise and topical lyrics that would soon push him into stadiums.

RESTLESS NIGHTS (OUTTAKE. *TRACKS*)

"'Restless Nights' was kind of a psychedelic mixture of The Animals, Strawberry Alarm Clock, the Byrds, sort of all in one," Springsteen told *Rolling Stone*'s Anthony DeCurtis in 1998. "I was listening to all of these power-pop records like the Raspberries. So we'd go in and I'd write my three-minute single before the session." "Restless Nights" may well be the single greatest of the tragically discarded power-pop songs that make up much of the Tracks boxed set's second disc, which Steve Van Zandt has called the best E Street Band album. "It's something you can't take for granted," Van Zandt told *Rolling Stone*'s David Fricke in 2016. "That's what made me mad sometimes. I'd get angry with him. Here I am, struggling to write a good song; every fucking one of them is war. And I'd be like, 'Hey, man, you're annoying me here. You're taking this shit a little bit for granted. What do you mean you're throwing out this song other people would have a career with?' 'Restless Nights.' That's a career."

The drumming on the song, Weinberg says, is one of the ultimate *River*-era examples of "me being Keith Moon." He took the recommendation to emulate Moon's wild-man style seriously, doing his homework: "That's me going home, literally putting on headphones and playing to *Who's Next* and *Live at Leeds.*"

WHERE THE BANDS ARE (OUTTAKE. *TRACKS*)

Another superb pop song that should've made the album. Springsteen acknowledged to DeCurtis that he could have easily switched this song with "Out in the Street" and not "fundamentally altered the essence of what the record was." Still, had he done so, maybe "Out in the Street" might've been considered a lost classic.

DOLLHOUSE (OUTTAKE. *TRACKS*)

An edgy, condescending kiss-off to an ex-girlfriend ("you're living in a dollhouse") that, for all of its musical excitement, trades Springsteen's usual empathy for something close to churlishness.

LIVING ON THE EDGE OF THE WORLD (OUTTAKE. *TRACKS*)

Springsteen probably had the Ramones on his mind (again!) when he wrote this revved-up, hand-clappy road song. Many of the lyrics would reappear nearly verbatim, minus the chorus, as "Open All Night" on his next album.

TAKE 'EM AS THEY COME (OUTTAKE. *TRACKS*)

An extraordinary, punchy pop-punk blast that's a lot more musically interesting than many of the up-tempo songs that actually made the album. Sleek and guitar-driven, the song has a curiously futuristic tinge to it (which, to be fair, is aided by the 1998 mix it received for *Tracks*)—when the emo band Jimmy Eat World covered it in 2007, it sounded like they had just written it.

RICKY WANTS A MAN OF HER OWN (OUTTAKE. *TRACKS*)

Springsteen's youngest sister, Pamela, was growing up by 1979, and her apparent teenage rebellion—and his obvious fondness for her—gave him the opportunity to write the lightest song about his family he'd create until "The Wish" in the nineties. He explicitly casts his sister as a character out of a Chuck Berry song, singing "She's almost grown!"

> **"WHAT DO YOU MEAN YOU'RE THROWING OUT THIS SONG OTHER PEOPLE WOULD HAVE A CAREER WITH?"**
>
> STEVE VAN ZANDT

Opposite: Clarence Clemons and Bruce Springsteen, chasing spirits in the night.

I WANNA BE WITH YOU (OUTTAKE, *TRACKS*)

An amusingly over-the-top garage rock song that dates back to the very first night of the *Darkness* sessions. The narrator memorably loses his job at a Texaco station because he's too busy fantasizing about his lover. Carly Simon, whose own background was far from blue-collar, happened to stop by the studio as they tracked the song for *The River*. "She joked that *she* used to work in a Texaco station," Dorfsman recalls. "But nobody got the joke, everybody thought she was telling us the truth."

MARY LOU (OUTTAKE, *TRACKS*)

The first version of "Be True," with a scrappier arrangement.

HELD UP WITHOUT A GUN (B-SIDE)

Springsteen harvested the final arrangement of "You Can Look" from this incredibly concise (one minute and 16 second) little song, notable for melding a complaint about high gas prices with the image of a cigar-toting record exec exploiting some "damn fool with a guitar."

FROM SMALL THINGS (BIG THINGS ONE DAY COME)
(OUTTAKE, *ESSENTIAL BRUCE SPRINGSTEEN*)

A near-perfect rockabilly cut, recorded so quickly that Springsteen's vocal is noticeably flat in at least one spot. "I busted out my Gretsch 'Country Gentleman' guitar and the band drove the hell out of it in a take or two," Springsteen recalled in liner notes. He ended up giving the song to Dave Edmunds, who in 2017 wrote about the backstage encounter that spawned his recording of it. "He asked me if I'd been recording lately," Edmunds wrote, "and I said, 'No, got anything?'" He strapped on his Fender Esquire and explained, "This is like a Chuck Berry thing that tells a story without repeating any of the lyrics, like 'The Promised Land.' And he played [the song] from beginning to end. It was perfect for me! 'It's yours, man!'"

BRING ON THE NIGHT (OUTTAKE, *TRACKS*)

Some version of the power-pop blast "Bring on the Night," or at least a song by the same name, appears to have shown up early in the *Darkness* sessions. Bootlegs of solo songwriting sessions and band rehearsals from well after that album, however, reveal Springsteen reworking the song from scratch, with the solo versions featuring wildly different melodies and lyrics – one draft has the "is a dream a lie" line that would end up on "The River." Despite a strong chorus, the song didn't quite feel finished even by the time the band recorded it early in the *River* sessions at the Power Station in 1979, as the notably awkward lyric "forbidding close inspection of who's tellin' who lies" suggests. Several lines from "Bring on the Night" would reappear on "My Love Will Not Let You Down."

Right: Bruce Springsteen portrait with New York City in the background, circa 1980.

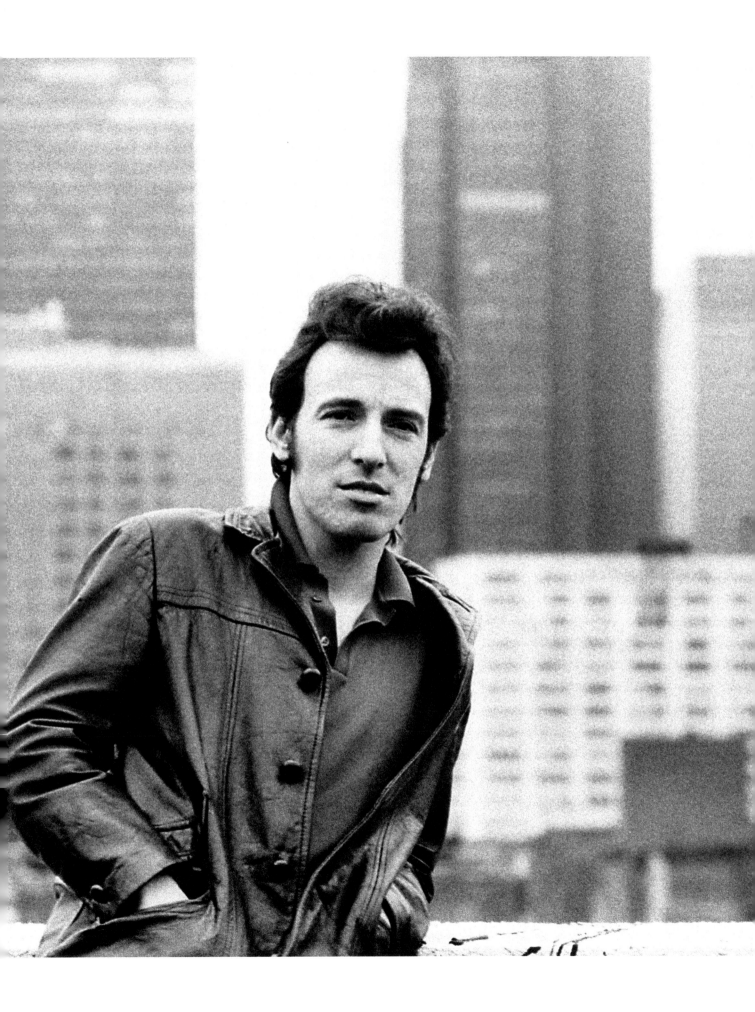

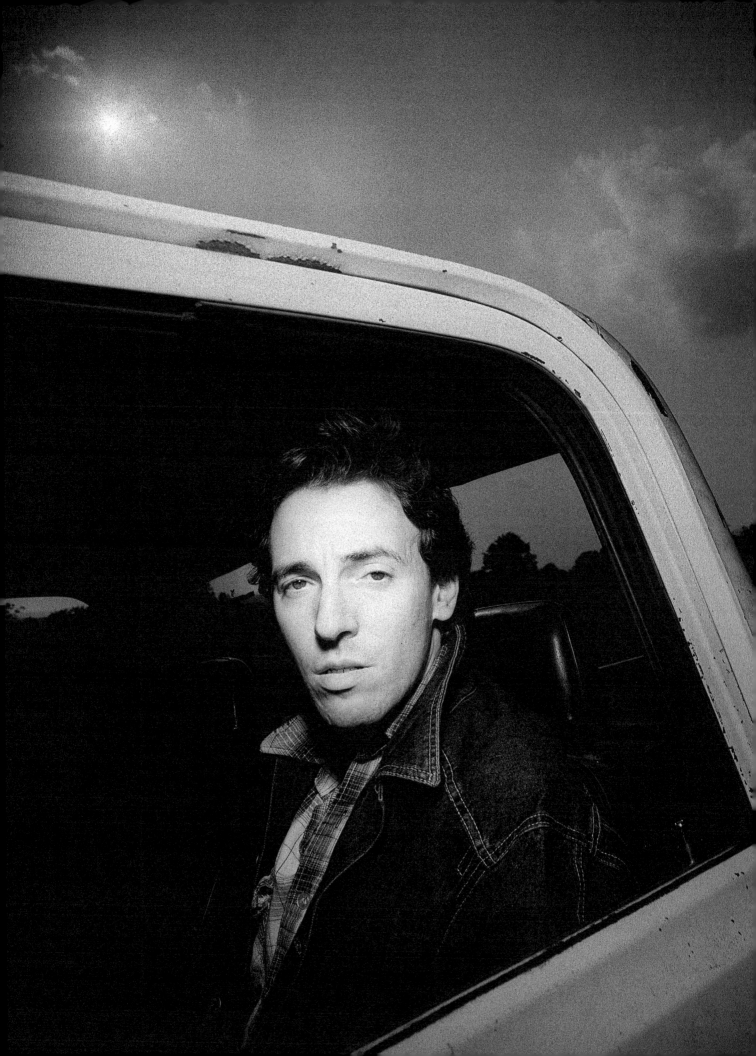

1982
NEBRASKA

NEBRASKA

"I'm an alienated person by nature," Springsteen told me in 2010. "Always have been, still am to this day. It continues to be an issue in my life, in that I'm always coming from the outside, and I'm always trying to overcome my own internal reticence and alienation. Which is funny, because I throw myself the opposite way onstage, but the reason I do that is because while the stage and all those people are out there, the abyss is under my heels, and I always feel it back there." You can't write something like "Nebraska," he continued, "without having had at least a taste of the abyss."

When the River Tour ended in September 1981, Springsteen settled into a rented ranch house in the quiet farm community of Colts Neck, New Jersey. He had real money in the bank for the first time in his life. Still only thirty-two years old, he was a hit-making rock superstar with a limitless future. But he was restless, maybe a little lonely. "He kind of went into seclusion," says drummer Max Weinberg. "You didn't see a lot of him, and for a while none of us even knew where he lived. I remember that distinctly. I think he felt the stirrings of what was to come, and it freaked him out a little bit, the loss of control over the thing generally, his privacy and everything else."

Springsteen found his thoughts turning to the stark strangeness of his early childhood, when his family still lived with his father's parents. His grandparents had lost their daughter at the age of five, and consequently indulged their first grandchild to a damaging degree. "It was a terrible

freedom for a young boy," Springsteen wrote in *Born to Run*, recalling staying up until three o'clock in the morning as a preschooler. "Our ruin of a house and my own eccentricities . . . shamed and embarrassed me." When his parents moved a few streets away and "tried to set some normal boundaries," Springsteen would run back to his grandparents' house, which was crumbling, as were its aging, increasingly dysfunctional occupants. He would sleep next to his grandmother on a couch in the house's one functioning room. That house was, perhaps, the abyss itself, the crucible of all that alienation.

He started writing songs suffused with the feeling of those years, drawing on the Flannery O'Connor short stories he had been reading and the noir movies and novels that obsessed him, while continuing the plainspoken narrative writing of "The River" and "Stolen Car." He watched Terrence Malick's 1973 *Badlands*—inspired by a murder spree committed in 1958 by a Nebraska teenager named Charles Starkweather with his girlfriend Caril Ann Fugate at his side—and started researching the real-life case, reading Ninette Beaver's book *Caril* and phoning up its author. He began writing a song he initially called "Starkweather." At first, the tale was told in the third person; soon enough, however, Springsteen was singing from Starkweather's own perspective. The opening line, with Fugate twirling her baton, is also the first scene of *Badlands*. A glockenspiel creeps in for the final verse, as if to provide an unsettling subconscious reminder of how far we have traveled from "Thunder Road."

After spending way too much time and money in studios recording all those abandoned songs on his last couple of albums, Springsteen decided he wanted to be able to more effectively prescreen his material. He sent his guitar tech, Mike Batlin, off to buy some simple home recording equipment, and he returned with a Teac 144, the first cassette four-track recorder. The Teac was a major step up from the boom boxes Springsteen had previously used for primitive home demos. Now he could overdub and build modest arrangements. In the space of a few weeks, Springsteen recorded what were supposed to be demos for his next album, sitting in a creaky chair as he sang in a soft, confidential tone that was unlike anything he had captured on record before. He mixed the takes down to a boom box, adding echo via a Gibson Echoplex guitar pedal, which lent the recordings much of their atmosphere; you can hear the echo cracking up into distortion on the word "ride" during the first verse of "Nebraska."

Before Springsteen worked up arrangements of the songs with the E Street Band, Jon Landau advised Weinberg to study the spare drumming on Bob Dylan's stripped-down *John Wesley Harding*. They rehearsed and recorded band arrangements, most of which were subtle. "It was in the vein of 'Drive All Night' or 'Wreck on the Highway,'" Weinberg says. "Big whole notes on the bass drum, these big spaces."

Little of it worked, at least not as well as Springsteen's demos. "We recorded through everything once or twice, maybe even three times," says Chuck Plotkin. "And we had to confront the issue that although we had made very good recordings with the band of the *Nebraska* material, that some quality of it that was absolutely essential to sort of the emotional experience of it, the whole subtext, was being undermined. We had managed to take this little cassette reel of demos and a strange, dark, magical moving collection of songs, and just conventionalize the whole lot to the point where it was like we had turned it into drivel." They had Springsteen record some songs solo in the studio, but that didn't work, either. It was Steve Van Zandt who first suggested that the demos were an album in their own right, and that's what they became, after overcoming some harrowing technical obstacles.

> **"I'M ALWAYS TRYING TO OVERCOME MY OWN INTERNAL RETICENCE AND ALIENATION."**
>
> BRUCE SPRINGSTEEN

Previous spread: David Michael Kennedy took this photograph as part of a series of atmospheric images for *Nebraska*.

Opposite: Another David Michael Kennedy image from the Nebraska-era shoot.

Springsteen saw the title track as the center of the album. "I was probably using Charlie Starkweather to write about myself for the most part," he told writer Bill Flanagan in 1987. It's the final verse, he has said, where the song leaps from a straightforward accounting of facts into something more internal and mysterious. "You had to go inside to find it," he said onstage in 2003, asserting that the feeling of being "declared unfit to live" is universal. He also leaps completely into fiction, with Starkweather suddenly echoing The Misfit, the serial killer from Flannery O'Connor's short story "A Good Man is Hard to Find," as he bemoans "a meanness in this world."

"I think you can get to a point where nihilism, if that's the right word, is overwhelming," Springsteen told *Rolling Stone*'s Kurt Loder in 1984, "and the basic laws that society has set up—either religious or social laws—become meaningless. Things just get really dark. You lose those constraints, and then anything goes. The forces that set that in motion, I don't know exactly what they'd be. I think just a lot of frustration, lack of findin' somethin' that you can hold onto, lack of contact with *people,* you know? That's one of the most dangerous things, I think—isolation."

"*Nebraska* was about that American isolation: what happens to people when they're alienated from their friends and their community and their government and their job. Because those are the things that keep you sane, that give meaning to life in some fashion. And if they slip away, and you start to exist in some void where the basic constraints of society are a joke, then life becomes kind of a joke. And anything can happen."

ATLANTIC CITY

Several lyrics in "Atlantic City" first appeared in "Fist Full of Dollars," a song Springsteen demoed in early 1981, which also shared some lines with his Elvis lament "Johnny Bye Bye." "Fist Full" is more explicitly about the lure of gambling, describing how a week's salary "turns to dust," with the narrator hit so hard that he hocks his guitar. The song begins, like "Atlantic City," with a reference to the death of the Chicken Man, which means Springsteen wrote it sometime after March 15, when a nail bomb killed the real Chicken Man, Philadelphia mobster Philip Testa. The bomb was under his porch, and it blew up his house, too. (In 1982, the Chicken Man's son, Salvatore Testa, sold an Atlantic City nightclub to Donald Trump at a considerable profit.)

Testa's was only the latest death in a battle between New York's Five Families and the Philadelphia mob over control of the coastal New Jersey town, where the legalization of gambling in 1978 kicked off an organized-crime gold rush. "Keep your filthy hands out of Atlantic City," Jersey governor Brendan Byrne warned the Mafia, who were undeterred. The "gambling commission" Springsteen mentions was indeed "hanging on by the skin of its teeth" by 1981, as it faced a corruption investigation by the FBI.

Springsteen drew his "everything dies . . . " chorus straight from dialogue in the 1980 movie *Atlantic City*, itself a tale of crime in the resort town: "I don't mind that Dave's dead," one character says. "It just means he'll be reincarnated sooner, that's all . . . Everything comes back." Springsteen always saw "Atlantic City" as the rock anthem it later became onstage, and Weinberg recalls the E Street Band recording it as such. The attempts at recording the *Nebraska* material were entwined with the first *Born in the U.S.A.* sessions, and "Atlantic City" could have easily appeared on either album.

"**THAT'S ONE OF THE MOST DANGEROUS THINGS, I THINK – ISOLATION.**"

BRUCE SPRINGSTEEN

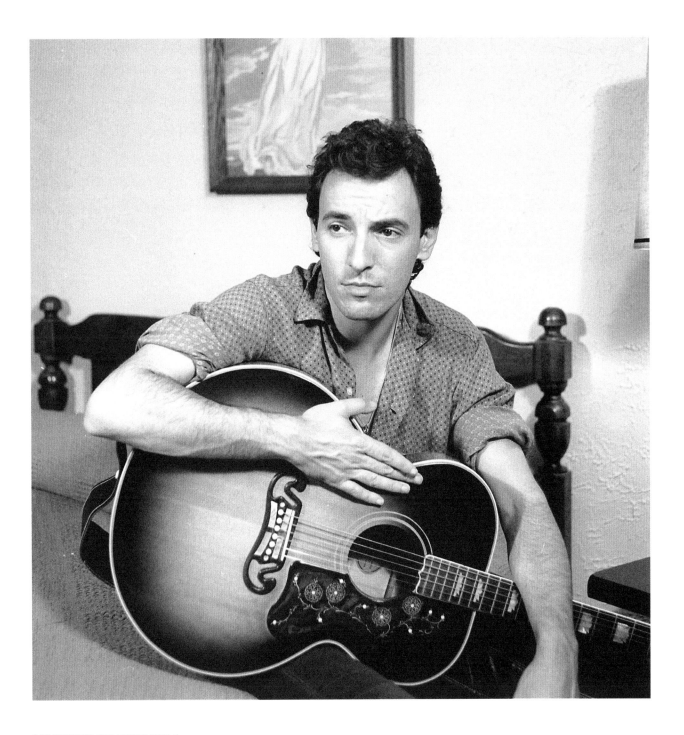

MANSION ON THE HILL

Springsteen started work on "Mansion on the Hill" as early as 1977–78, with scraps of the lyrics popping up in his *Darkness on the Edge of Town* notebook, although at that point he was writing about his father taking him to see a "palace on the edge of town." There is also a reference to "the palace of drunken fathers," which suggests a darker song altogether. He finished the song, which took significant inspiration from the Hank Williams composition of the same name, during the River Tour.

"At night my pop would take me and we'd all ride in the car," Springsteen recalled onstage in 1990. "And we would drive around the town. It was funny, we'd lived there, always, but yet we'd go sightseeing. And he'd always drive past the big nice houses and it always seemed really mystical. I did not understand

Above A Frank Stefanko portrait of Bruce Springsteen from 1982.

what those people had to do with me or my Dad or who we were." Playing the song live in the eighties, he would add, "And now when I dream, I'm sometimes outside the gate looking in . . . and sometimes I'm the man inside."

JOHNNY 99

Ford Motors closed their plant in Mahwah, New Jersey, on June 20, 1980, leaving some 3,800 auto workers out of a job. The demise of Bergen County's largest employer was heavily covered by local media, who watched as workers decorated the final car off the line with an American flag. One worker pulled out a wad of bills and waved it at a television reporter, according to the *Asbury Park Press*. "Here's my last paycheck, honey," he yelled. "Why don't you take a picture of it?"

 Among the country artists Springsteen began studying in the late seventies was Jimmie Rodgers, who in 1932 recorded "Ninety-Nine Years Blues" ("You've got two sixes, they're all upside-down"), a song written by a friend of his, Raymond Hall, who was serving a life sentence in prison. Springsteen begins "Johnny 99" with his best stab at a blue yodel, a strong hint that Rodgers provided Springsteen's direct inspiration for the tale of a laid-off auto worker who turns to crime, rather than Julius Daniels's similarly themed 1927 song "Ninety-Nine Year Blues," cited by some critics.

 Critics painted *Nebraska* as a response to Ronald Reagan's America, but only two tracks, this one and "Atlantic City," directly addressed the times. The climax of "Johnny 99," where the protagonist explains the forces behind his actions, the "debts no honest man could pay," is actually a direct rejoinder to some of Reagan's ideas: "We must reject the idea that every time a law's broken, society is guilty rather than the lawbreaker," Reagan once said. (Springsteen also used the "debts" line in "Atlantic City"—he explained to Bill Flanagan that he would have cut it from one of them if not for the unconventional recording process.)

> **"WE WOULD DRIVE AROUND THE TOWN. IT WAS FUNNY. WE'D LIVED THERE. ALWAYS, BUT YET WE'D GO SIGHTSEEING."**
>
> **BRUCE SPRINGSTEEN**

Above: Woody Guthrie with his famous 'This Machine Kills Fascists' sticker, *circa* 1943. The folk singer became a key Springsteen influence in the eighties.

Opposite: David Michael Kennedy took a series of outstanding photographs of Springsteen, as well as the *Nebraska* album cover image.

HIGHWAY PATROLMAN

In a letter to Jon Landau accompanying the original *Nebraska* tape, Springsteen explained that he was focused on songs that "break a little new ground for me." That is certainly the case for "Highway Patrolman," which represents one of the most remarkable creative leaps of Springsteen's career, cramming a novel's worth of narrative into five minutes and thirty-six seconds, even making room for a lovely, classic-country refrain. The idea of two brothers in moral conflict may have come from *True Confessions*, a 1981 Robert De Niro movie Springsteen had recently seen and loved, but the song is, overall, a pure burst of invention. The Roberts brothers—Franky the criminal, Joe the cop—could also be seen as one character split in two, representing Springsteen's vision of a bifurcated human nature, caught between hope and fear, creation and destruction.

Given Springsteen's obvious narrative gifts, Chuck Plotkin once wondered aloud why he hadn't written himself a movie. "Well, Charlie, here's the problem," Springsteen replied, as Plotkin recalls. "The problem is that what I've gotten good at is being able to take a big story, and tell it in three minutes, condense it down to where you can get across everything that's meaningful to you about this particular story in a certain amount of time and space. And the problem for me if I were to try to write a movie, something that lasts for an hour and a half, is that it would involve a thing that would feel to me like elaborating. And that's not my gift." Springsteen left it to Sean Penn to do the elaborating—he adapted "Highway Patrolman" into a movie called *The Indian Runner* in 1991.

Springsteen is perhaps too drawn to neat endings and didacticism, and the conclusion of "Highway Patrolman," where Joe lets Franky escape into Canada despite his latest crime, felt too ambiguous to him—which is one of the reasons why the song is so great. "There was a certain inconclusiveness to it that always made me feel like it wasn't finished," Springsteen told journalist Bill Flanagan in 1992, comparing it to the elliptical ending of "My Beautiful Reward."

STATE TROOPER

"I dreamed this one up comin' back from New York one night," Springsteen wrote to Landau, continuing with, " I don't know if it's even really a song or not . . . It's kinda weird." Over guitar so steady-chugging it's unnerving, Springsteen spins a tale of a solo ride down the Jersey Turnpike that drifts into despair, punctuated with madman whoops inspired by Suicide's "Frankie Teardrop."

USED CARS

This is straight, demythologized autobiography, or "the exciting story of my own personal life," as Springsteen said in his letter to Landau. "My parents love that song 'cause we had so much car trouble," Springsteen told Flanagan in 1987. "It was beyond belief. We had some bad cars. I remember my dad has this one car that wouldn't go in reverse and we constantly had to push it backward out of parking places . . . That song just kind of popped out."

OPEN ALL NIGHT

"In which the hero braves snow, sleet, rain, and the highway patrol for a kiss from his baby's lips," Springsteen wrote to Landau, not mentioning that he had heard most of the lyrics before on "Living on the Edge of the World." It is the only *Nebraska* appearance of an electric guitar, which sounds like he plugged it straight into the Teac and chugged away on the song's Chuck Berry rhythm figure.

> **"WHAT I'VE GOTTEN GOOD AT IS BEING ABLE TO TAKE A BIG STORY, AND TELL IT IN THREE MINUTES."**
>
> BRUCE SPRINGSTEEN

Opposite: Another of the David Michael Kennedy Nebraska photographs, titled *Bruce in Garage*.

Springsteen later explained that he had taken lyrical inspiration from a short story by the American writer William Price Fox, although he could not recall which one. In 1992, he said onstage that he wrote the song "in homage to the king's highway, that great royal road, the New Jersey Turnpike. I used to ride down from New York City. I'd get on the phone, call my girl early in the morning, she'd have a peanut butter-and-jelly sandwich waiting for me. I'd be promising her all sorts of sexual favors when I got home . . . I got home, I ate the peanut butter-and-jelly sandwich."

MY FATHER'S HOUSE

A late addition to the *Nebraska* sessions, recorded months after everything else on the same equipment, the song opens with a dream that transplants New Jersey's pine trees into a scene from one of Springsteen's favorite movies, the 1955 noir classic *Night of the Hunter*. "That was poetic when the little girl was running through the woods," Springsteen told journalist Chet Flippo in 1984.

The song also drew from Springsteen's compulsive habit of returning, again and again, to his hometown of Freehold in late-night drives. "I'd always drive past the old house I used to live in," he said onstage in 1990. "I got so I would do it really regularly for two or three, four times a week for years, and I eventually got to wondering, 'What the hell am I doing ?' So I went to see a psychiatrist . . . and I sat down and I said, you know, 'Doc, what am I doing?' And he says, 'Something bad happened and you're going back, thinking you can make it right again. Something went wrong and you keep going back to see if you can fix it.' And I sat there and I said, 'That *is* what I'm doing.' And he said 'Well, you can't.'"

REASON TO BELIEVE

A bulletin from the abyss, "Reason to Believe" is the bleakest song Springsteen has ever written, almost dangerously so. "That was the bottom," he told author Dave Marsh in *Glory Days*. Over music that's as deceptively cheery as a grifter's smile, he surveys the world around him and sees people buoyed by delusion instead of faith, exemplified by the guy standing on the road in the first verse, poking in vain at a dead dog as if it might resurrect itself. (In a letter to Landau, Springsteen implied that he had seen that very sight on a New Jersey highway.) The chorus, with its invocation of "every hard-earned day," led one academic to assume it's another Springsteen ode to the "nobility of the working class." But if anything, it's the artist mocking his own past certainties, wondering aloud if everyone is fooling themselves. The song is an existential cry for help, a road map to depression, and it's fortunate that its creator got himself into therapy soon after its creation.

THE BIG PAYBACK (B-SIDE)

Another solo electric track in the vein of "Open All Night" or a stripped-down "Working on the Highway," it's described by Springsteen in liner notes as "a little mean rockabilly [song] cut at home shortly after the *Nebraska* album." It seems out of place with the *Nebraska* ethos, until the final verse, when the narrator quits his job and gets hold of a knife, "long and black."

Right: A Frank Stefanko portrait of Bruce Springsteen: Secret Garden.

Overleaf: Two of David Michael Kennedy's photographs, including (right) the cover shot from *Nebraska*.

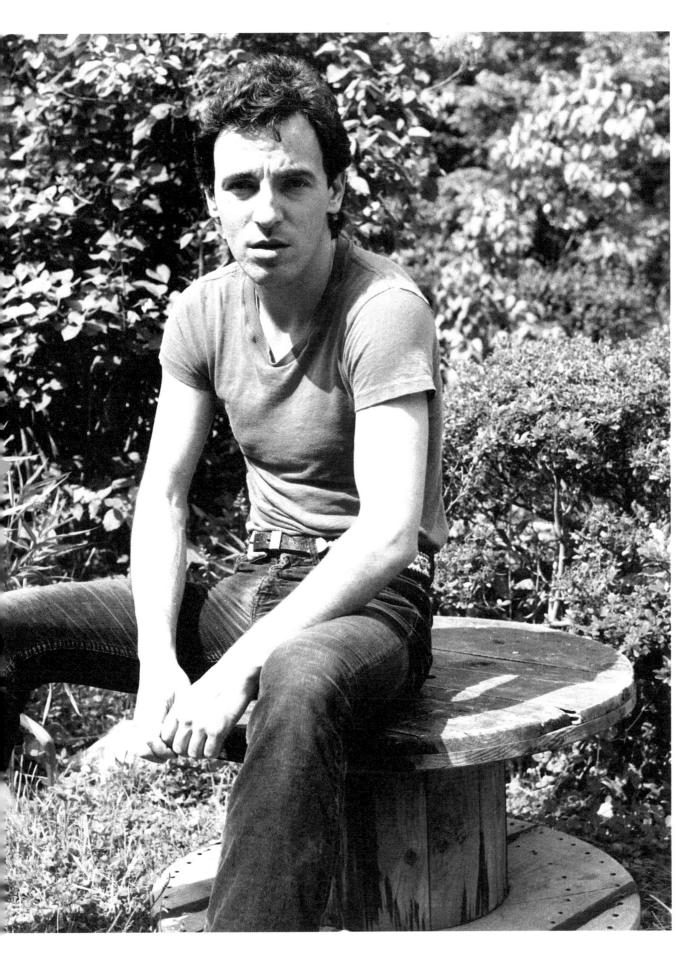

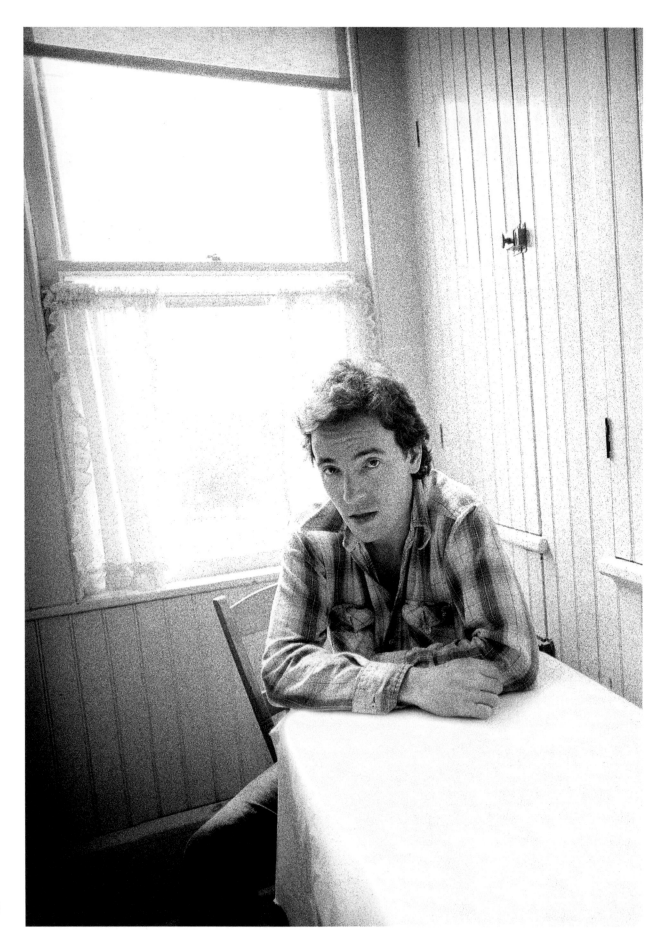

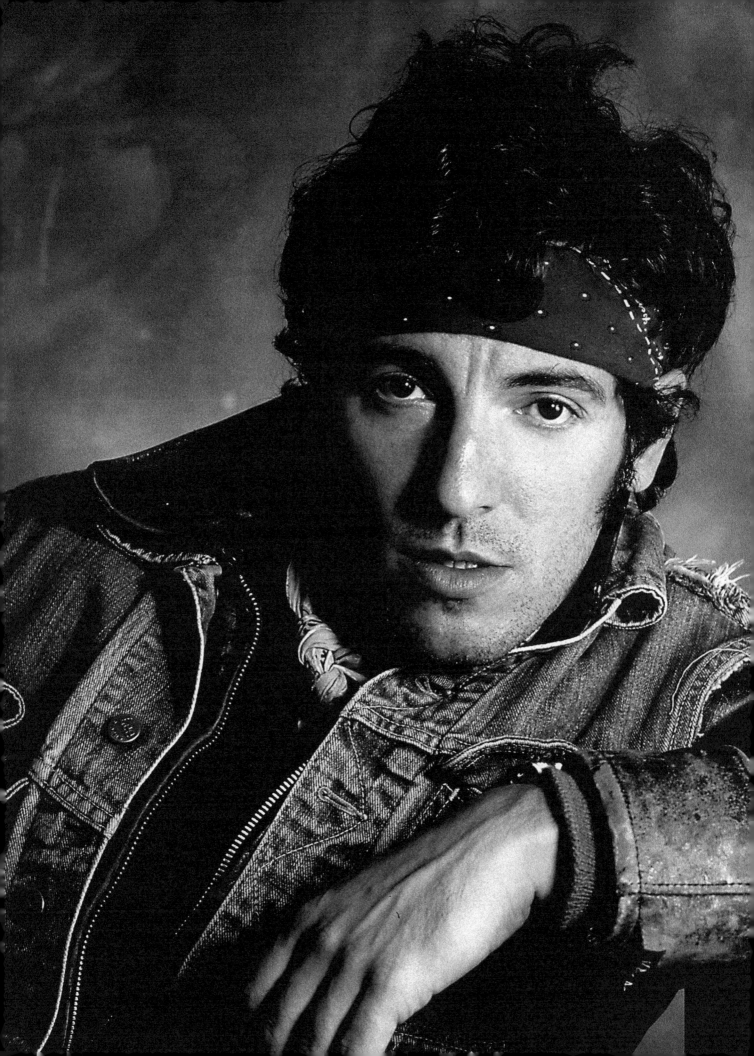

CHAPTER 7

•

1984

BORN IN
THE U.S.A.

•

BORN IN THE U.S.A.

In 1968, Springsteen had every intention of dodging the draft. His efforts to convince a Newark, New Jersey, selective service board of his abject unsuitability for combat in Vietnam apparently extended to claiming he was both gay and tripping on LSD, but none of it was necessary. He flat-out failed his physical, thanks to a concussion he suffered in a nasty motorcycle accident the previous year. Springsteen was relieved—elated, even—but years later, he would admit to occasional pangs of guilt. "Sometimes," Springsteen wrote in his memoir *Born to Run*, "I wondered who went in my place."

During the Darkness Tour, he read *Born on the Fourth of July*, Ron Kovic's searing memoir of enlisting in the Marines as a blindly patriotic kid, only to come back from Vietnam paralyzed from the waist down and turn to antiwar activism. Soon after Springsteen picked up the book in an Arizona drugstore, Kovic himself happened to roll up to Springsteen by the pool at the Sunset Marquis in Los Angeles. They became friendly, and Kovic connected him with activist Bobby Muller, cofounder of the struggling Vietnam Veterans of America. Jon Landau helped arrange for Springsteen and the E Street Band to play an arena benefit concert for that organization in August 1981, with a group of veterans, many of them disabled, watching from places of honor on the side of the stage. It was a pivotal moment for the Vietnam veterans' movement in the United States. "Without Bruce and that evening," Muller said, according to Dave Marsh's book *Glory Days*, "We would not have made it."

When Springsteen returned home the next month and began writing the songs that ended up on *Nebraska*, he also started something called "Vietnam," perhaps taking some light inspiration from Jimmy Cliff's protest classic of the same name. Springsteen recorded a couple of boom-box demos of his tale of a returning veteran who is told everywhere he goes that he "died in Vietnam." Some of the lyrics would reappear on the B-side "Shut Out the Light," but one verse, with a factory manager claiming he would hire the narrator if it were up to him, would recur in brilliantly condensed form elsewhere. There is a repeated line about the veteran's girlfriend running off with a rock 'n' roll singer (a hint of that survivor's guilt?), and when he sings "the stranger is me," it is a reference to what would become one of Springsteen's touchstones, the Stanley Brothers' "Rank Stranger."

Springsteen had a screenplay on the oak writing table in his Colts Neck, New Jersey, house called *Born in the U.S.A.*, sent his way by the film director Paul Schrader. Soon after writing "Vietnam," Springsteen nicked the title of the script and began to transform the song. The first chorus he wrote rhymed "born in the U.S.A." with a soon-to-be-discarded line sardonically saluting "the American way." His reading of American history had recently included the 1979 book *Sideshow: Kissinger, Nixon and the Destruction of Cambodia* (a paperback copy shows up in photographer Frank Stefanko's 1982 shots of Springsteen's house), and one draft of the new song feels like private venting over what he learned. After marveling that Nixon never spent a day in prison, Springsteen suggests an alternative punishment: They should have "cut off his balls," he sings (really). This draft also makes clear, in case anyone ever really doubted it, that the reference to being sent off to fight "the yellow man" in the final song was intended as an antiracist statement. They would not treat "the white man that way," he sings, while musing over what it felt like to be Cambodian and witness the horror of bombs "falling like rain." Other drafts show how skilled Springsteen had

> **"WHAT I TRIED TO CONJURE UP IS A SOUTHEAST ASIAN SORT OF SYNTHESIZED, STRANGE SOUND. AND I PLAYED THE RIFF ON THAT."**
>
> ROY BITTAN

Previous spread: Bruce Springsteen in classic *Born in the U.S.A.*-era attire.

Opposite: The blockbuster Born in the U.S.A. Tour took Springsteen and the E Street Band into outdoor stadiums for the first time.

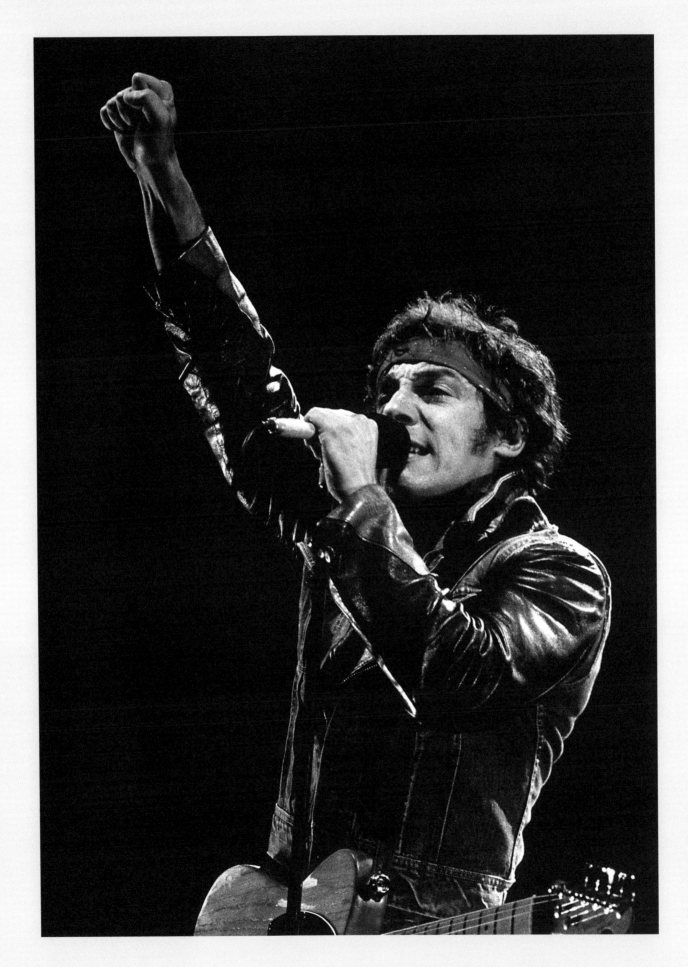

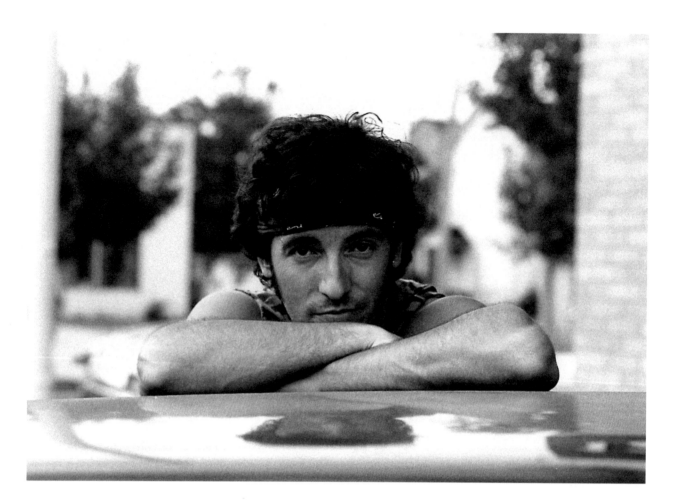

become at editing and compression; we learn a lot more about the refinery, down to a description of its pollution blanketing the town, material that only merits a hint in the final song.

Springsteen recorded "Born in the U.S.A." on his four-track along with the rest of the *Nebraska* songs, including it on the cassette he sent to Landau. The melody had yet to coalesce, and the echoey home recording blunts whatever impact the song might have had—*Nebraska*'s low-fi fairy dust loses its magic here. The subtle electric guitar Springsteen overdubbed for the final forty seconds does begin to hint, just barely, at a signature riff, and the falsetto howls over the outro suggest a louder noise to come.

In April 1982, Springsteen and the E Street Band returned to Studio A at the Power Station, intending to wade through the *Nebraska* songs. Author Clinton Heylin, who obtained Sony studio records, finally confirmed in 2012 that the E Street Band attempted most or all of that album, although none of it has leaked—that, presumably, will have to wait for the inevitable boxed set. On the second day, Springsteen pulled out "Born in the U.S.A." As Roy Bittan recalls, he played it on acoustic guitar and sang it for the band, rather than putting on the four-track demo.

By that point, the melody had evolved, and Bittan recalls pulling a six-note motif from the chorus Springsteen sang. "When I heard him sing it, I said, 'That's a riff,'" Bittan says. "A very succinct, simplistic riff." He went over to his new Yamaha CS-80, a highly flexible analog synthesizer, and started shaping a sound. "I was always intensely listening to the lyrics to see what the hell the song was about," Bittan says. "So I heard what he was talking about, and what I tried to conjure up is a Southeast Asian sort of synthesized, strange sound.

Above: Springsteen poses for a portrait by David Gahr in June 1984.

Opposite: Sporting a trademark bandana on the Born in the U.S.A. Tour, which started on June 29, 1984.

And I played the riff on that." By the second time Bittan played the riff, Max Weinberg was slamming his snare drum along with it.

From there, with Danny Federici playing piano for once and Steve Van Zandt on acoustic guitar, they started recording the song. "Bruce heard Max and me, and he said, 'Wait, wait, wait. Stop. Okay. Roll the tape,'" Bittan says. "'Does everybody have the chords?' Yes, everybody had the chords. 'Okay, roll the tape.' Boom. There it was."

Weinberg remembers a different set of events. In his memory, they first recorded a version of it as "a country trio," with a country beat. Then, Weinberg recalls, Springsteen started strumming a rhythm that reminded the drummer of the Rolling Stones' "Street Fighting Man" and he started playing along. "Everybody else came out," Weinberg recalls, "and he said, 'Just keep playing this riff over and over again.' And he kinda arranged it." (At the same time, Weinberg does not want to dispute Bittan's memories: "Roy may have gotten that riff. You can call this chapter *Rashomon*!")

However it started, the version on the album is an early live take (with a few minutes of jamming chopped out). In the years since Springsteen sat him down in the *River* sessions, Weinberg had rebuilt his chops from scratch, taking lessons from master session drummer Gary Chester. Everything he learned is on display in "Born in the U.S.A." During the take heard on the album, Weinberg recalls, Springsteen "raises his hands and he kind of plays the air drums, like, 'Do a solo.' So, if you listen to that moment, Roy and Danny, they were playing the riff. Where they were positioned in the studio, they couldn't see him stop. So you hear the riff go on . . . But then they felt the rhythm stop, so they stopped, and they do that whole thing. And then he counts off one, two, three, four and we go back into it."

They finished around three in the morning. Six hours later, Springsteen drove by Weinberg's house with a boom box and a cassette of Toby Scott's rough mix of the song. The engineer had applied gated reverb (using a broken reverb plate) to Weinberg's snare, which, combined with the overloaded room microphones in Studio A's ceiling, made it sound like heavy artillery going off at the bottom of the Grand Canyon. (On the final mix, Bob Clearmountain somehow made it even more gigantic.)

"We sat on my deck having freshly squeezed orange juice, and we listened to 'Born in the U.S.A.' about twenty times," says Weinberg. "I'll never forget it, because I went from 'I could have lost this job' to the drums on that record. He told me, 'The drums on this song are as important as the vocal. Because it sounds like confusion and bombs and you perfectly illustrated what I thought the song was about.'" Springsteen knew he and the band had just made one of their greatest recordings, even if the rest of the world wouldn't hear it until two years later.

For the narrator of "Born in the U.S.A.," his birthright has been stripped of everything he thought it should mean, just as life itself had been for the guy singing "Reason to Believe." But if the furious blare of the music—so confusing to so many listeners—signifies anything, it's that the singer is determined to find his own meaning, to hold his ground, maybe even to rediscover some remnant of what Springsteen would later call "the country we carry in our hearts." "The big difference between 'Born to Run' and 'Born in the U.S.A.,'" Springsteen told me in 2005, was that "'Born in the U.S.A.' was obviously about *standing* someplace."

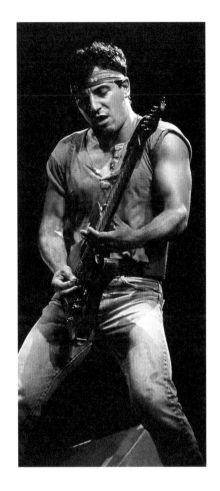

"'BORN IN THE U.S.A.' IS OBVIOUSLY ABOUT *STANDING* SOMEPLACE. "

BRUCE SPRINGSTEEN

COVER ME

After producer Quincy Jones asked Springsteen to write a track for disco star Donna Summer, he obliged with an unusually direct and modern pop song called "Cover Me." During the January 1982 sessions for *On the Line*, a Gary U.S. Bonds album Springsteen and Van Zandt were co-producing, the E Street Band laid down a quick, unrehearsed demo, which happened to have one of the hottest guitar solos Springsteen ever laid down in a studio. "I remember Bruce saying, 'this is for Donna Summer' to Jon [Landau]," says Neil Dorfsman (who recalls engineering the song despite the written credit going to his assistant at the time), "and Jon going, 'Let's just take a second and think about this.'" Landau ended up rescuing another hit, and Springsteen gave a song called "Protection" to Summer instead.

A year later, Springsteen and the band recorded a harder-hitting rewrite, "Drop on Down and Cover Me," with slightly more fleshed-out lyrics, a melody he soon reused on the B-side "Janey Don't You Lose Heart" (bizarrely, they were once on a proposed track listing together) and a "Roulette"-like beat. By the time they were sequencing "Born in the U.S.A." in late 1983, Springsteen had long since dismissed the original "Cover Me," but Landau's lobbying helped get that early recording onto the album, complete with a drum performance Weinberg always felt was unpolished. (Although the groove is unusually sleek for the E Streeters, it is nowhere near actual disco; Weinberg says, however, that there is a full-on Springsteen disco song, the title of which he cannot recall, somewhere in the archives.)

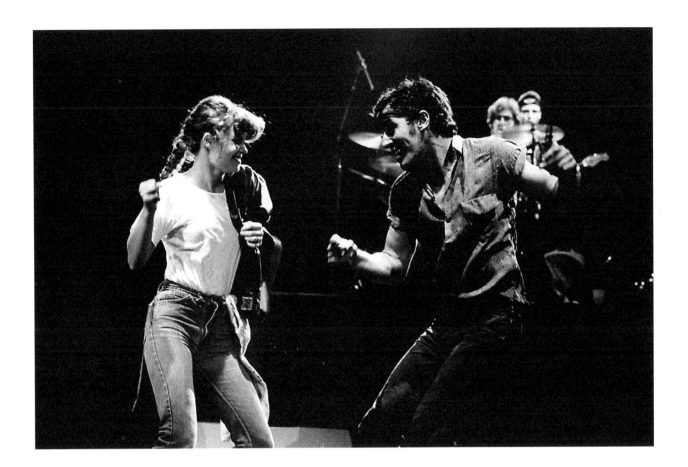

DARLINGTON COUNTY

Springsteen wrote a version of this road-trip-gone-bad romp as early as 1977, judging by his *Darkness*-era notebooks, although it is unclear if he recorded it back then. As it is, "Darlington County" sounds like a beefed-up *River* track, with the drum part nodding to the Stones' "Honky Tonk Women" and "Tumbling Dice," and the rhythm section more locked in than ever. Again, the snare is mammoth: "It was always like 'louder snare drum, louder snare drum,'" says Clearmountain. Recorded in May 1982, it was another in-the-studio live performance, with a few overdubs. The real Darlington County in South Carolina is home to a NASCAR raceway; Springsteen also mentions "Darlington" in "The Promise."

WORKING ON THE HIGHWAY

It's hard to think of a better illustration of Springsteen's Janus-faced nature than the evolution of this song, which began as the *Nebraska* outtake "Child Bride." The lyrics of the two songs are nearly identical— a construction worker becomes involved with an underage girl, only to be taken away in a police car—but the downcast acoustic tune paints it (rightfully, one would think) as a tragedy. However, just a couple months later, Springsteen led the E Street Band into a handclapping rockabilly groove and recast the story as farce, adding the call-and-response chorus, a strummed acoustic hook, and a new ending couplet about joining a prison road gang that he delivers with defiant, near-demented joy. In a way, it's more subversive than anything on *Nebraska*, where Springsteen found empathy for criminals of various kinds; on "Working on the Highway," he got millions of pop fans to do the same.

Above: Bruce Springsteen and the E Street Band at the Joe Louis Arena, Detroit, Michigan, July 30, 1984.

Opposite: Springsteen and the band (L–R Clarence Clemons, Garry Tallent, Roy Bittan, Patti Scialfa, Springsteen, Nils Lofgren, Danny Federici, Max Weinberg) at the Spectrum, Philadelphia, Pennsylvania.

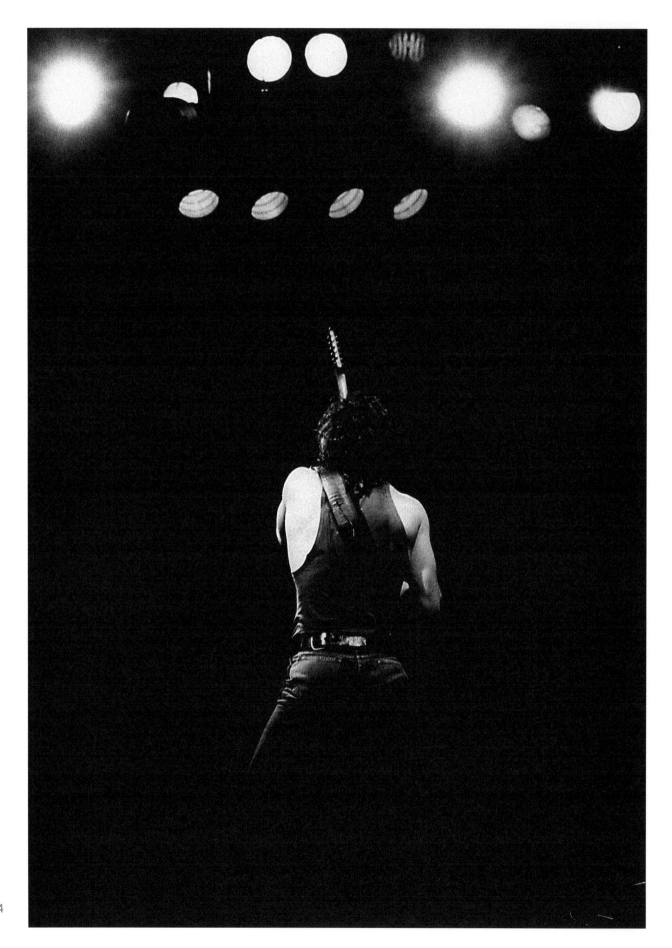

DOWNBOUND TRAIN

The Nebraska-outtake version of "Downbound Train" is much more frantic and overwrought than the E Street take, with yelping reminiscent of Suicide. The released "Downbound Train" is initially driven by an unusually memorable rhythm guitar part, but beginning with the second verse, Bittan's ghostly synthesizer starts to take over. When the song breaks down in the third verse, as the narrator describes a dreamlike visit to his "wedding house," the combination of synth, voice and hushed acoustic guitar comes as close as Springsteen ever did to casting Nebraska's shiver-inducing spell in a professional studio.

With the instrument everywhere on the radio, Bittan went synth-shopping when the band got home from the River Tour, bringing home the Yamaha CS-80, the same 200-pound-plus instrument heard on the soundtrack for the movie Blade Runner. "We started those sessions, and I brought a synthesizer in, and you would have thought I killed somebody," Bittan says, laughing. "I think Clarence and Garry were pretty against it at the time. 'What is that thing?' You know. And then I said, 'Well, maybe we can use it.' I think Bruce understood that now we were again in the process of exploring, and I showed him some sounds. It had enough anonymous sounds that you could use it as a pad, just a backdrop."

"And he responded to that." Bittan continues. "Because he realized that you could change the landscape. You could broaden it, and it didn't have to be strings, it didn't have to be a horn section, it could be something anonymous, and evoke something entirely different. So he understood it from a conceptual point of view. It was up to me to sort of suggest certain sounds. There were times I would come up with a sound and he's like, 'No, we can't use that.' I understood that we needed to use it conservatively if we were gonna use it at all. And it's kind of what we did on that album."

I'M ON FIRE

The song was built around a metronomic guitar pattern Springsteen started playing in the studio, a fantastic brush-driven drum performance by Weinberg, and one of Bittan's most evocative synth parts. Bittan recalls walking away from the studio for a couple minutes and coming back to find a song he had never heard before already taking shape. When he heard Springsteen sing the refrain, he pretty much instantly crafted a synth intro, holding a single note for a full bar before hinting at the chorus melody before you hear it. "Roy's not a synthesizer player," says Weinberg. "He's a pianist. So, when he plays the synthesizer, he plays stuff that a synth player wouldn't play. It's not electronic, it's unbelievably musical." Recorded in May 1982, "I'm on Fire" was another song that Springsteen was ready to jettison, perhaps on grounds of excessive sexiness, until he "finally stopped doing my hesitation shuffle," as he wrote in Born to Run.

NO SURRENDER

Springsteen released Nebraska on September 30, 1982. A few weeks later, he took a road trip to Los Angeles, and along the way, a lifetime of isolation and suppressed emotions suddenly caught up with him. He plunged into clinical depression: "black sludge is threatening to smother every last living part of me," he wrote in Born to Run. He stayed mostly in L.A. until the following spring, beginning therapy for the first time in his life. "You carry your baggage," Springsteen told me in 2016, "and if you don't start unpacking, your bags get heavier as you move along. So at some point the weight becomes impossible to carry, and you look for some way to unpack

> **"WE STARTED THOSE SESSIONS, AND I BROUGHT A SYNTHESIZER IN, AND YOU WOULD HAVE THOUGHT I KILLED SOMEBODY."**
>
> ROY BITTAN

Opposite: The LSU Assembly Center, Baton Rouge, Louisiana on December 2, 1984.

those bags. And it can get pretty messy. That's what happened to me."
At the same time, Springsteen had recording engineer Toby Scott set up a real home studio in the house he owned in the Hollywood Hills, where he began recording a new set of more subdued songs on his own. For a time, he considered releasing another solo album, despite having much of what would become *Born in the U.S.A.* already completed.

Instead, he returned to New Jersey and started recording again with the E Street Band. Van Zandt, who had started a solo career, wasn't around for the sessions. His official exit was gradual, but it was pretty clear he was headed out. Throughout May and June 1983, producer Chuck Plotkin found himself unmoved by much of what Springsteen was recording—and indeed, almost all of it was destined to become outtakes or B-Sides. Plotkin thinks Springsteen was processing Van Zandt's exit, and couldn't break through his stasis until he wrote "Bobby Jean" and then, a few months later, "No Surrender"—two songs built out of their friendship. At that point, Plotkin says, "We were in the home stretch, and he could feel it."

Still, Springsteen felt "No Surrender" was naive, "too glib," as he once said, and he came close to releasing a version of Born in the U.S.A. without it. It was Van Zandt himself who convinced Springsteen of the song's merits, and he added it at the very last minute. (The take they used on the album, according to Weinberg, was specifically chosen because of a brief but thrilling bass riff Tallent plays at the beginning of the first chorus.)

Above: Springsteen on stage with future wife Patti Scialfa, circa 1984. Max Weinberg on drums in the background.

Opposite: Relaxing before one of six nights in Philadelphia on the Born in the U.S.A. Tour, September 1984.

BORN IN THE U.S.A.

126

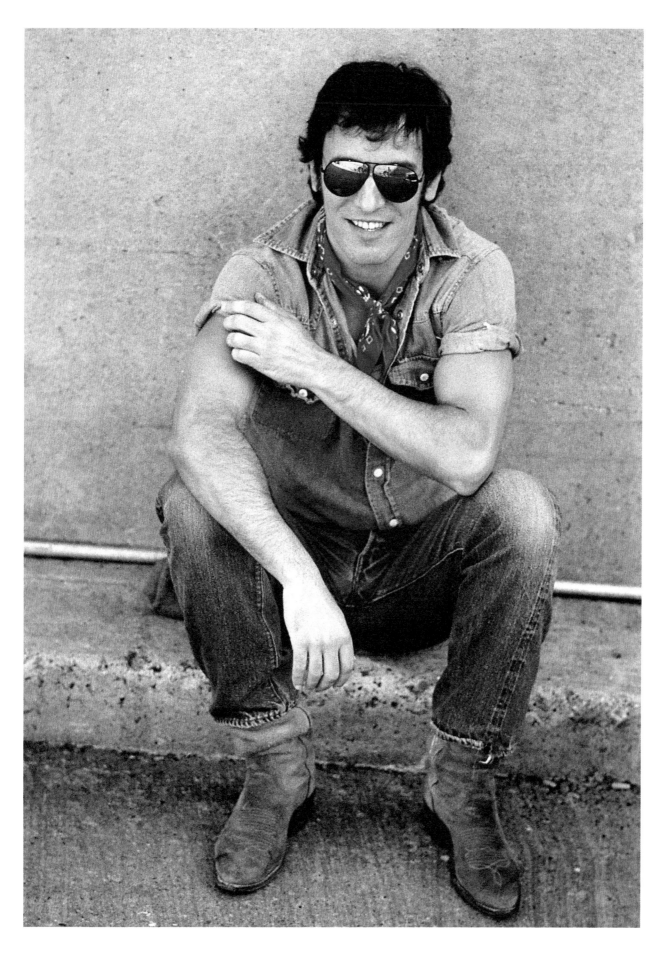

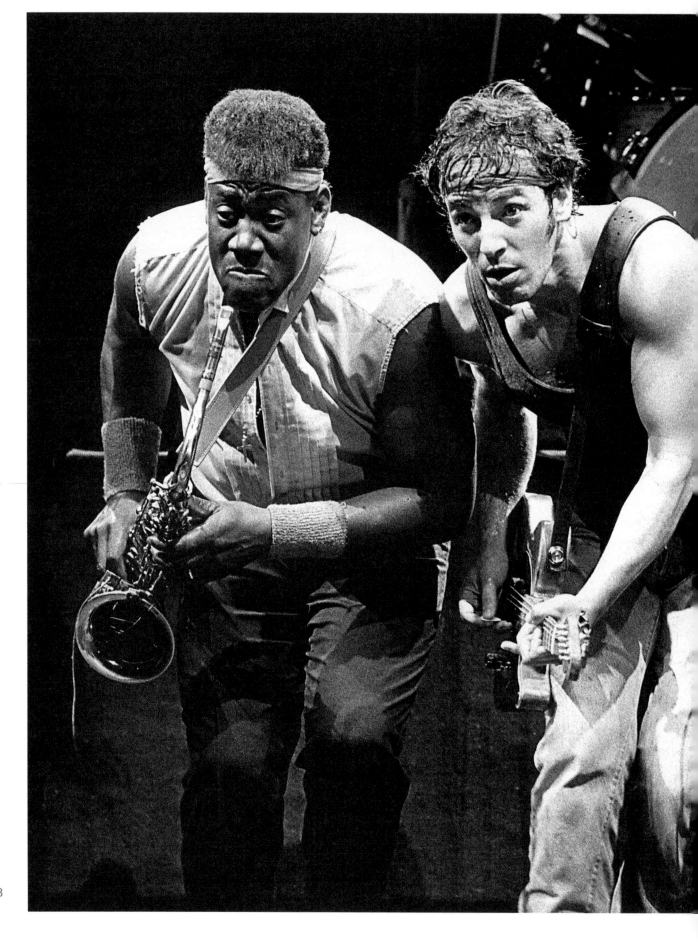

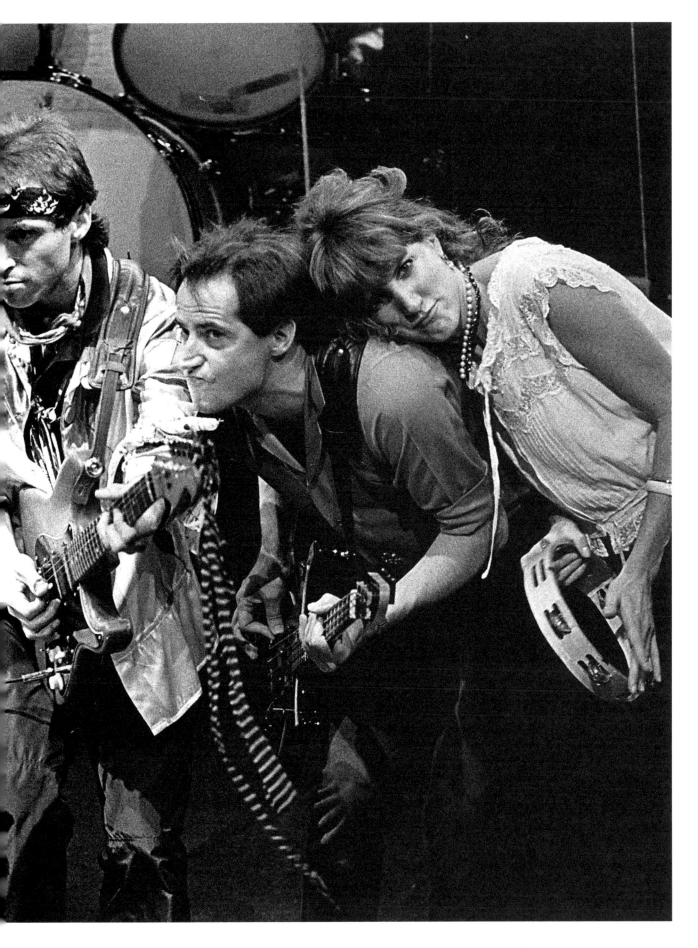

BOBBY JEAN

Plotkin believes that, for Springsteen, the emotional impact of Van Zandt's departure was "a bigger deal than any of us could really know. When I heard 'Bobby Jean,' I went, 'Oh, fuck. That's what part of what this summer was about.'" All the other songs, Plotkin theorizes, were "a distraction. He couldn't actually move forward without being able to address Steve's departure. Bruce was trying to write his way out of this kind of nightmarish reality that Steve was gone from the band. And 'Bobby Jean,' it's a kind of love song to a pal, you know what I mean?"

The song appeared in late July, just after an awkward conversation between Plotkin and Springsteen, who was convinced they had finished recording and were ready to mix. Springsteen's preferred track list at that point omitted most of the 1982 songs in favor of a mix of home recordings from Los Angeles and 1983 studio songs—"Cynthia" and "None But the Brave," among them—that Plotkin did not much like. Plotkin was hesitant to tell Springsteen that they were letting the album slip away; instead, he hoped he could play Springsteen an acetate of the rough mixes and let him realize it for himself. "He said something like, 'Charlie. Do I not pay you enough,'" Plotkin recalls. "'Just tell me what you think.' So I thought, 'Okay, well, I'm about to get fired.'" Plotkin told him the album needed to start with "Born in the U.S.A." and end with "My Hometown," and that a lot of the 1982 songs needed to come back. And the toughest part: "A little something is missing," Plotkin told him. Studio records indicate that Springsteen responded by bringing in "Bobby Jean" shortly thereafter, maybe even the next day.

Still, Dave Marsh wrote in *Glory Days* that Springsteen still had not completely given up on his odd preferred track listing. It took Landau actually playing him that acetate to break the spell. "It just wasn't a record," Springsteen told Marsh. "It didn't sound like one." Landau also wrote a five-page letter arguing the merits of an album based more around the 1982 sessions. Finally convinced he was making a rock record, Springsteen returned to the studio in September, cutting both the final version of "Bobby Jean" and "No Surrender."

I'M GOIN' DOWN

A simple, melodic rock song banged out in May 1982, it was, of course, nearly lost to history. Springsteen explained the song's not-too-subtle story in a 1985 concert: "When you first meet somebody, you know how everything's great all the time and everything they say is brilliant? . . . Then you come back about six months later or a year later, and it's like, 'Are we going out tonight, or do I have to sit here and look at your face all night?' 'Are you gonna make love to me, or do we have to wait for the full moon?'"

GLORY DAYS

A leaked early acoustic demo reveals that one of Springsteen's most fun songs started as yet another major downer. He had the first verse, about running into an old baseball teammate, almost intact, but mentioned vanished glory days only in passing. Instead, the chorus expressed a "Jackson Cage"-like sentiment: "You just don't count," he sang, if you were from a town called Stockton. By May 1982, he had reworked the song with a fresh theme: the tragicomedy of time's passage. But he couldn't stop himself from including an out-of-place verse about the narrator's unemployed dad, who never had any glory days. At some point in the process, they simply sliced that verse out of the recording.

> ## "BRUCE WAS TRYING TO WRITE HIS WAY OUT OF THE NIGHTMARISH REALITY THAT STEVE WAS GONE."
>
> CHUCK PLOTKIN

Previous spread: Tight band: Clarence Clemons, Bruce Springsteen, Nils Lofgren, Gary Tallent, Patti Scialfa.

Opposite: Springsteen chose a dramatic backdrop for the Born in the U.S.A. Tour.

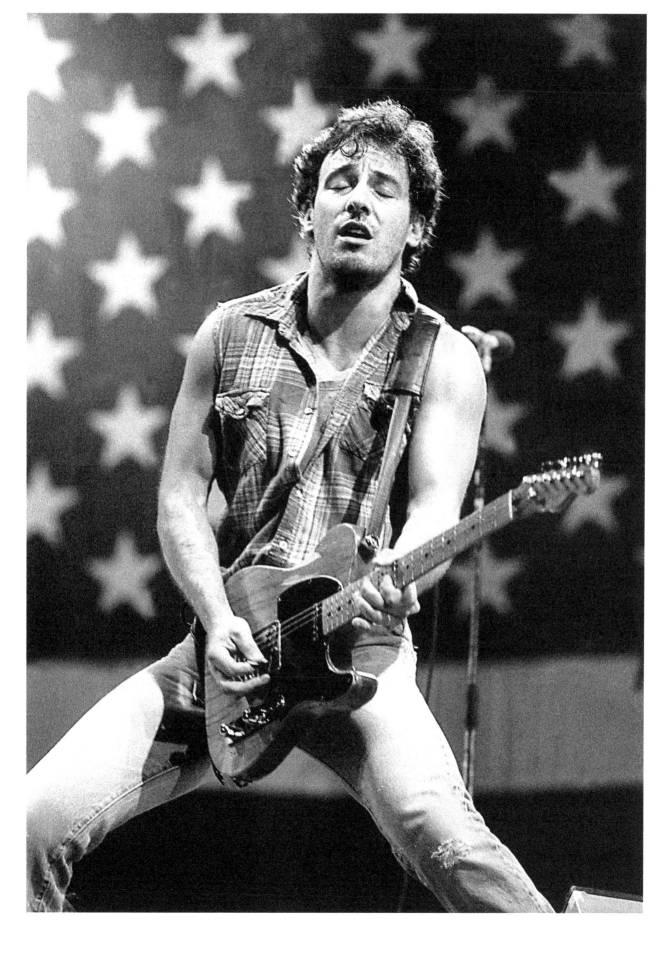

BORN IN THE USA

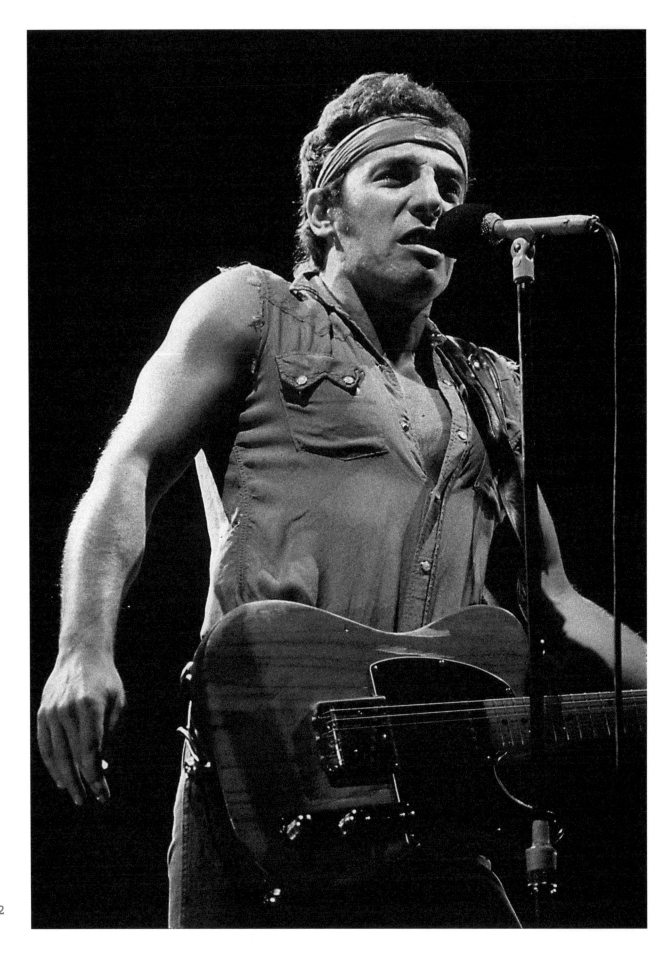

In 2013, Van Zandt told *Rolling Stone*'s Andy Greene that "Glory Days" was a favorite. "When you're doing a live-in-the-studio record, it's automatically garage-y, if you're us," Van Zandt said. "It's got the garage-y organ, and that simplicity." Van Zandt kept a mandolin on a stool as they played the song, and when the bridge came around, he played his mandolin part into his vocal mic. Van Zandt saw the song, in part, as Springsteen's reminder "to not take himself too seriously. I think he's always been aware of that, which is where all the humor comes from in his songs. Occasionally, you need some comic relief."

The record captured what was apparently Springsteen's favorite snare sound of all time; for years afterward, Clearmountain says, he used samples of the "Glory Days" snare to replace the drum sounds on other songs, including on the *Live 1975–85* boxed set.

DANCING IN THE DARK

Springsteen recorded the album's first single, destined to become his biggest hit, so late in the process that they canceled a day of mixing to lay it down. It started, famously, when Landau sat Springsteen down and told him that despite all the songs he had written, the album was missing a lead-off, defining single. After an initial burst of anger, Springsteen simply went home and wrote the thing, exorcising the frustrations of the last couple years. The line about getting sick of "trying to write this book" was actually about his album, of course, but it could have also drawn on another recent experience. Springsteen had just spent a substantial amount of time helping Weinberg edit his book of interviews with drummers, *The Big Beat*. (Weinberg thinks the lyric is just a coincidence.)

By February 1984, when they recorded the song, Bittan owned a new digital Yamaha synthesizer, which had a "funny horn sound" he selected for the session. "I did what songwriters have done for a hundred years, which is take the melody of the chorus and use it as a melodic motif before you hear the chorus," Bittan says. He also recorded a churning low-end synth "pulse" that serves as the song's de facto bass line; Tallent is there, but

Opposite: Bruce Springsteen on stage in 1984, shot by Lynn Goldsmith, who dated him in the seventies.

Below: Ireland's Slane Castle, site of the first European concert of the Born in the U.S.A Tour, June 1, 1985.

he's overwhelmed by the synth. "It always was more about the pulse," Bittan says. "Because if you're talking about pop music of that period, there was a lot of that."

In the first few takes, "Dancing in the Dark" was a rock song. But Landau walked into the live room, approached Weinberg, and said, "I got an idea. Play this like 'Beat It.'" He was referring, of course, to the Michael Jackson song that went to number one in 1983 (and featured drummer Jeff Porcaro, who would play with Springsteen on 1992's *Human Touch*). "I knew what that meant," Weinberg says. "Just play it metronomically, no fills. Simple bass drum, constant hi-hat. They wanted a dance record. And I did it. I played 'Beat It.' And we had it."

MY HOMETOWN

On a Monday night in May 1969, on the corner of South Street and Route 33 in Freehold, New Jersey, a shouting match between carfuls of white and black kids nearly turned fatal, according to an *Asbury Park Press* account. One of the white combatants pulled out a shotgun and opened fire; a passenger named Dean Lewis lost his eye, and racial tensions erupted into a small-scale riot that night.

Decades later, Springsteen was in his Hollywood Hills house when his thoughts turned back east. He started writing a song about his hometown and childhood, one without the dreamlike psychological weight he placed on them in *Nebraska*. This one was more about the prosaic realities—the failing economy, the racial strife, a simple memory of his dad. He put the 1969 shotgun incident in there, although he placed it four years earlier. In the final verse, he ventured into an area of life he had noticeably avoided in song, giving the narrator a son of his own.

"I hated the town I grew up in," Springsteen told a London audience in 1992. "I guess that's not much different than anybody else. But about ten years ago, I was living in Los Angeles and I wrote this song when I was kind of thinking back to what it was like where I grew up at the time and what my dad was like. They say that nothing you ever do for a child is wasted, and that's true. Because my dad, when he'd take me in the car and he put me on his knee and let me pretend like I was driving . . . to him, it was just a laugh or something nice that he was doing. But it kind of created this permanent work of art in my head. This was me imagining myself as a dad at a time when I couldn't imagine myself as a dad."

His home takes on the song were up-tempo and vaguely countryish, with a jauntiness that undercut their emotional impact. With the E Street Band, he slowed it down and found its core, again aided by Bittan's synth. "You put in that little anonymous sound," says Bittan, who now finds some of the eighties synth sounds primitive, "'Is it brass? Is it muted horns?' It doesn't matter. It evokes something, and it takes you somewhere."

When Plotkin was trying to push Springsteen toward a different vision of the album, he had one certainty in mind. "We're in the midst of making a great record," he would say. "And the record starts with 'Born in the U.S.A.' And it closes with 'My Hometown.' And all we got to do is figure out what goes in between."

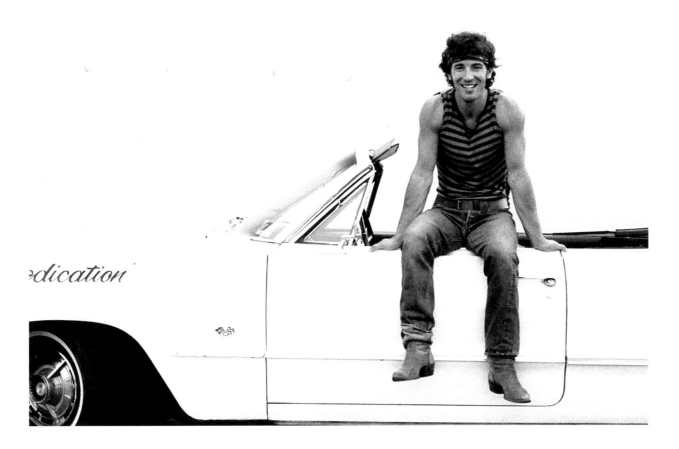

edication

WAGES OF SIN (OUTTAKE. *TRACKS*)

In its very first solo demo, "Wages of Sin" was on its way to becoming
another deceptively cheery rock song, but it quickly turned as gloomy as
its lyrics. Springsteen told *Billboard*'s Melinda Newman that he tossed the
song because it "cut close to the bone," which was especially true of one line
that didn't make the finished track: "All my life I've been guilty, but I don't
know what it is I've done," he sang, in one of the most revealing lines he
ever wrote, considering all of the cryptic references to sin and secrets in his
work. As it is, there's a line about the fear he repressed for years suddenly
"rushing up," which now seems deeply autobiographical as well. The finished
song combines the kind of images of domestic strife that wouldn't appear
in Springsteen's released work until *Tunnel of Love* with a final verse about
running through a forest as a boy that appears to have to inspired him to
write "My Father's House" directly after.

MURDER INCORPORATED (OUTTAKE. *GREATEST HITS*)

A proposed May 1982 track listing for *Born in the U.S.A.* slotted this fierce,
then-just-recorded protest song as the second track, right after the title song
—that sequence alone would've made it come off as Springsteen's loudest,
angriest album. The band rehearsed "Murder Incorporated" alongside the
Nebraska songs in Roy Bittan's living room that spring. "It sounded great
in there," says Weinberg. "I have a tape of us doing 'Murder Incorporated'
there—it's the best we ever played that song, the best version I ever heard."

The song's narrative follows a city resident who seems to be on the run
from the mob, but could be interpreted as a more widely damning statement,
suggesting that the paranoia and danger he's experiencing is "everywhere" in
a corporatized society. "I guess this is a song about how there's a body count

Above: A David Gahr portrait of Springsteen,
used for the cover of the "Cover Me" single.

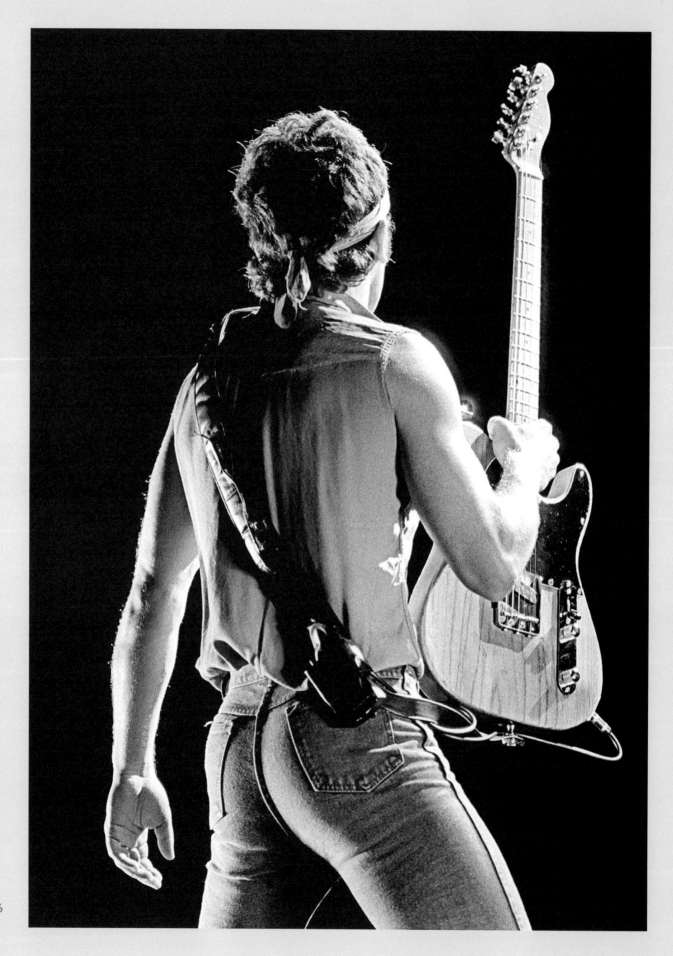

incorporated into our way of life," Springsteen said onstage. "We've come to accept the expendability of some of our citizens' lives and dreams as just a part of the price of doing business."

The recorded version suffers from anemic-sounding guitars—it needs to crunch and blare in a way that the band wasn't ready to embrace until "Murder Incorporated" made its live debut in the nineties.

COUNTY FAIR (OUTTAKE, *ESSENTIAL BRUCE SPRINGSTEEN*)

A 1983 Los Angeles home recording, "County Fair" comes off as a sweetly nostalgic tale of a late-summer evening, with a restrained country feel that hints at his *Tunnel of Love* approach. But in *Born to Run*, Springsteen relates an anecdote that may hint at the actual inspiration behind the song: During his 1982 road trip to California, somewhere near Texas, he and his road buddy Matt Delia encountered an idyllic-looking fair, with a local band playing. Springsteen had an outsized reaction to it. "From nowhere, a despair overcomes me," he wrote. "I feel an envy of these men and women and their late-summer ritual." Watching them, he had something of an emotional breakdown, realizing that he'd blocked himself off from the "normal messiness of living and loving." It's hard not to assume that he was still working through that moment when he wrote "County Fair" just a few months later.

NONE BUT THE BRAVE (OUTTAKE, *ESSENTIAL BRUCE SPRINGSTEEN*)

This ode to seventies Asbury Park, and by extension, Steve Van Zandt, recorded with the E Street Band in mid-'83, is one of the songs Chuck Plotkin didn't think was working. "It sounds like a guy *trying*," Plotkin says. "You hear the effort. It feels forced." The song has its merits—particularly the opening Clarence Clemons solo and an unusually melodic guitar lead—but overall, Plotkin had a point.

JOHNNY BYE BYE (B-SIDE)

An L.A. home recording of a song that dates back to the River Tour, "Johnny Bye Bye" adapts Chuck Berry's song of the same name into a farewell to Elvis Presley, lamenting the ugly circumstances of his death. When I asked Springsteen in 2016 about Presley's later years, he was resolutely non-judgmental. "Everybody makes their maps, and people will look at the one I wrote and there will be things they'll want to follow and things they won't want to follow," he said. "I got so much from Elvis as an inspiration, and I admire that voice so deeply right until the end. And everybody struggles. There are a lot of distractions along the way and a lot of places you can lose yourself. I was very aware of that, thanks to the people that came before me. And I worked very hard to avoid some of those pitfalls, and still do."

SHUT OUT THE LIGHT (B-SIDE)

Another Hollywood Hills home recording, this small-scale tale of a veteran struggling with the psychological aftereffects of war was released as the B-side of "Born in the U.S.A."—an appropriate pairing, considering that the two tracks not only share subject matter but were both derived from the song "Vietnam." The keenly observed details—he notes the vet's girlfriend undoing an extra blouse button to prepare for the homecoming—help explain why Springsteen started thinking of releasing a *Nebraska* sequel instead of a rock album.

> **"I GOT SO MUCH FROM ELVIS AS AN INSPIRATION, AND I ADMIRE THAT VOICE SO DEEPLY RIGHT UNTIL THE END."**
>
> BRUCE SPRINGSTEEN

Opposite: The final show of the Born in the U.S.A. Tour in Los Angeles on October 2, 1985; sixteen months after the start.

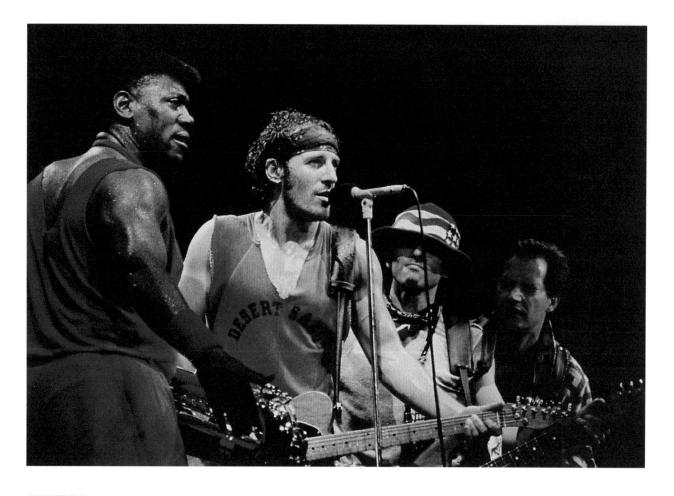

CYNTHIA (OUTTAKE. *TRACKS*)

A throwaway '83 rocker from Plotkin's least favorite period of recording that somehow ended up on Springsteen's preferred track listing for the album that year, slotted between "Born in the U.S.A." and "None But the Brave." "I know we've been calling them rockers all summer," Plotkin recalls telling Springsteen. "But they're not rocking."

MY LOVE WILL NOT LET YOU DOWN (OUTTAKE. *TRACKS*)

Destined to rock arenas in 1999 and 2000, this song popped out at the end of a session devoted to other material, as Toby Scott remembers it (they first worked on it the same day in May 1982 as "Glory Days," according to studio records.) "He would go through his book and say, 'Oh let's try this one,'" Scott says. If the studio version feels a touch unfinished (it's oddly dominated by acoustic guitar, and Springsteen's vocals are scratchy-throated even by his standards), it's probably because "My Love" just didn't lend itself to the unrehearsed spontaneity that sometimes sparked magic. Scott, for one, was "confused" by Springsteen singing "my la-la-la-love." "I was like, 'hmm, this doesn't seem completely realized. But that hasn't stopped it from being performed at a few hundred concerts!"

Plotkin is a fan, and wonders if Springsteen left it off because of its emotional nakedness. "By the way, who is that sung to?" he asks. "It's not sung to a particular person. If you track the rest of the lyrics, you realize it's being sung to somebody he's looking for, not somebody he's found. It's like the promise of something to come. It may be that he remained uneasy about that, which is why it didn't end up on a record."

Above: Clarence Clemons, Bruce Springsteen, Nils Lofgren and Garry Tallent.

THIS HARD LAND
(OUTTAKE, *TRACKS*; RE-RECORDED FOR *GREATEST HITS*)

One of Springsteen's best songs, written in a Woody Guthrie mode, set in a picturesque fantasy of the West, and probably most effective in live solo acoustic renditions. "This is a song about hope, hard times, happiness, community, brotherhood, sisterhood," Springsteen said onstage in 1996, "[and] every Western I ever saw." The key is the song's last verse, which ends with a kind of blessing bestowed on a friend that doubles as one of Springsteen's foundational statements: he encourages him to "stay hard," to remain hungry and alive, adding, with infinite compassion, "if you can." On Springsteen's original 1982 track listing for the album, "This Hard Land" was the album-closer.

FRANKIE (OUTTAKE, *TRACKS*)

Poor "Frankie": A highlight of 1976 live shows, a majestic Van Morrison-inflected love song filled with glittering imagery and a perfect riff, the track would have been a highlight of whatever album might have come between *Born to Run* and *Darkness*. Springsteen recorded it in the earliest *Darkness* sessions, but by the time that album's identity asserted itself, "Frankie" never had a chance. Springsteen was willing to toss any number of potential classics, but giving up "Frankie" without a fight was too much even for him: In those fruitful May 1982 sessions, they gave it another shot. He toned down the sweeping romanticism of the lyrics, to the song's detriment, and had to replace lines about machines and fire that he had already transplanted into "Drive All Night."

TV MOVIE (OUTTAKE, *TRACKS*)

For a few days in June 1983, it was suddenly rockabilly time in the studio— no doubt to the particular delight of Garry Tallent, who loves the genre, resurrecting its walking basslines with palpable joy. Clearly inspired by Buck Owens' "Act Naturally," the rollicking, lightweight "TV Movie" is Springsteen's first attempt at addressing his own growing fame in song, with winning self-deprecation that would return later on "Local Hero."

STAND ON IT (B-SIDE)

A couple days after the "TV Movie" session, recalls Weinberg, "we were done for the night, and all the equipment was packed up. We had two equipment guys at the time, and they were preparing to take the equipment out onto the street, and Bruce stopped them. 'Set it up.' It was, like, three o'clock in the morning. It wasn't the whole band. I don't know if Clarence was there." Springsteen pulls off the nearly impossible here, cramming densely imagistic, narrative lyrics—mostly racecar narratives, with one amusing verse about Christopher Columbus—into a wildly up-tempo song catchy enough to become a minor country hit for singer Mel McDaniel in 1986. "You could make a movie out of it," Weinberg says. It's one of the few post-seventies songs to suggest that the logorrhea of, say, "Blinded By the Light" never really went anywhere.

LION'S DEN (OUTTAKE, *TRACKS*)

This infectious, if anomalous, retro soul-pop song was recorded in those January '82 Gary U.S. Bond sessions, and way well have been meant for Bonds to sing, though he never released it. Either way, the recording was left unfinished, with the essential horn section not overdubbed until 1998. Weinberg points out it's yet another song built on a template similar to "Paradise By the 'C.'"

CAR WASH (OUTTAKE, *TRACKS*)

A totally solid working-woman's lament, recorded in 1983, that could have easily replaced, say, "I'm Goin' Down" on the finished album. It's intriguing to hear Springsteen sing in the first person from a female perspective, especially when you learn that the narrator dreams of scoring a record contract and hearing that her life thus far has all been a "mistake."

ROCKAWAY THE DAYS

In January of 1984, Springsteen was still bringing in new songs, like this effortless-feeling country-folk tune about a *Nebraska*-esque screw-up named Billy. It's the kind of fully formed outtake that makes you mourn the extra album or two that could've come out of these sessions.

BROTHERS UNDER THE BRIDGES (OUTTAKE, *TRACKS*)

This musical sibling of "No Surrender" surfaced just before that song, in late 1983. Only one could survive.

MAN AT THE TOP (B-SIDE)

Another January '84 song, this gentle pop tune pondering American ambition sounds like the work of a man who knows he's about to release a life-changing album.

PINK CADILLAC (B-SIDE)

The first and best "Pink Cadillac" was a lonely little rendition on the Nebraska tape. Springsteen was wary of the song, and resisted Chuck Plotkin's suggestions to try it with the E Street Band in 1982. While Springsteen was off recording on his own in L.A., Plotkin started work on an album with Bette Midler. When he played her some of Springsteen's recent songs, she seized on the solo "Pink Cadillac." "She loved it because it was smoky and sultry and sexy," says Plotkin. "She said, 'Oh, I must cut that.' I said, geez, we couldn't, it hasn't been released. We can't do it without Bruce's permission, and frankly I'm trying to get *him* to cut it." When he mentioned it to Springsteen, he said, "well, let her have it, I'm not going to cut it".

Midler recorded her version, which was set to be the title track of her 1983 album, but Plotkin decided he needed to play the recording for Springsteen "just to be sure." It didn't go well. "He listened to it," says Plotkin, "and said, 'Charlie, I can't let you put this out, I withdraw my permission. It's just embarrassing. I mean, it's just in your face.' He said, 'Charlie, don't you realize what your job is here with me? Your job is to keep me from embarrassing myself!' Midler was not happy; in one eighties interview, she claimed to have spent $25,000 recording the song, and called Springsteen "a stiff."

In May of 1983, Springsteen finally cut an E Street version of "Pink Cadillac," with a twangy vocal where he "plays a character, which gives him some distance," says Plotkin. "He has to make a joke of it." The producer is not fond of the somewhat listless studio recording, which he calls a "fake . . . strange, 'Crocodile Rock' version of it. From a musical point of view, he threw it away." The punchline, as far as Plotkin is concerned, came when Springsteen mysteriously turned around and embraced the song on the Born in the U.S.A. Tour, turning it into a comic showpiece.

> **"FROM A MUSICAL POINT OF VIEW, HE THREW 'PINK CADILLAC' AWAY."**
>
> CHUCK PLOTKIN

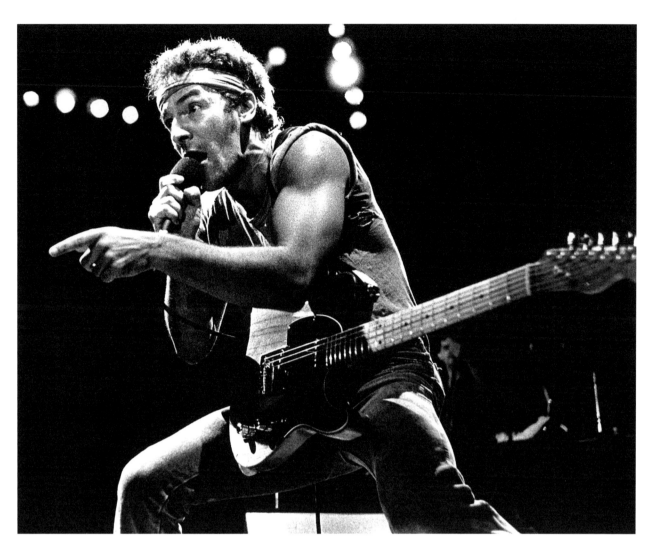

JANEY DON'T YOU LOSE HEART (B-SIDE)

A gentle song of consolation recorded in June 1983, with an arrangement that prefigures both "Bobby Jean" and "Dancing in the Dark" in the sleekness of its rhythm. Toby Scott has some recollection of Springsteen sending this song off to Stevie Nicks in hopes she'd record it, which never happened. It's hard not to imagine that Springsteen is singing to himself as much as to "Janey," especially with its image of lying in bed and feeling "this emptiness." When Springsteen was preparing to release the song as the B-side to "Glory Days" in 1985, he brought new E Streeter Nils Lofgren into the studio to add vocal harmonies. "Bruce had his own harmony on it," Lofgren says. "He said, 'Look. I just want you sing your own version of it,' which I did, and it was just right up my alley. It was in my range. It was just his way of including me."

A GOOD MAN IS HARD TO FIND (PITTSBURGH) (OUTTAKE, TRACKS)

This aching ballad was recorded in the same week in May 1982 that yielded "Glory Days" and "Downbound Train," in a subtle country arrangement that offers a glimpse of how some of the E Street attempts of the *Nebraska* songs likely sounded. It's another song exploring the wounds of the Vietnam War, this time focused on a woman left behind, with a reprise of the "meanness in this world" line from "Nebraska," and a title bitten from the same Flannery O'Connor short story that helped inspire that song.

Above: The first of four nights at the Capital Center, Landover, Maryland, August 25, 1984.

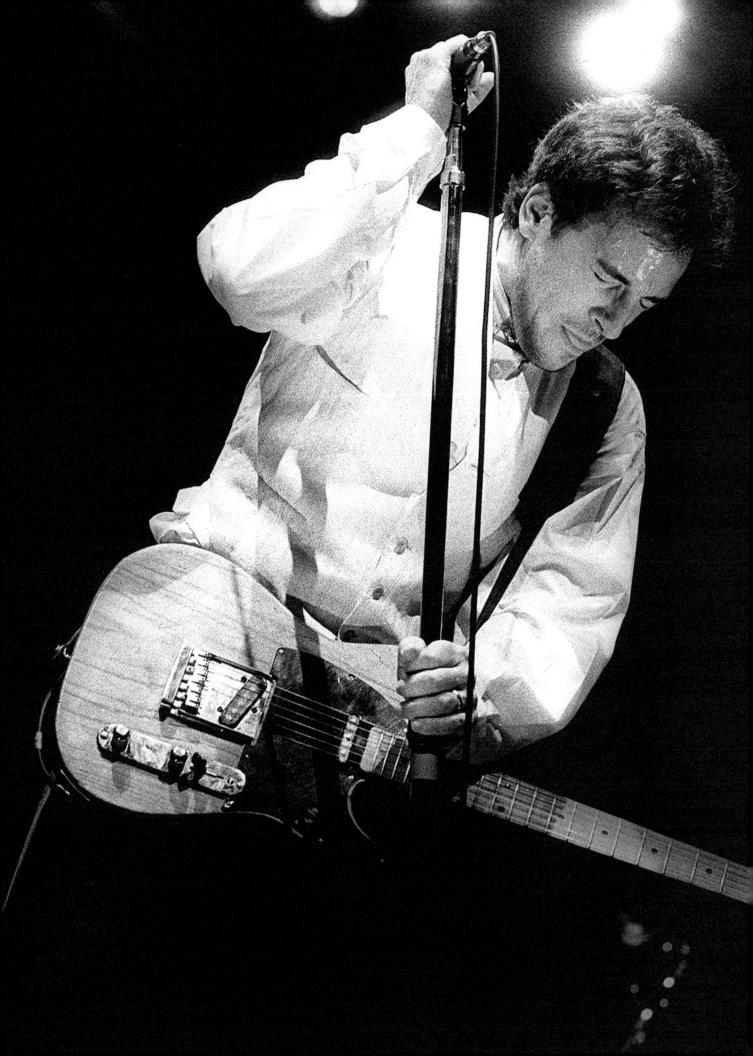

•

1987
TUNNEL
OF LOVE

•

AIN'T GOT YOU

Born in the U.S.A. begins with a chiming synth and a world-shaking *thwack* from Max Weinberg's snare drum; the album that follows starts off with just Bruce Springsteen's voice, shoved off to the right channel, and the sound of fingers snapping. "Ain't Got You" builds to an arrangement that could barely shake a coffeehouse, with chugging Bo Diddley-ish acoustic guitar (he'd pair the song with "She's the One" in concert), harmonica, percussion. *Tunnel of Love* was a deliberate downsizing after the biggest album and tour of Springsteen's career, capped with a career-spanning live boxed set that hit No. 1 in its own right. It was time to take off the bandana and bring the giant flag down.

"I really enjoyed the success of *Born in the U.S.A.*, but by the end of that whole thing, I just kind of felt 'Bruced' out," Springsteen told *Rolling Stone*'s Jim Henke in 1992. "I was like, 'Whoa, enough of that.' You end up creating this sort of icon, and eventually it oppresses you. So when I wrote *Tunnel of Love*, I thought I had to reintroduce myself as a songwriter, in a very non-iconic role. And it was a relief."

"It's not simply a response to the last record," says co-producer Chuck Plotkin. "it's a response to all kinds of things, obviously. There is this shifting from side to side. It's the same thing as *Nebraska*, in a way. Just in terms of where on his path it comes up. It comes up after a big, raucous, commercial

Previous spread: A moment of concentration on the Tunnel of Love Express Tour, 1988.

Opposite: Springsteen and Clemons duel at the Capital Centre, Landover, Maryland, April 4, 1988.

Below: Worcester Centrum, Worcester, Massachusetts, February 25, 1988.

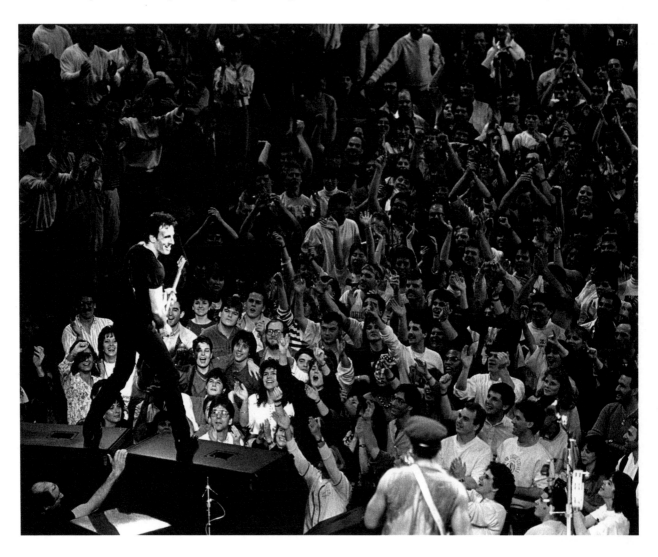

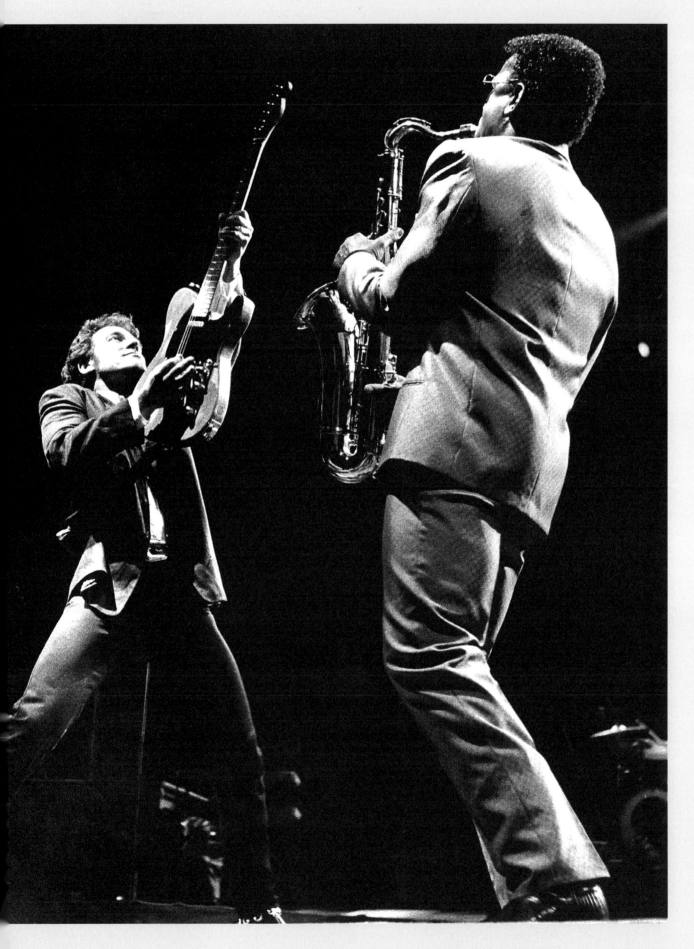

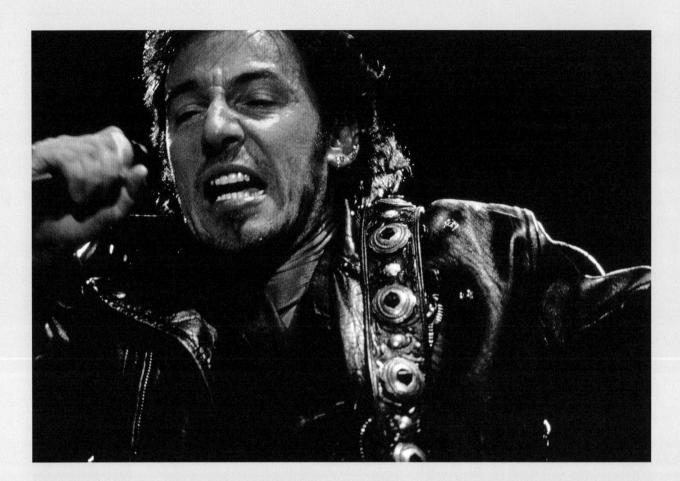

record, a big tour, and videos and all that stuff. Who wants all this? Who wants this responsibility? Who wants all this having to worry about everybody else? It's just like, wait a second. Who wants all this publicity? Who wants all this rock star shit? There's a way in which *Tunnel of Love* is Bruce, once again, pulling back and into a much more private space. Doing so, again, without the band. I'm sure he was right on the edge of dismissing the band permanently."

As music critic Dave Marsh pointed out, "Ain't Got You" is a riff on Billy Boy Arnold's 1956 blues single "I Ain't Got You," which Springsteen no doubt encountered in covers by The Animals and The Yardbirds. By offering an amusingly cartoonish version of his actual wealth and fame—as rich as he had become, he didn't have houses lined up across the country, "baby, end to end," and he probably was not gobbling caviar by the pound—he both defused the lingering issue of his newfound anti-everyman success, and set up the theme of the album: He's got everything, but love is tricky.

The song was also the first hint of an almost paralyzing self-awareness that would push Springsteen away from political songwriting for the next seven years or so. For Steve Van Zandt, who'd left the E Street Band during the recording of *Born in the U.S.A.*, the dip into autobiography, however self-mocking, was a mistake. "We had one of our biggest fights of our lives," Van Zandt told *The New Yorker*'s David Remnick. "I'm, like, 'What the fuck is this?' And [Bruce is], like, 'Well, what do you mean, it's the truth. It's just who I am, it's my life.' And I'm, like, 'This is bullshit. People don't need you talking about your life. Nobody gives a *shit* about *your* life. They need you for *their* lives . . . And we fought and fought and fought and fought. He says 'Fuck you,' I say 'Fuck you.' I think something in what I said probably resonated."

TOUGHER THAN THE REST

Downsized or not, it was still the eighties, as the overblown drum sound in the opening of "Tougher Than the Rest" will remind listeners until the end of time. Consider it overcompensation: *Tunnel of Love* was, in the end, a home recording, although it was hardly *Nebraska*, thanks to the sophisticated-for-1987 studio equipment Toby Scott installed in a sunny, 240-square-foot room above the guesthouse garage on Springsteen's Rumson, New Jersey, estate. "It's not really a studio," Springsteen told MTV News' Kurt Loder. "If you walked in, it's an apartment." He played bass, guitar, and synthesizer, building over beats from a LinnDrum (the same drum machine used on Prince's "When Doves Cry" and many other eighties hits) programed with the help of Scott. Springsteen compared the machine's rhythms to a "ticking clock" that underscored the album's themes of mortality.

When Springsteen began work on what he thought were demos in early 1987, he had been married to actress Julianne Phillips for less than two years. He scoffed at the idea of "married music" just a couple years earlier, but now he was intent on making some. "For 20 years I'd written about the man on the road," he wrote in his book *Songs*. "On *Tunnel of Love,* that changed, and my music turned to the hopes and fears of the man in the house."

The tracks Springsteen recorded in his little studio sounded like finished recordings, not mere templates. "Ten years earlier," says Plotkin, "it would have been his set of demos for the next record, but he'd developed a great deal over that period of time as a record maker. This is Bruce working in private, locating some things that he doesn't really expect the band to be able to either deeply understand or be able to express in a way that is natural as the way that he expresses it himself." When Plotkin first heard the songs, he suggested that it might be interesting to hear some of them re-recorded by the full band. "For which suggestion," he says with a laugh, "I almost got fired."

Still, Springsteen wasn't content to leave the recordings entirely untouched. The drums, for instance, sometimes felt a touch too perfect. So Weinberg dropped by the house. "There's a big difference between the way I play a backbeat and the way a machine plays a backbeat," says Weinberg, who could place himself milliseconds ahead or behind the beat in ways that electronics couldn't match, at least back then. He doesn't remember ever playing a full drum set in Springsteen's little studio, just doing some piece-by-piece overdubbing. That led to the bizarre experience of sitting in a room with Springsteen, doing little more than applying a stick to a snare drum every other beat, as heard on "Tougher Than the Rest." Weinberg also hits precisely one cymbal crash on the song.

"But it was fun," says Weinberg, "It was actually the first time I got to interact with Bruce by myself in the studio. At the same time, it obviously was the beginning of the end of the E Street Band, and I didn't realize that until the first rehearsal for the Tunnel of Love Tour. I realized that if you put all the elements together, something's going on here. I felt the beginning of the end. That's when I decided to go to law school."

"Tougher Than the Rest" began life as a jokey rockabilly song with some lyrical similarities to 1992's "Real Man," complete with references to Tarzan, Rambo, and wrestler King Kong Bundy. It evolved into a boastful come-on with an undercurrent of terror that surfaces most clearly in the narrator's Johnny Cash-derived image of monogamy as walking a "thin, thin line" on a dark road—sounds fun!

"Tougher" is one of Springsteen's most obviously country-influenced

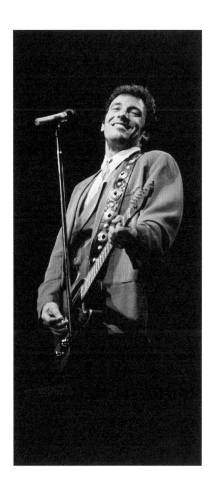

> **"IT OBVIOUSLY WAS THE BEGINNING OF THE END OF THE E STREET BAND."**
>
> **MAX WEINBERG**

Above: Springsteen charms Madison Square Garden, New York, May 19, 1988.

Opposite: Amnesty International Concert, Wembley Stadium, London, 1988.

recordings, especially on the twangy, low-end guitar solo, which may have scared him a little with its blatant nods to Nashville. When mixer Bob Clearmountain worked on the song, he found Springsteen had recorded both that solo and another, more rock-leaning take.

"I just immediately went to the baritone solo," says Clearmountain. "And then he came in and goes, 'well, what about the other guitar solo,' and I said, 'no, Bruce.' I mean, very rarely would I ever do that, and I would've done whatever he wanted, but I was very insistent."

ALL THAT HEAVEN WILL ALLOW

Springsteen once compared the sweet, spritely, Buddy Holly-ish vibe of "All That Heaven Will Allow" to the Raspberries, although that seems more applicable to his *River*-era stabs at power pop. The only Springsteen song that tiptoes anywhere near its sound is the *River* outtake "Cindy," and maybe "I Wanna Marry You." He borrows lines about not wanting to die "young and gloriously" from another of the most joyous songs he ever recorded, the obscure *Darkness* discard "City of Night." Weinberg is credited with drums on the track, but you don't hear much more than a clicking backbeat. On an album filled with darkness and doubt, this is one of the bright spots, a pop fantasy tinged with mortality. The narrator wants the sugar rush of early love—of life itself, maybe—to last forever, but he knows he'll only get as long as heaven might allow. "Heaven" is also faintly linked to "Here She Comes Walkin," a doo-wop-infused song Springsteen apparently wrote circa *Born to Run* that he's used onstage as a prelude to both "I Wanna Marry You" and this song.

SPARE PARTS

Moving from "All That Heaven Will Allow" to this track is a deliberately brutal jump cut, a harsh awakening. Any hint of romance dies a violent death in the first few lines, where we learn—with jarring bluntness—that a guy named Bobby breaks his promise to "pull out," and his girlfriend Janey gets pregnant. "Wasn't any sin," Springsteen shrugs. His sympathies here are inchoately feminist: Bobby "runs away," but there's nothing heroic about hitting the road this time; his fecklessness and fear, not to mention his violation of consent, leave human wreckage behind. The last verse tastes of some dark, lost Bible story, with an epiphanic conclusion worthy of Raymond Carver. Janey brings her baby to the riverside and wades into the water, ready to leave him to the current. She feels the sun shining down on them, and something shifts: She picks up her baby and takes him home. That night, she digs out her engagement ring—a piece of jewelry also mentioned in "All That Heaven Will Allow"—and sells it for some "good cold cash."

The music, propelled by a relentless kick drum, is exciting—a hint of an electrified *Nebraska* and a preview of the grittier moments of *Lucky Town*. Garry Tallent complained to Springsteen biographer Peter Carlin of a bizarre "beat-the-demo" exercise on this album; he and several other E Street members came in and were expected to play on finished *Tunnel* tracks before even getting a chance to learn the chord progressions. If Springsteen liked their parts better than the demo, they stayed in; otherwise he used his own. "Spare Parts" is the only track with Tallent on it, and his loping, aggressive bass line is memorable; maybe annoying him was a fruitful strategy.

Opposite: Performing at the Human Rights Now! concert, in aid of Amnesty International, Wembley Stadium, London, September 2, 1988.

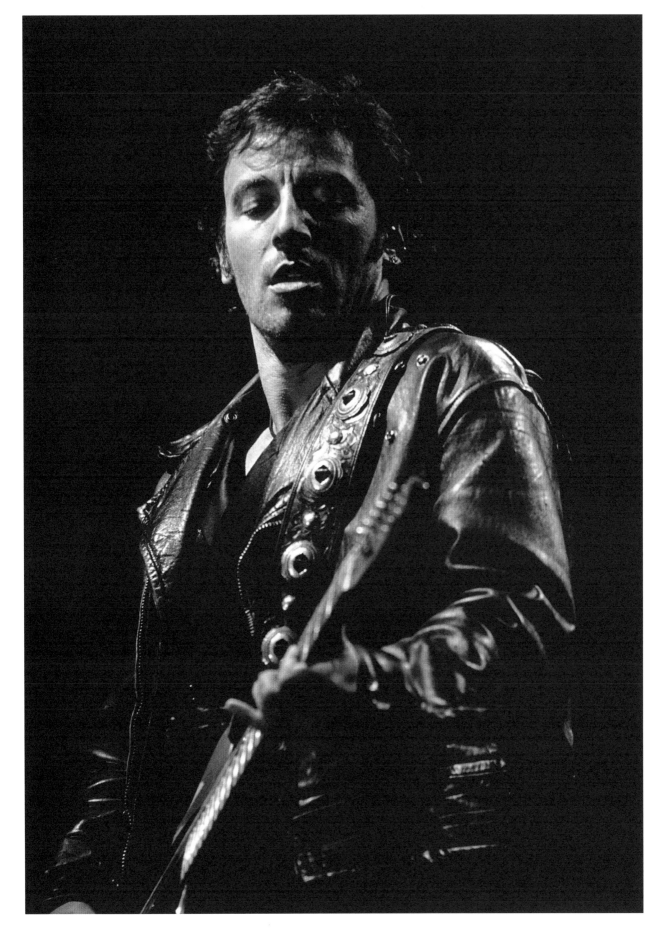

CAUTIOUS MAN

Robert Mitchum's murderous character in the 1955 movie *The Night of the Hunter* has LOVE tattooed on the knuckles of one hand and HATE on the other. Billy Horton in "Cautious Man" claims to have "love" and "fear" tattoos on his hands instead, and he's caught between the two. Springsteen told Carlin that this is as autobiographical a song as he's written—a disconcerting revelation, given its narrative. The character falls in love, marries, but fears his wandering heart. One night he wakes from a nightmare and walks out to the highway, where he finds "nothing but road." It is, perhaps, the key moment on the album, where the romance of escape curdles, leaving no choice but to find a way home. But when Billy walks back to his bedroom and his sleeping wife, he's flooded not with love, but an existential "coldness . . . that he couldn't name." He hasn't found home; he's just trapped in a house.

WALK LIKE A MAN

Springsteen's relationship with his father was always more complicated than he let on his songs, but here he finally musters pure warmth for the old man. The images are novelistic in their clarity: the roughness of his dad's hands on the narrator's wedding day, the memory of tracing his footsteps in the sand as a child—and the story of watching couples getting married at a church near his childhood house is straight from Springsteen's real life. "There's something so strange and righteously true," says Plotkin, "about a guy standing up there waiting for his bride to walk up the aisle to him, and he's thinking about his father."

The simple song had the most technical issues of any track on the album—Plotkin noticed that something was odd about the way Springsteen's playing and singing pulled against the drum machine, and because the artist didn't want to recut it, he endeavored to fix the rhythm track. It still wasn't right by the time Clearmountain was mixing it. "The feel kept shifting around every two bars," he recalls. He thinks someone hit the wrong setting on the LinnDrum, saying "they really didn't know how to work that thing." It was before the age of easy digital editing, so fixing it was a "major operation."

TUNNEL OF LOVE

Springsteen was already mixing a version of the album when he came up with the song that became its centerpiece. "Tunnel of Love" is a fairly complex, multi-section pop composition, with gaudy-for-Bruce electronic flourishes and elaborate drum programming by Scott that sounds like a charmingly clunky attempt at emulating Prince. Overall, it sounds like the beginning of some other album altogether, a gesture in a direction that Springsteen never fully pursued. "It was a vibe I never heard from Bruce," says Nils Lofgren. "and I was very taken by it, musically and emotionally. There was this nice churning rhythm, but there was a pleasant hauntedness to the music." "Walk Like a Man" described a pair of newlyweds climbing into their limousine for a "mystery ride." The metaphor was extended at length here, in pleasing detail: take the "fat man sitting on a little stool" selling tickets to the carnival ride while staring down the narrator's girlfriend. The track is more of a group effort than the rest of the album. Roy Bittan orchestrated the main synth riff, working from a melody that Springsteen came up with (it's pretty similar to the Band's "Chest Fever").

When the song breaks down to just Patti Scialfa's voice (in a significant hint of things to come) and synth, the Who-like part is Bittan's idea. "What

> ## "IT WAS A VIBE I NEVER HEARD FROM BRUCE BEFORE."
>
> **NILS LOFGREN**

I envisioned was, when the roller coaster starts going up," says Bittan, who grew up near New York City's Coney Island and its amusement park, "and it's clattering and clanging. So that's what I tried to do. I had a very fast pattern, a fast arpeggio, not unlike the end of 'Jungleland.' And then we had a little melody that went with it." (Two minutes and 44 seconds into the song, in the left channel, there's a mysterious moment; Scialfa speaks for a second, saying something like "lose it.")

Lofgren's guitar solo is his biggest showcase on any Springsteen studio recording, a short but virtuosic blast that sounds positively radical compared to Springsteen's own playing, complete with a quick Eddie Van Halen-style two-hand tapping part. "I was a little overwhelmed that he wanted me to play on his record, 'cause, you know, he's a great guitar player," says Lofgren, with typical humility.

All he knew in advance was that the song was in the key of C, and he prepared a couple of licks. When he arrived at Springsteen's home studio, "we started plugging in effects pedals and he said, 'Here's the solo section. Why don't you just take a crack at it.'"

"And as we kept playing, we'd add more and more pedals, like kids in a music store, looking for a bit more unusual sound, something that fit the whole ride of the song. We must've had seven or eight pedals plugged in—different choruses, flanges, phases, overdrives—and we came up with a sound that I was comfortable with and Bruce would tweak. And then I started taking shots at it. And again, just because of the haunted nature of the piece, I felt these couple little [tapping] spots made sense, and I introduced my harmonics here and there. And then he said, 'The second half, I want you to kind of get off of playing lines and just find some kind of repetitive thing to hang on.' And we worked at it a few hours, and a lot of foot pedals later and turns and dials, we came up with a solo Bruce was happy with. It was really a cool adventure."

As on an obvious inspiration, "Palisades Park," the 1962 hit about a New Jersey amusement park (complete with a lyric about giving a girl a hug "in the tunnel of love") "Tunnel of Love" features the real sounds of roller coaster riders, recorded by Scott in the Shore town of Point Pleasant, New Jersey.

TWO FACES

In Springsteen's 2016 autobiography, he revealed a decades-long struggle with depression. When I asked him, upon its release, where he sees his depressive nature in his songs, "Two Faces" was the first title he mentioned. The song is more or less a rewrite of Lou Christie's 1963 song "Two Faces Have I," but the idea of a sharply divided personality, with one side that weeps and "does things I don't understand," obviously cut deep for Springsteen.

In keeping with the divide at the core, the song veers into almost self-mocking cheer at the end, thanks to a sixties-style, Farfisa-like organ solo that's a blatant nod to Christie's original. The credits of the album suggest that Springsteen played it himself, but it's so manifestly in the style of Danny Federici that either the credits are wrong or Springsteen managed to uncannily channel his longtime comrade.

BRILLIANT DISGUISE

With its Latin-flavored rhythm, "Brilliant Disguise" is one of Springsteen's lightest-on-its-feet songs. Plotkin says one of his own few direct contributions to the album was helping shape this track's beat, which is almost all drum machine, save for one live fill played by Weinberg, leading into the bridge. "I think he may

Above: Bruce Springsteen and Patti Scialfa on stage in East Berlin, July 19, 1988.

have flown me out to L.A. to play that one fill," Weinberg says. "It's happened!" (If the album's drums come off as surprisingly organic, credit Clearmountain, who replaced the LinnDrum sounds with more realistic samples throughout.)

The song, with Springsteen harmonizing with himself like a one-man Everly Brothers, is about lovers unable to reveal their true selves to each other, and the terror of a man doubting "what he's sure of." But it can also be heard as Springsteen's commentary on his public persona—that's certainly how it felt when he opened his myth-busting 1990 Christic Institute concerts with it. In most live performances, however, Springsteen harmonizes with Scialfa, and a song about potential betrayal becomes something more complex, as the prospect of redemption looms.

The bridge is another album-defining moment: he thinks he's doing his best, but it all collapses when the lights go out. The odd reference to a fortune-telling gypsy who may have lied, meanwhile, is a clever nod to Lou Christie's "The Gypsy Cried."

ONE STEP UP

A country song, in spirit, at least, recorded during a sojourn to an actual studio in Los Angeles. It's still a solo production, except for some backup from Scialfa, but everything sounds a little slicker. Here, the marital torment bubbling through the rest of the record boils over. There are arguments, slammed doors, and, finally, a flirtation with a stranger in a bar. At the end, the narrator is dancing with his wife again—but only in his dreams. (Somewhere in San Diego, a young pre-Pearl Jam Eddie Vedder was listening closely—he once went in the studio and re-created this track in its entirety.)

WHEN YOU'RE ALONE

The breakup is real now, and this simple song, which echoes the beat of "Brilliant Disguise," emphasizes the emptiness of solitude. Nobody knows how love dies, he sings, but once it goes, "it's gone, gone," he sings. Lofgren and Scialfa recorded background vocals together, and Clarence Clemons has a credit for vocals as well, although it's hard to hear him.

Top: Springsteen and Scialfa pictured together outside the Westbury Hotel, New York, August 24, 1988.

Above: Springsteen receives the light, 1988.

VALENTINE'S DAY

The album ends with order restored, leaping back to a point in a relationship more like the one caught in "All That Heaven Will Allow." The narrator is on the road, but he has a destination: home. A call from Jon Landau was the inspiration for the line about a friend becoming a father, which means this lovely, loping, chorusless song was indirectly prompted by the 1985 birth of Kate Landau, who would grow up to be an artist manager in her own right.

LUCKY MAN (B-SIDE)

This ominous bluesy track nearly made the album, and it would have fit well as a counterbalance. The narrator is an itinerant truck driver who has learned none of the lessons of the other characters, convincing himself that his solitude is his good fortune. The adage "he who travels fastest travels alone" appears in both this song and "Valentine's Day," but only this guy is deluded enough to believe it.

THE HONEYMOONERS (OUTTAKE, *TRACKS*)

This John Prine-ish half-spoken wedding remembrance is notable only for its obvious emotional ambivalence. He took another shot at the subject, after taking another shot at marriage, on 1992's "Book of Dreams." Springsteen told Loder he recorded with the windows open and that the microphones never picked up passing cars or barking dogs—but the end of this track seems to be an exception.

WHEN YOU NEED ME (OUTTAKE, *TRACKS*)

The original idea for *Tunnel*, Springsteen told Loder, was to write some love songs; it obviously got more complicated along the way. This track is one of the most straight-ahead pledges of devotion he had written up to that point, but it's also kind of boring. (The released version has *Tracks*-era drum overdubbing from Gary Mallaber, which make it sound more like a nineties song.)

THE WISH (OUTTAKE, *TRACKS*)

"My mother will be happy that 'The Wish' is finally coming out," Springsteen told *Rolling Stone*'s Anthony DeCurtis in 1998. "Enough songs about my dad! She's been waiting for some time." It's another kind of love song altogether, a celebration of his mother's joy and optimism, not to mention her purchase of Springsteen's first guitar. "When you sing about your mother, you're taking a big risk in the rock 'n' roll business," Springsteen said onstage in 2005, in an amusing introduction to "The Wish." He continued, "In country music, when you sign your contract, I think there's a thing that says that every other album, there's gotta be a song about your mother. Merle Haggard, 'Mama Tried'; Hank Williams III just put one out called "I'm the Only Hell My Mama Ever Raised.' The basic line is, 'Mom tried, but you're just bad.' Then, you can sing about your mother in rap music—Tupac ['Dear Mama'], a beautiful song about your mom. In rock, I guess you gotta do like Jim Morrison, who finessed the whole thing by singing about screwing his mother. It's more, supposedly, correct in the rock 'n' roll business to take that approach to it." After years of obscurity, "The Wish" would find a home as a tear-jerking highlight of *Springsteen on Broadway*.

TWO FOR THE ROAD (B-SIDE)

A sweet, slight, mostly acoustic song that reprises themes from "Two Hearts" (and even the line about being treated "hard and cold"). Springsteen harmonizes with himself like a one-man Everly Brothers, and plays a Buddy Holly-ish guitar solo. It's all over in under two minutes.

> **"WHEN YOU SING ABOUT YOUR MOTHER, YOU'RE TAKING A BIG RISK IN THE ROCK 'N' ROLL BUSINESS."**
>
> **BRUCE SPRINGSTEEN**

CHAPTER 9

•

1992
HUMAN
TOUCH

•

HUMAN TOUCH

"Throughout '88 and '89, every time I sat down to write, I was just sort of rehashing," Springsteen told *Rolling Stone*'s Jim Henke. "I didn't have a new song to sing. I just ended up rehashing *Tunnel of Love*, except not as good. And it was all just down and nihilistic." In late 1989, Springsteen moved to Los Angeles with Patti Scialfa, who would give birth to their first child, Evan, in July of the following year. Feeling musically restless, and fed up with relationships that he believed, in some cases, to border on codependency, he let the E Street Band know he was moving forward without them—a hiatus that many of the members feared was a permanent breakup. "Occasionally you would hear from him that he felt burdened by the responsibility," says producer Chuck Plotkin, "and burdened by the way in which the thing being too narrowly defined by its own history would be an impediment to his progress."

Cut loose from his bandmates, his first marriage, and his home of a lifetime, Springsteen was a free man. Or maybe he was just adrift. The songs still weren't coming. After a dinner with Roy Bittan, about a month after the band's October 1989 split, the keyboardist played him some songs he composed in his home studio. Springsteen wrote lyrics and melodies over the tracks, and invited Bittan to join his production squad for the first time. "Roy bought his way back onto the team," says Plotkin, "as all of us had to do, in one way or another, at one time or another."

The fresh stimulus broke through Springsteen's block, and he began writing a batch of his own new songs, making demos of them with Bittan. "I played synth bass, and synthesizer, and I would start the drum machine and he would play guitar and sing," says Bittan. "So we were a two-man band. And that's how we demoed all the *Human Touch* stuff—and recorded it."

On bass, Springsteen enlisted Randy Jackson, a top-level session musician and producer with jazz and funk chops, who played on Lionel Richie's "Dancing on the Ceiling" and Madonna's *Like A Prayer*, and had just toured with Journey. (Jackson already had the perpetually enthused personality that would lead to his fame as an *American Idol* judge in the early 2000s. Springsteen's longtime recording engineer Toby Scott recalls Jackson saying stuff like "Yo, dawg, that's a great song!") On drums, they tried out several of the best session players alive, including Steve Jordan (later to appear on *Devils & Dust*), Omar Hakim (David Bowie, Madonna), and, apparently, the rootsier Jim Keltner ("he would have been too laid-back," says Scott). Springsteen settled on Jeff Porcaro, who had already played on his first post-E Street recording, a cover of "Viva Las Vegas." Rock-snob critics would later attempt to malign Porcaro by pointing to his membership in Toto, the band behind "Africa," but he was also the guy who conquered Steely Dan's insanely tricky "Your Gold Teeth (Part 2)" when he was nineteen years old. In a letter to Porcaro's wife after the drummer's sudden death in August 1992, Springsteen wrote that his playing "went beyond craft and precision into the realm of the spirit."

Many of the songs on *Human Touch*, including the title track, according to Bittan, were "tracked to the demo," which means the rhythm section played over the two-man band versions he and Springsteen created. In his book *Songs*, Springsteen explained how they would often overdub onto the demos, but then also re-record the songs live from scratch—and "pick what worked best." Either way, a certain sterility pervades the album. "Looking back on

> **"I JUST ENDED UP REHASHING *TUNNEL OF LOVE*, EXCEPT NOT AS GOOD."**
>
> **BRUCE SPRINGSTEEN**

Previous spread: Springsteen performing live on London's Wembley Arena stage, July 12, 1992 on his 1992–93 World Tour.

Opposite: Admiring the large crowd at the Milton Keynes Bowl, UK, May 22, 1993.

it," Springsteen told me in 2016, "I might have cut those songs somewhat differently, and with a different sound."

But the title track, recorded in the spring of 1990, was the exception. "One of the early turning points was when he came up with 'Human Touch,'" music critic Jon Landau told journalist Steve Harris in 1992. "We knew that was really something. And also something that seemed to get across philosophically the overall idea that Bruce was still really interested in—which was basically human connections between people, trying to, in an incredibly chaotic, overstimulated environment, live your life in a way where you still are able to focus and connect on the most basic level." Across the album's lyrics, Springsteen displays a newfound habit of telling more than showing, shouting out his themes rather than suggesting them, which, in general, is not a great artistic strategy. However, it works in the powerhouse bridge of "Human Touch," where he dives back into the "Cautious Man" battle between love and fear, presenting risk, pain and intimacy as inextricably linked.

Given the apparent recording process, it's a tribute to Jackson and Porcaro's chops that "Human Touch" grooves as hard as it does—in its final 20 seconds, the rhythm section gets legitimately funky, sounding closer to Minneapolis than Asbury Park. (Jackson's main riff is lifted from what Bittan created on synth bass.) Bittan's warm-bath synth chords and an overly genteel rhythm-guitar sound make the production somewhat limp, but it still can't quite dampen the excitement of the performances. "You can sense the joy," says Jackson. "We had a blast."

"When you get musicians of that caliber," says the album's assistant engineer, Rob Jaczko, "even if they have a rough skeleton that they are actually hearing as they play new parts, it still gets a vibrant, anthemic feel. These guys were tacked on at the end, and that is truly the skill of their musicianship to make it feel like they were there at the beginning."

In all, with its roller-coaster dynamics, along with Bittan's synth chimes and a spotlight on Scialfa's vocals, the song resembles nothing so much as a live-band evolution of *Tunnel of Love*'s title track.

As Springsteen's glossiest album, with lyrics that could veer into what *The New York Times*' Jon Pareles memorably described as "steady-chugging didacticism," *Human Touch* never won much favor with critics. And the musical landscape was shifting violently beneath them. Landau told *Billboard* that *Human Touch* had a lot of guitar "for a nineties record"—just as Nirvana's "Smells Like Teen Spirit" was taking over MTV. "Nirvana hit at the moment that it came out," Springsteen told me in 2016. "I remember Jon at the time was nervous that the records hadn't done as well as he'd hoped—or we'd hoped. We had a conversation, 'Jon, it's just not our time. We'll have other times. And if you have a long life and a long work life, you're going to go through that. Sometimes it's just not your time. It was somebody else's.'"

Still, the tides of cool are always changing. When Tegan Quin of the long-running indie-pop duo Tegan and Sara sat down to get a tattoo of a Springsteen lyric, she chose a line from the first verse of "Human Touch." "It's a really great lyric," she told me. "And I love that record."

> **"SOMETIMES IT'S JUST NOT YOUR TIME. IT'S SOMEBODY ELSE'S."**
>
> BRUCE SPRINGSTEEN

Opposite: Dortmund, Germany, April 4, 1993.

SOUL DRIVER

With a reggae-inflected feel, complete with a mildly dub-influenced bassline from Jackson, plus "spooky" *X-Files*-themelike synthesizers, "Soul Driver" doesn't sound like it belongs on a Bruce Springsteen album—but it also doesn't sound like it belongs anywhere in particular, except maybe on a nineties adult-contemporary radio station, next to Sting. "We were tweaking and working with things and experimenting with sounds," Bittan says of the time. "It was a period of growth for him. It was a little bit scary and difficult, feeling his way." (The 1990 Library of Congress copyright for "Soul Driver" attributes the music to Roy Bittan, but the album's liner notes do not. The keyboardist says the initial credit was simply an error.)

Synthesizers were about to slip deeply out of fashion, but Bittan was under instructions to play nothing else—no piano allowed, "even if it cried out for it," he says. "There was a reason they didn't want that. Because it sounds like E Street when I play the piano. Inadvertently! It sounds like E Street sometimes even when I play with other people."

The earthiest, and best, moments on "Soul Driver" arrive via a couple of powerhouse organ solos from David Sancious, who popped in for a couple hours from another Los Angeles session. Afterward, Sancious and former E Street drummer Ernest "Boom" Carter, who was also in town, drove over to Springsteen's house, where they had lunch and hung out with their former boss for the first time in many years.

"THERE CAN BE SO MUCH GOING ON AND NOTHING HAPPENING"

BRUCE SPRINGSTEEN

57 CHANNELS (AND NOTHIN' ON)

In December 1990, after two spectacular solo-acoustic benefit concerts
for the Christic Institute the month before, Springsteen started recording
a new set of minimalist songs built around his own bass guitar playing.
They stood apart from the *Human Touch* material and, for a while, he saw
them as the core of a potential separate album. Until the 1998 release of the
outtakes boxed set *Tracks*, the sole survivor from that group of songs was
"57 Channels." "That was a great little moment," Jon Landau told *Billboard* of
that song's introduction. "Because its inclusion brought another dimension
in terms of the music and the humor." Springsteen was a fan of Leonard
Cohen's 1988 album *I'm Your Man*, which combined the Canadian legend's
deadpan poetry with spare electronic production, and his bass songs
sometimes sounded like primitive versions of, say, "First We Take
Manhattan."

At the Christic concerts, he debuted a rockabilly take on the song that felt
like pure fun. The album arrangement conveyed more of the alienation at the
song's core, with Springsteen attempting a deliberately affectless, Lou Reed-
with-twang vocal delivery. (He retained the true-to-life opening of buying
a Hollywood house with a with a pile of hundred-thousand dollar bills, but
dropped a reference to getting "hot and horny.")

"This is about loneliness," he said, introducing it at a Christic show. "How
there can be so much going on and nothing happening." He subsequently
retrofitted the song with a Los Angeles riots theme, with help from a
bracingly bold remix from Steve Van Zandt that added power chords,
percussion, and current-events samples.

Above: Bruce Springsteen, Patti Scialfa, and
Steve Van Zandt dine out, New York, 1993.

Opposite: Bruce Springsteen and '92–'93
backing musicians Shane Fontayne (left) and
Crystal Taliefero (right) in concert at Nassau
Coliseum, Uniondale, NY, 1992.

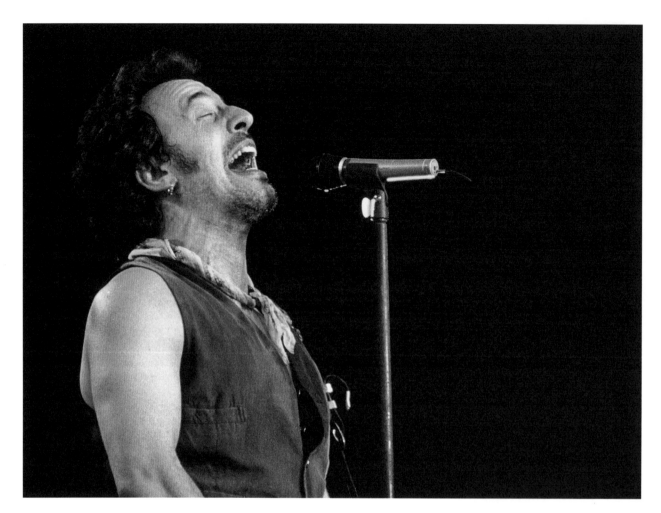

For Chuck Plotkin, the album version of "57 Channels" was something of a missed opportunity. "It was his first thing where you could tell he had heard some hip-hop," he points out. "I would have gone all the way to hip-hop with it, had Bruce seemed to me to be prepared to go that far."

CROSS MY HEART

Although Sonny Boy Williamson II's 1958 single "Cross My Heart" isn't a particularly famous Chess Records blues cut, it is pretty great, with a hurricane of a harmonica solo. Bruce Springsteen's own, libidinous "Cross My Heart"—which borrows so many of that tune's lyrics that he gave the already long-dead Williamson a co-writing credit—is somewhat tepid in comparison, with an overly direct message about the "spaces in between" right and wrong. The final verse, where the narrator paints existence as a "cold, hard ride," is at least interesting in its darkness.

GLORIA'S EYES

Springsteen once described *Human Touch* as a product of "little writing exercises" in various genres. (He actually used the word "generic," which may have been a Freudian slip.) "Gloria's Eyes" is a straight-ahead guitar-rock song with a repetitive riff and a lyric about a wandering lover who has finally pushed Gloria too far. There is little else there other than Springsteen's wild-man bluesy leads, which sound like he's trying to solo hard enough to make the song great, and a tasty drums-and-voice breakdown.

Above: Waking up the crowd, Milton Keynes Bowl, UK, May 22, 1993.

WITH EVERY WISH

Described by Springsteen as a dark fairy tale, this evocative acoustic track is about the "curse" that follows every dream come true. Thanks to a muted trumpet from Mark Isham and backing from Isham's band, it's Springsteen's jazziest track since "Meeting Across the River." Isham told Matty Karas of the *Asbury Park Press* that they overdubbed a demo that was "very much in a *Nebraska*-type vein . . . He said the rest of the record wasn't quite in the same vein, and he wanted to flesh this tune about." The song ends with the narrator ready to roll the dice on love and worry about the curse later—leading right into the album's next track.

ROLL OF THE DICE

Soon after Springsteen broke up the band, Bittan composed and demoed a song that "couldn't have been more of an E Street thing," he says. "Maybe it was my way of saying goodbye to E Street." He thought maybe he could pitch the track, along with a couple of the others he had created, to the Eagles' Don Henley. Instead, Springsteen wrote "Roll of the Dice" over the track, with its supercatchy, up-and-down-the-scale piano-and-glock riff, on the same night Bittan first played it for him (it was written, obviously, before the institution of the no-piano rule). It was the first song Porcaro played on, and his Hal Blaine-style snare fills helped win him the gig, according to Landau. Soul singer Bobby King, who'd later join Springsteen on tour, takes Van Zandt's back-up vocals slot. "He had basically the exact harmonies he wanted me to sing," King told Karas.

REAL WORLD

Roy Orbison's album *Mystery Girl*, released posthumously in January 1989, includes "In the Real World," a kind of sequel to "In Dreams," a Springsteen favorite released in 1963. Ten months or so after the release of Orbison's album, Springsteen wrote his own "Real World" over another Bittan track, this one a hyperactive soul-rock thing with a prominent synthesized bell ringing through it. It was the most personal of the *Human Touch* songs, with intriguingly self-referential lyrics: he's playing off "Thunder Road" when he sings that he still has "a little faith," but needs some proof. The reference to silent church bells seemed to allude to his and Scialfa's initial decision not to get married; "no flags unfurled" could be seen as a good-bye to the *Born In the U.S.A.* era, or maybe it is simply the only word that rhymes with "world."

Nearly a year after he recorded the song, but well before he released it, Springsteen played an arresting piano-and-voice arrangement of "Real World" at the Christic concerts, delivered in his best soul bellow. Eventually, Springsteen would concede that version's superiority, but even he may have forgotten that the song wouldn't exist at all if not for Bittan's original arrangement. "It was the precursor," says Bittan, who's well aware of the criticism. "The music was what inspired the lyrics. That's a great argument for the next time someone says something about it!"

> **"MAYBE IT WAS MY WAY OF SAYING GOODBYE TO E STREET."**
>
> ROY BITTAN

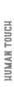

ALL OR NOTHIN' AT ALL

A much-maligned rock song about commitment that's actually not bad; it just cries out for a more garage-y treatment. Marshall Crenshaw's obscure cover of the song, with a rougher band, is the definitive version. "I don't think anything Bruce ever does is slick," argues Randy Jackson, who rejects the idea that he was simply too advanced a player for a song with barely more than two chords. "I came from [jazz] fusion stuff and now I'm playing three chords with Bruce Springsteen. It's not about the chords. It's about the feeling."

MAN'S JOB

One of the few perfectly realized tracks on *Human Touch*, "Man's Job" is a bright soul-pop song with sweet, jangling guitar (plus a hint of "Sleep Walk" slide) and prominent backup vocals from both King and Sam Moore of Sam and Dave fame. All that's missing is a sax solo.

I WISH I WERE BLIND

A mid-tempo song that gestures toward country without fully embracing the sound, "I Wish I Were Blind" has underplayed backup vocals from Bobby Hatfield of the Righteous Brothers. Plotkin couldn't understand why a song where the narrator is so heartbroken that he wants his sight blotted out didn't convey any anguish. "The thing was a bit slick, formal, polite," says Plotkin, who thought that it should perhaps rock harder. "What is the emotional subtext? Are you not angry about this in any way? How sad are you?" When Springsteen moved on to *Lucky Town*, all these concerns got shoved aside. "What happened is, instead of being able to address these issues, he had a whole new album," says Plotkin.

THE LONG GOODBYE

After Springsteen had bid farewell to the E Streeters but before Bittan came aboard, he told Scott he wanted to find a new guitar sound. So the engineer brought in "a bunch of different guitars—Stratocasters, Gibsons, hollow-body guitars—and two or three amps," anything other than Springsteen's usual setup of a Telecaster through a Bandmaster amp. But what happened every time he tried a new setup serves as a metaphor for Springsteen's inability to break much real new ground on *Human Touch*. "Bruce would just adjust the tone controls on the guitar," Scott remembers, laughing, "and then, he'd adjust the tone controls on the amplifier, until it sounded like . . . a Telecaster through a Bandmaster!"

He did end up with at least one new sound. "The Long Goodbye" is an amusing confessional about Springsteen's failure to leave New Jersey for the seventeen years since "Born to Run." He meant to leave two decades back, he sings, but he'd been "packing kinda slow." The track's guitars have an anomalous-for-Bruce ZZ Top crunchiness, which Scott attributes to the use of a Rockman, the Walkman-sized amplifier substitute created by Boston guitarist Tom Scholz that helped define albums such as Def Leppard's *Hysteria*.

REAL MAN

Critics couldn't decide whether the horrifically catchy synthesized horn riff that kicks off this track more precisely evoked Huey Lewis or Phil Collins, but they pretty much all agreed that Springsteen had recorded a truly bad song. "This next song is a very corny song," Springsteen said in 1992, introducing

> ## "IT'S NOT ABOUT THE CHORDS. IT'S ABOUT THE FEELING."
>
> RANDY JACKSON

Previous spread: Rotterdam, April 1993 on the 1992–93 World Tour.

Opposite: Wembley Arena, London, July 12, 1992.

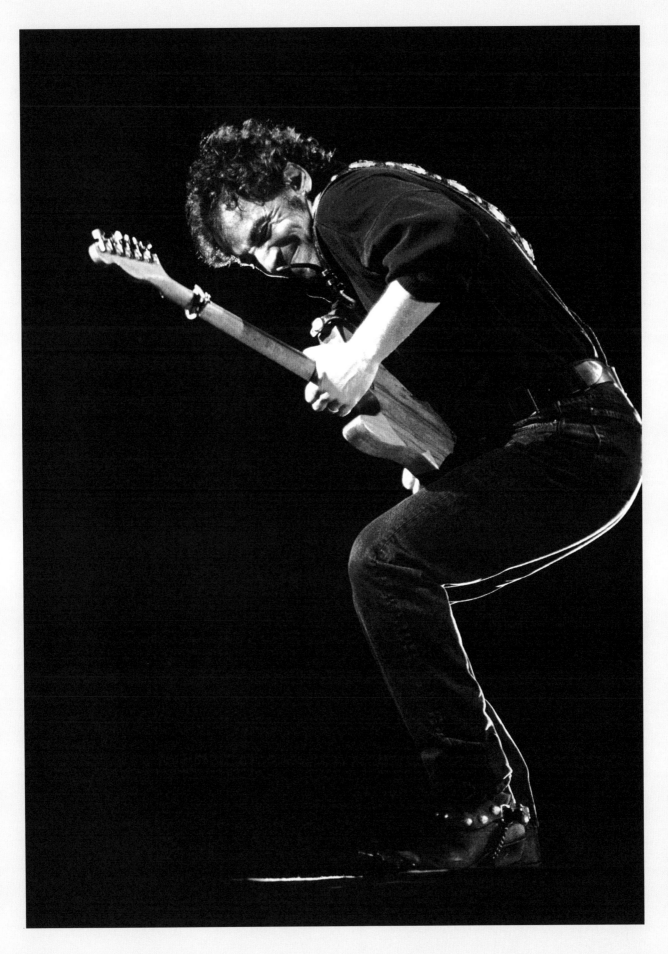

one of its exceedingly rare live appearances, "so corny I almost threw it off the damn record." If it were up to Plotkin, it never would have been released. But overall, the producer says, he was not feeling at his boldest in this period. "I watched the band get fired," he says. "The whole band! And I've been through the experience myself of expecting to get fired any minute. There are times when you have to pick your moments. And I suppose one of my moments would've come if he hadn't started writing and recording *Lucky Town* before we had actually finished the other record."

PONY BOY

In a tender acknowledgment of his new-dad status, Springsteen performed an acoustic duet with Scialfa on a song he had found remarkably soothing for baby Evan, one that he remembered his own grandmother singing to him. He couldn't remember the lyrics to the verses, so he made some lines up. By the time Springsteen's firstborn was a teenager, however, his feelings had shifted somewhat. "Evan hates that fucking song," Springsteen revealed in 2005.

30 DAYS OUT (B-SIDE)

One of Springsteen's most obscure released songs, as yet never included on any compilation album, "30 Days Out" is energetic but forgettable. It's notable mostly for a heavier guitar sound than anything on *Human Touch*, as well as prominent use of the supposedly *verboten* piano.

TROUBLE RIVER (OUTTAKE, *18 TRACKS*)

Another discarded rock track that's a little fiercer than the stuff that made *Human Touch*. It may well be one of his coded songs about depression. The narrator is haunted by a river that's "cold and deep and black," and he can't "keep from crying."

PART MAN, PART MONKEY (B-SIDE)

Springsteen's only full-fledged reggae track, with a plot line about the 1925 Scopes "monkey trial," in which a high school substitute teacher was prosecuted for violating a Tennessee law against teaching the theory of evolution. Springsteen played it regularly on the Tunnel of Love Express Tour, and he recorded it early in the *Human Touch* sessions. It was, predictably, inspired by a viewing of *Inherit the Wind*, although Springsteen used to mention a 1988 TV adaptation of the play, not the classic 1960 movie.

TROUBLE IN PARADISE (OUTTAKE, *TRACKS*)

This mellow Bittan–Springsteen collaboration is the easiest to imagine in the hands of the keyboardist's original target, Don Henley. It addresses infidelity head on, a subject Springsteen mostly hints at on *Human Touch*. Overall, it feels linked to the mystery songs Springsteen was writing in 1988 and 1989, part of a connective tissue between *Tunnel of Love* and *Human Touch* rather than a real potential track for the latter album.

SAD EYES (OUTTAKE, *TRACKS*)

A sturdy, wistful pop ballad with a falsetto chorus, "Sad Eyes," as Plotkin says, "could've been some kind of hit." Instead, it reached its moments of greatest visibility on an episode of *Dawson's Creek* and in an Enrique Iglesias cover. "I think probably the majority of the fourth CD is as good or better than the record that I ended up putting out," Springsteen told *Rolling Stone*'s Anthony

> **"THE SONG IS SO CORNY I ALMOST THREW IT OFF THE RECORD."**
>
> BRUCE SPRINGSTEEN

Opposite: Ready to spring into action. Dortmund, Germany, April 4, 1993.

DeCurtis, referring to the disc of *Tracks* filled with *Human Touch* outtakes. "It's more interesting in some ways, a lot of that material. It may get closer to what I was actually trying to write about than the record that I put out at that time, in some fashion."

LEAVIN' TRAIN (OUTTAKE. *TRACKS*)

A close musical and sonic relative of "The Long Goodbye," but even more obviously ZZ Top-inspired, with blues-rock riffing and that distorted Rockman sound. Using this track and "Seven Angels" might have helped wake up *Human Touch*.

SEVEN ANGELS (OUTTAKE. *TRACKS*)

Manifestly better than, say, "Gloria's Eyes," with metaphorical lyrics that show a lighter touch than most of the album, "Seven Angels" is among the strongest of the *Human Touch* rock outtakes. Randy Jackson's bass guitar plays a rare, John Entwistle-style lead role here, taking mini-solos in between power chords.

MY LOVER MAN (OUTTAKE. *TRACKS*)

Maybe it's a wish-fulfillment fantasy: Over a "Brilliant Disguise"-like beat, Springsteen sings from the point of view of a highly forgiving woman, one who tells her man she's grown accustomed to his foolishness, and welcomes him back after he strays.

WHEN THE LIGHTS GO OUT (OUTTAKE. *TRACKS*)

Introducing an acoustic version of this paranoid song at the Christic Institute concerts, Springsteen drew a link between unfaithful lovers and secretive, corrupt governments. In the studio, it was one of his bass-driven tracks. "There's a series of things that are just bass, a rhythm machine, and a synthesizer," Springsteen told DeCurtis (on this one, however, Porcaro is credited with replacing the drum machine). "Initially, there was a point where I thought of making a complete album where the original '57 Channels' was part of that group of material. It had a way of framing the songs that was very stark. It was very different."

OVER THE RISE (OUTTAKE. *TRACKS*)

Applying an echo effect to a repeating bass riff here creates an Edge-like effect that feels genuinely experimental and fresh. The lyrics include the striking image of a wedding ring lying at the bottom of a river. "Those things had a feeling all of their own," Springsteen told DeCurtis of this group of songs, "and it would've been a nice album."

GOIN' CALI (OUTTAKE. *TRACKS*)

In this blatantly autobiographical, nearly spoken-word track with a hint of Chuck Berry in its vocal cadence, Springsteen chronicles his West Coast rebirth, with more vibrant lyrics than anything on *Human Touch*. He recorded "Goin' Cali" in January 1991, and you can feel Springsteen barreling toward *Lucky Town*, with multiple lyrics that would end up on that album.

LOOSE CHANGE (OUTTAKE. *TRACKS*)

Another January 1991 bass song finds Springsteen—out of nowhere— suddenly plugged back into his storytelling gifts. It's a tale of an aimless,

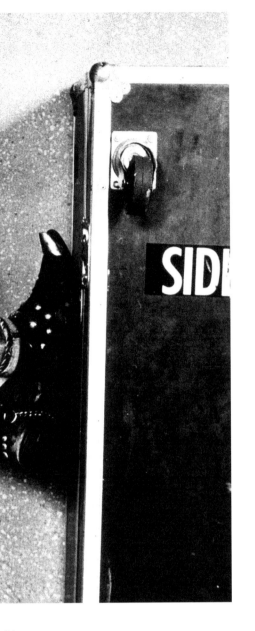

isolated man's bar hookup, with a level of detail that hints at where he would head on 1995's *The Ghost of Tom Joad*. It ends with a striking evocation of stasis: The narrator sits in his car at a traffic light, letting the lights turn from green to red to green, never moving.

After Springsteen accumulated about half an album's worth of these songs, he decided they "felt like too much of a genre project" that wouldn't lend itself to a big rock tour. "It was something that would have been interesting," he told DeCurtis, "but I wanted to go out and play. So I tended to move closer toward the rock material that I'd recorded."

GAVE IT A NAME (OUTTAKE, *TRACKS*)

Springsteen recorded the released version of "Gave It A Name" from scratch with Roy Bittan for *Tracks* after he couldn't locate the original recording, from his batch of his bass songs. It's about nothing less than the invention of Satan, painting portraits of people who couldn't face what he described, in a *Billboard* interview, as "the parts of themselves they don't like very much."

Above: Relaxing with his feet up backstage at the Brendan Byrne Arena, East Rutherford, New Jersey, July 28, 1992.

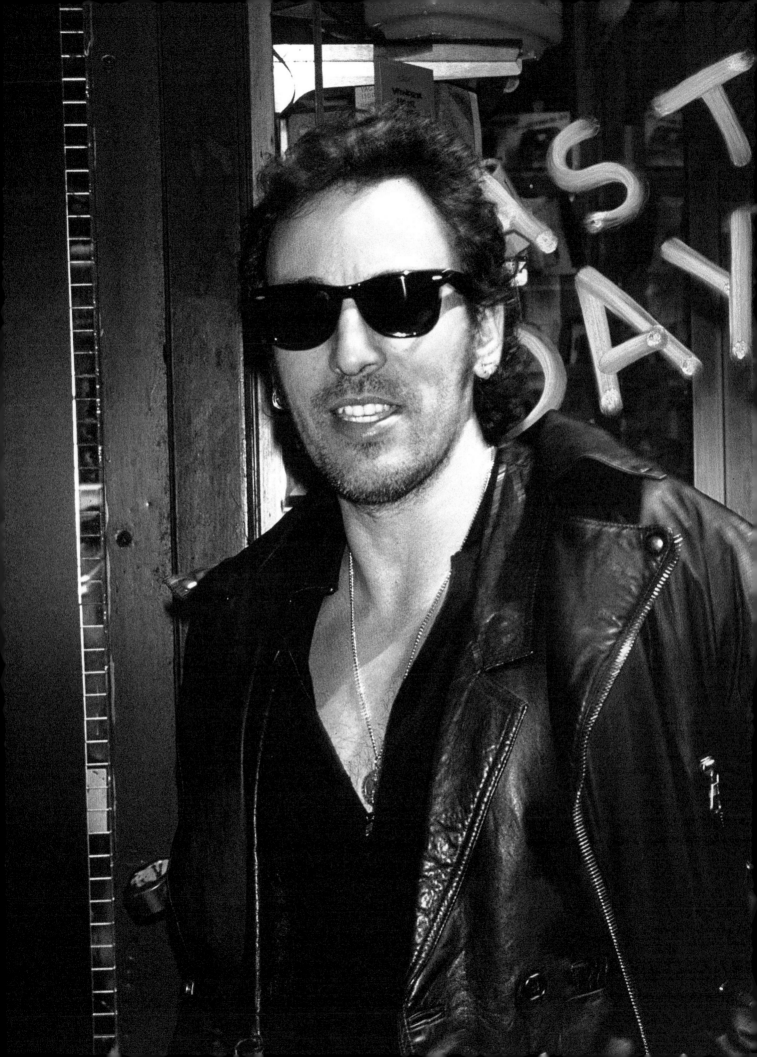

CHAPTER 10

•

1992
LUCKY
TOWN

•

BETTER DAYS

He was supposed to be finished, although those who knew him best had their doubts. By summer 1991, Springsteen settled on a preliminary sequence for what would become *Human Touch*, and he called a halt to recording sessions at A&M Studios. Springsteen was a newlywed and expecting his second child. "By the time I finished the album," Springsteen told the *Los Angeles Times'* Robert Hilburn, "I was at a different place in my life. I was a father and having this uplifting and happy relationship. I felt revitalized, and I didn't feel it was reflected in the *Human Touch* album." In 2016, Springsteen told me that his dissatisfaction with that album's production may also have been weighing on him—it was so polished that Steve Van Zandt told him to scrap it all and re-record it with the E Street Band, according to the journalist Peter Carlin.

After a week off, Springsteen asked his recording engineer, Toby Scott, if he could set up a studio on his Beverly Hills property, using the mobile digital setup they bought to record concerts. Scott installed the equipment in a large reverberant room inside a guesthouse, near a swimming pool and the courtyard where Springsteen and Scialfa had married in June. With that, Springsteen had the home studio that would birth much of his nineties music, including *The Ghost of Tom Joad*. After dragging himself through forty or so songs for *Human Touch*, Springsteen was about to embark on a wild creative sprint.

With only Scott assisting him, Springsteen wrote and recorded a new song, "Living Proof," playing all the instruments over a drum machine, just as he had on *Tunnel of Love*. An entire album's worth of songs emerged from there, with the basic tracks for the rest of *Lucky Town* exploding out in what Scott estimates as two weeks (Springsteen has said it was three). "It was almost a 24-hour-a-day thing for him," Scott says. As on *Tunnel of Love*, they were not making demos; they were recording an album.

At one point, Springsteen brought in Scialfa and two of her friends, Soozie Tyrell and Lisa Lowell, to record gospel-style background vocals on two songs—and then asked them to stick around the next day to sing on a third track. When Scott asked him which song he was talking about, Springsteen replied, "I haven't finished writing it yet." "So he finished the song that night," Scott says, "and I met him in the studio at like ten in the morning or something and we knocked out the track and the girls came in the afternoon and they sang on it." Scott recalls. "And I think that might have been 'Better Days.'" As on much of *Lucky Town*, you can feel the speed of the song's creation both in its urgency and in a certain bareness. This song and others have no opening riff at all; after a snare hit, it just starts.

As on the rest of the album, the gifted drummer Gary Mallaber (Van Morrison, Steve Miller Band) replaced the drum machine, achieving a grittier effect than Jeff Porcaro on *Human Touch*. The drum machine parts he heard were "the most basic timekeeping track, just something that went boom-crack, boom-crack, nothing else to it," says Mallaber, who had room to craft his own parts. "Better Days" is the only track where they had Randy Jackson overdub the bass instead of letting Springsteen's own bass parts stand.

Just before the *Lucky Town* sessions, Springsteen dropped in at a New York studio to help out on Southside Johnny's new album, produced and largely written by Van Zandt. Springsteen offered a new song, "All the Way Home," playing it for Southside on piano instead of presenting a demo, and sang on Van Zandt's boardwalk-nostalgia track "It's Been a Long Time," taking lead

> **"I FELT REVITALIZED, AND I DIDN'T FEEL THAT IT WAS REFLECTED IN THE *HUMAN TOUCH* ALBUM."**
>
> **BRUCE SPRINGSTEEN**

174

Previous spread: The future's bright, 1992.

Opposite: Wembley Arena, London, July 12, 1992.

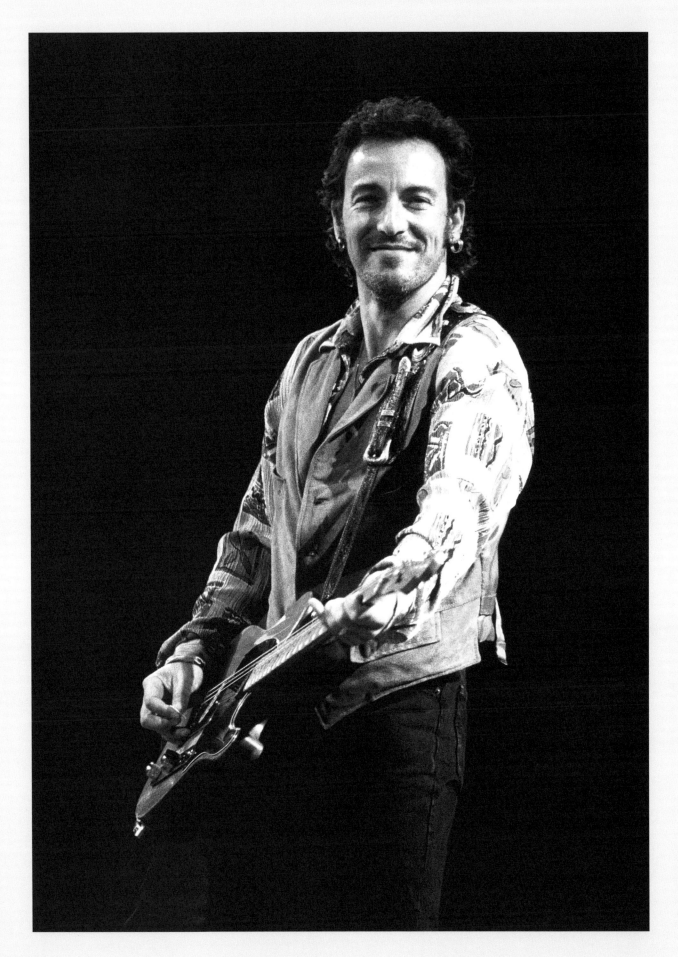

vocals on a line about "dreams of better days." That album was already in the mixing phase, so Springsteen no doubt heard the title track, too. It was called "Better Days," based on the idea that good times had to be coming, because the present "couldn't get no worse."

Springsteen inverts that concept here. "*These* are better days," he sings, his homemade gospel trio underscoring him in a rainbow of harmonies. He hits a vein of honesty missing from most of *Human Touch*, confessing his fear of pretense, of becoming a "rich man in a poor man's shirt." Springsteen told Hilburn that on *Human Touch*, "I didn't hear the 'hallelujah, raise your hands to the sky' of someone who felt as thankful and as blessed as I did." Only "Better Days" filled that slot, complete with an actual hallelujah chorus. When it came out in spring 1992, the song's hard-won buoyancy felt true to Springsteen's joyful new life, and entirely out of tune with the troubled state of the larger world.

LUCKY TOWN

"Lucky Town" is probably the high point of Springsteen's twin albums, with a tough storm-and-twang punch that dips into outlaw country. (He would play with Joe Ely, an exemplar of the genre, multiple times on the tour that followed). It's unclear when Springsteen first heard the L.A. roots-punk band Social Distortion, whose praises he sang in 1992 interviews (and who would've been on L.A. radio as early as 1990 with "Ball and Chain"), but "Lucky Town" bears at least a spiritual resemblance to that band's work. Springsteen had started going on motorcycle trips through the California deserts, and you can feel the dust of those adventures on this track.

On his new set of songs, Springsteen switched back to the folk and country structures he had been playing with since *Darkness on the Edge of*

Town. After singing most of *Human Touch* in a soul shout, he found a literal new voice, a fresh character to embody, via a throaty growl that was not without some Dylan nasality—most evident on the title track. (Springsteen is hyperaware of the point of view he's singing from, imagining different voices as different people. "I could do it as this guy or that guy," he would say to Brendan O'Brien years later, trying out different approaches.)

LOCAL HERO

"Local Hero" begins with what Springsteen has claimed to be a true story. At some point, back in his hometown of Freehold, New Jersey, he saw his own face painted on a black velvet canvas in the window of J. J. Newbury's on Main Street, a now-defunct branch of a chain of five-and-dime convenience stores. As you might expect from a guy who would soon write a song called "I'm Turning Into Elvis (And There's Nothing I Can Do)," he couldn't resist buying the portrait.

From there, over Keith Richards-derived rhythm guitar, Springsteen offers a half-confessional, half-self-parodic version of his career, with more bite then people might expect from the wholesome bard of Monmouth County. He describes outfitting himself with the "right style" and the "right smile," not to mention "religion and a story to tell," while offering a quick chronology that suggests he took some post-*Born in the USA* criticism to heart; first he became royalty, he sings, before ascending to the papacy—but "then they brought the rope." By the end, he's supposed to be retired from the hero act, but there's this voice whispering in his ear, calling him back. "You don't ever not hear that," Springsteen told Bill Flanagan of *Musician* magazine. "That never goes away. That's the point. That's what makes your choice mean something."

IF I SHOULD FALL BEHIND

An essential Springsteen ballad that carries multiple meanings, "If Should Fall Behind" started as a romantic contract before evolving into a broader social statement and then a story of friendship, thanks to a live E Street rendition that had almost the entire band trading vocals. Introducing one 1992 performance, he put the song in the context of the L.A. riots. "This song is about learning how to live with somebody, learning how to make the compromises and find the blessings those compromises bring," he said. "This has been a real tough month here in Los Angeles, the kind of a month when the veil got pulled away and we got a chance to see how profoundly estranged from each other we really are."

For producer Chuck Plotkin, the song's strength is in its realism, its suggestion that the narrator *will* fall behind from time to time, that his love *will* let you down. On tour in 1992, Springsteen played "If I Should Fall Behind" directly after "Darkness on the Edge of Town" more than once, suggesting onstage that the same character is in both songs. "After you've kind of stripped everything away to refind yourself," he said, "this is about finding that thing you were looking for."

LEAP OF FAITH

Musically, it's not that different from "Better Days," while betraying a general weakness on *Lucky Town*. Without a band to bolster him, Springsteen's exceedingly straight-ahead rhythm guitar isn't interesting enough to carry multiple songs, leaving a hollowness at the core of the arrangements. If *Human*

> **"WE GOT A CHANCE TO SEE HOW PROFOUNDLY ESTRANGED FROM EACH OTHER WE REALLY ARE."**
>
> BRUCE SPRINGSTEEN ON THE 1992 LOS ANGELES RIOTS

Opposite: Advertising for *Lucky Town* on the side of the Whisky A Go Go, Los Angeles, California, 1992.

Touch was overproduced, *Lucky Town* errs in the opposite direction. Referring to the album as a whole, Roy Bittan—who co-produced the album, played on three tracks, and is credited with (hard-to-hear) keyboards in "Leap of Faith"—says, "It would have been great if the E Street Band had recorded it." Bittan still loves *Lucky Town*, but he was taken aback when he first heard Springsteen was recording it, worried that it would mean the demise of all of the *Human Touch* material. "I didn't hear from him," Bittan recalls, "and then I finally called Jon. I said, 'What's going on?' He said, 'He's recording in his house.' I said, 'Really? By himself?' 'Yup, recording by himself. And Toby.' I was like, 'Oh no.'"

Onstage, Springsteen jokingly compared "Leap of Faith" to a controversial, then-current Madonna single. "This is a song about love, faith, hope, sex, romance, faith in romance, in your sexual ability," he said one night, laughing. "This song is like my 'Erotica'. . . It's a diary of my own personal sexual habits that I'm willing to share with thousands of people right now . . . If you want to get from here to here—you got fear over here and love over there—it takes a leap of faith."

THE BIG MUDDY

Springsteen took the title for "The Big Muddy" from an otherwise unrelated Pete Seeger song, and grabbed the line about a poisonous snakebite rendering its victim "poison too" from *Paris Trout*, a 1988 novel by Pete Dexter. (In the novel, the reference is actually to a different animal: "Her brothers said when the poison fox bit you, you were poison too"—the reference is to rabies, which, frankly, makes more sense.)

The song, probably among the first Springsteen recorded for *Lucky Town*, is a condensed, far superior version of all the *Human Touch* tracks that struggled to get across the theme of a world without moral certainty. The characters, like the guy who keeps a mistress downtown, "a little something that he did for himself," lay it all out without the narrator needing to break out the Cliff's Notes. "When we grow up, our parents kind of teach us to believe that there's good, there's evil, and that there's a right thing and a wrong thing to do," Springsteen said onstage. "I think as you get a little older and you find your way through life a little bit, you realize you bump into all those spaces in between, which is where most of us, I guess, end up living."

The track's sound, with its buzzy acoustic slide guitar and near-falsetto vocals, could be influenced by the mutant country blues of Chris Whitley's excellent 1991 album *Living with the Law*, which Springsteen heard and loved—he placed two songs on his preshow mixes over the years.

The drums on "The Big Muddy" sound programmed, but Mallaber insists they're actually live. "I was kind of mimicking the machine," he says. "Bruce had that laid out, so I didn't want to draw outside the margins of that one." Bittan is credited with a keyboard-bass part that's impressively indistinguishable from a bass guitar.

LIVING PROOF

In March 1991, Bob Dylan—who has shared with Springsteen the curious habit of leaving some of his best songs unreleased—put a number of his lost tracks out via the first volumes of his *Bootleg Series*. Among them was "Series of Dreams," a track with a U2-like groove and oblique but nevertheless soul-baring lyrics, a journey into Dylan's subconscious. "I loved the song," Springsteen told Hilburn. "It was one of my favorite things of the past decade, and it inspired me." (He may have been cued to pay attention: The track directly preceding it on the boxed set,

> ## "[LUCKY TOWN] WOULD HAVE BEEN GREAT IF THE E STREET BAND HAD RECORDED IT."
>
> **ROY BITTAN**

Opposite: Dortmund, Germany, April 4, 1993.

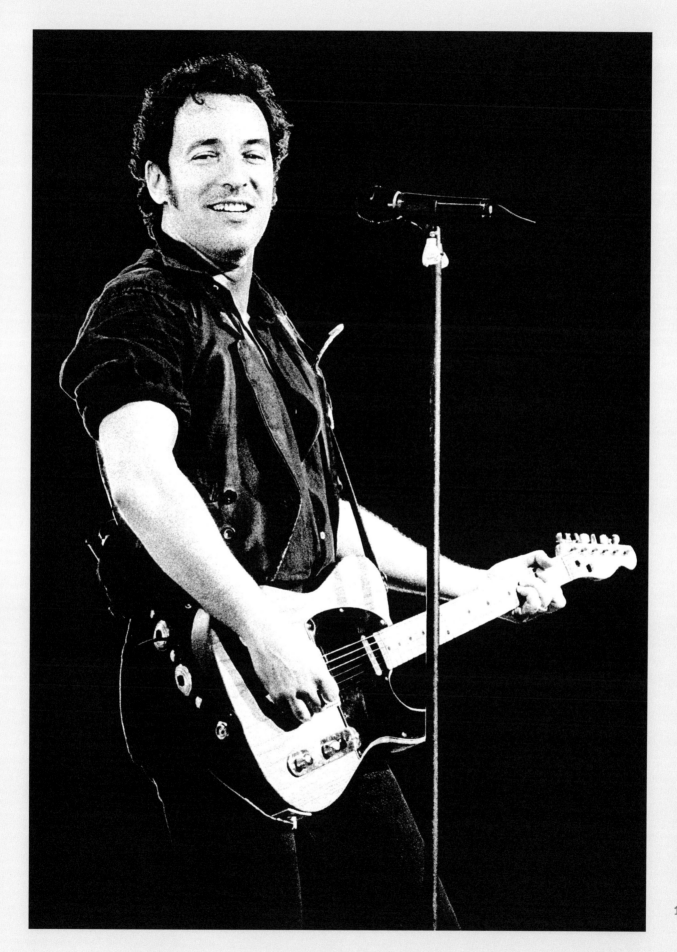

"When the Night Comes Falling from the Sky," features Bittan and Van Zandt, and Dylan reportedly complained it came out sounding too Springsteen-like).

It's hard to draw a straight line between the songs, but Springsteen told Hilburn "Series of Dreams" somehow led to the transcendent "Living Proof," the first song of what became *Lucky Town*. It was the first time he wrote about the emotions unleashed after the birth of his son Evan. "I realized here was one of the biggest experiences of my life," he said, "and I felt like, 'I'm hiding something.' I hadn't written anything about it. Suddenly I wanted to talk about all I felt, the way you walk through the fear to find the love. In the song, you find the world of doubt, of loss, of faithlessness, of humiliation, self-debasement . . . along with the world of hope, of love, of transcendence and redemption and thankfulness and a world of beauty."

With its dirty-sounding guitars and Crazy Horse-like folk-rock feel, it's clear why this song never felt like it belonged on the same album as the *Human Touch* material; there was brief talk of pairing them as a double album instead of the separate, simultaneously released LPs they became. Mallaber recalls working out the bass-drum intro in the studio with Springsteen, and then recording the entire drum performance in a single take.

When he wrote "Living Proof," Springsteen told *Rolling Stone*'s Jim Henke, "I landed hard in the present, and that was where I wanted to be. I'd spent a lot of my life writing about my past, real and imagined, in some fashion. But with *Lucky Town*, I felt like that's where I am."

BOOK OF DREAMS

A finely drawn (second) wedding day song that's far more effective than anything so inherently sentimental has a right to be. Scars may not fade, he sings, but the pain behind them does. Mallaber plays with a delicacy that foreshadows his work on *The Ghost of Tom Joad*.

SOULS OF THE DEPARTED

Springsteen may have thought his days of "topical songwriting" were done, but events were already pulling him back. "Souls" is honest to a fault, describing various contemporary tragedies—soldiers killed in Iraq, a young boy murdered by an East Compton, California, gang—through the lens of rich men up in the hills, who just "sigh and shake their heads." Springsteen, or the narrator, admits to working in a land where money rules and "your silence passes as honor," while confessing a desire to build an unbreachable wall around his house. Critics carped about that line, although it was obviously a self-effacing confession of an impulse to protect his family. Still, *The Ghost of Tom Joad* would in some ways be the sound of that wall coming down.

MY BEAUTIFUL REWARD

The album ends on an existentially unsettled note with "My Beautiful Reward" and an increasingly death-haunted series of dreams. "I planned to write a nice song about my kids," Springsteen told Hilburn. "It just took a funny turn." With every passing year, the song feels more like a folk-gospel standard, as if Springsteen had discovered it instead of written it. "Notice how he doesn't go to the resolution chord at the end of the chorus," Plotkin says. "He keeps it unresolved. He keeps the uncertainty by not giving you the security blanket of closing the thing harmonically."

In the first verse, the narrator travels the world, searching for his prize in vain; in the second, he's in an empty mansion on a hill, wandering from room to room, "but none of them are mine."

> "I'D SPENT A LOT OF MY LIFE WRITING ABOUT MY PAST. BUT WITH *LUCKY TOWN*, I FELT LIKE THAT'S WHERE I AM."
>
> BRUCE SPRINGSTEEN

In the startling third verse, he takes flight, "his feathers long and black," but he's still searching, still unfulfilled. "I kept trying to make it nice and neat," Springsteen told Hilburn, "to tie up the ending and make it more concrete. . . But . . . I realized it was right the way it was."

HAPPY (OUTTAKE, *TRACKS*)

Recorded in January 1992, well after the *Lucky Town* sessions were over, this song's opening lyrics are nearly identical to "My Beautiful Reward," suggesting a common origin—or even that Springsteen considered it as a possible replacement on the album. If "Happy" was supposed to be a less clouded declaration of family satisfaction, he once again couldn't help painting in streaks of gray and black. Springsteen sings of encroaching darkness over enveloping synth-string chords that point toward the sound he would use on "Streets of Philadelphia" two years later.

"Talk about striking a complicated note," says Plotkin. "Have you heard anybody sound less happy than he sounded saying he was happy?"

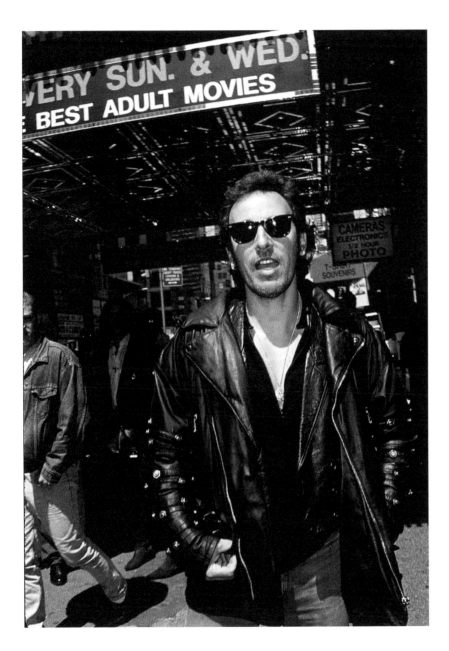

Left: Walking in Times Square, New York City, NY, 1992.

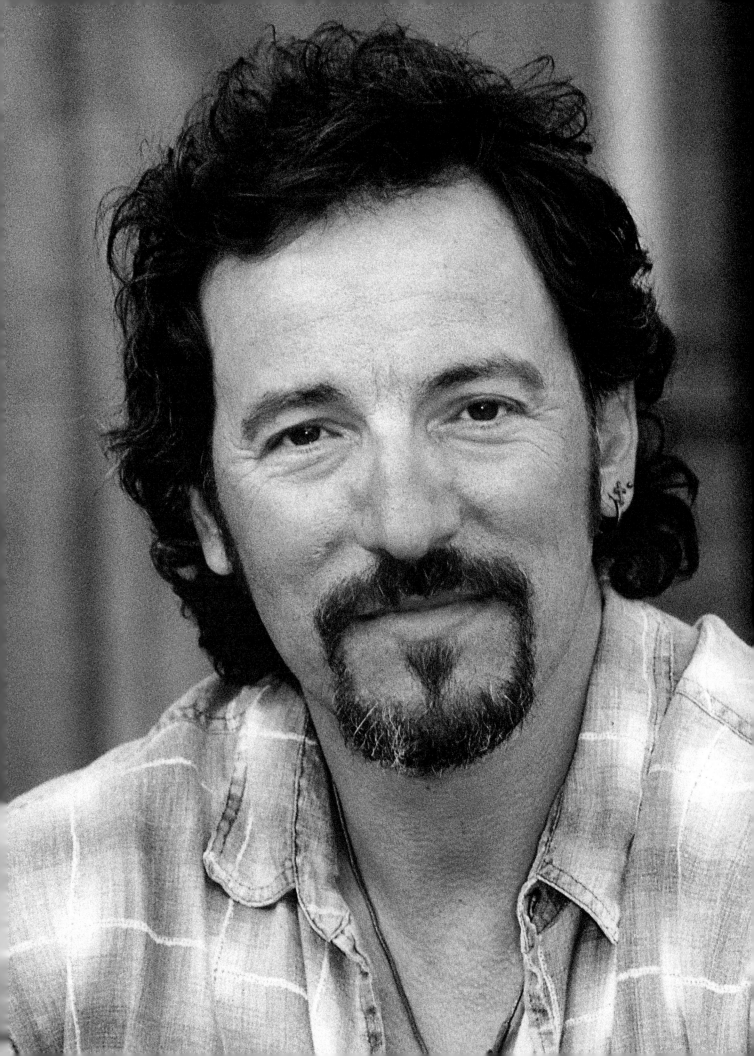

CHAPTER 11

•

1995
GREATEST
HITS
SESSIONS
AND MISCELLANEOUS
1990s RECORDINGS

•

STREETS OF PHILADELPHIA (*PHILADELPHIA* SOUNDTRACK)

Springsteen is among the most stubbornly self-directed and unmalleable musicians of his generation, but at the same time, he's written some of his most consequential songs more or less on demand. Both "Blinded by the Light" and "Dancing in the Dark" were in response to requests for viable singles, as was "Born to Run," in its own way. The ultimate example is "Streets of Philadelphia," a written-to-order track that shifted the course of his career.

In 1993, Jonathan Demme was editing *Philadelphia*, a movie he intended to shatter the homophobic stigma around HIV and AIDS—which meant he needed to reach middle America. He had Tom Hanks in the lead role, but he also wanted music that would "reassure people," Demme told Anthony DeCurtis in *Rolling Stone*. "I thought, 'Let's get these guys who, if anything, are identified with a testosterone, machismo kind of thing. What we need is the most up-to-the-minute, guitar-dominated, American-rock anthem about injustice to start this movie off.'" The first artist he reached out to was Neil Young, who six weeks later sent back a delicate piano ballad instead. "We were crying the first time we heard it," Demme recalled. "I went, 'Oh, my God, Neil Young trusts this movie more than I do. Isn't that pathetic?'"

Not ready to surrender, Demme called Springsteen, telling him he wanted his movie to reach "the malls." Springsteen did his best. "I kind of formulate my idea as I go about demoing something," he told *Rolling Stone*'s Mark Binelli in 2002. "I'll go in with an idea sometimes and it'll end up completely failing. So I'll stand there at a microphone with an acoustic guitar and a rhythm machine and I may try different beats, different keys, different chords. Jonathan Demme told me he wanted a rock song to start the movie, so I went over, had the lyrics, had some loud music, sang to it. It wasn't any good. So I fiddled through the day and then at the end I came up with that little drum beat, the little synthesizer, first couple of chords. I did it in about thirty or forty minutes and sent it off to him." The arrangement was a more effective version of what he had tried on "57 Channels" and his other bass-and-synth songs, with his most obvious stab yet at a hip-hop beat. The churchy orchestral synth sound was his go-to for demos, one that producers would try to pry away from him in the following decades.

"Again," said Demme, "it was not the guitar anthem I had appealed for. Springsteen, like Neil Young, trusted the idea of the movie much more than I was trusting it." But Demme loved the song anyway and wanted to use it. "We've got to make a record of this for them," Springsteen told producer Chuck Plotkin, and they went to work, running into a familiar problem along the way. "We put something together," Plotkin says. "It was a little more orderly and a little more conventional and we ironed out the things that sounded demo-ish. But none of it was as good as the demo!" All that survived from those efforts, according to Plotkin, were backing vocals from Tommy Sims, who played bass on Springsteen's 1992–93 tour. (In 1993, *Billboard* reported an attempt at adding live drums to the song, but Plotkin doubts that's the case: "We weren't that stupid.")

It's seldom noted that the version of the song heard in the movie's opening credits has obvious differences from the commercially released recording, including softer drums, Springsteen-only backing vocals, more prominent bass, and different synth parts. (It may well be the all-but-untouched original demo.) About twenty-nine minutes into the movie, an alternate version of the song's instrumental finale plays, with prominent, wordless falsetto vocals from jazz singer Little Jimmy Scott. Scott even shot a scene for the "Streets of Philadelphia" video on December 6, 1993, just fifteen days before the movie

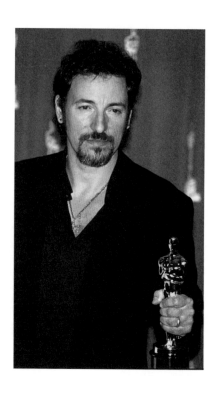

came out, suggesting that his part was mixed out at the last minute. (Reports suggest, intriguingly, that free-jazz saxophonist Ornette Coleman also recorded discarded overdubs). "Springsteen fell in behind the extras," *The Inquirer* wrote, describing a scene that never made the finished video, "walking away, leaving Scott alone, arms outstretched, his voice soaring achingly high as the Ben Franklin Bridge lit up the night sky behind him." Scott told *The Inquirer* that it was Demme's idea to add him to the song, and that he recorded his parts in October.

A young friend of Springsteen's, Kristen Ann Carr, daughter of co-manager Barbara Carr and biographer Dave Marsh, died in January 1993 of liposarcoma, a rare form of cancer. She was only twenty-one years old and had spent the previous summer working on Springsteen's tour; he spoke of seeing her smile right before he went onstage each night. The pain of her passing was fresh as Springsteen wrote the lyrics of "Streets of Philadelphia," with its images of "wasting away." "It was a devastating experience, being close to illness of that magnitude," Springsteen told Judy Weider in the *Advocate*. "Part of that experience ended up in the song."

There is a curious kinship between "Streets" and an unreleased song called "Waiting on the End of the World," which Springsteen recorded both with the E Street Band and for a shelved 1994 solo album. The bootlegged E Street version shows that it shares some lyrics, as well as what appears to be a general theme of illness and death. He recorded it after "Streets," but he probably wrote it first. It could be a first attempt at a song for Demme or just a similarly themed song he scavenged for "Philadelphia."

The last verse in "Streets," where the character pleads, "receive me, brother," is a variation on the theme of "If I Should Fall Behind." "That's all anybody's asking for," Springsteen told Weider. "Basically some acceptance and to not be left alone. "There was a certain spiritual stillness I wanted to try to capture. Then I just tried to send in a human voice, as human a voice as I possibly could. I wanted you to be in somebody's head hearing their thoughts—somebody who was on the cusp of death but still experiencing the feeling of being very alive."

In addition to winning an Oscar and becoming Springsteen's biggest hit since the eighties, the song nudged Springsteen away from the personal writing he had favored since *Tunnel of Love*. "There was a period after Born in the USA," he told me in 2016, "where I felt my topical songwriting was, perhaps, over. You know, I certainly curtailed it. That changed when I wrote 'Streets of Philadelphia.'"

BLOOD BROTHERS (*GREATEST HITS*)

One of Springsteen's most blatantly autobiographical songs is also one of his most well-documented, thanks to Ernie Fritz's excellent documentary *Blood Brothers*, which tracks multiple attempts to get it right with the E Street Band during their brief 1995 reunion to record bonus tracks for his *Greatest Hits* collection. Springsteen told the journalist Neil Strauss that the song was "sort of trying to understand the meaning of friendship as you grow older. I guess I wrote it the night before I went in the studio with the band, and I was trying to sort out what I was doing and what those relationships meant to me now and what they mean to you as you move through your life." As powerful as the song was, the fact that he couldn't muster a convincing new rock track for the band may have influenced Springsteen's ultimate conclusion that it was too soon for a full-fledged reunion.

The second verse is a brutal blast of middle-aged honesty, with lyrics about adult life making a mockery of youthful dreams, and, by the final verse, he's directly referencing his own ambivalence about the band ("I don't know why I made this call")—which made dragging them through so many different

> ## "IT WAS NOT THE GUITAR ANTHEM I HAD APPEALED FOR."
>
> JONATHAN DEMME

Previous spread: A July, 1995 portrait of Springsteen.

Opposite: Springsteen, with Oscar, at the Academy Awards, 1994. He won Best Song for "Streets of Philadelphia."

versions of the song slightly perverse. As captured in the documentary, they tried every conceivable arrangement, from Appalachian-tinged rock to the slow-building, moving ballad that made the record.

At least one member was happy just to be there: Nils Lofgren never had a chance to record with the full band in the studio before. "That, to me, is the band at its best, where you have the acoustic guitar with the rhythm section and the great keyboards from Roy and Danny," says Lofgren, who played an echoing part he calls "a primitive nod to U2 . . . just kind of a little percussion instrument with some notes in it."

In July 2000, at the final date of the E Street Band reunion tour, Springsteen debuted yet another version of "Blood Brothers," with a new final verse that replaced the hesitance with pure love, singing of "so many friends around me." He'd revive the country-rock version, too, in 2008, as a tribute to Danny Federici after his death.

SECRET GARDEN (GREATEST HITS)

Springsteen tried recording this ballad for a solo album with members of his 1992–93 touring band—who seem to have recorded separately, not as an ensemble—but he abandoned the album shortly before the *Greatest Hits* sessions. He's never stopped trying to finish it, although Max Weinberg remembers hearing what seemed to be a completed version at one point in the nineties. ("It was really, really good," he says.) Musically, the album was meant to pick up where "Streets of Philadelphia" left off, which you can hear in the synth-heavy, gentle groove of "Secret Garden." Plotkin recalls trying to sell Springsteen on his own estranged band around that time. "I remember saying to Bruce, these guys could do whatever you asked them to do. If we need them to cool it, they can cool it."

Lofgren tried out swells meant to evoke a French horn; Clarence Clemons blew a solo that fulfilled his on-camera promise of a "cosmic flow"; Roy Bittan played piano and Federici took the lead on synthesizer. With everyone live in the studio, they made a finished-sounding record in the time it took to perform it. "We're whipping the demo," Springsteen said, a rare admission. (They tried a string arrangement and took band votes on whether to use it; mixer Bob Clearmountain says that's the only time he remembers such a vote taking place.)

"It was just really complete as a live track," recalls Lofgren. "I was so blown away. I thought, 'This is a masterpiece song and recording.' And then as we took a break and went to listen, I thought, 'Well, now the record company has their follow-up to 'Streets of Philadelphia.'"

When the song initially didn't hit the top 40, Lofgren says, "I was like, 'What the hell's wrong with them? He just handed you the masterpiece follow-up.'"

It took the director Cameron Crowe's prominent use of "Secret Garden" in the 1996 movie *Jerry Maguire* to push the song onto the charts. Crowe, who never got a chance to discuss it all with Springsteen, recalls playing the song on set:

> I was obsessed with the song, and used it when we shot all the actual scenes in the movie where it is used. It's playing before and even during all the takes, them in the street, everything. It was in my head when I was writing it, and then it worked even better on the set and in the movie—rarely happens that way. I remember after we shot the medium close-up push-in on Renee Zellweger seeing her son hug Jerry Maguire, with the music playing, I was so knocked out with the song and, at the moment, I remember thinking for the first time, "this is what I want to do with the rest of my life." I was sitting there kind of quietly as they were breaking down the equipment, with "Secret Garden" still playing. Janusz Kaminski, the great cinematographer said, "Get over it! It's just a scene in a kitchen, man!" Bruce also gave us the separated tracks to the song, which we also used as score.

Crowe heard that as Jon Landau walked out of his first screening of the movie, the

manager said, "'I knew that song was a fucking hit!'"

MISSING (*THE ESSENTIAL BRUCE SPRINGSTEEN*)

Sean Penn was a longtime Springsteen friend who had already drawn on the plot of "Highway Patrolman" for a previous movie, *The Indian Runner*. Springsteen gave him "Missing" for the 1995 movie *The Crossing Guard*. The song, Springsteen wrote, was the product of post-"Streets of Philadelphia" "experimenting with drum looping at my home studio." Longtime Springsteen engineer Toby Scott confirmed in a 1996 interview that the song was originally part of the abandoned Springsteen solo project, and the sound of "Missing," with its wah-wah rhythm guitars, aggressive lead playing, and interwoven loops, suggests that the album would have been a genuine surprise.

LIFT ME UP (*THE ESSENTIAL BRUCE SPRINGSTEEN*)

"Director John Sayles called and said he was looking for a song to end his film *Limbo*," Springsteen wrote in liner notes. (Sayles had directed videos for "Born in the U.S.A.," "Glory Days," and "I'm on Fire.") "The picture ends with a small plane approaching an island his main characters were stranded on. I tried to pick up the hum of the plane's engine and write something ethereal using the falsetto voice I'd developed in the nineties." Kelly Clarkson, apparently enough of a Springsteen fan to make it through the bonus disk of the *Essential* collection, told me in 2009 that she wanted to cover this song, calling it "beautiful."

DEAD MAN WALKIN' (*THE ESSENTIAL BRUCE SPRINGSTEEN*)

Written for a Tim Robbins movie about a death-row convict, starring Sean Penn. "I tuned the E string of my guitar down to a D and cut it in as low a key as possible," Springsteen wrote, "to get as much deepness and darkness I could out of the music." He sings that the world is "between our dreams and actions," which may well be a paraphrase of a Cormac McCarthy line in his 1992 novel *All the Pretty Horses*: "Between the wish and the thing the world lies waiting."

BACK IN YOUR ARMS *TRACKS*

A killer soul ballad, the kind of thing he'd usually give to Southside Johnny or Gary U.S. Bonds, captured in the *Greatest Hits* sessions. Federici's resounding organ and Clemons's melancholy solo are standouts, although neither the recording nor the arrangement feel finished. The lyrics seem to be a typical come-back-baby scenario, but Plotkin has always been convinced there's something else going on. "It sounds and feels to me," says Plotkin, "like this was written to his audience." He may well be right. "I've felt the absence of that dialogue"—between himself and his fans—"in the past in my life, and it was a terrible emptiness," Springsteen told *Rolling Stone*'s Joe Levy in 2007.

WITHOUT YOU (*OUTTAKE, BLOOD BROTHERS EP*)

Springsteen and the E Street Band recorded this charming, low-key, doo-wop-tinged soul-pop throwback, complete with "Sherry Darling"-style party noises, in the *Greatest Hits* sessions. "We had a big sing-a-long in the room," Nils Lofgren recalls. The song would feel entirely out of place in Springsteen's nineties songwriting (assuming he didn't actually write it years earlier), if not for the equally retro "Back in Your Arms."

> **"I WAS OBSESSED WITH 'SECRET GARDEN'."**
>
> CAMERON CROWE

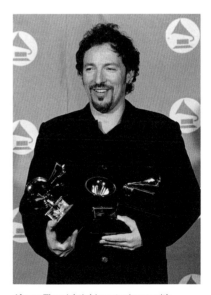

Above: The night's biggest winner with four awards, including Song of the Year. Springsteen at the 37th Annual Grammy Awards, March 1, 1995.

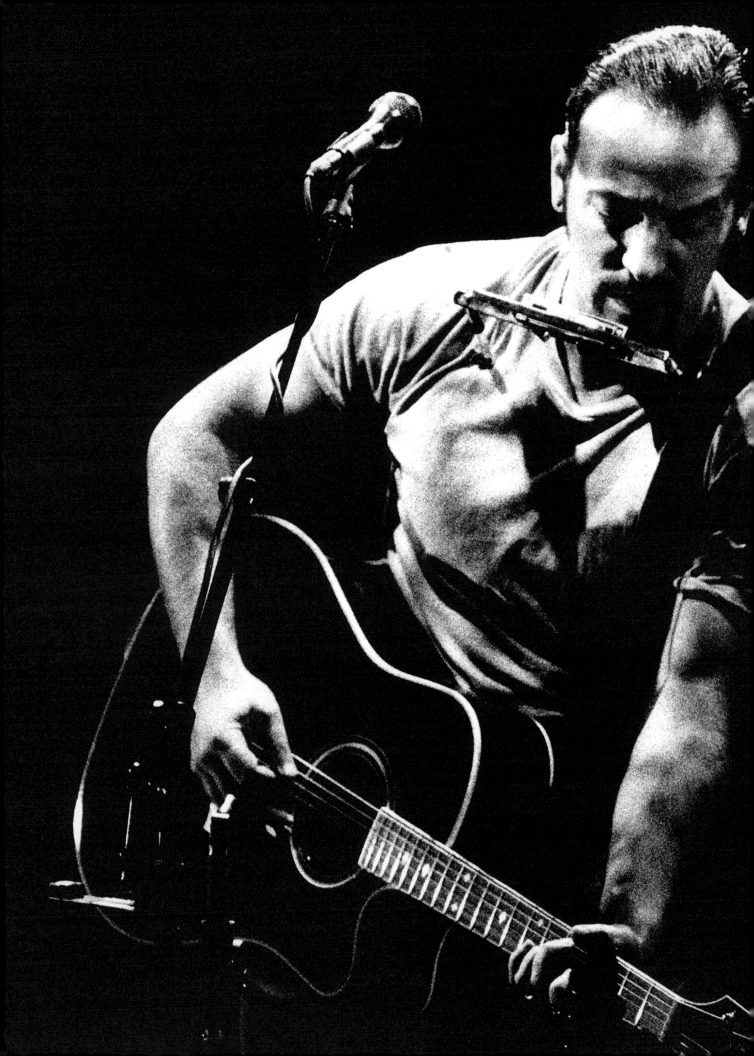

•

1995
THE GHOST
OF TOM JOAD

•

THE GHOST OF TOM JOAD

World-conquering success in the eighties left Springsteen too self-conscious, for a while, to write any more songs about the plight of the working man. He also worried that he had simply exhausted that vein—even immediately after "Streets of Philadelphia," he was still writing relationship-driven songs: "Secret Garden," "Missing." He told me in 2016, "You're always in a box and you're an escape artist, if you do what I do, or if you're a creative person, period. You build your box and then you escape from it. You build another one and you escape from it. That's ongoing. And you may at some point escape enough boxes where you find yourself back around to the first one again and you go, 'Oh, I didn't think I had anymore to say about these things.'"

Springsteen, a longtime fan of John Ford's movie adaptation of John Steinbeck's *The Grapes of Wrath*, began writing "The Ghost of Tom Joad" for the E Street Band to play during the *Greatest Hits* sessions, but he "couldn't finish it" in time, he told me. The song, as he wrote in his autobiography, *Born to Run*, was the result of an "inner debate" over two questions: "Where does a rich man belong?" and "What is the work for us to do in our short time here?"

He may have put it even better in a 1996 backstage interview in Canada. "'The Ghost of Tom Joad' was a conversation I was having with myself," he said, "in my own head. I wasn't saying, 'Where is [Tom Joad] in the world?' I was saying, 'Where is he in me?'"

"What I always loved about Steinbeck's work was that it wasn't afraid of being heroic," Springsteen added at a 1996 benefit for the Steinbeck Research Center. "And that he risked. He hung his ass out there . . . for you, for me." In part, "The Ghost of Tom Joad" was Springsteen trying to once again locate that heroism within himself.

Springsteen assembled a small band: Garry Tallent on bass, Danny Federici on keyboards, Marty Rifkin (who had just played on Tom Petty's *Wildflowers*) on steel guitar, Soozie Tyrell on violin, and Gary Mallaber (who played on *Lucky Town*) on drums. He had asked Max Weinberg to play on the album, but Weinberg couldn't get away from his Conan O'Brien duties. The band played live in a library room, facing each other, under a high, two-story ceiling with skylights inside Springsteen's guest house—but Mallaber was isolated in a nearby bedroom with its own resonant high ceiling, watching Springsteen via a live feed from a Sony video camera. "It was a great-sounding room," says Chuck Plotkin, and the result was the only Springsteen album that audiophiles adore, thanks to its real sense of acoustic space. The sessions were as cozy as recording with a superstar could get, with Springsteen making peanut butter-and-jelly sandwiches for the musicians.

During the day, they would mostly play up-tempo songs that Springsteen has described as "a Western swing thing," among them a rockabilly track called "Tiger Rose." (By 2018, associates suggested he had finally finished an album from those sessions, although there was no sign of any plans to actually release it when this book went to press.) At sunset, the mood would shift. "I don't even think they had lights, as I recall, in that room," says Rifkin. "Every night that we would play, there were all these wrought-iron candle holders of different heights, some low and some very tall. Bruce would just walk around the room and light all the candles."

"The Ghost of Tom Joad' was a nighttime song, a whispered story. It is, overall, one of the most extraordinary recordings in Springsteen's catalog. "I was right across from Bruce," says Rifkin. "I remember how he would just

> **" WHAT I ALWAYS LOVED ABOUT STEINBECK'S WORK WAS THAT IT WASN'T AFRAID OF BEING HEROIC. "**
>
> BRUCE SPRINGSTEEN

Previous spread: Rotterdam receives the Ghost of Tom Joad Tour, February 25, 1996.

Above: *The Grapes of Wrath* by John Steinbeck, published in 1939.

Opposite: The Ghost of Tom Joad Tour hits the road, Palais Theatre, Melbourne, Australia, February 15 1997.

191

.

lean in the mic and sing so softly, which puts you in a place as a player to have to work with that." The band entered the second verse more delicately than any ensemble on any prior Springsteen recording. Mallaber played with brushes, unfazed by Springsteen's habit of dropping beats in the song—there are multiple bars of 3/4 time thrown in without warning. Rifkin responded to Springsteen's vocals with parts that were more like train-whistle moans than licks. "I figured out a style to play with him," says Rifkin, "It had to be evocative, but not busy and not country." For years afterward, he had producers asking him to "do the *Joad* stuff."

Mallaber, whose brushwork on the song is remarkable in its concentrated subtlety, compared the magic of the "Joad" session to his experiences playing with Van Morrison on "Crazy Love" and "Into the Mystic." The drummer explains, "Van starts the song and part of you wants to go, 'Oh shit' and stop playing and listen—and you realize I can't stop, I'm in it! And the same thing happened with Bruce. Here we go again. I did get goose bumps. When something sounds right, there's some alignment that happens. And if you recognize that alignment, you surrender, you let the moment of that recording take over."

The album uses engineer Toby Scott's rough mixes, done on the day of recording. "It was never fucked with after that," Springsteen told me. "It was very plain sounding. But that's why the stories ring true on it. I didn't want to dress it all, similar to *Nebraska*, you know. These were records that were made at the very moment the music was made." After he finished the album, Springsteen had about a dozen fixes he wanted to make to the recordings, including lyric changes. In the process, the songs were remixed into a "more conventional sound," Plotkin recalls. For a while, Springsteen actually favored the remixes, until he came around to the "magic in the bottle" of the original versions, according to Plotkin.

STRAIGHT TIME

"This is a song about how it's hard to be a saint in the city, I guess," Springsteen said onstage. "A fellow gets out of prison, trying to find his way back into his family and back into the world, trying to learn how to be new . . . I think everybody reaches a place where their old answers and their old ways of doing things run out on them, but it's hard to let those things go. Sometimes those are the things that just feel like you. They're how you know yourself even if they're the things that are killing you, so everybody's done a little straight time." It's another gentle ensemble recording, with Tyrell's violin stepping forward.

Springsteen never discussed it, but he must have gotten the theme and title for the song from the 1978 movie *Straight Time*, also about an ex-convict, played by Dustin Hoffman, who was in the audience for the song's Los Angeles debut. It's one thing to trace inspiration, but the sudden flowering of detail and specificity in Springsteen's songwriting—the narrator sips a beer as he saws off a shotgun in his basement—is impossible to explain except as another glorious mystery of creation. "Those are my little films," Springsteen told me. "I got very close to the narrative of writing during that record. It's a style of writing I get a great deal of enjoyment out of."

HIGHWAY 29

Springsteen introduced this noir tale as a case of "self-knowledge coming a little too late, as it usually does, after you've made a big mistake." It is also the acutely observed, highly compressed story of a shoe salesman breaking bad: He meets a femme fatale, robs a bank, gets in a nasty car crash. "I had a gun, you know the rest," Springsteen sings, with resigned weariness.

Above: Danny Federici, Bruce Springsteen and Patti Scialfa onstage for the grand opening of the Rock and Roll Hall of Fame Museum, Cleveland, Ohio, September 25, 1995.

Opposite: Bob Dylan and Bruce Springsteen perform "Forever Young" onstage at the opening of the Rock and Roll Hall of Fame, Cleveland, Ohio, September 25, 1995.

YOUNGSTOWN

Dale Maharidge wrote, "The history of steel in the Mahoning Valley is the history of America," in *Journey to Nowhere: The Saga of the New Underclass*, his 1985 book with photographer Michael Williamson. "The dead steel mills stand as pathetic mausoleums to the decline of American industrial might that was once the envy of the world." Springsteen bought the book when it first came out, and, in a moment fraught with symbolism, tucked it away on a shelf.

One sleepless night, late in the *Joad* sessions, Springsteen picked up the book and read it in a single sitting. He was subsequently inspired to write "Youngstown" and "The New Timer," drawing images and details from the book's terrifying chronicle of post-industrial America. He plugged back into the wellspring of his inspiration, picking up where "My Hometown," "Factory" and the populist fury of his mid-eighties song "Seeds" left off.

"What Hitler couldn't do, they did it for him," a former millworker, Joe Marshall, told Maharidge—a line that ended up almost verbatim in "Youngstown," as did a litany of decline in the book that runs "from the Monongahela Valley of Pennsylvania . . . to the Mesabi Iron range of Minnesota and the coalfields of Appalachia." There is also a passage where steelworkers are "staring into hell. And hell is beautiful." But Springsteen did additional research, beginning his song with the story of James and Dan Heaton, who built Hopewell Furnace and introduced iron making to the town in 1802 or 1803 (Springsteen uses the latter date).

Maharidge also interviewed Joe Marshall Jr., who, when the *New York Times* caught up with him in 2016, was a retired policeman and "an ardent Trump supporter." Springsteen told me he wasn't surprised. "Not really," he said. "Not if you see the history of Youngstown and what happened. . . I believe there's a price being paid for not addressing the real cost of the deindustrialization and globalization that has occurred in the United States for the past thirty-five, forty years and how it's deeply affected people's lives and deeply hurt people to where they want someone who says they have a solution."

The song was recorded on a Friday night—June 16, 1995, per Rifkin's notes. Tyrell recalls Springsteen asking for a signature riff; she summoned a few ominously repeating notes, a motif that survived even to the E Street Band's eventual arena-rock rendition, with its monumental Nils Lofgren guitar solo.

SINALOA COWBOYS

As a Los Angeles transplant, Springsteen read about unfolding dramas along the Mexican border in his newspaper each morning, while getting a feel for the landscape of his new home in long, dusty motorcycle trips. "That whole thing probably began with this Mexican guy I bumped into in this Four Corners desert town at the end of the summer," he told *Mother Jones'* David Corn.

> We were all sitting outside at a table, drinking beers. It came up that his brother had been a member of a Mexican motorcycle gang in the San Fernando Valley, and he told us the story of his brother's death in a motorcycle accident.
>
> Something about that guy stayed with me for a year. Then I read an article on the drug trade in the Central Valley. All that led to the song "Sinaloa Cowboys." The border story is something that I hadn't heard much of in the music that's out there. It's a big story. It's the story of what this country is going to be: a big, multicultural place.

> ❝I WANT TO MAKE MUSIC THAT FEELS LIKE THIS HEAT.❞
>
> **BRUCE SPRINGSTEEN**

Left: *Journey to Nowhere: The Saga of the New Underclass* by Dale Maharidge and Michael Williamson, with an introduction by Springsteen.

Opposite: Portrait of Springsteen, circa 1995.

The article Springsteen found, by *Los Angeles Times* reporters Mark Arax and Tom Gorman, explained how Mexican nationals were increasingly drawn to the manufacture of methamphetamine. "Unwilling to let outsiders horn in, these 'Sinaloa Cowboys' with their beaver hats, boots and ostrich-skin belts are armed and dangerous," they wrote. The brothers in Springsteen's song aren't dangerous to anyone but themselves; there is a "Johnny 99"-like fatalism to their story, as poverty and desperation drive them toward a deadly choice.

THE LINE

For several songs on *Joad*, Springsteen drew on the work of Sebastian Rotella, a full-time border reporter for *Los Angeles Times*. Rotella says he got a call in 1995 from Terry Magovern, Springsteen's longtime assistant, which he failed to return at the time—Magovern was playing it so low-key that he didn't identify his employer. "The Line," which tells the story of an Immigration and Naturalization Service (INS) patrolman finding himself in love with a Mexican detainee, draws a key lyric from one of Rotella's 1994 stories. A vendor named Ramon told the reporter that an INS crackdown wasn't going to work. "The people are many," Ramon said. "Hunger is a powerful thing." The song also seems to have been inspired by the 1982 Jack Nicholson movie *The Border*, and it may borrow some of the melody of Bob Dylan's "Love Minus Zero/No Limit".

The "line" is the Mexican border, of course, but it is also the moral crossroads that the narrator faces, and both lines blur beyond recognition. Is he doing the right thing or the wrong thing when he helps Louisa slip across—without knowing about the drugs strapped to her brother's chest? The moment when his colleague Bobby Ramirez catches him and lets him go unpunished is reminiscent of the end of "Highway Patrolman," another chronicle of moral ambiguity. "It's a very confusing job," Springsteen said, introducing the song one night. "It's very difficult to know where the line really is."

BALBOA PARK

Based specifically on "Children of the Border," an article Rotella wrote in 1993, "Balboa Park" is about itinerant, drug-sniffing street children who work as prostitutes in San Diego. "It was one of the most memorable things of my entire career to have him do what he did," says Rotella. "He took this single story and put it to song in this incredibly poetic way. And I spent a lot of time with that article, because it was such a chilling situation with those kids."

For Springsteen, then a new father, the idea of defiled innocence stuck with him. "It could be anybody's kids, you know, yours or mine," he said in concert. "It's about what happens, I guess, when that grace is violated."

With no chorus and a thin melody, "Balboa Park" veers close to spoken word, as if Springsteen was so intent on his narrative that more than a hint of music would break the track's dark spell. This track and the other sparse moments on *Joad* are "almost like recitations," he told me in 2016.

DRY LIGHTNING

Springsteen told a Canadian reporter that on one of his motorcycle trips, "I thought, I want to make music that feels like this, like this heat, like this night, that has this kind of dryness." The sublimely crafted "Dry Lightning," a searing, bitter love song set out West, with its unforgettable image of a "piss-yellow" sunrise, embodies that sound. When Willie Nelson covered it in 2013, the only question was why it had taken so long.

Opposite: Springsteen onstage at the 39th Grammy Awards performing "The Ghost of Tom Joad," February 26, 1997. He won Best Contemporary Folk Album.

Below: Journalist and author Sebastian Rotella wrote several articles that influenced *The Ghost of Tom Joad*.

THE NEW TIMER

The narrator in this song – a lament drawn from tales of modern-day hobos in Maharidge's *Journey to Nowhere* – left his family to ride the rails. The one friend he made on the way, an old man named Frank, is murdered by "Nebraska"-style thrill seekers. At the end of the song, all the narrator wants is the "name of who I ought to kill"—but like the evicted farmer in *The Grapes of Wrath*, whose aim is to "kill the man that's starving me," he'll never get his answer.

ACROSS THE BORDER

The album's emotional narrative bottoms out with "The New Timer," then arcs toward hope with this song, an immigrant's fantasy. It is, in part, a product of Springsteen's longtime fondness for Ry Cooder's "Across the Borderline," with its tale of yearning for "the broken promised land." "I got to the end of the record, and there had been a lot of mayhem," Springsteen told Corn. "I wanted to leave the door open, so I wrote 'Across the Border.' That song is a beautiful dream. It's the kind of dream you would have before you fall asleep, where you live in a world where beauty is still possible. And in that possibility of beauty there is hope."

At the song's climax, Springsteen lets Federici loose on the accordion ("He was so proud of him," Rifkin recalls), joined by a multitracked onslaught of Tyrell's violin. "They must have laid down an extra eight to ten tracks of me playing over the whole track," she says. "I was like, 'Oh, I don't like that one.' But "Bruce went, 'No, no, no it's fine. Do another. Let's keep doing them.' He ended up using all of them, all together. When he was playing it back after I had finished that day, I was really taken aback, like, 'Oh my god. You're gonna use all those? There's some crummy parts in there.' He's like, 'No, no, I love that.'"

GALVESTON BAY

Beginning in the late seventies, shrimpers along Texas' Gulf Coast faced unexpected competition from Vietnamese immigrants, leading to growing racial tension. In 1979, a fisherman named Billy Joe Aplin was shot dead in Seadrift, Texas, after fighting with Vietnamese competitors. Locals set Vietnamese boats on fire, and the Ku Klux Klan rode into town. The furor inspired Louis Malle's 1985 movie *Alamo Bay*, as well as Springsteen's "Galveston Bay."

"In election years, there's always candidates and people out there looking for scapegoats," Springsteen said onstage, presciently, in 1996. "Trying to blame what's wrong with the country on somebody, anybody they get their hands on. It's usually somebody whose skin is darker or he speaks a little differently than they do. And there are plenty of code words for it, too . . . you hear all about 'America for Americans' and all that stuff."

Springsteen wanted to follow "Across the Border" with a more concrete story of hope, "a little bit of light," he said onstage. "Something that's not a dream, something that's not a fantasy, something that's hard, real, true-life." Like "Spare Parts," but in a different setting, "Galveston Bay" (another near-"recitation") recounts a redemptive last-minute decision. A Vietnam veteran nearly murders a Vietnamese fisherman who had shot his friends in self-defense, but in the end, the vet pulls back and lets the fisherman pass. The song's story mirrors its own creation. Its first draft had a "more violent ending" that began to "feel false" to Springsteen.

BROTHERS UNDER THE BRIDGES (OUTTAKE, *TRACKS*)

"Brothers" is another tale of a Vietnam veteran, this one living with his homeless brethren in the mountains outside of Los Angeles. He ends up telling his story to his grown daughter, who went looking for him. The narrator was doing all right when he first got back from the war, but then "something slips," Springsteen sings at the song's conclusion, as the band's backing unravels into nothingness. It's one more character who crossed to the wrong of the side of the line, and he's probably not coming back.

MY BEST WAS NEVER GOOD ENOUGH

The narrator of Jim Thompson's 1952 noir novel *The Killer Inside Me* is a psychopathic sheriff who, when not committing multiple murders, enjoys wielding cliches ("every cloud has a sliver lining") as a conversational weapon: "If there's anything worse than a bore, it's a corny bore," as the character puts it. In his book *Songs*, Springsteen credits the novel with inspiring "My Best Was Never Good Enough," which is little more than a sinister string of cliches, some of them straight from Thompson's book, linked by a chorus. Some listeners, including Dave Marsh, have interpreted the song as a jab at fans who lost faith in Springsteen's early nineties work; it also seems like a condemnation on the pervasive banality of American discourse, complete with sardonic delivery of two lines from *Forrest Gump*, released the year before the *Joad* sessions. There also may be some self-mockery here, rebuffing the idea of Springsteen himself as a source of lyrical uplift and inspiration, at the end of an album that so often thwarts those expectations.

> **"ACROSS THE BORDER' IS A BEAUTIFUL DREAM, WHERE YOU LIVE IN A WORLD WHERE BEAUTY IS STILL POSSIBLE."**
>
> BRUCE SPRINGSTEEN

Opposite: Springsteen at the Rainforest Benefit concert, supporting a charity founded by Sting and Trudie Styler, Carnegie Hall, New York, 1995.

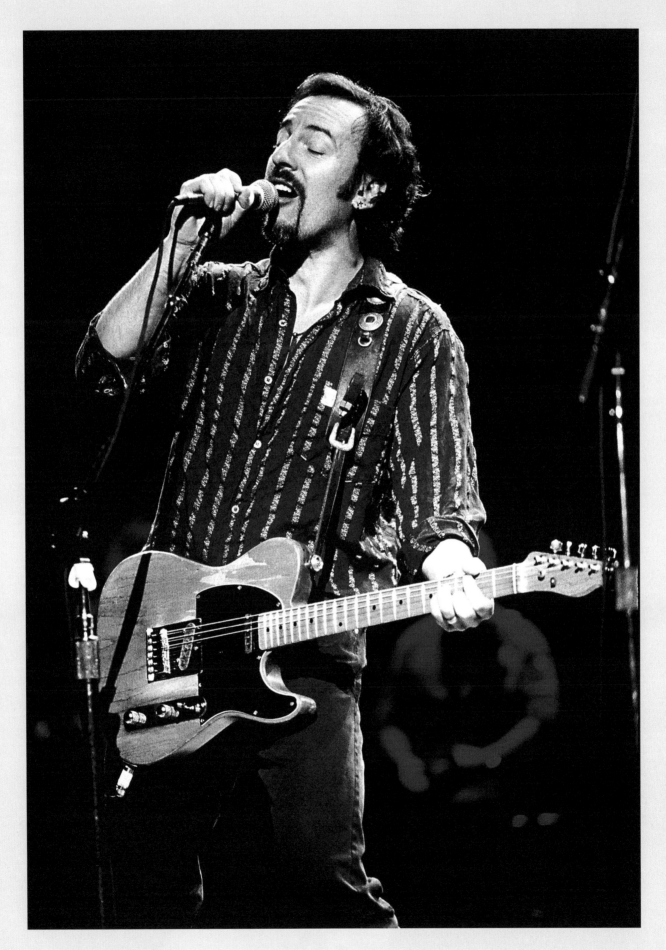

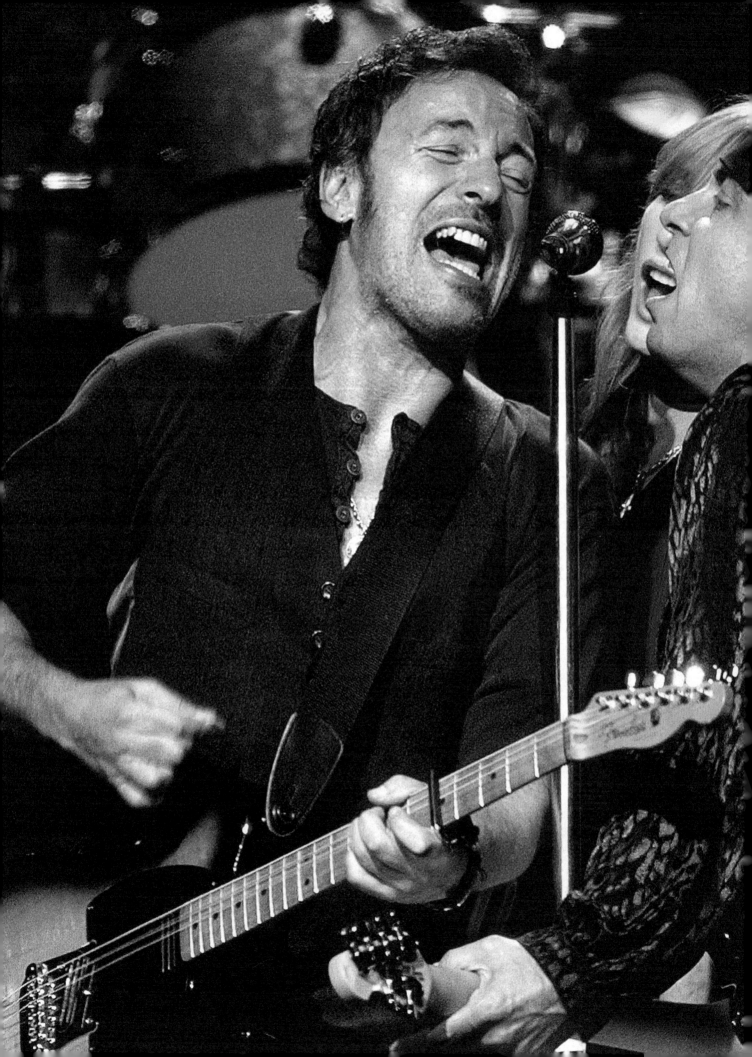

CHAPTER 13

•

2002
THE
RISING

LONESOME DAY

With two years' worth of E Street Band reunion concerts still ringing in his ears, Springsteen was ready to make a big, noisy album again. It had been a while. If he was once—as he'd shout onstage—a prisoner of rock 'n' roll, he spent the nineties largely on parole. He hadn't managed to record a new album with electric guitars on it since *Lucky Town*, and he hadn't made a full album with the entire E Street Band since *Born In the U.S.A.* Along the way, Springsteen grew worried that he had lost track of his "rock voice"—and his first stab at recording sessions with the band and his existing production crew, in the spring of 2001, failed to assuage his concerns. "We struggled to record a few songs," Springsteen told me in 2009. "We couldn't come up with something that sounded fresh enough." (Chuck Plotkin recalls those sessions as more like full-band demos: "It wasn't an official recording session," he says. "We were just putting stuff down.")

So, for the first time in his career, Springsteen reached out to an outside producer. He admired the "urgency and power" of Brendan O'Brien's work with Pearl Jam, among others, and the feeling was mutual: "People always asked, 'If you could work with anybody, who would it be?,'" says O'Brien, who had come recommended by Don Ienner, then the head of Sony Music. "I never had anybody except for Bruce." They had one friendly meeting in New Jersey and agreed to a second. Before they could get together again, terrorists struck New York and Washington, D.C.—147 people from Springsteen's native Monmouth County alone died in the attacks. Now, just making a great E Street Band album wasn't going to be nearly enough.

In their first encounter after 9/11, Springsteen played O'Brien "Into the Fire" and "You're Missing," and the producer gave him a pep talk. "Here's how it works," Springsteen recalled O'Brien saying. "We go down to Georgia, and we do a couple swings with the band and everybody gets excited, and then you come back to New Jersey and start writing some more really good songs. That's how you make a record!" Springsteen was skeptical; it had rarely been that simple for him. (O'Brien had notably omitted "months of tortured debate and introspection" from his plan.) But after a recording session in O'Brien's favored studio, Southern Tracks in Atlanta, Georgia, the prediction came to pass.

"We made the whole record in seven-and-a-half weeks," Springsteen told

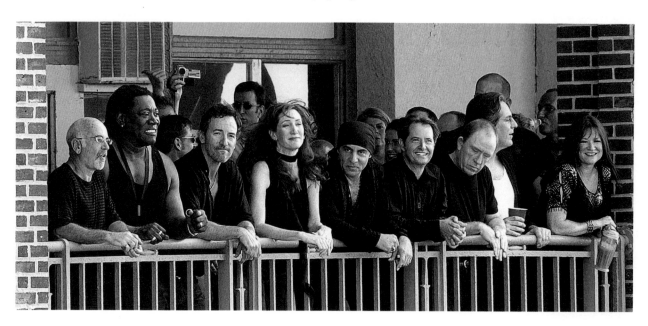

Mark Binelli, "because we weren't talking about it!" Among the first "really good" new songs Springsteen came up with back home in Colts Neck was "Lonesome Day," one of his most dynamic and melodic rock creations since the early eighties. But styles had changed, and O'Brien recalls, in general, trying to nudge Springsteen away from the synthesizers he had been using since *Born in the U.S.A.* "I was not as stoked about the synth stuff," says O'Brien. "He had gotten a little dependent upon that stuff. We needed to take it out of that era and bring it into something a little more timeless."

It was Springsteen's idea to emphasize real strings instead, starting with Soozie Tyrell's violin, which carried the intro riff on "Lonesome Day" and elsewhere. (John Mellencamp probably deserves some credit for his similar use of the violin, starting with 1985's *The Lonesome Jubilee*.) Tyrell was the only outside musician Springsteen called upon for help on his home demos, and she would soon become a full-fledged member of the E Street Band. "I think Bruce had ideas that he probably wrote on synths but didn't want to use synths for," says Tyrell. "The demos were really so similar to what became the album." (If it was up to O'Brien, they might have skipped the demos and worked up arrangements from scratch with the full band, but Springsteen already had his fill of that approach by the early eighties.)

"Lonesome Day" is the first glimpse of another major shift for the new century. For the first time since his earliest songs, Springsteen was allowing himself to write oblique, nonlinear lyrics. The first verse, as Springsteen said, could be a "break-up song," with lines about an unknowable lover that could have come from "Secret Garden." From there, the picture widens and we're in a post-9/11 world, with a blackened sun, a burning house, and revenge in the air—even as the narrator of the second verse and the one in the third disagree over the efficacy of vengeance. All the while, the music pushes against the bleakness, cresting in a repeating section that's all pop assurance: a call and response of "It's all right, it's all right/yeah," with the band charging hard enough to make you believe it. (It's such a primal move that he could have borrowed it from anywhere or nowhere, but Springsteen is a fan of The Del Fuegos, who had a similar back-and-forth part on their 1985 song "It's Alright.") "I remember the vocals at the end of the song took on a life of their own," says O'Brien, who did an edit to extend that final string of "all right/ yeahs."

For the album's basic tracks, Springsteen played with the core of the E Street Band—Max Weinberg, Garry Tallent, and Roy Bittan—and everyone else overdubbed later. They would lay down no more than eight takes of a song, usually with Springsteen on acoustic guitar, and O'Brien would edit together the best sections. ("He'd piece together a drum thing he liked here," said Springsteen, "the way the band moved there, a certain crescendo.") On "Lonesome Day" and the album's other up-tempo tracks, Weinberg played with a new, in-the-pocket swagger that was, in part, the product of performing five nights a week, in every conceivable style, as leader of the Max Weinberg 7 on *Late Night with Conan O'Brien*.

His skills had improved to the point where he could chart out an entire song in notation, fills included, as Springsteen played demos. He was also thrilled to be there. "I never thought we'd be recording as a band again," says Weinberg. "There were these phenomenal songs—and Brendan was great because he liked the splashy drums." Engineer Nick DiDia recalls Weinberg adding a "really smart" twist that he'd never seen before. The drummer would run his own click track that he'd sometimes switch off, allowing him to

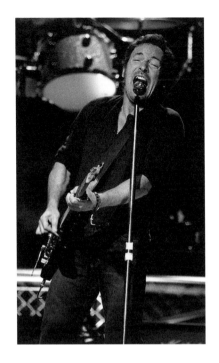

"I NEVER THOUGHT WE'D RECORD AS A BAND AGAIN."

MAX WEINBERG

Previous spread and above: The Rising Tour, Los Angeles Forum, August 24, 2002.

Opposite: Springsteen and the E Street Band kickstart The Rising Tour, Asbury Park, New Jersey, July 30, 2002.

push and pull the tempo in a classic rock style as needed.

On "Lonesome Day," the E Street Band's new sound is evident as soon as Tyrell's opening riff drops off. Chunky layers of rhythm guitars—previously absent from Springsteen's albums, despite Little Steven's best efforts—were suddenly driving everything. (Roy Bittan's piano can be hard to hear, but, O'Brien says, "his rhythm really helped lay the bed for everything else and worked right with the guitars. Roy was very integral to doing all that stuff.") O'Brien had a huge collection of guitars and amps, and he spent more time than Springsteen was used to in finding the right sounds. "I remember him being really excited about that," says O'Brien, "and excited about playing. He's an excellent guitar player." Danny Federici's organ and Clarence Clemons's sax get big moments along the way, too. "Some of the stuff got a bit dense," says O'Brien, "because there's a lot of people and they all want to play on it. We need them all involved. That was sort of the theory of the record in general—there was going to be a lot of action going on."

INTO THE FIRE

On the evening of September 10, 2001, forty-seven-year-old Staten Island firefighter Joe Farrelly left a love note on his wife Stacey's pillow before heading out to a twenty-four-hour shift in Manhattan. They had been together since she was eighteen and he was twenty-one, and the note wasn't an unusual gesture for him. Farrelly was also the kind of guy who took in infant foster children, waking in the middle of the night to comfort them—he was a salt-of-the-earth character straight out of a Springsteen song, and a fan of the music as well. After that night, Stacey Farrelly never saw her husband again. The next morning, amid the unfolding horror at the World Trade Center, he ran up the stairs, into the fire.

Reading 9/11 obituaries, Springsteen kept seeing his own name. As a result of geography, demographics and the decades he had spent burrowing into American hearts, a remarkable number of the victims had been hardcore Bruce fans. He began making phone calls, including one to Stacey Farrelly. "After I got off the phone with him, the world just felt a little smaller," she told *Time* magazine. "I got through Joe's memorial and a good month and a half on that phone call." The artist has never talked much about the calls, which weren't meant to be publicized, and Springsteen almost certainly started writing "Into the Fire" before that conversation. Still, once you know the Farellys' story, it's hard not to hear all that faith, hope, and love in the chorus as belonging to Joe, at least in part, and to hear the bereaved narrator as someone much like Stacey Farrelly.

Springsteen had long been moved to write about "nobility in everyday life," but he was awed by the "size of the sacrifice" made by the first responders. "Whatever they're paying you to be a fireman or a policeman, they're not paying you [for] that," he told Binelli. "And that goes to some deep central point about how people experience their duty, their very selves, their place in the world, their connection to the people alongside them and to complete strangers. It was something that shocked people."

"Into the Fire" was the first song Springsteen wrote after 9/11, and the first to be recorded with the E Street Band at Southern Tracks for *The Rising*. It was a moment he would return to again and again in interviews. Hearing the basic tracks played back convinced him that O'Brien had found a way to move the E Street Band's sound into a new century. ("That was not by accident," says O'Brien. With the stakes high, he and his team had scrambled to make sure

> ## "IF I COULD WORK WITH ANYONE? IT WOULD BE BRUCE."
>
> **BRENDAN O'BRIEN**

Opposite: Fired up for The Rising Tour, 2002.

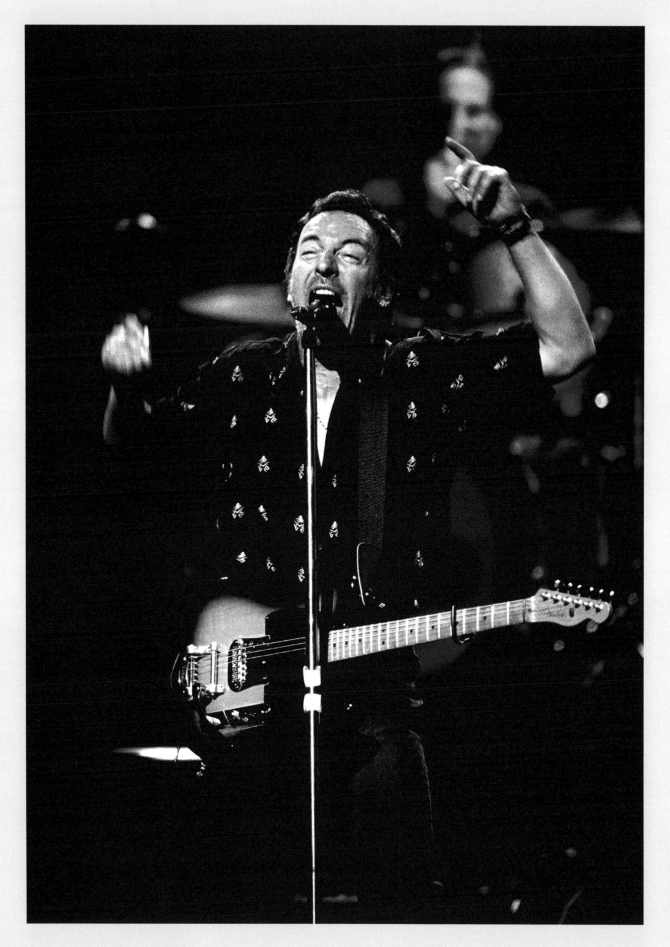

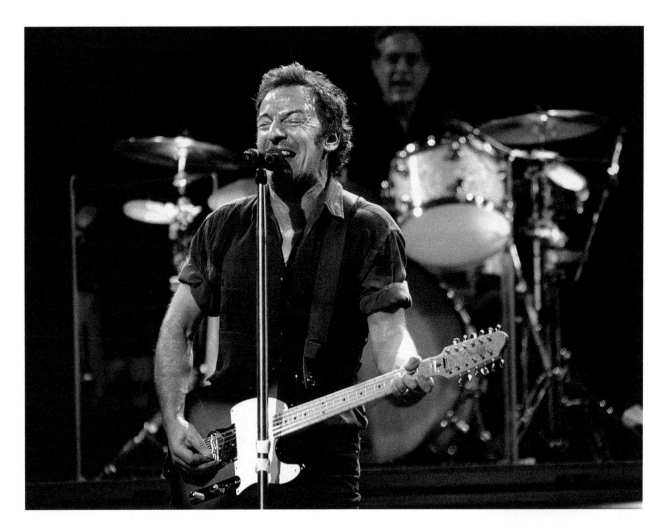

the playbacks would sound as close to a finished record as possible.)

O'Brien had Springsteen and the band record the song's acoustic intro separately from the rest of song, and he then edited the sections together—making the full band's dramatic entrance something of a clever illusion (the producer wanted the song to skip a couple beats between sections, a transition Springsteen initially found uncomfortable). As on other tracks, Tyrell played multiple violin parts that O'Brien blended. "It was doubling and doubling," she says, "harmonizing parts to create a larger sound from just little old me." Meanwhile, Nils Lofgren overdubbed the prominent bottleneck slide on a dobro resonator guitar that doubles Springsteen's voice at the beginning, re-creating a part from the demo at Springsteen's request (I'm not a bottleneck player," the indefatigable Lofgren said at the time, "but it looks like I'm gonna have to learn how to be.")

In Springsteen's original demo, the "may your faith . . ." section was less emphasized, not showing up until later in the song. "That's your hook," O'Brien told him, encouraging him to make it the full-fledged chorus. "At first I said, 'I'm not sure,'" Springsteen told Binelli, 'but then when we played it for real, it made all the sense in the world and brought the whole thing home." For Springsteen, it's all about the contrast between that part and the rest. "The gospel and the blues," he said. "That's where the fight starts. And that's all we do, as a band. That's all that we're built for. That's the service we provide."

> ## "THE GOSPEL AND THE BLUES. THAT'S WHERE THE FIGHT STARTS. AND THAT'S ALL WE DO AS A BAND."
>
> **BRUCE SPRINGSTEEN**

WAITIN' ON A SUNNY DAY

Some songs, Springsteen has said, are written so he can hear his audience singing them back to him—except, he added, those are often the ones he tries to throw out, at least until Jon Landau stops him. But he's glad his pop songs exist. "They free my mind from the interminable bullshit I put myself through on the other stuff," he said on his VH1 *Storytellers* episode. The retro-poppy "Sunny Day," Springsteen has said, drew on Rockpile (the Dave Edmunds/Nick Lowe "supergroup," who often emulated Buddy Holly and The Everly Brothers), Phil Spector, and—for vocal phrasing—Smokey Robinson. Springsteen had finished a first draft of the song by 1999, when he soundchecked it with the E Street Band, trying out an awkward-sounding bridge using the lyrics that became the second verse. The recorded version changes keys twice—the kind of classic pop songwriting trick that Springsteen had long since left behind as his music became ever-more stripped down. (Indeed, *The Rising* is full of key changes, often to emphasize instrumental breaks.)

Something about the song reminded O'Brien of Lee Michaels's 1971 organ-driven hit "Do You Know What I Mean?," and he wanted to get as close as possible to the sound of the keyboards on that song (he also seems to have compressed the drums in a similar manner). "We didn't really know how to get that sound, but I had a ton of organs around," says O'Brien. He had Federici play his part over and over on each of the organs, and blended them all together. Federici was an instinctual, improvisational musician who wasn't big on repeating himself, but he went along with it. "I'm not saying he was thrilled about it," says O'Brien. "I'm just saying he did it great. He was sort of a cranky guy, interesting dude. Always so funny."

NOTHING MAN

Springsteen wrote this song circa 1994, intending it as the lament of a possibly suicidal soldier struggling with his return home. (One of Springsteen's favorite writers, Jim Thompson, wrote a somewhat lurid novel called *The Nothing Man* in 1953, about a disfigured, alcoholic veteran who turns to murder.) "A lot of guys went, and a lot of guys didn't come back," Springsteen once said of the Vietnam War. "And a lot that came back weren't the same anymore." The narrator seems to be in a haze of post-traumatic stress disorder and depression, marveling that the sky is still the same shade of blue, that his old friends are still hanging out, even as he is so irrevocably altered.

"Nothing Man" was one of the demos Springsteen played for O'Brien at their first meeting, and the producer immediately responded to it. (Springsteen had also attempted the song with the band during those abortive sessions in early 2001, according to Chuck Plotkin). Except for a couple of arrangement changes, "I pretty much copied his demo," says O'Brien, which means Weinberg is doing his best impression of one of Springsteen's drum machine patterns. The ghostly swells that answer the vocals are the work of Lofgren, using his guitar's volume knob to create an eerie fade-in effect—he spent one of Springsteen and O'Brien's days off trying various overdubs with engineer DiDia. "I'd find spots that weren't repetitive," says Lofgren, "that came in a little bit late and maybe had a little bit of an oddball resolve to it, to match the character in the song."

COUNTIN' ON A MIRACLE

Springsteen had a hazy memory of taking inspiration for this song from a newspaper article, but the actual source may have been an ABC News

Above: Clarence Clemons blows the house down, Los Angeles Forum, August 24, 2002.

Opposite: E Street drummer Max Weinberg and Springsteen, The Rising Tour, Wembley Arena, London, October 27, 2002.

broadcast on October 3, 2001, where a reporter spoke to families awaiting news of loved ones lost at the World Trade Center. Some still held out hope. "You still counting on a miracle?," the reporter asked. "You hear about them every day," replied a woman who was seeking a beloved cousin. "That's all I've got. I'm going to continue looking for him until they say not to anymore."

The version on the album is a big, nearly generic modern-rock song, most notable for a bridge where the clamor suddenly cuts off, leaving just Springsteen's voice and "Eleanor Rigby"-like strings. "I probably referred to the Beatles on this record more than anything else I've done, with the exception of some of the outtakes from *The River*," Springsteen told Binelli.

Photographer and filmmaker Danny Clinch, who shot most of Springsteen's 2000s-era album covers, first heard the song in an acoustic version, with an entirely different melody. Bruce had played it for him on a couch at Southern Tracks after Clinch asked for a performance he could capture on film and video. "He busted out a slide and his acoustic and he plays 'Countin' On a Miracle' in a Delta blues style," says Clinch. "I was blown away. The audio is from the microphone on my shitty-ass video camera." Clinch was shocked when he got the finished album and heard "a whole different song" instead. The hissy, falsetto-laden acoustic version that played on the video screens at shows on The Rising Tour and ended up as a bonus song on 2003's *The Essential Bruce Springsteen*, is arguably the keeper.

EMPTY SKY

The final song recorded for the album, driven by Springsteen's giant-sounding compressed acoustic guitar, with a dramatic little piano intro by Bittan. "I love the sound of it," says O'Brien. "It's very basic, very minimal. It's the last one we did, and part of me was like, 'Damn, maybe we should go back and do some more of these songs!' But obviously at that point we were like, 'We're done here.'" Springsteen is playing a John Lennon-esque pattern on his acoustic, and, in turn, Weinberg says his simple part was "Ringo all the way."

The initial idea for the song came from a photo sent by Springsteen's art director, presumably as potential album art, that showed a cloudless blue sky. But Springsteen had grown accustomed to seeing the World Trade Center, on clear days, from a bridge near his old house in Rumson (probably the Navesink Bridge, from his description). "It all didn't really hit home," he told Robert Hilburn, "until I took a ride across the bridge and there was nothing where the towers used to be." On September 10, 2010, the state of New Jersey unveiled a twin-walled structure in a state park, its official monument to the state's 9/11 victims. It's called Empty Sky.

WORLDS APART

"You write a song," Springsteen told Binelli, describing what it's like when his process is going well, "and it leads you to the next song and that leads you to the next one. It makes you wonder about another character related to the characters you've been writing about." Springsteen was deep into *The Rising* when he realized all of his songs were set in the United States, despite the fact that he was writing about an event with worldwide consequences. That, and seeing a news broadcast that showed Afghan women unveiled after the fall of the Taliban ("their faces were so beautiful") led Springsteen to "Worlds Apart," a tale of forbidden romance not unlike the one in "The Line."

The Pakistani qawwali singer Asif Ali Khan and his band added guest vocals via ISDN line from Los Angeles, with Plotkin handling the recording

> ## "IT DIDN'T HIT HOME UNTIL I TOOK A RIDE ACROSS THE BRIDGE AND THERE WAS NOTHING WHERE THE TOWERS USED TO BE."
>
> **BRUCE SPRINGSTEEN**

Opposite: Springsteen testifies on The Rising Tour, MCI Center, Washington, DC, August 10, 2002.

for them. "I didn't know where we were going with it on that song as much as the other ones," recalls O'Brien. "But Bruce had a real vision for that one. I was like 'Okay, it's my job to get this sounding great, let's make it work,' and he had this idea to have those guys singing on it. And they were incredible. It sounded like, 'Wow, this is a whole different thing here. This is the real deal.'"

LET'S BE FRIENDS (SKIN TO SKIN)

That subtitle could just as well be "American Skin to American Skin"—talk of tearing down walls and different ways of walking make it clear that this is a song about race relations disguised as a come-on, or at least embedded in one. The track is also out of place on *The Rising*, although it's at least a thematic cousin to "World's Apart," which is probably why they're adjacent on the album. It was recorded before *The Rising* sessions began, and it's the only song recorded with longtime Springsteen engineer Toby Scott instead of with O'Brien. Consequently, it lacks the full E Street firepower of the rest of the record—it seems to be a mildly tweaked demo. What Kurt Loder once described as the song's "entirely unexpected beach-beat bounce" hasn't aged well. Regardless, the Sly and the Family Stone-influenced chorus is one of the strongest on the whole album, complete with an appealing vocal from gospel singer Michelle Moore, who later sings and raps on 2012's "Rocky Ground." Her sweet soprano is an appealing counterpoint to Springsteen's gravel, even if the rest of the track never exactly congeals.

O'Brien is not a fan of this particular song. "I will just say, I do remember that one," he says. "I'm gonna leave that one right there." And he did push for a shorter album. "It was a lot of songs," he says. "Maybe too many. As we were finishing, I was going, 'It would be great if we could just make this a great eleven-song record. It would be classic.'" But Springsteen responded, "You

know, you're probably right, but I don't know when I'm doing this again. So we're putting them all on there." Springsteen played "Let's Be Friends" live precisely one time, in 2003, introducing it as "party music."

FURTHER ON (UP THE ROAD)

Springsteen admired the L.A. roots-punk band Social Distortion (how could he not love a song called "Born to Lose"), and this crunchy tune evokes what "Lucky Town" would have sounded like if they had backed him. The lyrics about "lucky graveyard boots" and a skull ring begged to be sung by Johnny Cash, and he did so shortly before his death. Those lines also appear on "Maria's Bed," from 2005's *Devils & Dust*, although Springsteen may actually have written that song first (another *Devils* track, "All I'm Thinkin' About," shares the first line from "Further On."). In all, the song seems to add up to a "Prove It All Night"-style promise from Springsteen to his audience—however tough the road may be, he'll be there from now on.

Springsteen debuted the song at Madison Square Garden with the E Street Band in New York in 2000, and he attempted to record it with Plotkin and the others in those pre-*The Rising* sessions. It was one of the first songs he played for O'Brien. The final version is nearly identical to the live performances, besides eliminating a distracting synth part and letting the full band come in from the start (after four bars of Weinberg's unaccompanied drums) instead of using the old Springsteen trick of holding them back until the second verse.

THE FUSE

Every national tragedy has its heroes—as well as, presumably, its terrified bystanders who run home and have a bunch of sex while they can to prove they're still alive. "The Fuse" tells the latter tale, making it the most offbeat

Opposite: Rocking out with the band on The Rising Tour, Wembley Arena, London, October 27, 2002.

Below: Performing with the E Street Band for the 2002 MTV Music Video Awards at the Museum of Natural History, New York, August 29, 2002.

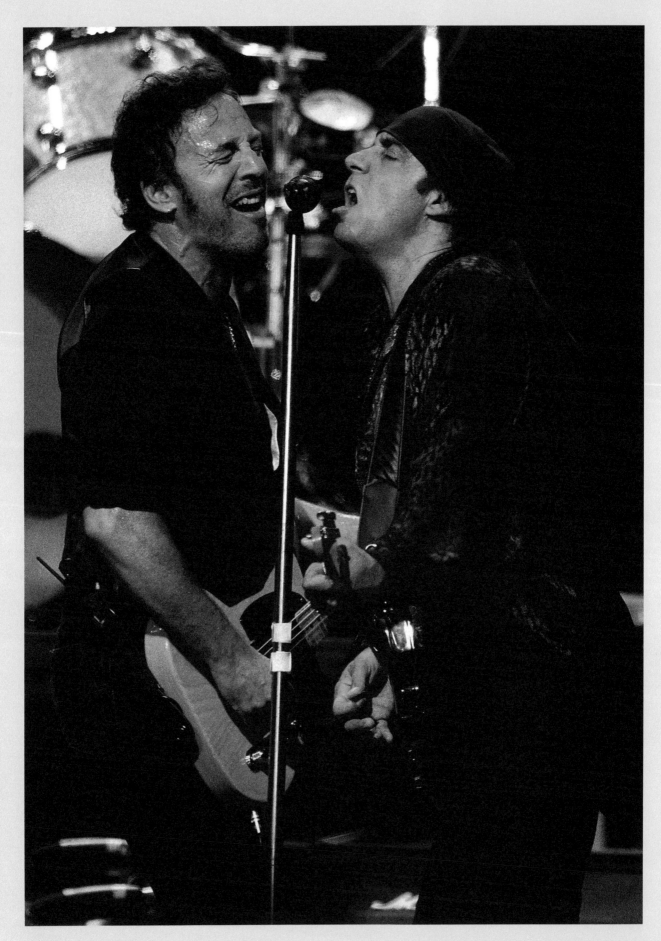

and bold track on *The Rising* (complete with a fairly explicit description of oral sex). Even so, it's probably as true to life as any of the stories on the album.

O'Brien is fond of the echo effect on the hip-hoplike drum part, which Weinberg had in his headphones as he played, and the producer was baffled to hear the version Spike Lee used in his 9/11-adjacent movie *25th Hour*. "They remixed it for the film, and there was no echo on it," he says, laughing. "It was like, 'What's wrong with you people?' It's a whole part of the song!"

MARY'S PLACE

A deliberate attempt at a sprawling soul-rocker, complete with a horn section, offsetted by lyrics about a party that's either a wake or, as Springsteen has hinted, takes place in the afterlife. "It's a party song," he told Binelli. "I haven't written a song like that since 'Rosalita.' But then you go, why are they at the party? What's the party about? What's the meaning of it on that night?" (The chorus of Sam Cooke's "Meet Me at Mary's Place," although melodically different, was an obvious inspiration.) Amid the verses' depiction of mourning, there are references to various religious traditions, from a mention of Buddha to "seven days, seven candles," an evocation of the Jewish practice of sitting shiva for the dead.

"We wanted the track to sound a little bit more like old-school Bruce stuff," says O'Brien, "and we had the drums done a certain way, and everything kind of had a certain sort of sound to it. Later on with the mixing process, Bruce was like, 'Hey, can we make the drums sound more like the other songs for this one?' I go, 'Um, probably not.'"

YOU'RE MISSING

"I was with Patti and the kids one night in the living room," Springsteen told Binelli, "and I sat at the piano and played the little piano thing that opens the song, and was like, 'oh, that's a nice riff,' so I built the song around it." Springsteen's original attempt at the song was up-tempo and poppy, but he slowed it down to match the lyric, which evokes grief with superbly drawn details (some of which were also on his mid-nineties song "Missing"). Working on the demo with O'Brien, at their second meeting, helped convince Springsteen of the producer's skills, although he was initially taken aback when O'Brien suggested changing some of the chords.

The arrangement is simple, mostly Bittan's rumbling piano (which turns into something more typically E Street-ish in the bridge), metronomic drums, and Tyrell's plangent violin parts, which she created "free form," after some suggestions from Springsteen. "That song was all about how to present the lyric in the best way," says O'Brien. "And to stay very restrained." The song originally had a quiet, subtle ending, but Springsteen switched it up: "We've gotta have a big organ solo at the end of this song," he said. Federici came in and nailed it, playing an effortless, lonely-stroll-on-the-boardwalk melodic burst. "The guy was just a remarkable musician when it came to that stuff," says O'Brien.

THE RISING

A few critics slammed this album's lyrics for "vagueness," but no one could apply that particular critique to the title track, which begins with a novelistic, first-person account of a firefighter's journey to the World Trade Center— perhaps the same person being mourned on "Into the Fire." "That song sort of runs you through the day," Springsteen told Binelli, "and I tried to think,

> ## "WE WANTED THE TRACK TO SOUND A LITTLE BIT MORE LIKE OLD SCHOOL BRUCE."
>
> **BRENDAN O'BRIEN**

Opposite: Springsteen and Steve Van Zandt go head to head, Los Angeles Forum, August 24, 2002.

'Well, what would your thoughts be?' You think of your wife, your children. The last verse is where that ascension is taking place—a literal ascension. What do you want? You want a kiss. You want to feel their physical selves again. You want to feel the realness of your blood. And then it goes into this kind of spiritual mantra—that was something that just kinda came out. I wrote it down in a hurry and it takes the character the rest of the way up."

To match its subject matter, "The Rising" is sonically distinct from the rest of the album, in part due to a long, ghostly echo O'Brien chose for the vocal. "It just made it sound more ethereal," says O'Brien, "and sort of even made it sound a little bit like an out-of-body experience." The memorable "dream-of-life" back-and-forth toward the end was "all Bruce," O'Brien says, pulled straight from his demo. The wild tremolo on Springsteen's guitar solo came after O'Brien gave him a whammy bar-equipped vintage Gretsch guitar to play; he soon acquired a few models of his own.

Springsteen saw "The Rising" as the first of a three-song "spiritual litany" that completes the album, tracing the resurrection imagery to everything he absorbed, like it or not, in his grade-school Catholic education. The imagery of souls ascending skywards previously popped up in the Iraq verse on 1992's "Souls of the Departed"; the moment where the narrator compares himself to a catfish on a hook, teetering between life and death, came from Springsteen's own occasional fishing trips.

The song was a Landau favorite, and he pushed to make it the title track.

PARADISE

This mostly solo-acoustic track, enhanced with subtle, slow-building atmospheric production (including ghostly Patti Scialfa vocals), hinted at the approach Springsteen would take on his next album, *Devils & Dust*. Lyrically, it complicates the narrative offered on the rest of *The Rising*, if you follow its conclusions all the way. The first verse tells the unsettling tale of a real-life teenage suicide bomber Springsteen had read about. "The way that paradise was used as a motivational tool, it just made me very angry," Springsteen said. The second verse came from a conversation he had with a woman who had lost her husband in the 9/11 attack on the Pentagon—the bereaved character dreams of meeting with her beloved in the afterlife. In the final verse there is a dreamlike descent into a limbo where you get a glimpse of the deceased, but their eyes are empty, as "empty as paradise."

Multiple songs on *The Rising* rely on hints of an afterlife—paradise—as consolation for earthly sacrifice. Otherwise, there's nowhere to rise and it's all a fairy tale. However, the album's creator seems to have his doubts. "There's a lot of ways people could interpret it," Springsteen said, referring to the last line of "Paradise." "Really, I was just trying to say that, hey, all we have is this life, and we have this world. It's all we count on."

MY CITY OF RUINS

By the end of the twentieth century, after years of failed attempts at development projects, Asbury Park had fallen into disrepair. The beachside haven of "Sandy" was all but abandoned, while the largely African-American west side of town faced crime, poverty, and crumbling schools. Building it around the same sixties' soul chord progression Curtis Mayfield used for the Impressions' "People Get Ready," Springsteen wrote "My City of Ruins" circa 2000. It was, he said, "a prayer for my adopted city," with a gospel-inflected refrain that culminated in a cry to "rise up." Its meaning

> **"ALL WE HAVE IS THIS LIFE, THIS WORLD. IT'S ALL WE COUNT ON."**
>
> BRUCE SPRINGSTEEN

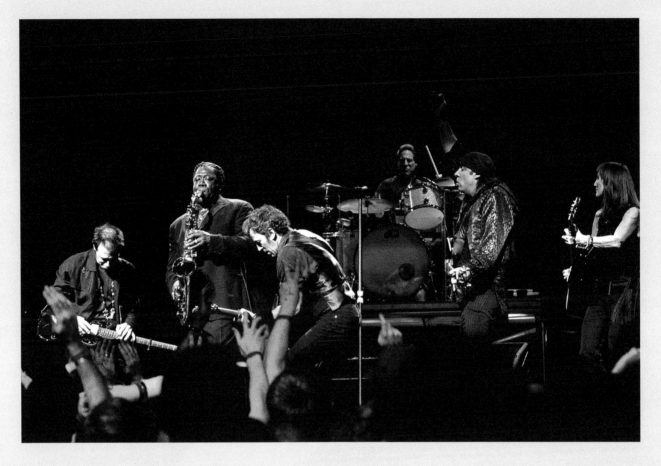

broadened after Springsteen tweaked a couple lines of the lyric and used it on September 21, 2001, to open the *America: Tribute to Heroes* telethon. Springsteen gave a hushed, candlelit, hard-to-forget performance (he had started writing both "Into the Fire" and "You're Missing" for the telethon, but didn't finish them in time).

O'Brien assumed that the song, recorded toward the end of the sessions, would be a centerpiece of the album. "There was no real theory to it," he says. "Let's just make it sound real warm, real straight, real unadorned, try to keep the production out of it, and the song just kind of happened." When Clemons sang his backup part in his incredibly rich, low voice, he took engineer DiDia so much by surprise that the engineer cracked up, laughing in delight.

Weinberg decided to "channel" the Band's drummer, Levon Helm, on the track, adding Helm's unique, New Orleans-style "little drags on the snare," which are particularly evident in the song's intro. (In 1987, Helm accidentally shot himself in the kneecap—a very Levon Helm thing to do—and asked Weinberg to play drums alongside him on tour. "He played the top, and I played the bottom, because he couldn't play the bass drum. So I was really able to get inside his drumming style.")

Asbury Park did rise up, sort of. Prompted by members of the LGBT community, who bought into the town at its lowest point, and a stalwart group of artists and hipsters, the town slowly recovered over the 2000s. By 2018, it was a destination again, with some of the Shore's best restaurants, luxury condos, hotels and, miraculously enough, an overflowing boardwalk on weekend summer nights. But longtime residents on the west side, located on the other side of an actual set of train tracks, were still waiting for a fair share of the city's renewed prosperity to come their way.

Above: Wembley Arena rises to its feet, London, October 27, 2002.

Opposite: Nine shows in. The Rising Tour. Los Angeles Forum, August 24, 2002.

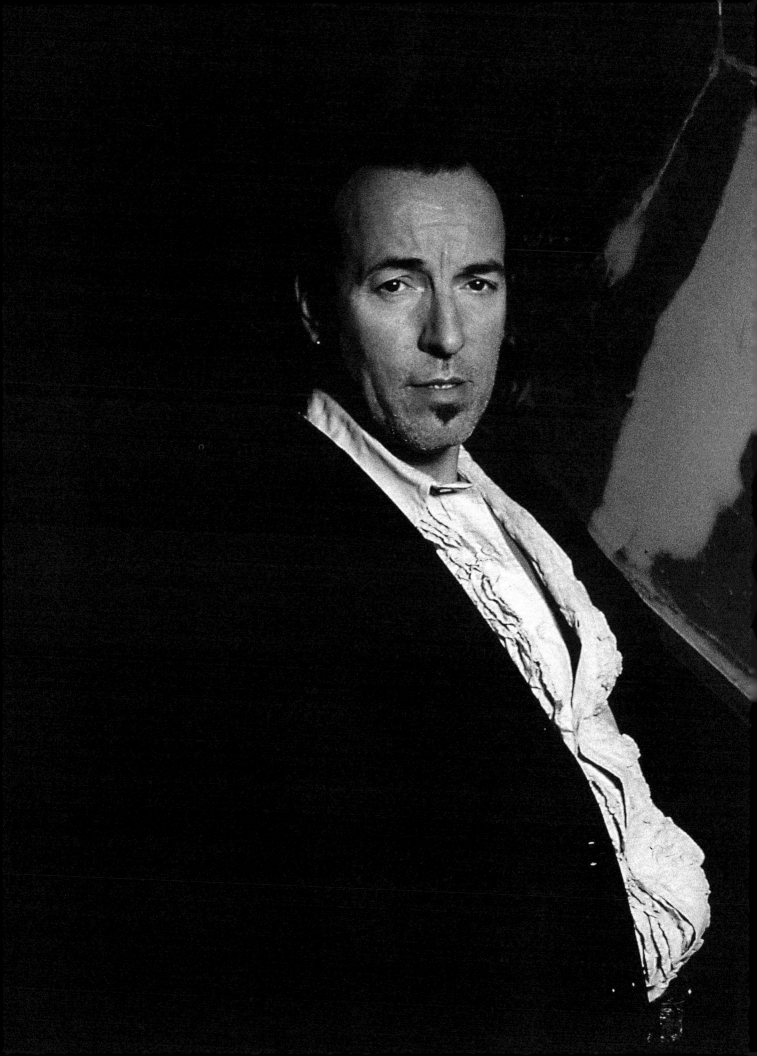

CHAPTER 14

•

2005

DEVILS &
DUST

•

DEVILS & DUST

Springsteen expended as much emotional energy as ever on his 1995–97 solo acoustic tour for *The Ghost of Tom Joad*, but without the usual shouting, sprinting, and crowd-surfing, the shows took less of a physical toll than he'd grown to expect. "I still had my voice," he told me in 2005, "because I hadn't sung over a rock band all night . . . That tour was very inspiring for me, and I wrote a lot of music after the show, when I'd go back to my hotel room. I'd go home and make up my stories. I was interested in the areas I was getting into in the last songs of *Tom Joad*. I had set my stories in the West, which I hadn't done a whole lot before. I started to look into some of the lives of the new migrant population. Those were interesting stories for me, and so I kind of continued a bit where that left off."

At home in New Jersey, around 1997, he recorded the new material on his own, intending to make "another acoustic album." "But when I made it, I said, 'Two of these in a row? I don't know,'" he told me in 2016. "Maybe it's not for me. I said, 'Well, I would have to ignore a lot of my other abilities to just do this.'" He turned his attention, instead, toward the outtakes boxed set *Tracks*, and soon called up the E Street Band. But he was led back to that group of songs, along with two outtakes from the *Tom Joad* sessions, after he wrote a 2003 song about a soldier in wartime.

"Devils & Dust" first appeared in April 2003, less than a month after the United States invaded Iraq, when Springsteen soundchecked it with the E Street Band in a stately sketch of an arrangement dominated by Roy Bittan's piano and Nils Lofgren's weeping pedal steel. At that point, the lyrics felt unfinished and were more explicitly about the Iraq war—the second verse is nearly an op-ed column, with a mention of oil bought with "gunpowder and blood" and a part about "smoke and mirrors" that points toward *Magic*. Springsteen thought about using "Devils" to open his shows on 2004's brief Vote For Change Tour, which had the explicit goal of pushing for the election of John Kerry, but he dropped the idea after coming up with an acoustic-guitar arrangement of "The Star Spangled Banner" that led into "Born in the U.S.A."

"Devils & Dust" could have just as easily been a big rock anthem. "I did a version like that myself in the studio next door and it worked very well," Springsteen told me. But "after the last band tour," he said, "I wanted to do something different. I took another look at these songs." Shortly after 2004's presidential election, he called up Brendan O'Brien and told him he was ready to get back to work.

For the title track, Springsteen told me, "Brendan found something that put it in the middle, between me playing it just by myself on the acoustic guitar [and the rock version]. It picks up a little beef as it goes, but it still remained primarily acoustic, which suited this particular record and the character's voice." They started with a demo made by Springsteen, but "went back and basically redid everything on that," O'Brien recalls. The drums are a combination of loops and performance, both from Steve Jordan (who's played with Patti Scialfa, Keith Richards, and John Mayer—as well as on some early *Human Touch* sessions that didn't make that album). As on the rest of *Devils*, O'Brien played bass, and they added a strings-and-French horns arrangement that the producer compares to Aaron Copland (again, they were probably replacing Springsteen's synth parts).

The crux of the song—and perhaps the album as a whole—arrives in the moment when the narrator fears that in trying to stay alive, you could "kill the things you love." It's a fate that could befall an entire nation, as

> **"I STARTED TO LOOK INTO SOME OF THE LIVES OF THE NEW MIGRANT POPULATION. THOSE WERE INTERESTING STORIES FOR ME, AND SO I KIND OF CONTINUED A BIT WHERE THAT LEFT OFF."**
>
> **BRUCE SPRINGSTEEN**

Previous spread: A rare moment of sitting still, October, 2005.

Opposite: Behind the scenes, October, 2005.

Springsteen would later explore on "Long Walk Home." "That can happen in a lot of different places and ways," he told me. "It was pretty much written around that particular subject."

ALL THE WAY HOME

This song, along with "Long Time Comin'," were recorded in *The Ghost of Tom Joad* sessions and heavily tweaked for this album, with Steve Jordan replacing Gary Mallaber's original drum tracks and O'Brien overdubbing the bass. The two tracks were both among what steel guitarist Marty Rifkin calls "daylight songs," the more uptempo tracks that came out in those sessions before sunset, when Springsteen would light candles and the moodier songs that actually made the album would emerge.

"All the Way Home" is even older than the *Tom Joad* sessions. Springsteen wrote it for Southside Johnny's comeback album *Better Days* in 1990 with an entirely different arrangement and melody, and Southside even performed it on stage with Springsteen one or two times. (Rifikin says he's not surprised to hear the song's origins—Springsteen was pulling out all kinds of material from his notebooks in the daytime sessions.) In 2005, Springsteen couldn't recall exactly why or how the song resurfaced in its new, stark outlaw-country arrangement, which is reminiscent of Steve Earle. "I'm not sure why I lifted those lyrics and put them to that country kind of thing," he told me. "I think I liked the idea of a guy saying, at the end of the song, maybe your first choice is gone, but that's all right."

"I like that sort of character. You make do with what you have in this world and sometimes good things come out of it. It's not always about the ideal situation and you don't know who you're going to end up walking beside and you don't know what's going to bring your life to life. These are things you find out as you go. I like the idea of setting the song around this character, who's kind of pitching himself. He's been through a few things and he's pitching himself to this girl at the bar. It's a very kind of out-front come-on."

As long ago as he wrote it, it's still tempting to read the first line of the song—about failing with everyone watching—as applying to Springsteen's efforts on behalf of John Kerry. "You can hear it on any good fall," he told me, laughing. "It will strike a note for any good tumble that anyone's taken." (Chuck Plotkin is credited with playing piano on the song but has no recollection of doing so—Rifkin recalls Danny Federici being off that day of the *Tom Joad* sessions, and Plotkin stepping in to play the keyboard at the encouragement of the other musicians.)

RENO

This song, about a heartbroken man turning in vain to a prostitute for consolation, cost Springsteen a Starbucks distribution deal for *Devils*, thanks to a single line that emphasizes the loveless crudity of the transaction: "Two-fifty up the ass," she says, listing prices. "I remember hearing it," says O'Brien, "and going, 'Wow, that's some harsh shit right there.' I just wasn't ready for that from him. You know, God bless him, he didn't care—it was his thing."

Springsteen shrugged off the line when I asked about it. "That's how I wrote it," he said. "There wasn't any more thinking about it than about any of the other songs. That was just the circumstance. I once made a short trip to the biggest little city in the world myself in the late seventies, with, I believe, Steve Van Zandt, and a couple other friends and, for some reason, the location always stuck in my mind after that." He laughed. "So I had this story

Above: A rare smile for the camera, 2005.

Opposite: Going solo in support of *Devils & Dust*, Fox Theater, Detroit, Michigan, April 25, 2005.

of a love affair that went south. That's just the way I wrote it. It's just what felt right." The lost love on the track is named Maria—could it be about the romance from "Maria's Bed" gone wrong? "I never thought about it, but could be," he told me. "They're all the same person anyway, I guess."

LONG TIME COMIN'

"I have a problem with the whole original sin idea," Springsteen told Mark Binelli in 2002. "But I can understand it as an adult concept. There's a lot that gets passed on to us. Part of our duty as adults is to shake off the sins, the bad habits of your parents and their parents before them. Your adult duty and the way you honor your family and your parents is by not making the same mistakes."

He grappled with those ideas on "Adam Raised a Cain" and "My Father's House," with its ending line about unatoned sins, along with the outtake "Wages of Sin."

The narrator, out on a camping trip with his pregnant partner and their two kids, has an epiphany under the stars, realizing all he wants for his children is a chance to make their own mistakes, commit their own sins. The song feels like an ending, and a happy one at that, for a certain personal strand of Springsteen's album-spanning narrative. He even allows himself to name the love interest "Rosie," granting us the giddy possibility of the romance in "Rosalita (Come Out Tonight)" made good. It is no coincidence that Springsteen quoted some of the lyrics in "Long Time Comin'" at the beginning of the final chapter of his memoir, *Born to Run*. "This is a song about rebirth," Springsteen said, introducing the song live. "Kids give you a lot of grace, and a whole lot of second chances."

He recorded the song in the *Tom Joad* sessions and reworked it for *Devils* with the Jordan–O'Brien rhythm section. He probably kept the vocals and guitar, but the only element we know for sure was carried over from the original recording is pedal steel from Rifkin, who gets to cut loose and answer the vocal with country-ish licks for once instead of the atmospherics of the *Tom Joad* songs.

> ## "KIDS GIVE YOU A LOT OF GRACE AND A WHOLE LOT OF SECOND CHANCES."
>
> **BRUCE SPRINGSTEEN**

Opposite: Frank Stefanko portrait, 2005.

Below: Pouring sweat over the set list before a hometown New Jersey show, May 19, 2005.

BLACK COWBOYS

Springsteen traced the inspiration for this wrenching, short-storylike (or short-movielike) song to Alan Kozol's 1995 book *Amazing Grace: The Lives of Children and the Conscience of a Nation*, a portrait of children in the poorest neighborhood in the United States, Mott Haven in New York City's South Bronx—with the kids born into this life paying for the sins of an entire society. The opening image of candle-and-flower street memorials to murdered young people is straight from the book, and Kozol spends a lot of time with one family, the Washingtons, who have a close mother-son relationship not unlike the one in the song's first verse.

The cowboy obsession Springsteen gives to his protagonist, young Rainey Williams, is pulled from his own life, and the overlooked story of the black cowboys of the Old West is real. The tale of Rainey leaving his drug-addicted mother to ride an Amtrak train to the real West—and an uncertain fate—is pure invention. "I was just interested in the way the West and the Southwest feels in my imagination, I suppose," Springsteen told me, "and capturing it lyrically in a certain way and the characters that aren't set there, the kid in 'Black Cowboys,' his dreams are placed there."

"Black Cowboys" could have been as bare as something like "The New Timer" from *Tom Joad*, but the chorus-less narrative is elevated by a lush arrangement. When O'Brien first heard this set of songs, he recalls telling Springsteen, "You can put it out like this and people would love it, but you can also make more of a presentation out of it and it might reach more people. There's a lot of room to still keep it intimate and raw but flesh some of these songs out."

Engineer Nick DiDia recalls O'Brien getting arranger Eddie Horst to figure out exactly what mix of orchestral instruments were being emulated in the "Streets of Philadelphia" keyboard patch Springsteen favored, and replacing them with live performances throughout the album. "But during the mix," DiDia recalled, "Bruce kept asking for a bit more of his original keyboard. It still sounded good—I think that's my favorite record of his that I worked on—but it was funny watching him creep the original in."

MARIA'S BED

Springsteen may have thought of *Devils & Dust* as a sequel to *Tom Joad*, but in its up-tempo moments it also became something of a successor to *Lucky Town*, with triumphant personal narratives shot through with twang. Still, Devils' often-overlooked rock tracks are simultaneously smaller in scale and more alive. "Steve Jordan is incredible," Springsteen told me. "He was very attuned to this particular kind of music and he just played great, kind of raw and sloppy on some things, yet very focused. And Brendan, outside of being an amazing producer, is an incredible musician and played the hell out of the bass. We had this little rhythm section that kept the stuff very organic sounding."

There's a sepia-toned country feel to many of these tracks, including "Maria's Bed" (which shares some lyrics with "Further On Up the Road" from *The Rising*.) "That's also Soozie Tyrell's fiddle," Springsteen told me. "Soozie has an incredible raw feeling and the minute the bow starts to go across the strings, that sound comes out. I also wanted to keep it raw like that, because I think what's slipped out of a lot of modern country music is that certain sort of chill-to-the-bone sound."

O'Brien recalls "Maria's Bed" as the first song he and Jordan recorded with Springsteen, and it may well have been fully redone from the demo. For this and a couple other songs on *Devils*, Springsteen told O'Brien he was thinking of Rod Stewart's 1970 album *Gasoline Alley*, which has an unvarnished acoustic-rock sound, like a grimier *John Wesley Harding*, complete with occasional violin.

SILVER PALOMINO

A hushed ghost of a song, again set against the landscape of the western United States, "Silver Palomino" was inspired by a friend of Springsteen's family who died young, leaving two children behind. "That's every parent's nightmare . . . when you're a kid, the loss of your parents is about as frightening as it gets," Springsteen said in concert, explaining that the song is "about this young boy who loses his mom and sees her spirit in a horse that comes out of the mountains at night . . . I got to live around horses the past ten years and, if you get a good horse, they can really take care of you. There's something big-spirited about them, makes them wanna work in concert with the likes of us for some reason."

JESUS WAS AN ONLY SON

"I was raised Catholic, so Jesus is my de facto homeboy," Springsteen said onstage one night. "And all that brainwashing really sticks." Realizing that the *Devils & Dust* songs were full of mother–son relationships, he set out to write a song about Jesus along those lines. "It's really about Jesus's

Right: A solo acoustic performance for the taping of *VH1 Storytellers* broadcast on April 4, 2005 at the Two River Theater in Red Bank, NJ.

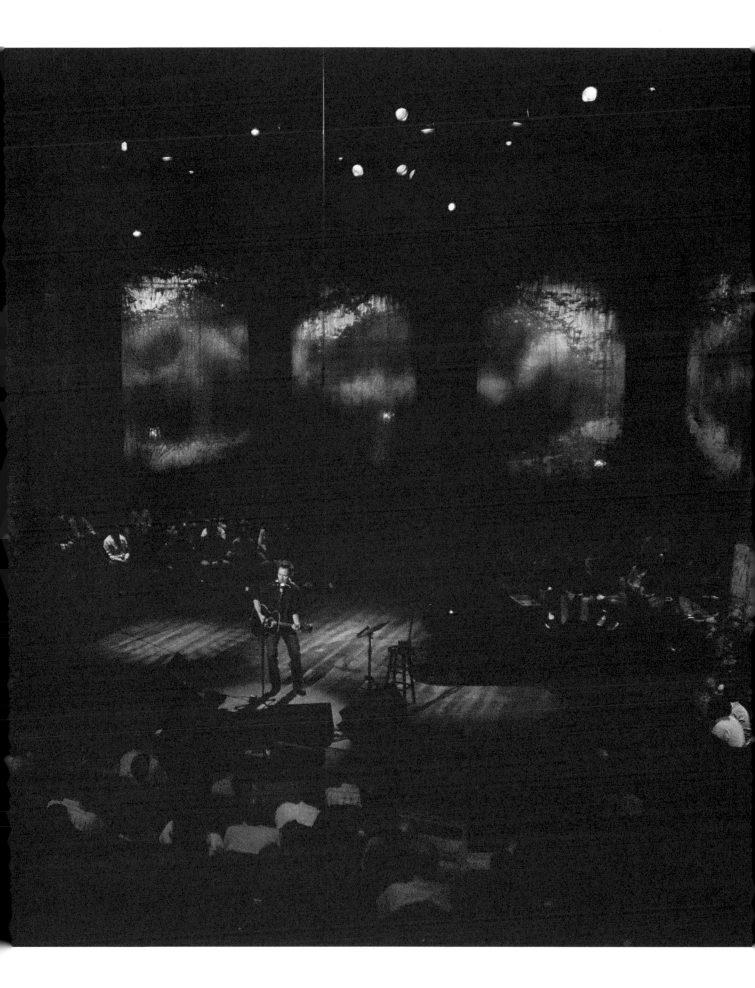

relationship with his mother Mary," Springsteen told me. "In the second verse, you have him in the fields reading the Psalms of David with his mother, which is a very nurturing image. Then you have the verse where she prays for him—so it's about Mary's desire to protect her son. The next-to-last verse was just about choices and the finality of death. It's really a song about the fulfillment of a child's own destiny and the parent's desire to protect them from the things in the world that can hurt them. Ultimately, you can't protect them from their own destiny. They have their own work to do."

It was the only one of Springsteen's solo demos that he'd fleshed out, playing drums, piano, organ, and bass (other than some background vocals, the demo made it straight to the album). "It had this very organic, but quite complete sound," Springsteen told me, that helped inspire the rest of the album's production. "Brendan said, 'All the stuff should sound like this song.'"

LEAH

Springsteen got the title for this deep cut from the 1961 Roy Orbison song, and the riff anticipates the one he'd use on 2012's "We Take Care of Our Own." It's another track that seems linked to *Lucky Town*; the protagonist is ready to start a new life with Leah, and these are better days. Introducing the song in concert, Springsteen said, "We walk through the world carrying the seeds of our destruction, along with the seeds of the things that we can use to build and create. This is about a man who just figures out how to come down on the right side of that story."

The essential lyric, he's said, describes holding a hammer in one hand and a flaming lantern in the other: one for building, one for burning. "I think everybody feels those two things," he told Joe Levy in 2007. "It's just how you balance them. There's a lot of fire in the burning, but it don't do you any good if you ain't got the hammer for the building." The song is probably another all-but-untouched demo; Springsteen plays almost every instrument on the song except for Mark Pender's trumpet and uncredited background vocals.

THE HITTER

Springsteen introduced "The Hitter" as the flip side to "Leah." The beaten-down boxer he sings about never got past the fire and destruction in his nature, and he couldn't even stay true in the end, throwing a fight for big money. The song's pathos-filled narrative conceit is that the boxer is telling his ugly life story to his mother, through a door she won't even unlatch, as he begs her to let him in and just rest for a while. "I tend to like to write songs about people whose souls are at risk," Springsteen said in concert. "Probably goes back to being told that every day for eight years as a child at school. Those things tend to stick with you. But I later on found out that writing about it momentarily put my own soul at ease."

Midway through the song, the strings and horns come in, but almost subliminally. "I learned something from him on that," says O'Brien. "We spent a lot of money and a lot of time doing these string arrangements. And he was so intent on keeping that stuff way down in the mix. My thought was, We paid for this, just turn it up! But his thing was 'No, no, no, way down,' and I really became a believer in that from that point forward. He really understood that it would sound even better and more sort of spooky if it's way down in there."

> **"I TEND TO LIKE TO WRITE SONGS ABOUT PEOPLE WHOSE SOULS ARE AT RISK."**
>
> **BRUCE SPRINGSTEEN**

Opposite: A *Mojo* magazine photo session, October, 2005.

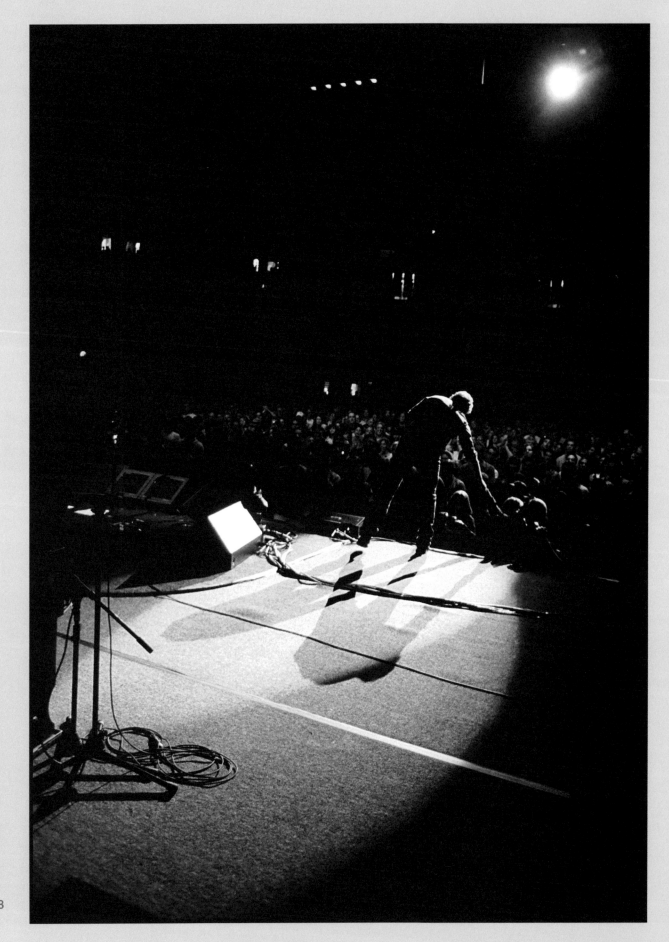

ALL I'M THINKIN' ABOUT

Evoking nothing so much as Canned Heat's hippie anthem "Going Up the Country," this pleasant departure of a love song is an endurance test for Springsteen's falsetto, the only song besides "Lift Me Up" where he attempts it for the length of an entire track. His squeaky slide playing matches the cracks in his voice. "The artist is always creating a box," Springsteen told Danny Clinch in the bonus video for the album. "And you're always trying to come up with different stylistic ideas to help you just suddenly kind of transition out of that box . . . I try to find small shifts in tone that sounded like the characters that I was singing about . . . a slightly different vocal tonality. What we're always trying to come up with is a voice you haven't sung from yet and makes the characters feel very alive."

MATAMOROS BANKS

Springsteen's essential seriousness and doggedness often won't allow him to let any particular subject matter go until he circles it from every angle. He's also allergic to offering false hope—to the point where he once hesitated to put "Out in the Street" on *The River* because he worried it was too unrealistic. So after *Tom Joad*'s "Across the Border," an immigrant's fantasy of life on the other side, imagined the night before his crossing, it was almost inevitable that Springsteen would write what he's described as a sequel. In it, we learn that the migrant never makes it out of Mexico, drowning along the way. By telling the story in reverse—the character is dead in the first verse but alive in the last—with music unmistakably suffused with hope, Springsteen emphasizes the migrant's bravery and humanity, while holding out the possibility that the paradise of "Across the Border" could be found via another, much more permanent kind of crossing.

Opposite: Springsteen thanks the crowd, May 19, 2005.

Below: Pensive portrait, 2005.

CHAPTER 15

•

2007
MAGIC

•

MAGIC

231
•

RADIO NOWHERE

For all of the E Street Band's onstage muscle, there wasn't much room for big, distorted rhythm guitars in Bruce Springsteen's recorded music, at least not until Brendan O'Brien showed up. "We had a huge keyboard presence," Springsteen told me in 2010, adding that the flaccid guitars were Steve Van Zandt's longtime "ax to grind." "But Brendan was coming from hard music—Rage Against the Machine, Pearl Jam—so he was interested in moving the thing slightly more in that vein. And I was interested in that, also . . . So now the guitarists, if we want, they crunch pretty hard." Hence the galvanizing opening track on *Magic*, which offers a glimpse of a guitar-centric E Street Band, with no audible keyboard whatsoever. (Some hear Tommy Tutone's eighties hit "867-5309" in the riff, but the resemblance is minor.)

From the first demo, recorded with O'Brien on drums, Springsteen had that sound in mind, according to the producer. "That was Bruce's thing," O'Brien recalls. "He wanted to hear a song that sounded like that. Guitars!" As on *The Rising*, the basic tracks were recorded by Springsteen with Roy Bittan, Garry Tallent, and Max Weinberg. "It sounded like a hit when I first heard it," says Weinberg, who says he was asked simply to "go wild" on the song, which he does. "It was the first song we recorded for that album. And it was just, 'go

for it.'" (If the song was partly inspired by nineties rock, it ultimately went full circle. "I was listening to that song 'Radio Nowhere,'" Pearl Jam's Eddie Vedder told his friend Danny Clinch in the summer of 2018. "What a song!")

The usually unstumpable pair of Roy Bittan (who again, can't be heard in the final mix) and Tallent were briefly thrown by a tricky chorus, where Springsteen unpredictably toggles between major and minor chords. "It was so confusing to those guys," recalls O'Brien. "It sounds like it's always the same chord progression, but it's not." Still, almost nothing could knock those two off course. "One of the most impressive things was Roy and Garry responding to key changes while we were tracking," recalls engineer Nick DiDia. "Bruce had a capo on his guitar and would start a song and then stop and say 'let's try that up a step' and move his capo—but Roy and Garry had to transpose what they were doing on the fly and it was instantaneous. But I guess that's part of why that band's so good."

Clarence Clemons's sax solo is doubled by a lead guitar, probably played by Nils Lofgren. "One of the things we did with the saxophone," Springsteen told Dave Marsh on E Street Radio, "to make the saxophone sound fresh, we'd treat it with a variety of filters, and double it . . . It still sounds like Clarence, but it sounds like Clarence right now. It's something that makes it come to life."

Previous spread: Springsteen in New York City, October 2007.

Opposite: Danny Federici, battling cancer, performs his last full show with Springsteen and the E Street Band in November 2007.

Below: Bruce watches the New Jersey Rangers Play the New York Devils in East Rutherford, N.J., 2007.

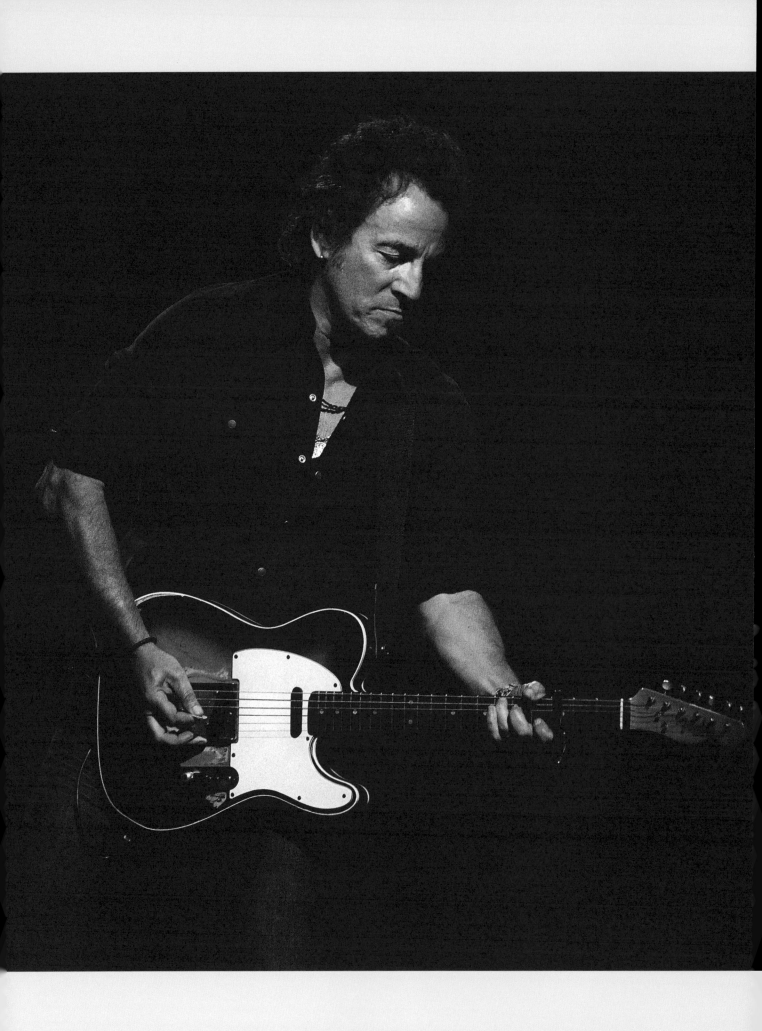

"Radio Nowhere" seems, at first, to be a complaint about homogenized, corporate radio, but something else is going on in the lyrics. The narrator is either driving through an actual postapocalyptic landscape, or indulging in a fantasy about one while crying out for signs of life. "Is there anyone alive out there?" a common piece of Springsteen stage patter, is transmuted into something bleaker and more desperate here. A reference to feeling like a "number lost in a file" seems like a nod to Bob Seger's "Feel Like a Number."

One ultra-Bruce-y couplet rhymes "driving rain" with "searching for a mystery train," and when *Rolling Stone*'s Joe Levy asked what that Presley-ian locomotive might signify, Springsteen offered this piece of spontaneous poetry: "What everybody's looking for. The ever-unattainable but absolutely there part of life that's slightly out of your fingertips, slightly shaded in the dark somewhere. But within, it contains all the essences and raw physical vitality and blood and bone and sweat of living. It's the thing that makes it all worth it at the end of the day, even if you just get the tip of your tongue on it. It's our history. It's that train that's been running since they friggin' landed over here on the boat, and it's roaring with all of us right now, that thing. That's what I like to look for."

YOU'LL BE COMIN' DOWN

Surpassing even the most tuneful moments on *The Rising*, "You'll Be Comin' Down" has a giant, glittery chorus that still has a where-did-this-come-from kick. It's so poppy that songwriters for the boy band One Direction used a nearly identical melody for their 2014 song "Night Changes." "I was enthralled with going back to writing—hopefully—beautiful melodies," Springsteen told a European television interviewer in 2007, "and a lot of pop influences and a really rich tapestry of sound and sort of classic guitars and choruses and I fell in love with doing that again." The instrumental interplay coming out of the magisterial sax solo, led by a flurry of notes from Tallent's bass, rivals anything in the E Street Band's seventies and eighties studio work. "One of my favorite-ever songs," Weinberg notes.

On the surface, the lyrics of "You'll Be Coming Down" tell the story of a shallow It girl headed for a fall—Springsteen snarls a line about "your pretty face" with uncharacteristic bile. But he's made it clear that the whole album has a Bush-era subtext, so he's also addressing the president and his hubristic crew—it's fun to think that he's symbolically linking them to the Paris Hilton types who thrived during their reign. A more unnerving reading is that he's addressing his overconfident country as a whole.

Magic is a beloved album among many of Springsteen's fans, but it did spark one consistent complaint: Its blaring sound falls victim to the so-called "loudness wars," a now-diminished trend where artists tried to make their albums as hyper-compressed as possible. "The only guys I ever heard bitch about that record were mastering guys," O'Brien says. "We did mix it kind of jammed up a little bit because that was sort of the quality of the music . . . I don't have a good answer for you except I don't give a shit." Bob Ludwig, the longtime Springsteen collaborator who mastered the album, has made it clear he was never a fan of the loudness wars. With *Magic*, he says, "As always, I was responding to the wishes of the artist and producer."

LIVIN' IN THE FUTURE

By the time The Rising Tour concluded in 2003, Springsteen had written several songs for what he conceived as a direct follow-up album. "My idea

> **"I WAS ENTHRALLED WITH GOING BACK TO WRITING BEAUTIFUL MELODIES."**
>
> BRUCE SPRINGSTEEN

Opposite: Madison Square Garden, New York, Magic Tour, October 17, 2007.

was to pick up with the political and social results of what came out of the tragedy of 9/11," he told Levy. "I had a few things, but I didn't have enough. So I set it aside." One of the first songs he wrote was "Livin' in the Future," and he thinks he may have had "Radio Nowhere" back then as well. He had "Devils & Dust" finished by then, too, so it could all have ended up on the same album—instead, "Devils" became the title track of his half-acoustic next LP, with a solo tour to follow. He then finished his *Seeger Sessions* album of folk covers, which led to another, highly unique tour.

So it wasn't until late 2006 that Springsteen summoned O'Brien to his house in Colts Neck, New Jersey, and played him a new batch of songs. "He sits down in the living room, and he hands me a book with lyrics and he plays me some songs," the producer told Andy Greene of *Rolling Stone*. O'Brien helped Springsteen select the ones that had "a certain voice," and those ended up on *Magic*.

"Livin' in the Future," with its references to "election day" and rush of apocalyptic images—blood-red skies, wild dogs set free—was essential to the album's theme. "It's about how terribly fucked up things have gotten," Springsteen told Levy, "and it's a song about apathy and how what you never thought could happen has happened already." At the same time, the music is a deliberate throwback to the boardwalk R&B of Springsteen's earlier work—part "Hungry Heart," part "Tenth Avenue Freeze-Out," with a distinct hint of "Out of Work," a song Springsteen wrote for Gary U.S. Bonds in the eighties. "The sound . . . is comforting," Springsteen told a European television interviewer, "and the thing underneath is subversive."

"That song just took care of itself," O'Brien says. "There's no attempt to make anything other than something that sounded like a great Bruce Springsteen E Street song, you know?" Clemons's baritone sax bolsters the song's rhythm guitars, and he takes multiple leads with his usual tenor. "I would try to direct some of that stuff where there's more of a sax arrangement," O'Brien recalls. "But when it came to the solo melodies and that kind of thing, that's all Bruce, with Clarence. I would try to walk Clarence through some of the stuff and he was not really responding. He was super-nice but not responding, and Bruce would walk out there and instantly have a rapport. I was like, 'Bruce, you are now Senior Vice President in charge of recording Clarence.' He goes, 'Dude, I've been doing that for 35 years.'"

YOUR OWN WORST ENEMY

Springsteen certainly didn't need R.E.M. to clue him in to the glories of Brian Wilson and the Beach Boys, but the expansive arrangement of "Your Own Worst Enemy," sleigh bell and all, does bear a certain resemblance to R.E.M.'s 1998 Wilson homage, "At My Most Beautiful." The biggest surprise here is that Springsteen revives the full-bodied, Roy Orbison-aping vocal sound of his "Born to Run" days. "I let my voice be full again and sing," he told Marsh. "It's almost crooning in 'Your Own Worst Enemy.' . . . I really let myself take a deep breath and sing out." Springsteen himself "cobbled together" the song's prominent string arrangement on a keyboard, O'Brien recalls, which an arranger then expanded. The song's subject, obviously, is self-destruction, whether it's one man's or an entire society. "The lyrics are 'we're always teetering on the edge,' and it's all about self-subversion," Springsteen told Levy, "and you can take it personally or however. That's what gives the record its tension, those two things—the perfect pop universe and then what's at its center."

"BUT WHEN IT CAME TO CLARENCE'S SOLO MELODIES, THAT'S ALL BRUCE AND CLARENCE."

BRENDAN O'BRIEN

GYPSY BIKER

The tale of a motorcycle-riding veteran who dies in an unnamed war concludes with the striking image of his friends pouring gasoline on his bike and setting it ablaze in the desert, Viking-funeral style. "Narrative writing within the rock form, when I've tried it, it never melded very, very well," Springsteen told me in 2016, although "Gypsy Biker" is a clear exception. It also has powerful resonances with his earlier work. When the chorus describes the gypsy biker "comin' home," it's not hard to imagine that it's the same motorcyclist from "Born to Run," finally at rest.

There's almost always a churning acoustic guitar somewhere in the mix of Springsteen's rock songs, and if it's an E Street production, you can hear Max Weinberg locked into it, and vice versa. On this track, which is folkier than the rest of *Magic*, the strummed acoustic leads the charge, along with Springsteen's keening campfire harmonica. It is less dense than O'Brien's other productions, leaving plenty of room for Danny Federici and Bittan's interplay. "That song could've been recorded thirty-five years ago, no problem," says O'Brien.

GIRLS IN THEIR SUMMER CLOTHES

As much as he came to be influenced by Woody Guthrie, classic country, and the Alan Lomax folk canon, Springsteen was originally a creature of sixties

Above: Getting ready for the Magic Tour. Springsteen backstage at Convention Hall, Asbury Park, New Jersey, September 13, 2007.

MAGIC

237

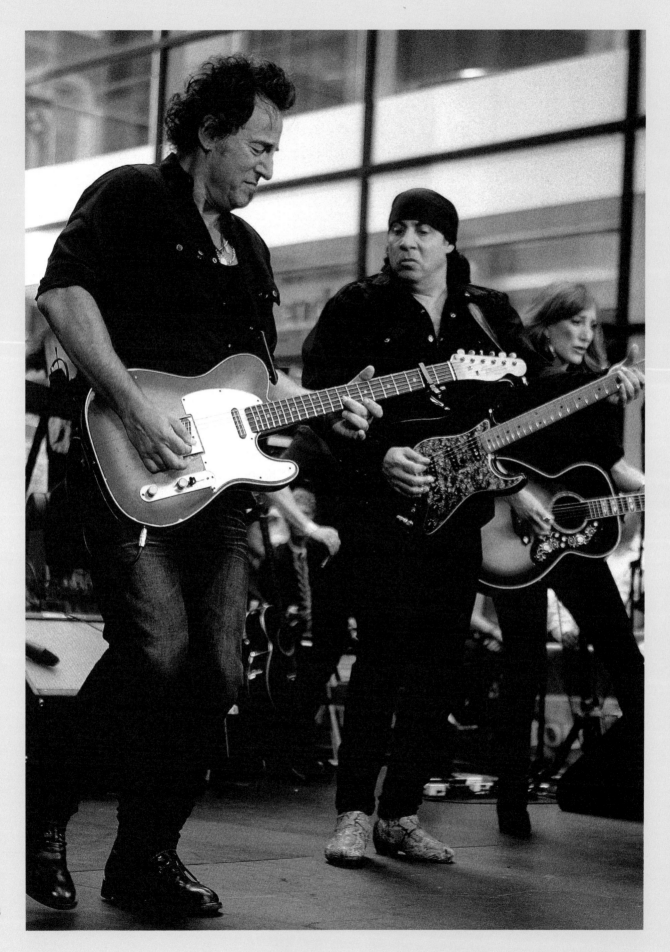

top 40 radio. In "Girls in Their Summer Clothes," he places his heartbroken protagonist in a "perfect pop universe" while letting him wander around an idyllic-sounding small town. "I guess its primary emotion is longing and also loss, because the basic story is the guy's just at the end of some relationship," Springsteen told Marsh. "He's sort of in this state of longing, and the thing I would compare it to was the way the singer sounded to me on the great Drifters records—'This Magic Moment' or 'Save the Last Dance For Me.' Why does the singer sound both so exhilarated and so sad? And I love those two things together." (U2's Bono had his own, canny take on "Girls," his favorite *Magic* track, when I spoke to him in 2009. He zeroed in on the part about the girls passing the narrator by: "It's about getting older, isn't it?")

For Springsteen, the lush pop of "Girls" was "like using a set of muscles you let sit for a while," he told a European television interviewer. "After *Born to Run*, I began to move more in the folk influence area. Even the chord structures of *Darkness* were much simpler—folk influences, country influences. I carried that pretty much through for quite a while. It was nice to go back—'oh, I can write these melodies and the band can sing these harmonies.' And I love the lush string sounds, and we know how to arrange those things. It was just a treat to go back and try to create something that would be a feast for people's ears, hopefully."

Springsteen also saw the song as a chance to let Weinberg indulge his own affinity for the Beach Boys and their frequent session drummer, Hal Blaine. "He said, 'Max, I've got a song for you,'" recalls Weinberg. "'This is right in your wheelhouse.' He knows I'm a fanatic Beach Boy fan. And I played with the Beach Boys many times when Carl Wilson was still alive. Brendan and Bruce threw me these somewhat tricky things to play, and I'd have to choreograph how to do them."

"That song probably had the most work of any song on that record," says O'Brien, who Springsteen credited with introducing one dramatic chord change into the composition. "He was into all that stuff, bringing the drama." The song's elaborate production was nearly finished when Springsteen realized, to O'Brien's mild dismay, that it was in the wrong key to deliver the kind of vocal performance he wanted—the keyboards could be digitally transposed, but the guitars and bass had to be replayed from scratch. "So that song was completely bushwhacked, and we kind of redid it. And again, Bruce was 100 percent correct. The end product is he sings it great."

I'LL WORK FOR YOUR LOVE

Bittan's lyrical piano intro, doubled by glockenspiel, to "I'll Work for Your Love" is so familiar that it's easy to forget how hard Springsteen ran away from that sound for many years. "I wrote all those *Born to Run* songs on the piano, but Roy, in the end, his attack and formulations of what I showed him really created a very, very unique sound," Springsteen told me in 2010, "and if people hear that today, they go, 'That sounds like the E Street Band.' So that became very, very powerful. Usually, when something like that happens, the first thing I do is I move away from it, because then you're just sounding like yourself. When Brendan came along, I had the courage to bring that back for a while, and 'I'll Work for Your Love' is one of my favorite things off of *Magic*, it was so fun to use that sound again." The lyrics are a playful pileup of Catholic imagery, all in the service of hitting on a cute barmaid—or maybe it's just a daydream of a relationship with her.

> **"IT WAS JUST A TREAT TO GO BACK AND TRY TO CREATE SOMETHING THAT WOULD BE A FEAST FOR PEOPLE'S EARS."**
>
> BRUCE SPRINGSTEEN

Opposite: Springsteen and the E Street Band performing "Radio Nowhere" on NBC's *Today*, in New York, September 28, 2007.

MAGIC

"I'm not sure what you're talking about," O'Brien told Springsteen as they put this song together, "but I know it's sinister."

"That's all I need," replied Springsteen, who played the song's spooky opening flourish on a rickety homemade pipe organ owned by the producer. The song's subject was the Bush administration's attempts to redefine truth; Springsteen was, like many of his fellow citizens, particularly disturbed by an infamous quote from an anonymous official (widely believed to be Karl Rove) mocking the "reality-based community." "We live in a time when anything that is true can be made to seem like a lie," Springsteen told Levy, "and anything that is a lie can be made to seem true, and there are people that have taken that as their credo. So when I wrote that song, that's all about illusion."

LAST TO DIE

"How do you ask a man to be the last man to die in Vietnam?," future senator John Kerry said in 1971, during testimony before the U.S. Senate Committee on Foreign Relations. "How do you ask a man to be the last man to die for a mistake?"

Springsteen used Kerry's language for a song about the Iraq War. "That's the line that captures what it means to send people off to die without taking into account the real consequences," he told Levy. "I really feel that it was the result of people that were so unbelievably naive, ideological, insecure, frightened of being made to look weak."

With images of stacked corpses and cities on fire, not to mention the memorable line "the wise men are all fools," there's no question about *Magic*'s subject matter by the time "Last to Die" is over. "The record reveals itself in the last three or four songs," Springsteen told Marsh. "That's when the subtext becomes text. I like the way that the record works like that. I like that it starts out with it, without those things burdening it."

With Soozie Tyrell's violin back in the mix, "Last to Die" is a nearly frantic rock song, perhaps less musically surefooted than the poppier moments on the album. "In hindsight, I feel like that's a little over the top, that song," says O'Brien. "There wasn't a lot of throttling back going on. Everything about that is sort of grandiose; the strings, the guitar. It's great, but it's definitely going for the fences, or the back row as they say."

LONG WALK HOME

This song was important enough for Springsteen to quote it in his 2008 endorsement of Barack Obama in the Democratic primary, evoking the ideal of a country where there's an indelible line between "what we'll do and what we won't." Springsteen debuted it in November 2006, during his tour with the Sessions Band, in a quieter arrangement that might better suit its lyrics than the bludgeoning E Street version on *Magic*. Like "Girls in Their Summer Clothes," the song follows a character walking through his hometown, but here everything's gone wrong. The neon diner of "Girls" is empty in this song, with a sign "that just says 'gone.'" (The original live version has lines about a "hurricane on Main Street" and "murder in my soul" that Springsteen subsequently discarded.) The narrator says the faces around him are all "rank strangers"—a nod to "Rank Stranger," the Stanley Brothers' bluegrass hit, which also has a character wandering a familiar landscape rendered alien.

At one point, "Long Walk Home" was the opening song on *Magic*, and O'Brien also thought it should be the title track. "I remember going, you really want to call

> **"WE LIVE IN A TIME WHEN ANYTHING THAT IS TRUE CAN BE MADE TO SEEM LIKE A LIE."**
>
> **BRUCE SPRINGSTEEN**

it *Magic*?," says O'Brien. "I said, it makes me think of a top hat, tails, and a rabbit. I said, what about '*Long Walk Home*?' Great song. And at some point he just said, 'it's going to be called *Magic*, I don't want to hear anymore about it.' Okay!"

DEVIL'S ARCADE

"That's the cost," Springsteen said of this song, which is at least partly told from the point of view of the lover of a gravely wounded soldier in a hospital. The powers that be took a gamble, Springsteen sings, and "somebody paid." The track is driven by a notably tricky, syncopated, rising and falling drum part. "That's one of my favorite things I've ever played," says Weinberg.

The song ends with the litany "the beat of your heart," which Springsteen sings again and again. The artist was surprised when Levy pointed out that the line connects elegantly with a lyric in the album's opening track, "Radio Nowhere": "I just want to hear some rhythm." "That's amazing," Springsteen said. "All I knew was that that song always felt right at the end of the record." The song ends with rhythm unadorned—a few bars of crashing, unaccompanied drums.

TERRY'S SONG (BONUS TRACK)

The album was all but finished when Springsteen's longtime assistant and friend, Terry Magovern, died suddenly. "Some people, when they die, take whole worlds with them," Springsteen said. He wrote an aching musical elegy to play at Magovern's memorial service and recorded it for *Magic* the next month. "Bruce just walked out there and it might have been one or two takes," says O'Brien, "and then a piano, and that was it."

Below: Milan, November 28, 2007.

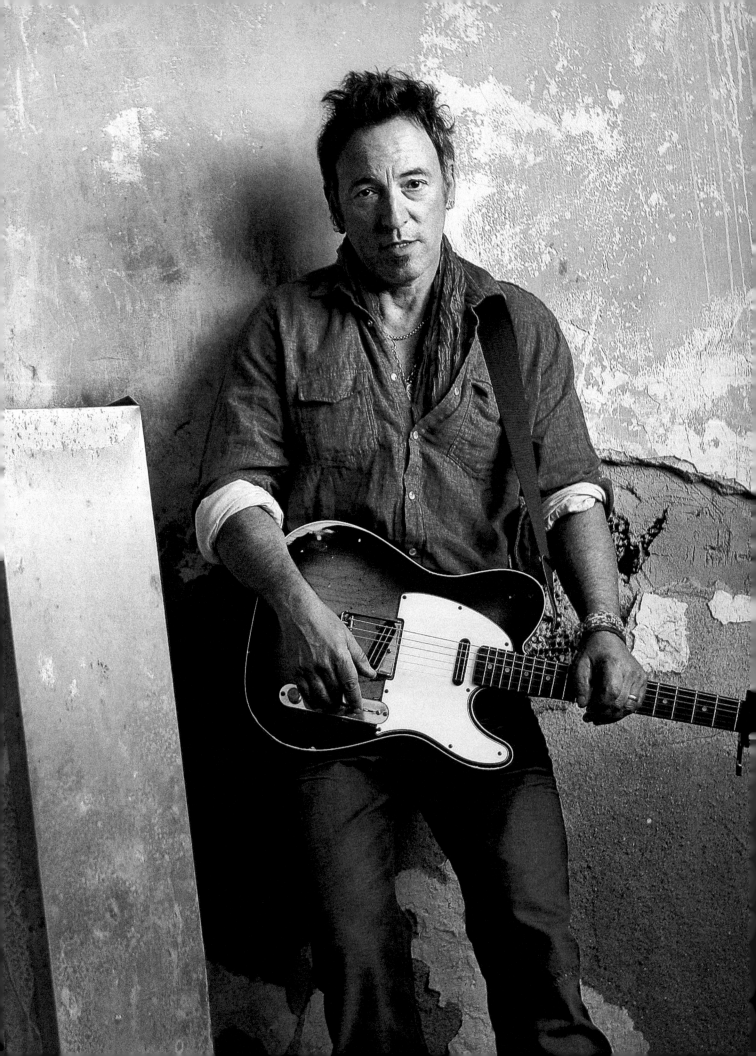

CHAPTER 16

•

2009

WORKING
ON A DREAM

•

OUTLAW PETE

How profoundly do Bruce Springsteen's central themes haunt him? Consider that he sat down to write a cartoonish song, he said, in the vein of "Rocky Raccoon" by the Beatles, starting it off with a scene of a diaper-wearing baby robbing a bank—and still ended up with the story of a man unable to escape the tides of history and the wages of sin, a man who couldn't walk away from the price he paid. In the story, Pete tries to go straight, to start his life over, but a bounty hunter from the old days finds him. "That was me coming up with a little operetta," Springsteen told me in 2009. "Once again, it's an overview of an entire life of somebody that struggles to connect and in the end doesn't quite get there, so that's a story I've been involved in telling for a long time."

"We all have to reckon with our own history," Springsteen told *Rolling Stone*'s David Fricke. "Because history catches up with you. That's what was not happening over the past eight years in the United States—that not knowing, the arrogance that led to thousands of people dying and the country having a complete financial nervous breakdown. If you do not reckon with your own history, it eats you. And if you have that level of authority, then it eats us."

"Outlaw Pete" comes in part from a children's book, *Brave Cowboy Bill*, that Springsteen's mother had memorized and recited to him at night when he was a little boy. The music, a deliberate effort to write the kind of multipart epic he'd abandoned after 1975, draws on Ennio Morricone and "Heroes and Villains" by the Beach Boys.

Springsteen jumped to *Working on a Dream* almost immediately after finishing *Magic*, and while he kept Brendan O'Brien aboard as producer and

Previous spread: Springsteen photographed at Convention Hall, Asbury Park, New Jersey, ahead of the release of his *Working on a Dream* album, and supporting tour, March 23, 2009.

Below: Setlist for Madison Square Garden, New York, November 7, 2009.

Opposite: Captured backstage at Convention Hall, Asbury Park, New Jersey, shortly before going on tour with his new album *Working on a Dream*.

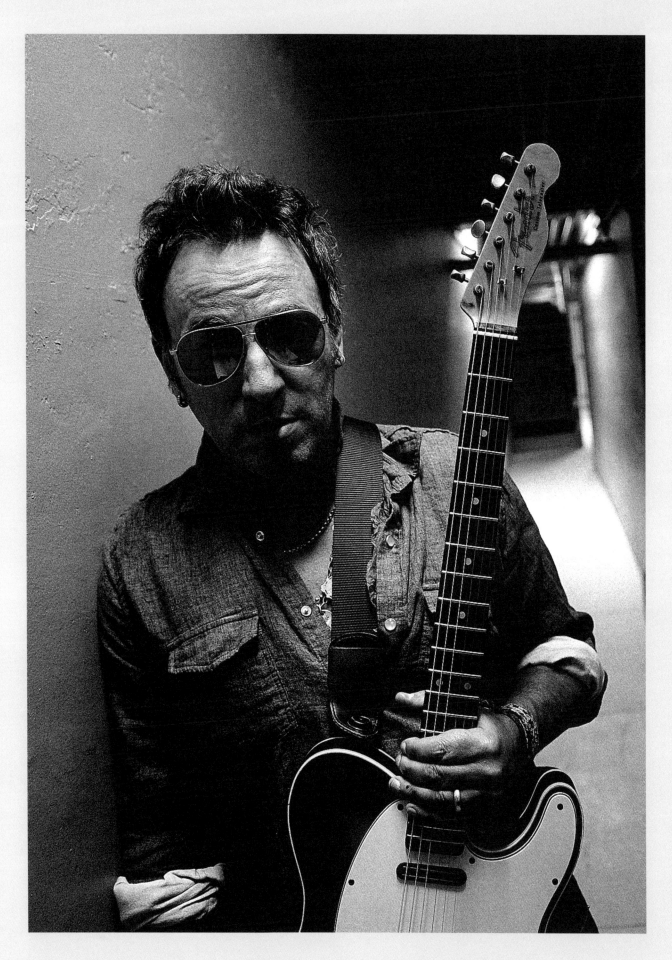

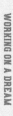

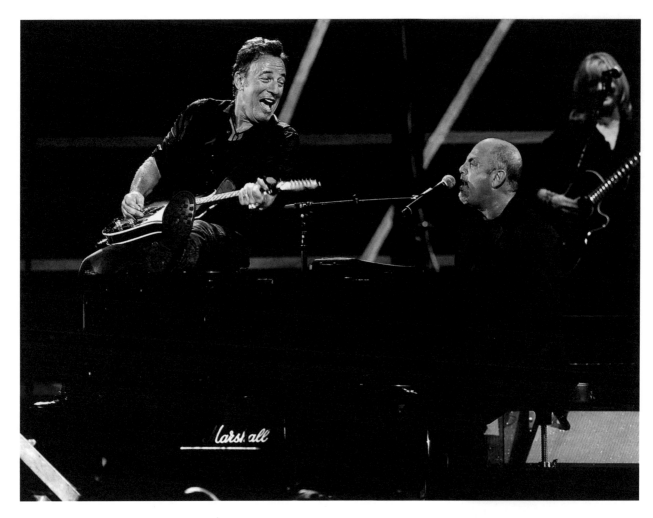

mixer, it was less of a collaboration. "That record's all Bruce," says O'Brien. "That's all his, a lot of the songs are kind of demoed out. I remember we rode around in his SUV, around Jersey, listening to these demos." O'Brien wasn't quite sure what to make of "Outlaw Pete," anticipating the largely negative reaction to the album. (My own, perhaps overenthusiastic-in-retrospect *Rolling Stone* review was one of the few raves.) "I can't say I connected with it the same way Bruce did," he says. "And I'm certain I would not have put that song first on the record, but he was committed to that. And God bless him. He had a vision for that song, and it was my job to help him make that happen, and I felt like we did that."

Recording it was complex, especially with only a couple days in a New York studio to get the basic track. "It probably had seven or eight different tempos," says O'Brien. "And it really is a collection of seven or eight different little songs that you've gotta figure out how to put them together." The band played each section separately, and the final song was stitched together. "They never played that song down once from the top. There was no way those guys, in the timeframe that we had, were gonna be able to learn that with any conviction over a couple days' period." Max Weinberg begs to differ and thinks it would've been easier simply to play the song. "The E Street Band is able to play 'Jungleland' and all the stuff on our second record. We can go from one section to the next, fast, slow, whatever." Steve Van Zandt stepped up to play the song's climactic, lyrical guitar solo, which is the song's most "Jungleland"-esque moment.

> **"PATTI IS ALWAYS TEASING ME THAT I DON'T HAVE THAT MANY LOVE SONGS."**
>
> **BRUCE SPRINGSTEEN**

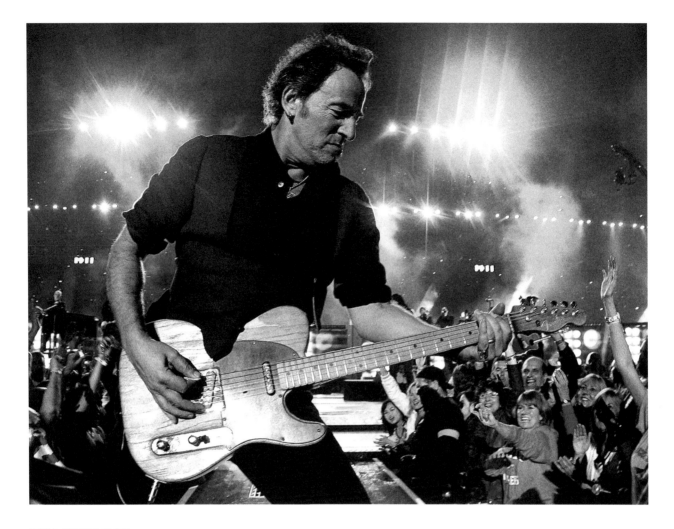

MY LUCKY DAY

An energetic, Stones-y rock track with great Van Zandt harmonies, this is the first of the album's many love songs, the profusion of which is one of the reasons *Working on a Dream* is an anomaly in the Springsteen catalog. "Patti, she's always teasing me," Springsteen told Joe Levy. "'You don't have that many love songs.' I wrote the love songs, I wrote *Lucky Town*!'"

The band—who recorded this song with the full lineup in the studio, not just the usual core—sounds particularly unrestrained, with Roy Bittan and Garry Tallent trading runs and riffs. "They just told me to go to town," Weinberg recalls. "I got to do all these little crazy fills, and they're not even fills, they're just like rhythmic permeations, within the context of a rock song. This is not easy to do and not very often called upon to do."

WORKING ON A DREAM

This was the only song Springsteen didn't have demoed into an arrangement before he played it for O'Brien, who was excited by its potential. "I just thought it was very simple, very catchy," says the producer. The track, which *Rolling Stone*'s David Fricke aptly described as "like a Pete Seeger work song sweetened with the mid-sixties Roy Orbison," features a rare whistling performance from Springsteen, although O'Brien thinks it may have originally been intended as a placeholder for an actual instrument.

Springsteen didn't consider the song's full political implications until after Obama's election in November 2008, he told Fricke. "That was just the simple

Above: Springsteen and the E Street Band at the halftime show during Super Bowl XLIII, February 1, 2009.

Opposite: Bruce Springsteen and Billy Joel at the 25th Anniversary Rock & Roll Hall of Fame concert, Madison Square Garden, New York, October 29, 2009.

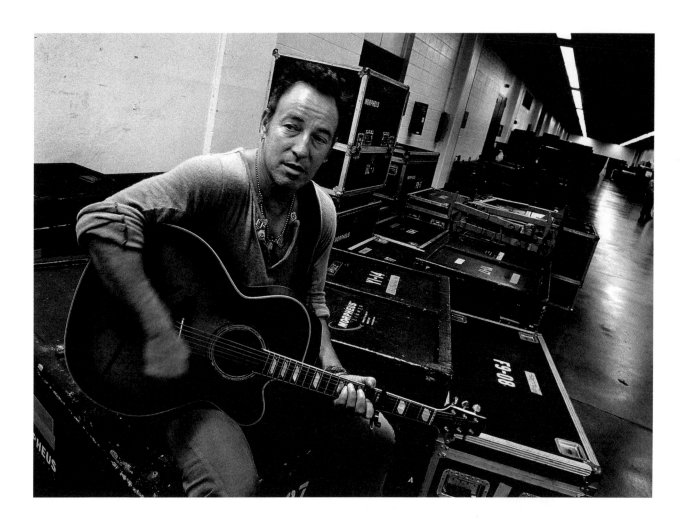

idea of effort," he said. "The ongoing daily effort to build something, and that you can't give up. I write my songs. I go around the world to sing 'em, about a particular place that I have imagined, that I have hopes is real. I don't see that often. A lot of what I see is the opposite—less economic justice, democracy eroded. Then, suddenly, election night. Suddenly the place you've been singing about all these years, it shows its face. You looked in the crowds, you saw people crying, people who lived and worked in the civil rights era, and you completely understood—it's real. It's not just something I dreamed up. It can exist."

QUEEN OF THE SUPERMARKET

In his regular visits to what he described as a giant new supermarket not far from his home (probably a Whole Foods store—the chain had been cropping up in New Jersey), Springsteen became convinced there was a sensual subtext to the store's endless, gleaming bounty. "It's like, 'Do people really want to *shop* in this store,'" he asked reporter Mark Hagen with a laugh, "'or do they just want to screw on the floor?'"

The result is an amusing, off-kilter character study about a customer obsessed with a checkout lady whose name he may not even know, with a vibe that modernizes Manfred Mann's "Pretty Flamingo." The setting and tone (a "twisted pop fantasia," I called it in 2009) seemed to rub uncomfortably against many listeners' expectations for a Springsteen song. "I don't know if I understand that song as well as he does," says O'Brien, "but it sounds great and he sings it beautifully, and I love the spooky ending."

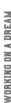
Above: Backstage at the Royal Farms Arena, Baltimore, November 20, 2009.

WHAT LOVE CAN DO

Springsteen wrote "What Love Can Do," a tight minor-key rocker with Byrds-inspired harmonies, in the final days of the *Magic* sessions, and it felt separate from what he'd been working on, like the first song of another album. At O'Brien's urging, Springsteen began a follow-up album sooner than he ever had before. "Patti said it, 'You are in a manic state, running like crazy from, let me think, death itself?'" Springsteen told Fricke. "It's a funny thing to say. But I've got a deadline! And that fire I feel in myself and the band—it's a very enjoyable thing. It carries an element of desperateness. It also carries an element of thankfulness." Recording what was supposed to be a rough vocal for the song, Springsteen sang so well on the first pass that O'Brien used the track, which meant he was also stuck with the loud acoustic guitar that went with it.

THIS LIFE

Springsteen's long-standing, although quiet, interest in outer space and cosmology slips out on this unusual track, which resembles the Walker Brothers' take on Bacharach/David songs but sounds like almost nothing in his own catalog. (He has said it uses chords never before played by the E Street Band.) "In the past, I was very often interested in making sure the band was a very tough rock band," Springsteen told me in 2009. "I could move away from that surface toughness and go, 'yeah I'm gonna make this big swinging, melodic ballad that uses the cosmos and stars as a metaphor for life and time and love.'" Or, as he told to Hagen, "At my age, I'm gonna make any kind of records I want."

GOOD EYE

On his tour behind *Devils & Dust*, Springsteen performed the occasional song (often "Reason to Believe") with his vocal mic running through his harmonica amp, creating an eerie, distorted Chess Records effect. "Good Eye," which Springsteen told his bandmates is "all about the groove," carries that concert approach into an original song, one of his few overtly bluesy compositions ("Ain't Got You" is also one.)

TOMORROW NEVER KNOWS

This gentle, loping track is one of Springsteen's most unabashedly Dylanesque moments. O'Brien was a fan and considers it of a piece, musically, with "Hunter of Invisible Game," which Springsteen worked on for this album but didn't release until 2014's *High Hopes*. The producer would have put that song high on his list for inclusion, but he didn't have any input on the track listing this time around. At some point in his work with most artists, O'Brien says, "everybody kind of gets to a point where they wanna start sort of doing their own thing more . . . they just get tired of getting told what to do a little bit. And no matter how loving and how much of a mutual thing it is, I think they kinda wanna start doing their own thing. And I think a lot of this record was, he was just starting to do more of that—and it was all good."

LIFE ITSELF

One of the best songs on the album, it's a deliberately claustrophobic take on alienation between lovers and fellow citizens alike, with some of the only psychedelic-rock sounds Springsteen has ever utilized. "It's a very oddball kind of arrangement," says O'Brien, who was impressed with how

> ## "THAT FIRE I FEEL IN MYSELF AND THE BAND - ITS A VERY ENJOYABLE THING."
>
> **BRUCE SPRINGSTEEN**

Springsteen arranged and performed the call-and-response backing vocals with Patti Scialfa. There's some "Eight Miles High"-style faux-sitar lead guitar, as well as backward solos from Nils Lofgren. "It was a very unusual thing to be doing," says Lofgren, who found it a challenge to his considerable technical skills. "It's not like I have a lot of experience at it."

KINGDOM OF DAYS

Springsteen had been with Patti Scialfa for twenty years around 2008, which led him to write one of rock's vanishingly few odes to longtime monogamy. "'Kingdom of Days' is something you write after having a long, long life with somebody," he told Fricke, "where you see how much you've built together. You also see its finiteness, the passing of the day's light on your partner's face."

"At certain moments," Springsteen told Hagen, "time is obliterated in the presence of somebody you love; there seems to be a transcendence of time in love. Or I believe that there is. I carry a lot of people with me that aren't here anymore. And so love transcends time. The normal markers of the day, the month, the year, as you get older those very fearsome markers . . . in the presence of love—they lose some of their power. But it also deals with the deterioration of your physical body. It drifts away, it's just a part of your life. But beauty remains. It's about two people and you visit that place in each other's face. Not just the past and today, but you visit the tomorrows in that person's face now. And everybody knows what that holds."

The song has a prominent, slightly syrupy string arrangement, but Weinberg—who calls it one of the best songs Springsteen ever wrote—said it sounded complete before the overdubs were added. He remembers recording it with the full band on the same day they tackled "My Lucky Day." In all, *Working on a Dream*, he muses, "would be an interesting album to hear stripped down, just the songs and a simple band. Like the Beatles did *Let It Be . . . Naked*. Not that I'm comparing records, I'm just saying."

Opposite: Springsteen wins the Super Bowl XLIII half time show, February 1, 2009.

Below: With fellow Kennedy Center honoree Robert De Niro. Pictured in the East Room of the White House, Washington D.C, 2009.

Overleaf: October 2005 photo shoot by Danny Clinch.

SURPRISE, SURPRISE

As Springsteen and Van Zandt recorded some of the many layers of backup vocals to this guileless, jangle-pop throwback (it starts with a birthday celebration), the frontman let out a whoop of joy. "That's very 5D, man," Springsteen said, referring to a favorite Byrds album, *Fifth Dimension*. "I remember with 'Surprise, Surprise,' it was Bruce and Little Steven, Patti, and me, all on one mic, surrounding him singing background," says Soozie Tyrell. Springsteen's former manager Mike Appel, who had never thought of his onetime client as a pop songwriter, was shocked when he heard the song, according to Springsteen biographer Peter Carlin. "That's surprisingly melodic," he told Springsteen. "I didn't think you had it in ya!"

THE LAST CARNIVAL

Danny Federici, who had played with Springsteen since the late sixties, died of cancer on April 17, 2008. "He was the first guy we ever lost," Springsteen told Hagen. After leaving the Magic Tour to pursue treatment, Federici walked onstage to play "4th of July, Asbury Park (Sandy)" one last time. "He wanted to strap on the accordion and revisit the boardwalk of our youth," Springsteen recalled, "during the summer nights when we'd walk along the boards with all the time in the world."

In "The Last Carnival," Springsteen eulogizes Federici by linking him with the title character of another song from the same album, "Wild Billy's Circus Story"—in the song, Billy is gone after a lifetime of adventures, too. "It started out as a way of making sense of his passing," Springsteen said. "He was a part of that sound of the boardwalk the band grew up with, and that's something that's going to be missing now." The song ends with a choir of Springsteen, Scialfa and Soozie Tyrell's layered voices, vaulting up to infinity. For a fallen comrade, as I wrote in 2009, it's one last opera out on the turnpike.

THE WRESTLER (BONUS TRACK)

Mickey Rourke asked Springsteen to write a full score for 2009's *The Wrestler*, which would've been an intriguing experiment—but the artist didn't have time, and had never scored a film. Springsteen wrote a song for the movie instead, finding psychological reality in the idea of a character who's built too much of his identity around pain and scars. The song includes what may be the most implausible, if effective, image in any of Springsteen songs: a "one-legged dog" somehow dragging itself down the street. Even the movie's director, Darren Aronofsky, wondered about that one, and the night Springsteen won a Golden Globe for the song, Aronofsky gently asked about the line. "Sometimes the art is in the mistakes," Springsteen told him. "The poetry is the mistakes."

A NIGHT WITH THE JERSEY DEVIL (ONLINE SINGLE)

A legit blues song, combining a full-on Muddy Waters riff with the same vocal treatment as "Good Eye." The song, released as a Halloween treat, tells the story of the Jersey Devil, an actual, creepy Garden State legend, playing it mostly straight, with the occasional wink, as when Spooky Bruce threatens to build himself a guitar "out of skin and human skull."

> **"IN THE PAST I WAS VERY OFTEN INTERESTED IN MAKING SURE THE BAND WAS A VERY TOUGH ROCK BAND."**
>
> **BRUCE SPRINGSTEEN**

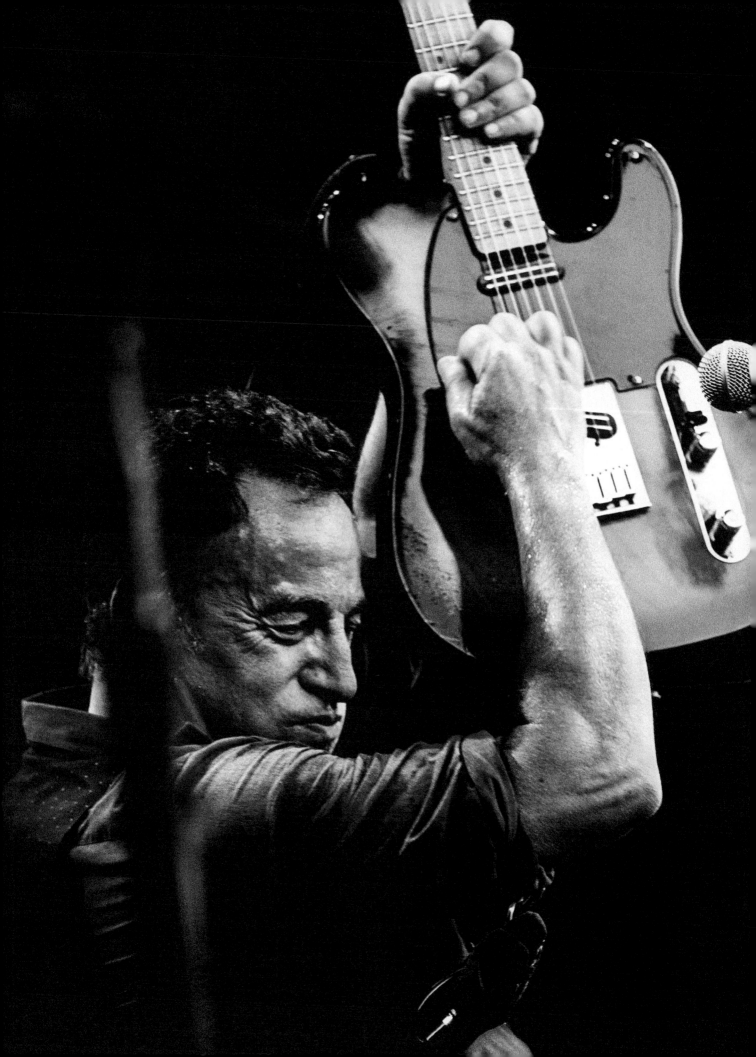

•

2012
WRECKING
BALL

•

WE TAKE CARE OF OUR OWN

Wrecking Ball is all about history repeating itself, so it's fitting, if ridiculous, that the album's opening track sparked "Born in the U.S.A."-style misreadings. More than one Bruce-phobic critic tried to paint its chorus as a jingoistic boast, but Springsteen shot back, "Whoever said that, they need a smarter pop writer." For anyone listening in good faith, the title phrase presents an ethos that's the opposite of the Reaganite "you're on your own," pitted against verses about a country falling entirely short of that ideal. There's also the lurking question of racial division—precisely whom would some Americans consider to be "their own," and who gets left behind? A reference to New Orleans' Superdome leaves little ambiguity—and it makes more sense when you learn that Springsteen wrote the song as early as 2009, when the memory of Hurricane Katrina was slightly fresher.

Springsteen lifted the opening guitar riff almost wholesale from "Mary Mary," a song he'd written earlier in the 2000s (but wouldn't release until 2014's *American Beauty* EP). Co-producer Ron Aniello recalls that Springsteen worried about one slightly dissonant note rubbing against the newer song's chords, but they left it in. As with almost all of the songs on *Wrecking Ball*, Springsteen and Aniello built the track in Pro Tools, layer by layer, in the sunny, well-equipped converted garage–studio on Springsteen's Colts Neck farm. "Patti putting the studio in has really changed his life," says Aniello. "He's never stressing about his music."

They began with a base of Springsteen's rough vocals and acoustic guitar, overdubbed everything else, and brought in outside musicians as necessary, following a modernized version of the solo-album process Springsteen

Previous spread: Springsteen rocks the Czech Republic. Prague, July 30, 2012.

Opposite: At the Stand Up For Heroes, New York Comedy Festival, November 8, 2012.

Below: Springsteen completing a soundcheck ahead of the first Australian show of his Wrecking Ball Tour, Brisbane Entertainment Centre, March 14, 2013.

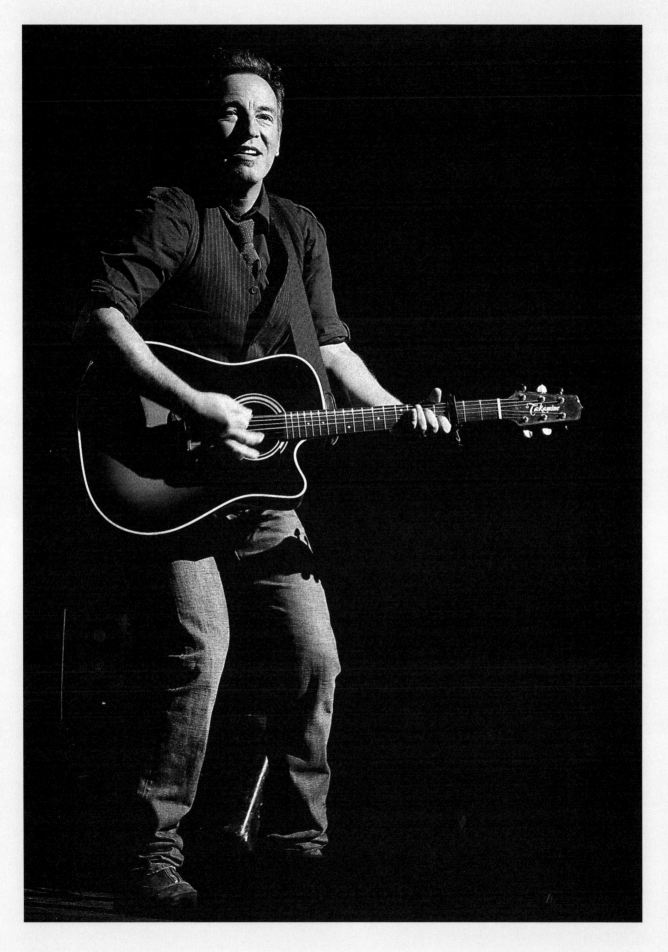

introduced with *Tunnel of Love*. The homespun approach left little danger of *Human Touch*-style slickness: On one of the many layered percussion tracks on "We Take Care of Our Own," Springsteen and Aniello play the same drum kit, live, simultaneously. "I think Bruce was playing the hi-hat and I was playing the kick and snare," says Aniello. "Because neither of us are great drummers." The four-on-the-floor beat of the verses isn't far from "Badlands," although Aniello also traces the album's recurring stomping rhythms to his fondness at the time for Adele's "Rollin' in the Deep." Overall, the track sounds much like the work of a modernized E Street Band, despite being anything but—and Aniello says they rejected a mix that had even stronger E Street vibes.

EASY MONEY

The *Wrecking Ball* songs arrived in the wake of another, less visceral, more orchestral set of tracks ("Grand Canyon music," as Springsteen described the project to one musician) that Springsteen had been working on with Aniello. Aniello, a tireless, digital-savvy, multi-instrumentalist producer recommended by Brendan O'Brien, initially visited Colts Neck to work with Patti Scialfa. He ended up staying in Jersey for months at a time, giving Springsteen a full-time, on-call producer on his own property for the first time in his career. "Easy Money" was the first of the new songs, and it arrived without warning. In early 2011, after finishing a day's worth of recording for his other project, Springsteen went out for a drink and found himself singing the opening lines on the drive home. Aniello and then-assistant engineer Rob Lebret were wrapping up for the evening and had locked the studio door. Their boss showed up outside, so eager to get in that he almost broke the doorknob. He picked up a guitar, got in front of a microphone, and said, "Just roll it! Just go," before breaking out a half-mumbled rough version of the song, a deceptively rousing tale of a small-time crook aping the larger-scale theft of the kind of criminals who wear suits and ties.

Springsteen demonstrated the song's syncopated beat by thumping it out with his hands on Aniello's back. The producer asked him to scratch it out on a muted acoustic guitar instead and built the loop that drives the song over it. Aniello wanted to layer in the stomps from Queen's "We Will Rock You," a common sample, but Springsteen nixed it. Instead, Aniello says, "we built a platform and we're all stomping on it. If we were gonna use samples and loops, they were gonna be organic." (Springsteen also jokingly banned the very mention of Queen, saying "these are *princess* stomps.") Springsteen—always full of counter-melody ideas—composed rough string lines for the song, which arranger Rob Mathes built into a full arrangement. Aniello played the guitar solo that blazes in after the first verse, creating a nasty fuzz sound with the same straight-into-the-board technique John Lennon used on "Revolution."

SHACKLED AND DRAWN

For the narrator of what Springsteen described as akin to a "slave song, a field chant," the real prison is unemployment—without work, they're trapped in a void of purposelessness. Meanwhile, the party up on "banker's hill" is raging. Springsteen wrote both this song and "Rocky Ground" for what he described in his memoir as a "gospel film project." In 2016, when I asked him to elaborate, he demurred, explaining that he's still hoping the movie will come out. Aniello had little idea which songs were new and which were older;

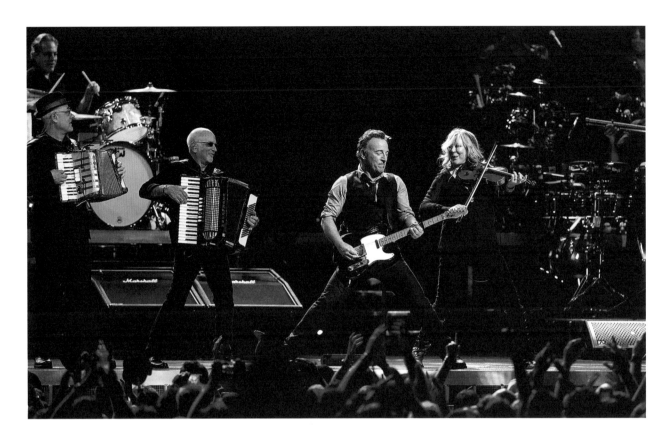

the gospel project seems to have predated his involvement and was separate from the batch of orchestral songs that directly preceded *Wrecking Ball*. The beat in "Shackled and Drawn" is built off Springsteen's percussive acoustic part (in this case, actually included at the beginning of the track), and the overdubs include a banjo playing something very much like power chords. The churchy, spoken-word part at the end draws on "Me And My Baby Got Our Own Thing Going," by James Brown protégée Lyn Collins.

JACK OF ALL TRADES

Springsteen wrote this tale of a displaced worker in one furious blast, circa 2009. You can feel the narrator slipping down verse by verse, from half-believed assurances that he'll find work; to hopes of a world remade after a cleansing flood, where people will actually follow the teachings of Jesus instead of just talking about them; to hungry, murderous desperation, as he threatens to shoot "the bastards" who left him behind. Springsteen described this character as a "resilient voice," but in the end it's hard to hear anything but justifiable despair—even the nihilistic narrator of "Reason to Believe" might tell this guy to cheer up. Springsteen arranged a horn part to evoke a Salvation Army-like, 1930s feel; throughout the album, the idea is to emphasize historical recurrences, the idea that these events have happened before and will happen again. The song seems like it's over when former Rage Against the Machine guitarist Tom Morello—he of the "Arm the Homeless" guitar sticker—storms in for the kind of coda Springsteen had rarely attempted since "Racing in the Street." The anger and frustration of Morello's solo is set against an elegiac trumpet part from Curt Ramm in the opposite channel. Morello was in New York to play at the Occupy Wall Street protest in Zuccotti Park when he got a call from Springsteen to come to Colts Neck and rework an earlier part he'd recorded remotely for "Jack of

> **"WE BUILT A PLATFORM AND WE'RE ALL STOMPING ON IT. IF WE WERE GONNA USE SAMPLES AND LOOPS, THEY WERE GONNA BE ORGANIC."**
>
> RON ANIELLO

Above: The E Street Band's accompaniment in full swing during a Wrecking Ball Tour show in Sydney, 2013.

Opposite: Performing at South By Southwest Music Festival, Austin, Texas, March 15, 2012.

All Trades." "I played more of a frenetic solo," says Morello, "and he requested 'something more elegant.' I went out to the farm, the studio out there, and spent the afternoon working on 'Jack of All Trades' and a couple of other songs that I don't think have seen the light of day yet, but 'Jack of All Trades' was sort of the main focus. I did a number of passes, and Bruce conducted. We got something that, at the end of the day, felt pretty elegant."

DEATH TO MY HOMETOWN

Springsteen was all of ten years old in 1959 when folklorist Alan Lomax stepped into a church in rural Alabama with stereo recording equipment. His aim was to capture the "fiery choral sound" of "white spirituals" known as Sacred Harp singing, after a favored hymnal. It's an eerie sound of curious power, unearthly yet rooted in the American South. One of the songs he recorded, the mournful "The Last Words of Copernicus," draws on what Lomax called "an old folk melody," probably Celtic in origin. One day, decades later, in his home studio, Springsteen gave Aniello a recording of the song, explaining that he had an idea to go with it. Writing over a sample was an impressive new trick for a sixty-something rock legend to pick up, although it's probably not that different from a long-ago interpolation such as the horn riff in "E Street Shuffle." Springsteen strummed a chord progression, and Aniello chopped up and heavily altered a segment of "Last Words" to match. They played up the Irish tinges to the sample, adding penny whistle, accordion, hurdy-gurdy parts and trills from an exotic instrument known as a Hammerchord, all following one of the melodies hidden in the antique four-part harmonies. They also added Matt Chamberlain's drums, augmented by Aniello's drum samples (which included a giant contrabass drum used on the Sessions Band Tour). Even Springsteen's lyrics take on the syntax of an Irish folk ballad ("no cannonballs did fly") as they tell the tale of "robber barons" wreaking more havoc than any foreign invader ever could. "I called on a lot of roots and Celtic elements, because I use the music to give the story a historical context," Springsteen told Jon Stewart. "'Death to My Hometown' sounds like an Irish rebel song, but it's all about what happened four years ago. I want to give people a sense that this is . . . a repetitive, historical cycle that has basically landed on the heads of the same people."

THIS DEPRESSION

This unusual song, which puts perhaps too much weight on the double meaning of "depression," is built around big, eighties-sounding drums played by Springsteen himself, layers of Morello's guitars, a choir of synths and organ played by Aniello and an inventive, ghostly backing vocal arrangement created by Scialfa. (Aniello, who thinks he may have bolstered the drums with actual eighties-era samples, also stuck in a rhythm guitar part inspired by U2's "One.") Springsteen gives one of his most anguished vocal performances—he sounds practically close to tears at points—and the lyrics may be his most direct account of his own clinical depression until the release of his memoir, not that anyone realized it at the time. The image of witnessing a bleak dawn after a sleepless night is straight from his own life. And with its talk of unanswered prayers, it marks the emotional low point of the album, before it swings toward hope and defiance. In Springsteen-ian archetypes, the album's first half is the blues, the second is gospel. Or to oversimplify even further, side one is his dad—economic marginalization, emotional chaos. Side two is his mom: hope, faith, joy.

> " **DEATH TO MY HOMETOWN**' SOUNDS LIKE AN IRISH REBEL SONG, BUT IT'S ALL ABOUT WHAT HAPPENED FOUR YEARS AGO. "
>
> **BRUCE SPRINGSTEEN**

Above: Springsteen at the Oracle Arena in Oakland, California.

Opposite: Springsteen during the Wrecking Ball Tour with Nils Lofgren and Charlie Giordano.

WRECKING BALL

And here's the defiance. Springsteen debuted "Wrecking Ball" back in 2009, when he and the E Street Band played the last dates at the old Giants Stadium, but in an unusually playful rhetorical twist, he sings from the point of view of the stadium itself. What could have been a throwaway ends up as something unique: A great rock anthem fit for a sixty-one-year-old man, built out of a shout in the face of mortality and obsolescence. The original live arrangement, a nod to Arcade Fire, came together during a soundcheck with the band—"like the old days," according to Steve Van Zandt. So for the album version, which adds some rhythmic reinvention, they tracked live, with Max Weinberg on drums, Aniello on bass, and Charlie Giordano on keyboards. There was some discussion of tweaking the lyrics to remove the stadium motif, but that didn't fly. Aniello also made his first and only lyrical suggestion of his time with Springsteen: "I said, 'You're saying: raise your glass—maybe you should say raise your fist.' He's like, 'Thank you. I'll take that into consideration.' And I go, 'Okay, do it again.' And he does, and he doesn't sing it." Aniello laughs. "I was the biggest idiot."

YOU'VE GOT IT

It may be a pure palette cleanser, a distant musical cousin of "All or Nothin' at All" and "Glory Days" (check the horn section riff). "It's the only song that had nothing to do with the concept of the record," argues Aniello. "It's really just to break it up." Introducing the song in a rare live performance, Springsteen offered a physics lesson to a bemused stadium crowd, comparing the ineffable

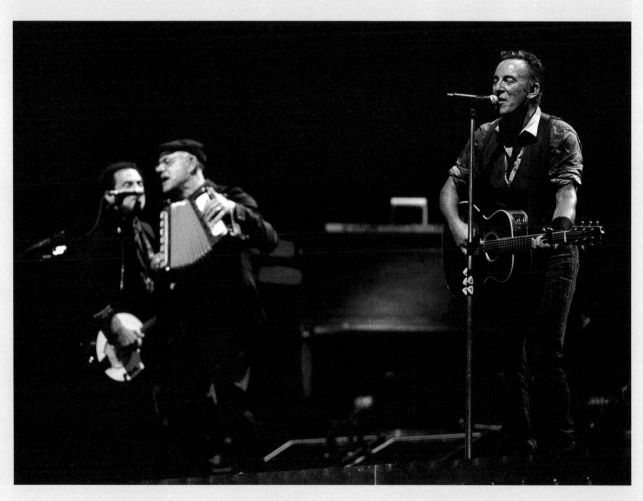

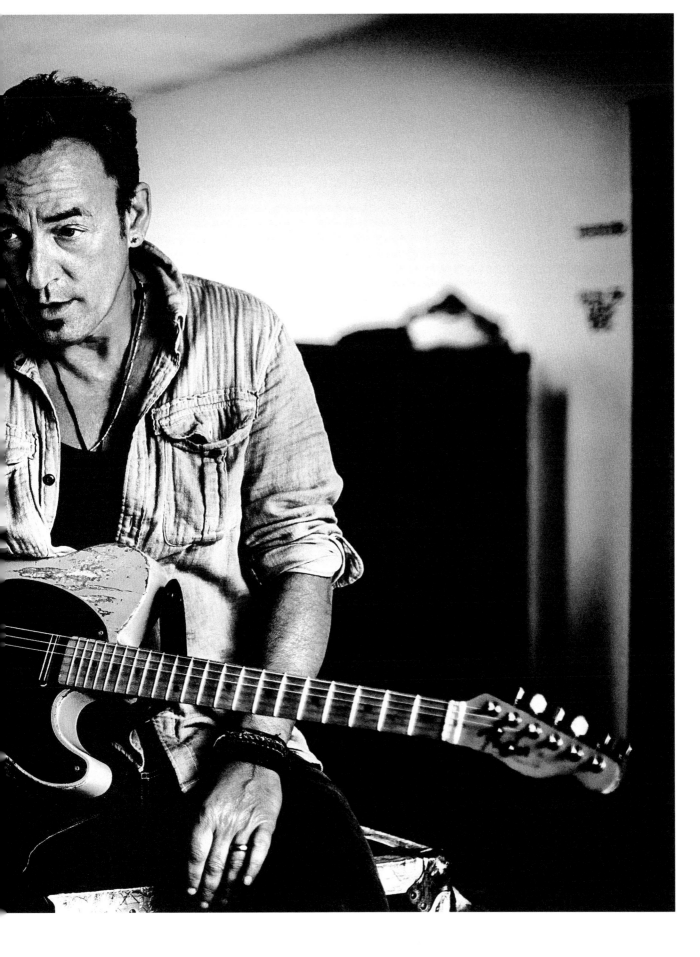

"it" of the title—basically sex appeal, soul, charisma—to the elusive Higgs boson particle, which had just been found by scientists in Switzerland via the Large Hadron Collider. "It's the particle that makes sure there's mass in your ass," Springsteen said. "It's the particle that makes everything solid somehow. They found it in the big machine. The Swiss! The big long tunnel that they shoot the particles around. So one of the biggest mysteries of science has been slightly solved for the moment. But life has many more mysteries than that. Because they can name the Higgs boson, but what I'm about to sing about is unnameable. It is unknowable, it's indescribable. It's just what it is." The blogger Jonathan R. Lack suggests that Springsteen is actually singing about the miracle of the human soul, which leads nicely to the triumvirate of spiritual songs that follow.

ROCKY GROUND

A mysterious, singular song that picks up the spiritual longing in "Jack of All Trades," "Rocky Ground" has a wide-screen sound suitable for the opening credits of whatever Springsteen's gospel film turns out to be. A loop of churning amp vibrato melds with an electronically altered cabasa part and drums played by Aniello to build the layered beat, bolstered by a sample of someone who is not Springsteen—but who sounds a lot like him—shouting "I'm a soldier." The line is from the gospel standard "I'm a Soldier (In the Army of the Lord)," but it's maddeningly hard to determine which recording; the liner notes credit a 1942 version that doesn't match what we hear. (It seems safe to say that Springsteen noted the line's melodic similarity to the chorus of "Soul Man.") Springsteen also played wah-wah rhythm guitar, a sound that is rare in his catalog ("Missing" might be the only other appearance).

Previous spread: A photo shoot for the *New Yorker* shows Springsteen enjoying a quieter moment between shows in Prague, Czech Republic, July 2012.

Below: More than 3.3 million fans across 26 countries—a record for Springsteen—attended the Wrecking Ball Tour worldwide.

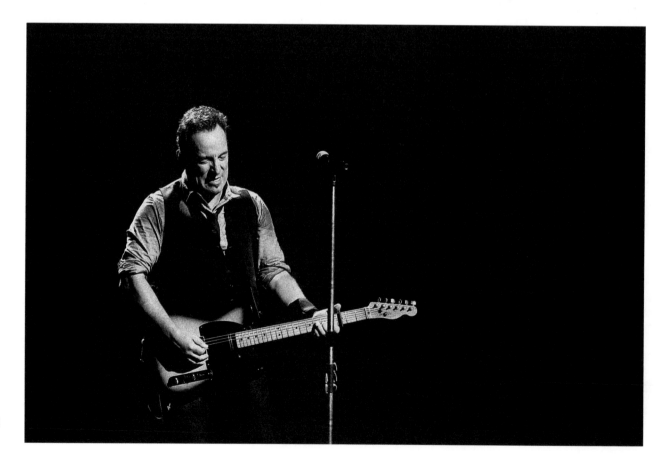

The highly abstract lyrics, mashing up Old and New Testament references, are inspired by the spiritual "Rise Up, Shepherd and Follow" and seem to function simultaneously as a prayer and a meditation on prayers' possible futility. Springsteen wrote a low-key rap section (it's closer to spoken-word, really, with a quick allusion to Stephen Foster's "Hard Times Come Again No More"), and Aniello pitched numerous ideas for guest vocalists, from Al Green to Nas. In the end, Springsteen selected the young, local gospel singer Michele Moore (also on "Let's Be Friends"), who sings the chorus throughout in her sweet, unadorned soprano, dropping the final "d" from "ground." She had never rapped before, leaving Aniello to heavily edit her performance afterwards. (Aniello still has the demo track of Springsteen himself rapping.) The rap ends with an image of silence where God should be—and yet another bleak dawn. But when Moore's delivery of the chorus is joined by a choir for the first time, suggesting the power of collective action, transcendence kicks in anyway.

LAND OF HOPE AND DREAMS

When Springsteen reunited the E Street Band in 1999, he felt like their tour needed a new song, something big and summational. During rehearsals at Asbury Park's Convention Hall, he kept thinking of his band as a "big train coming down the track," which reminded him of some unfinished lyrics in his notebook. He drew on the Impressions' "People Get Ready" and the gospel standard "This Train," but he inverted the latter song's lyrics: His train isn't just for the righteous, but for sinners, whores, and gamblers, too. "Land of Hope and Dreams" became an instant staple of E Street shows, with a long drum break by Max Weinberg and a climactic solo by Clarence Clemons that felt like a prayer in its own right. (Springsteen lifted the song's signature mandolin riff from a part he'd played on his friend Joe Grushecky's 1995 song "Labor of Love.") The lyrics are an enchanting fantasy of "that place where we really want to go," as he put it long before, a place where "dreams will not be thwarted . . . faith will be rewarded."

When he needed a song to follow "Rocky Ground," Springsteen came up with the idea of finally putting down a studio version of this live favorite. He and Aniello listened to a concert version, probably the one on 2001's *Live in New York City*, and Springsteen shook his head. "He goes, 'let's not ever listen to that again,'" Aniello recalls. "Because it was just too magnificent."

Aniello didn't realize how much fans loved the original song, so he took liberties. "I changed the beats and stuff," he says, adding some blatant electronic drums at the beginning and having Matt Chamberlain play a "funkier" drum part. Springsteen had always wanted Clemons to come in and play on the studio version, but the saxophonist wasn't feeling well and postponed his trip to New Jersey. Soon afterward, Clemons suffered a massive stroke and slipped into a week-long coma. Springsteen flew to Florida to sit at his side, strumming "Land of Hope and Dreams" on a guitar during his old friend's final moments.

Aniello went to work, splicing and altering Clemons's sax from a live version—in a different key and tempo—to make it work with the new recording. Springsteen had no idea the addition existed until they were mixing, and he mentioned that the track would always be missing Clemons's part. "I have that for you," Aniello told him, and put it on. As the saxophone played, Springsteen cried.

> "HE GOES, 'LET'S NOT LISTEN TO THAT EVER AGAIN,' BECAUSE IT WAS JUST TOO MAGNIFICENT."
>
> RON ANIELLO

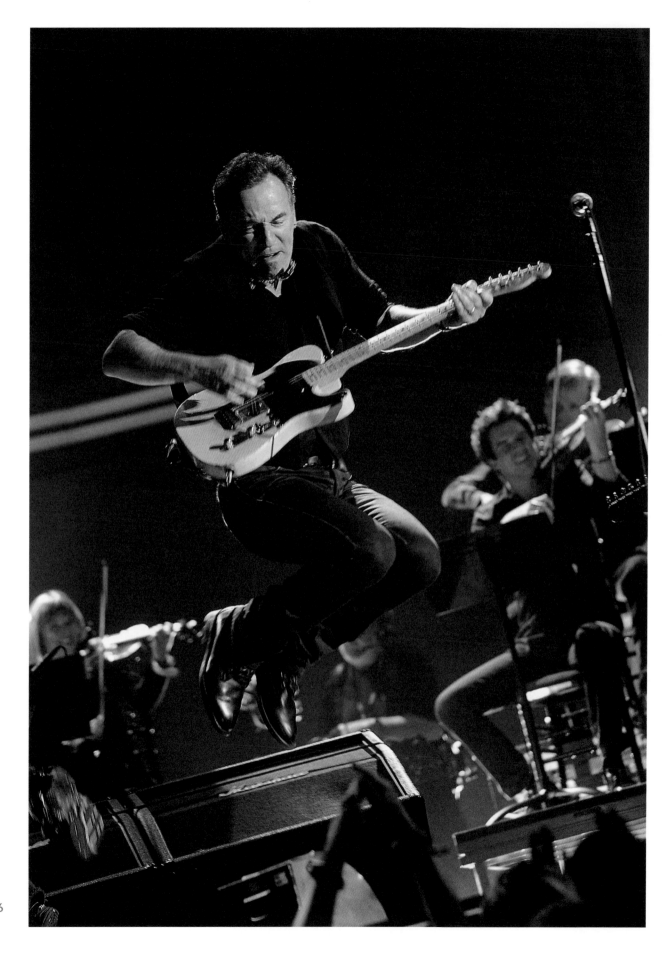

WE ARE ALIVE

"I needed one more song—I needed a strange kind of party," Springsteen told Jon Stewart. "And 'We Are Alive' provides that. It's a party filled with ghosts . . . whose voices and spirit and ideas remain with us and go on and on. That's why I talk about the girls in Birmingham, the workers in Maryland, and the new immigrants crossing the southern border. It's just the recurrence and how the blood and spirit of all those people regenerate the country and what America is, generation after generation." The version on the album is countrified, with a riff that draws on "Ring of Fire," beginning with a fade-in of Springsteen whistling Johnny Cash's standard. He wanted it to sound like he was coming "out of the darkness," much like the ghosts in the narrative. But there were at least two alternate versions, including an early one that Aniello describes as "punk rock," with Weinberg on drums. He plays part of it for me: It starts acoustically and then rocks hard, sounding not unlike the studio version of "American Land." "I've got to remember to play that one for Bruce," says Aniello, who also tried including an actual "Ring of Fire" sample on one version but hesitated to even play it for Springsteen.

SWALLOWED UP (IN THE BELLY OF THE WHALE) (BONUS TRACK)

Springsteen recorded the vocals for this underrated song in almost total darkness, and you can hear it. The track has the feel of a malevolent bedtime story, with Charlie Giordano's accordion evoking a haunted carnival. The lyrics, again written in impressively dead-on nineteenth-century syntax, recount a sailor's vivid nightmare of being consumed, Jonah-style, in a journey into the "belly of hell," as the Bible would put it. It could be read as a metaphor for economic displacement, but it's more effective as a stand-in for depression and emotional isolation. The arrangement sounds like little else in Springsteen's catalog, and the twelve-string acoustic part that drives the song is slightly out of tune, which drives Aniello slightly nuts to this day.

AMERICAN LAND (BONUS TRACK)

Springsteen debuted "American Land" in 2006, live with The Seeger Sessions Band, and it became an E Street staple, too. It was inspired by "He Lies in the American Land," a poem by the steelworker Andrew Kovaly (in his native Slovakian) set to music by Pete Seeger on the album *American Industrial Ballads* (not a bad alternative title for *Wrecking Ball*). Springsteen applied the same alchemy he used on Tom Waits's "Jersey Girl," stripping the song of its darkness and finding a populist anthem inside it.

The original live version owed a substantial debt to the Pogues' "Sally MacLennane." This studio recording—recorded live with Weinberg on drums, Aniello on bass, and Giordano on keyboards—plays up the Celtic-punk vibe, evoking Springsteen's Dropkick Murphys fandom as well, abetted by a drum loop that Aniello compares to M.I.A.'s "Paper Planes."

> **"IT'S JUST THE RECURRENCE AND HOW THE BLOOD AND SPIRIT OF ALL THESE PEOPLE REGENERATE THE COUNTRY AND WHAT AMERICA IS, GENERATION AFTER GENERATION."**
>
> BRUCE SPRINGSTEEN

Opposite: Onstage, Springsteen continues to prove it all night.

•

2014

HIGH
HOPES

•

HIGH HOPES

The Havalinas, a short-lived L.A. folk-rock band, got some play on MTV's Sunday-at-midnight "alternative" show 120 Minutes for their strummy, syncopated anthem "High Hopes" in 1990—around the time Springsteen was spending late nights at home as a new dad. It had a distinctly Bruce-y melody and lyrical approach ("Give me help, give me strength . . .") and the obscure song stuck in Springsteen's head long enough that he recorded it with the E Street Band during 1995's *Greatest Hits* sessions. Years later, Tom Morello was about to embark on a fill-in tour stint for a temporarily absent Steve Van Zandt when he heard that version on SiriusXM's E Street Radio. He texted Springsteen, "I could really jam on that," and it made the set. On a day off in Australia, Springsteen brought the entire E Street Band—which at that point included a horn section, background singers, and a percussionist—to record in a studio owned by producer Brendan O'Brien's former engineer Nick DiDia. They blazed through two strong takes of "High Hopes," and Springsteen let the band vote on which to keep. Morello remembers recording his extensively overdubbed "guitar shenanigans" late into the night, well after Springsteen left.

Previous spread: Springsteen at a press conference at Perth Arena, February 5, 2014, before beginning a tour of Australia with the E Street Band.

Left: Bruce Springsteen and Tom Morello perform onstage at the 2013 MusiCares Person of the Year Gala; Springsteen was the person of the year. Los Angeles Convention Center, February 8, 2013.

The song became the title track of an unusual Springsteen album: the only one in his catalog mostly recorded on the road; the only album besides 2006's *We Shall Overcome: The Seeger Sessions* to include more than one cover song; and certainly the only Springsteen album with Tom Morello shredding all over it. Almost all of the other tracks are revamped outtakes from the 2000s, along with two highly familiar songs, "American Skin (41 Shots)" and "The Ghost of Tom Joad." "It's a bit of an anomaly," Springsteen told Andy Greene, "but not much."

HARRY'S PLACE

An oddball outtake (apparently written before *The Rising* and recorded for *Magic*) that seems to function, in part, as another of Springsteen's coded denunciations of the Bush administration, this time painting them as cartoonish gangsters. Springsteen said that it was Brendan O'Brien who heard a piano version of the song and turned it into a "rhythmic thing." But O'Brien himself isn't crazy about the jarring, funk-noir, Tom Waits-meets-*Miami Vice* result. "It didn't quite work," he says. "They're not all perfect, they're not all incredible. That one got left off, and I thought that was a good plan."

Springsteen didn't give up, working with Ron Aniello to add to the O'Brien recording. The more outré aspects of the arrangement, including the relentless gated bass part, were already present on the O'Brien version. Letting Morello loose on the track was the final step. "Bruce just wanted a bunch of noise on it," says Aniello. "And Tom supplied the noise."

"It's dark and crazy in a *Sopranos* kind of way," says Morello, who worked on the track with Aniello in Los Angeles, after which the producer chopped up his performance from various takes. "Lyrically and musically, I don't even know how to describe it. I wanted to inhabit the chaotic, dark world that's in that lyric."

If there is pleasure to be had in this strangest of Springsteen recordings, it's getting to hear him growl lyrics about a doorman who asks visitors "who the fuck you are," not to mention the line "you don't fuck Harry's girls."

AMERICAN SKIN (41 SHOTS)

"American Skin" is a Black Lives Matter anthem written fourteen years before the movement got its name. Shortly after midnight on February 4, 1999, four New York City police officers saw Amadou Diallo, a twenty-three-year-old immigrant from Guinea, and cornered him in a vestibule, later claiming that he resembled a suspect in a serial rape case. Diallo, unarmed and innocent, may have taken his wallet out of his pocket. The officers fired at Diallo, forty-one times; nineteen bullets tore through his body.

Springsteen, who already had some lines about "American skin" in his notebook (focusing on "an entirely different subject I was thinking about") took note. "The sheer number of shots," he wrote, "seemed to gauge the size of our betrayal of one another." Just before Springsteen and the E Street Band were set to conclude their reunion tour with a series of shows at New York City's Madison Square Garden, they debuted "American Skin (41 Shots)," right after a version of "Point Blank" during a show in Atlanta, Georgia, on June 4, 2000. An audience recording of the song hit the then-burgeoning pirate service Napster, and the *New York Post* began publishing story after story about the track. The song, as Springsteen later wrote, is about the effects of systemic racism—he shows the cops kneeling over Diallo's body, "praying for his life"—but that's not how the NYPD heard it. Diallo's mother, Kadiatou

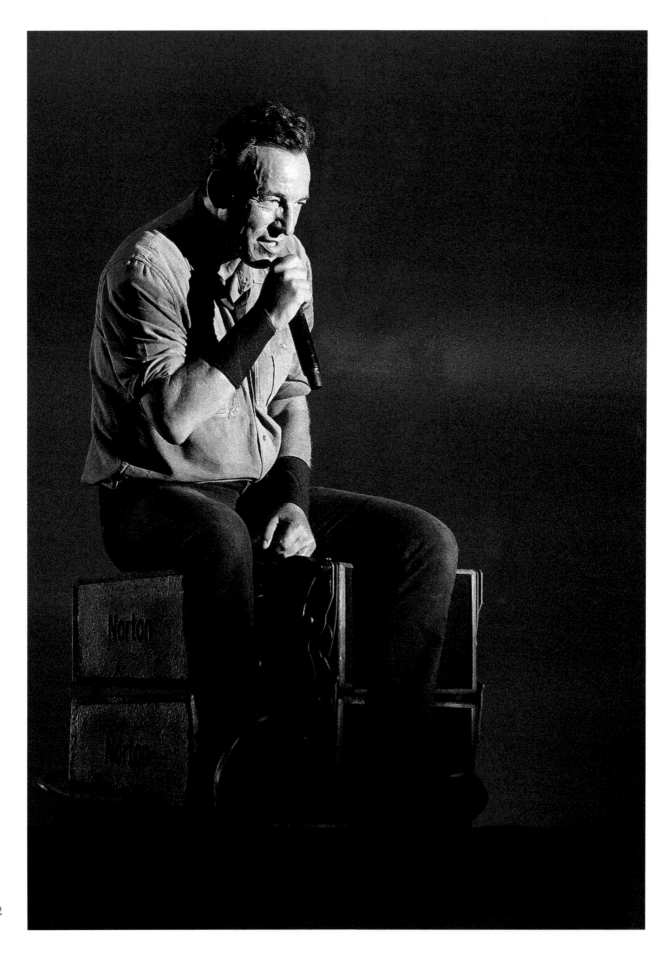

Diallo, was grateful for the song. "It keeps his memory alive," she said.

The controversy crested after a reporter for the music website SonicNet phoned Bob Lucente, president of the New York chapter of the Fraternal Order of Police. The reporter (who happens to be the author of this book) had already written stories about that organization's aggressive boycott campaigns against a wide range of other musicians, including Rage Against the Machine. Lucente felt especially betrayed by criticism from someone he seemed to have imagined was a right-wing supporter, and he lashed out at Springsteen during the interview. "He's turned into some type of fucking dirtbag," Lucente sputtered on the phone, adding, "he has all these good songs and everything, American-flag songs and all that stuff, and now he's a floating fag. You can quote me on that."

Those quotes went everywhere, prompting Springsteen to joke, years later, that the "floating fag" comment sent him to the dictionary. By the time the New York shows rolled around, there was genuine tension at Madison Square Garden. The band played the song ten nights in a row in New York City—to cheers and boos. At the first Garden show, I watched a man keep his middle finger raised high throughout the song; he later identified himself as a retired New York City police officer.

In the end, Springsteen wrote, "I received a small plaque that year from our local NAACP, and I was always glad that the song brought me just a little closer to the black community I always wish I'd served better." It was also a reminder, even to its creator, that after a few years in the pop-culture wilderness, Springsteen's music could still kick up a fuss, especially with his band behind him. He was, literally, back in the arena, and the stage was set for the noisy decade that followed.

In 2012 and 2013, Springsteen dedicated several performances of "American Skin" to Trayvon Martin, an unarmed black teenager shot dead in Florida, whose killer was acquitted. That led to the studio revival of the song for *High Hopes*. Aniello cut the basic track in an L.A. studio, holding down bass in a trio with Morello and Weinberg—they played to a live-in-concert vocal and rhythm guitar part from Springsteen that Aniello selected.

"A lot of times I trust my instincts, and the first take is the best take, and what I intuitively do on a track I trust," says Morello, whose best solo on the song has a soaring quality that lands somewhere between Eddie Van Halen and Clarence Clemons, "but that one I spent a lot of time on. I love that song from when Bruce first played it in 2000, and we had discussions about it—I'm no stranger to having law enforcement be critical of my recorded work. It's a really beautiful, deep song about America. I wanted to get the solo right on it. I was really frustrated, and I spent a lot of time *not* getting it right. Took a break, and went up there late at night, and then the next thing that happens was that melodic solo for it. I felt, okay, this may do the song justice."

There are many, many overdubs on the studio version: backward piano, backward guitar, Little Steven's guitar through a rotating Leslie speaker, drum loops, synths, percussion. Listening back in 2018, Aniello thinks he may have overdone it. "You don't really need any of it," he says. "This is so overproduced. Just trying too hard. I'm ashamed of myself." He laughs. "Just a case of just going a little too far. Not him, me. I'll take the blame. I wanted to make a masterpiece, because I thought the song was so good. And sometimes, you just try too hard, you know? But thank God the song's good enough to stand up against my abuse."

> ## "I WAS GLAD THAT THE SONG BROUGHT ME JUST A LITTLE CLOSER TO THE BLACK COMMUNITY I ALWAYS WISH I'D SERVED BETTER."
>
> **BRUCE SPRINGSTEEN**

Above: Amadou Diallo, an African immigrant, was returning to his home when four members of New York City's Street Crime Unit fired 41 bullets, killing Diallo. He was 22 years old.

Opposite: Springsteen on stage during a concert in the Rock in Rio Festival, September 21, 2013 in Rio de Janeiro, Brazil.

JUST LIKE FIRE WOULD

For local flavor, Springsteen was playing this 1986 song by Australian band The Saints on his tour of the country, and he ended up recording the track with the full band during their visit to DiDia's studio. It's similar to the original song, and, if anything, it's refreshing to hear a straight-ahead E Street Band performance in a period filled with studio experiments. "I always loved The Saints," Springsteen said in an E Street Radio interview. "It was just an enjoyable song to play. It had the great guitar riff and there were just places where the band just sat into it so naturally."

DOWN IN THE HOLE

An outtake from *The Rising* that was left off for reasons of thematic redundancy rather than musical quality—O'Brien likes this one. It hits 9/11 from yet another angle, with a harrowing tale of digging though Ground Zero for the remains of a loved one. It is almost certainly based on the real-life stories of the likes of retired firefighter Lee Ielpi, who scoured the rubble for ninety-one days after the attack until he found the body of his son, a twenty-nine-year-old firefighter named Jonathan. The eerie backing vocals are arranged by Patti Scialfa, who enlisted the help of her and Springsteen's then-preteen kids: Evan, Sam, and Jessica Springsteen.

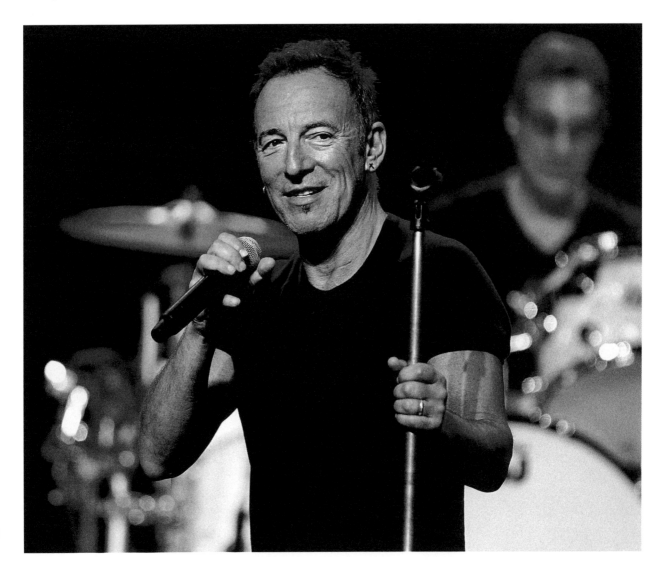

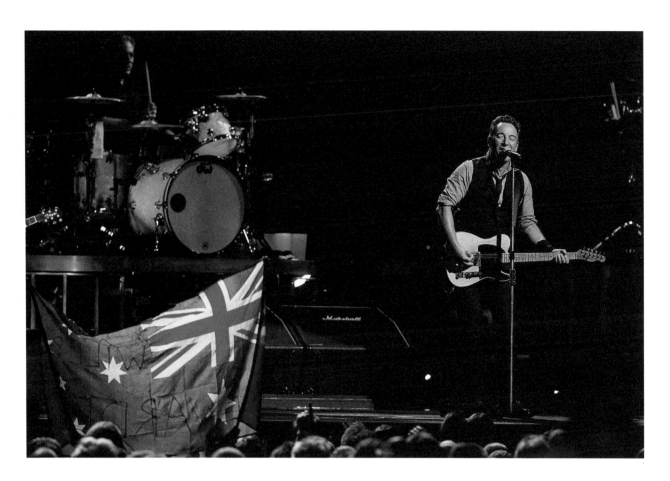

HEAVEN'S WALL

The lyrics draw on the spiritual "Joshua Fit the Battle of Jericho," recorded by Elvis Presley and Mahalia Jackson, among others—yet another confirmation of how deeply Springsteen was digging into gospel. "To me, it felt like a seventies rock song or something," Springsteen said on E Street Radio. The dueling guitar solos are actually both played by Morello. "It's a guitar competition with myself," he says.

FRANKIE FELL IN LOVE

An instant, why-not-a-whole-album-like-this favorite, with a feel so indebted to the Faces and early solo Rod Stewart that Aniello tried to squeeze in the actual "Maggie May" bass line until Springsteen nixed it. Although the vocal interplay between Springsteen and Steve Van Zandt may sound live, Van Zandt recorded his parts on his own and e-mailed them in—and the whole song was built over one of Springsteen's solo demos instead of being played live from scratch. One line describes love as when "one and one make three," an idea half-borrowed from Springsteen's speech inducting U2 into the Rock and Roll Hall of Fame, where he praised the rock 'n' roll math of Bono's "uno, dos, tres, catorce" intro to "Vertigo."

THIS IS YOUR SWORD

"We're gonna add bagpipes pretty soon—and a bugle," Springsteen promised a reporter back in 1973. The latter instrument never showed up, but Clarence Clemons was an occasional bagpipe player. (A 2002 attempt to spotlight them onstage ended in farce: after a solemn intro to "Into the Fire," Clemons knocked over a mic stand with his pipes, sending his bandmates into hysterics.)

Above: 2013 MusiCares Person of the Year, an award show honoring Springsteen, Los Angeles Convention Center, February 8, 2013.

Opposite: Soundcheck before a concert at the Perth Arena, Australia, February 5, 2014.

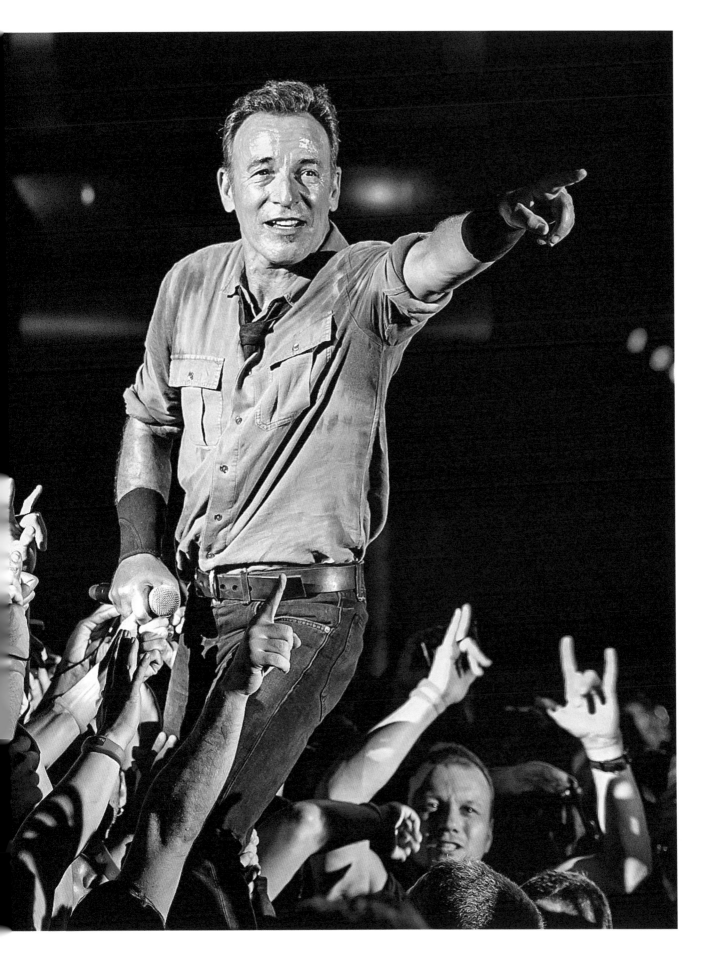

Without Clemons on hand, Springsteen and Aniello had to find a session piper to play the Celtic fanfare of "This Is Your Sword." They ultimately opted for a professional instead of Springsteen's original suggestion. "It's St. Patrick's day, I'm sure a bunch of those fuckers are out there drinking and marching," he told Aniello. "Just go get somebody!" The song itself is best understood as a father's advice to his kids as they head into the uncertainties of adulthood. Both the sword and shield, the lyrics make clear, represent "the power of love revealed."

HUNTER OF INVISIBLE GAME

Into-the-mystic Bruce is rare and precious; waltz-time Bruce, even more so. With its image-packed tour of some post-apocalyptic land, "Hunter" evokes both Bob Dylan's "A Hard Rain's A-Gonna Fall" and Cormac McCarthy's *The Road*, with the Old Testament ("gopher wood") and maybe a little Stephen King thrown in. It's one of Springsteen's best songs, serving as a late-life mission statement. The title is pinched from the gorgeous "Wean Yourself," by the thirteenth-century poet Rumi: "Little by little, wean yourself," Rumi wrote. "This is the gist of what I have to say/ From an embryo, whose nourishment comes in the blood/ Move to an infant drinking milk/ To a child on solid food/ To a searcher after wisdom/ To a hunter of more invisible game." Weinberg has fond memories of thumping a giant bass drum when the band originally recorded the track (for *Working on a Dream*, produced by Brendan O'Brien)—the drummer believes the track originally had a different title.

A short film co-directed by Springsteen with Thom Zimny literalizes the narrative (and adds an intriguing five-minute-plus instrumental score that rides right into the song). But "Invisible Game" is perhaps best understood as spiritual autobiography: It's about what Spanish Johnny of "Incident on 57th Street" was seeking "on the street tonight," it's that "place where we

> ❝IT'S ST PATRICK'S DAY, I'M SURE A BUNCH OF THOSE FUCKERS ARE OUT THERE DRINKING AND MARCHING.❞
>
> BRUCE SPRINGSTEEN

really wanna go" from "Born to Run," it's the title phrase in "My Beautiful Reward." "It's a metaphor for your discomfort in some way," Springsteen said on E Street Radio, "for your emotional and intellectual searching and dissatisfaction. To me that's the engine that drives all of your writing, drives when you go out on stage at night."

THE GHOST OF TOM JOAD

This full-band, Morello-spotlighting version of "Joad" began with a single show on April 7, 2008, in Anaheim, California. Springsteen invited Morello onstage to jam on "Joad," which the guitarist had convinced his Rage Against the Machine bandmates to reimagine on a recording produced by Brendan O'Brien back in 1997. "The band kind of looked at me sideways when I played it for them," Morello recalls. "I said, 'What if we put in this Sabbath riff that goes like this?'" Here is Morello's account of his first performance of "Joad" with Springsteen:

> When I spoke to Bruce on the phone, I said, "Should I learn it acoustic or electric?" He said, "Learn both." I said, "Do you want me to sing it?" He's like, "yeah." So I practice all night, every possible iteration of the acoustic or electric versions. I get there at 4:30, and I hear the band rehearsing it, and I realize that Bruce has changed the key of the song, and he's raised it like eight steps. I have this kind of baritone voice, and I had learned it like he sang on the record, but now all of the sudden it's in a Springsteen range, and I'm like, "oh my gosh." I had to transpose all the chords, and I had about seven minutes to do it. I'm panicking, because I don't have it figured out. Then I come on stage, it's just me and The E Street Band. My chance to play with Bruce Springsteen and The E Street Band, and I don't know how to play this song, and I can't sing this song now. It's not going well, and we're running through it, and Little Steven sees my distress, and he's still trying to talk me through how the chords are gonna go now.
>
> Bruce Springsteen surveys the situation, and comes over and does a master Jedi maneuver—this is why they don't call him "The Boss" for nothing. He puts his hand on my shoulder, looks me in the eye, and says, "We're gonna do it in this key, and it's gonna be great." I went, "okay." We made our way through a soundcheck, but during soundcheck, I didn't give the solo away. I just sort of Chuck Berry-ed my way through the solo section. Come that night, and a half bottle of Jameson later, I go on stage. The trick was, I had a few hours to prepare, but I just went out there and then I thought, you know what, I can sing a song about social justice with authenticity, and I can play a damn guitar solo.
>
> That first night, much of that solo was completely improvised. The thing about Bruce is he just said, "keep going," and so we just kept going, and it kind of unspooled into this crazy thing. A lot of the sounds that I played in that solo were ones that I played elsewhere in my career, but they were recontextualized by this powerful minor-key driving chord progression, which ended up sounding like nothing in my catalog, and like nothing in Bruce's catalog. At the end of that first night at Anaheim, we all just stood there and looked at each other, like, "What the fuck just happened, man?" It was a pretty stirring moment.

Morello ended up playing that version live many more times with Springsteen and the band, and the *High Hopes* version is meant to immortalize it. As with "American Skin," Morello, Aniello, and Weinberg recorded the basic

Previous spread: Springsteen greets his fans, Rock in Rio Festival, Rio de Janeiro, Brazil, September 21, 2013.

Opposite: Bruce Springsteen and Dave Grohl share a moment during The Concert For Valor, November 11, 2014.

track without Springsteen in the room, referencing a live version chosen by the producer. Incredibly, Morello doubled his solo, which means he played all the outlandish virtuoso tricks twice, exactly the same way.

THE WALL

This ballad about a visit to the Vietnam Veterans' Memorial in Washington, D.C., was among the tracks that Springsteen tried to record with the E Street Band circa March 2001, before *The Rising* (along with "American Skin," "Harry's Place," and "My City of Ruins.") The concept and title came from his friend Joe Grushecky, but the crux of the song arrived after Springsteen and Scialfa paid a visit to Washington, D.C., where he found himself sitting not far from Robert McNamara, one of the architects of the Vietnam War, at the Kennedy Center Honors. Earlier that day, Springsteen ventured to the memorial, searching the black stone until he found the name of Walter Cichon, who had been the Jersey Shore's leading rock-star-in-the-making before Springsteen took that title. "He was someone we were all scared of," Springsteen told E Street Radio. "He was the first rock star I ever came into contact with." Cichon was shot in the head in Vietnam on March 30, 1968. His body was never found, and he was declared missing in action soon after.

DREAM BABY DREAM

Springsteen is a longtime fan of the New York synth-punk duo Suicide (Alan Vega and Martin Rev), citing them as an influence on *Nebraska*, and it's only logical that he responded to their demon-Elvis-from-the- future sound. Suicide's original 1979 recording of "Dream Baby Dream," produced by the Cars' Ric Ocasek, is up-tempo, with a distinct Lou Reed feel to the late Vega's vocals. But in the version Springsteen introduced as a show closer on 2005's solo Devils & Dust Tour, he slows it down and sings it more like Roy Orbison. Other than some maximalist production touches by Aniello, this arrangement adheres closely to the live performances—which came approved by Vega. "On my death bed," Vega told Caryn Rose in *Backstreets*, "that's the last thing I'm going to listen to."

AMERICAN BEAUTY (AMERICAN BEAUTY EP)

Four of the songs Springsteen considered for *High Hopes* ended up on the *American Beauty* EP, released the same year. "These were all demos we elaborated on," Aniello says—in this case, a track recorded with Toby Scott during the period Springsteen was working with Brendan O'Brien, with lines that would reappear on various songs of the era. Oddly enough, Springsteen's vocals sound not unlike Keith Richards here. Jake Clemons, meanwhile, recorded a sax part for the song that didn't make the final version.

MARY MARY (AMERICAN BEAUTY EP)

"It's a Toby Scott demo that we were very gentle with," Aniello says of this delicate acoustic track, with a riff that would return on "We Take Care of Our Own" (and a chorus that nods to an earlier "Mary, Mary," recorded by the Butterfield Blues Band and the Monkees). "I tried a few things," Aniello says. "I had versions with drums—but got it wrong." In liner notes, Springsteen called the track "a lovely mystery, a small piece of heartbreak poetry that sneaks up on you with its slippery groove, punctuated string section and spectral lyrics."

HURRY UP SUNDOWN (AMERICAN BEAUTY EP)

Springsteen called this track a "fun piece of modern power pop," though it also sounds like his Byrds-influenced rockers from *Working on a Dream*. Drummer Josh Freese recorded his part the same day he worked on "This Is Your Sword."

HEY BLUE EYES (AMERICAN BEAUTY EP)

Springsteen recorded this demo with Brendan O'Brien, apparently as a prospect for *Magic*. It would have been that album's fiercest attack on the Bush era; Springsteen called it one of his "darkest political songs," painting the world that administration created as a "house of horrors." The blue-eyed woman addressed in the chorus is, at least metaphorically, a jailer at Guantanamo Bay. The lyrics are apocalyptic, with images of a world ablaze, a basement filled with pulverized bones and, drawing directly from a real Guantanamo photo, a naked man on a leash.

> **"WALTER CICHON WAS THE FIRST ROCK STAR I EVER CAME INTO CONTACT WITH."**
>
> BRUCE SPRINGSTEEN

Opposite: The Vietnam Veterans' Memorial in Washington, D.C. Springsteen's song "The Wall" was written about his visit there in 2009.

INDEX

ACKNOWLEDGEMENTS

Deepest thanks to Jen and Hannah, with all my love, for their months of patience and support as I worked on this project, and for so much more.

Chuck Plotkin, Bruce Springsteen's producer for many years, was the first person who agreed to talk for this book, giving ten hours of thoughtful interviews. Thanks so much, Chuck.

Many thanks to Bruce Springsteen, Jon Landau, Marilyn Laverty and Barbara Carr.

My profound thanks to all of my interviewees, who spent many hours enduring highly specific questions with grace, generosity and good humor. In alphabetical order: Larry Alexander, Ron Aniello (who was kind enough to welcome me into Springsteen's Colts Neck studio), Mike Appel, Roy Bittan, Bob Clearmountain, Danny Clinch, Cameron Crowe, Neil Dorfsman, Jimmy Iovine, Randy Jackson, Rob Jaczko, Louis Lahav, Nils Lofgren, Gary Mallaber, Tom Morello, Brendan O'Brien, Thom Panunzio, Chuck Plotkin, Barry Rebo, Marty Rifkin, Sebastian Rotella, David Sancious, Toby Scott, Soozie Tyrell, Max Weinberg and Thom Zimny.

Thanks to my Rolling Stone colleagues Mark Binelli, David Browne, Anthony DeCurtis, Andy Greene and Joe Levy, for sharing transcripts that allowed me to use previously unpublished quotes from Springsteen and others. All of them did so without the slightest hesitation, and I'm grateful for their help. This book would not be the same without them.

Thanks to Jann Wenner, Gus Wenner and Jason Fine for many years of support (and gainful employment!)

Many thanks to Jay Penske and PMC, for the same.

Thanks to Christian Hoard, Craig Inciardi, Rob Sheffield, Sean Woods, Alison Weinflash, Jerry Portwood, Simon Vozick-Levinson, Sacha Lecca, Brittany Spanos, Thomas Walsh, Nathan Brackett, Matthew Ianni, Courtney Rubin, Matty Karas, Will Dana, Jason Hirschhorn, Jodi Peckman, Vincent Todaro and Wendy Fonarow for their help and support.

All my love to Dr. Mark Hiatt and Dr. Doris Hiatt.

Much love and thanks to Eric Hiatt, Lauren Axelrod and Chloe Hiatt.

Thanks to Roland Hall.

I consulted many books, magazine articles and other resources in researching this book. Thanks to the tireless archivists at the website Brucebase, and to Christopher Phillips and all the writers and editors who worked on the back issues of *Backstreets* that served as essential references. Springsteen's own *Born to Run* and *Songs* were, of course, invaluable. Special thanks go to Dave Marsh, whose *Two Hearts* (which collects his books *Born to Run* and *Glory Days*) remains a wellspring—and whose writing led me down this career path in the first place. Thanks also to Peter Carlin for his revelatory book *Bruce*, and for his friendship and encouragement. Clinton Heylin's *E Street Shuffle: The Glory Days of Bruce Springsteen and the E Street Band* and Springsteen *Song by Song: A Critical Look* are important works; Heylin did an invaluable service for all future Springsteen researchers by obtaining 1972–1984 studio records. Other books included, in no particular order: *Upstage, Springsteen and Me* by Albee Tellone; *Greetings From E Street* by Robert Santelli; *Talk About A Dream: The Essential Interviews of Bruce Springsteen*, edited by Christopher Phillips and Louis P. Masur; *4th of July Asbury Park: A History of the Promised Land* by Daniel Wolff; *Written in My Soul: Conversations with Rock's Great Songwriters*, by Bill Flanagan; *Studio Stories*, by David Simon; *Bruce Springsteen: Like a Killer in the Sun*, by Leonardo Colombati; *Born in the U.S.A.*, by Geoffrey Himes; *Down Thunder Road: The Making of Bruce Springsteen*, by Marc Eliot, with Mike Appel; *Bruce Springsteen and the Promise of Rock n' Roll* by Marc Dolan; *Springsteen on Springsteen*, edited by Jeff Burger; *Racing in the Street: The Bruce Springsteen Reader*, edited by June Skinner Sawyers; *For Music's Sake: Asbury Park's Upstage Club and Green Mermaid Cafe, the Untold Stories*, by Carrie Potter-Devening; *Backstreets: Springsteen: The Man and His Music*, by Charles R. Cross; *Days of Hope and Dreams: An Intimate Portrait of Bruce Springsteen*, by Frank Stefanko.

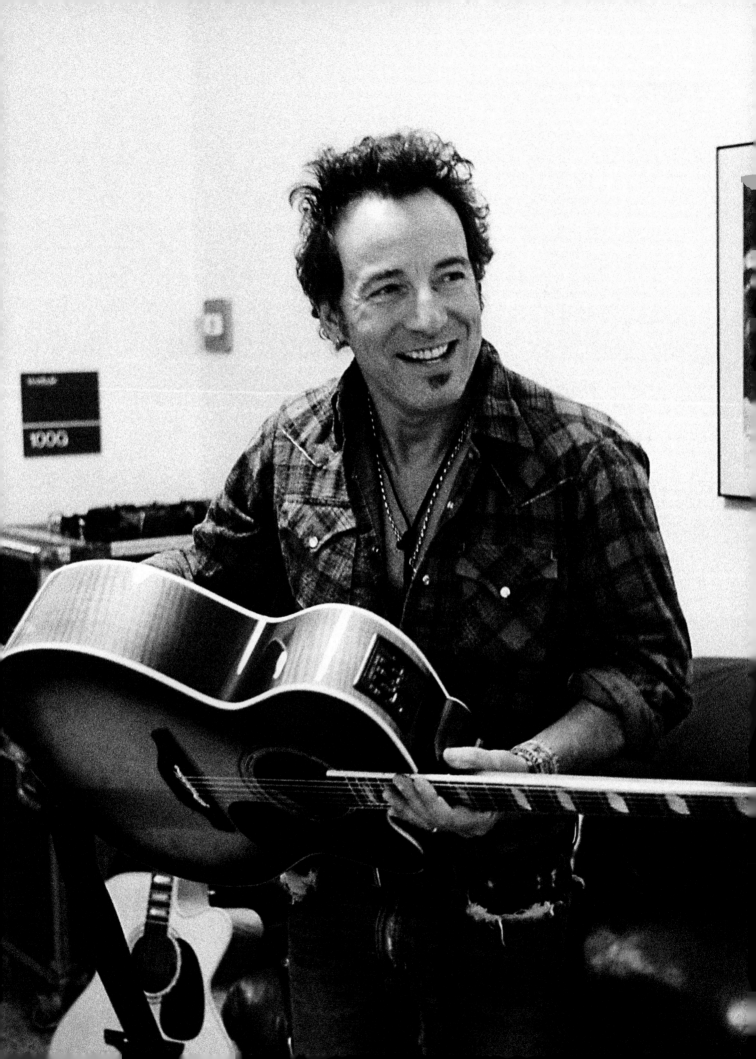

PHOTO CREDITS

The publishers would like to thank the following sources for their kind permission to reproduce the pictures in this book.

Alamy: Granger Historical Picture Archive 190; /Robert Landau 176

Avalon/Photoshot: Stella Pictures/Pacific Coast News 221

Getty Images: Waring Abbott 15, 60; /Richard E. Aaron/ Redferns 53; /Ulf Andersen 196; /Paul Bergen/Redferns 158, 168, 178, 188; /Andrew D. Bernstein 96-97; /Julian Broad/ Contour 254, 262-263; /Larry Busacca/WireImage 161; /Clayton Call/Redferns 85; /Stephanie Chernikowski/Redferns 29; / Danny Clinch/Contour 7, 219, 222, 226, 228, 237, 252-253, 286, 288; /Fin Costello/Redferns 45; /Peter Cunningham/Gems/ Redferns 12; /Chalkie Davies 54-55; /Georges De Keerle 149; / Rick Diamond 64, 66, 266; /Kevork Djansezian 270; /Monty Fresco/Evening Standard 38; /David Gahr 19, 23, 27, 29, 30, 34-35, 36, 78, 80-81, 86, 92-93, 100-101, 120, 122, 123, 124, 135; /Ron Galella, Ltd./WireImage 152 (top); /Robert Gauthier/Los Angeles Times 194, 220; /Gary Gershoff 136; /Lynn Goldsmith/Corbis/ VCG 59, 65, 73, 77, 87, 126, 132, 138; /Steve Granitz/WireImage 131, 200, 203, 207, 212, 214; /Stan Grossfeld/The Boston Globe 142; /Gijsbert Hanekroot/Redferns 41; /Richard Harbus 273; / Koh Hasebe/Shinko Music 98; /Mark and Colleen Hayward 48; /Tom Hill/WireImage 40, 44; /Mick Hutson/Redferns 157, 167; /Frank Johnston/The Washington Post 145; /Bradley Kanaris 256; /Roger Kisby 244; /Brooks Kraft LLC/Corbis 127, 128-129, 258; /Jeff Kravitz/FilmMagic, Inc 193; /Library of Congress 108; /The LIFE Picture Collection 152 (bottom); / Michel Linssen/Redferns 164-165; //Hayley Madden/Redferns 206, 210, 215; Richard McCaffrey 68; /Arnaldo Magnani 230; / Michael Marks/Michael Ochs Archives 83, 94; /Kevin Mazur/ WireImage 199, 224-225, 232, 234, 278; /Buda Mendes 272, 276-277; /Mark Metcalfe 259, 264, 275; /Keith Meyers/New York Times Co. 170-171; /Michael Ochs Archives 14, 24, 52; / Gary Miller/FilmMagic 258; /William McKim 202; /Paul Natkin 192, 261; /Terry O'Neill/Iconic Images 42, 46-47; /Larry C. Morris/ New York Times Co. 51; /Tim Mosenfelder 260; / Bill O'Leary/ The Washington Post 280; /Patti Ouderkirk/WireImage 160; / Lucian Perkins/The Washington Post 141; /Martin Philbey/ Redferns 191; /Christopher Pillitz 146; /Robin Platzer/Michael Ochs Archives 58; /POP-EYE/ullstein bild 182; /Michael Putland 63; /Aaron Rapoport/Corbis 116; /Ebet Roberts/Redferns 121, 147, 205; /George Rose 62, 74; / Will Russell 268, 274; /Harry Scott/Redferns 154; /Wally Skalij/Los Angeles Times 242, 245; / Jon Sievert/Michael Ochs Archives 119; /Jamie Squire 247; /Jim Steele/Popperfoto 162; /Allan Tannenbaum 16, 18, 28; /Time Life Pictures/DMI/The LIFE Picture Collection 172, 175, 181, 184; / Rob Verhorst/Redferns 133; /Theo Wargo/WireImage 246; / The Washington Post 248; / Mark Weiss/WireImage 90-91; Edd Westmacott/Photoshot 248-249; /Michael Williamson/The Washington Post 208; /Jeff Zelevansky/Icon SMI/Icon Sport Media 233

Hyperion Books: 195

© Photograph by David Michael Kennedy: 4, 102, 104, 109, 110, 114, 115

REX/Shutterstock: Stephen Chernin/AP 211; /Richard Drew/ AP 238; /Ron Frehm/AP 197; /David J. Phillip/AP 151; /Amanda Schwab/StarPix 257; /Mark. J.Terrill/AP 187

© Debra L. Rothenberg: 144

© Frank Stefanko: 8, 11, 56, 70, 82, 107, 112-113, 216, 223, 229

Every effort has been made to acknowledge correctly and contact the source and/or copyright holder of each picture and Carlton Books Limited apologizes for any unintentional errors or omissions that will be corrected in future editions of this book.

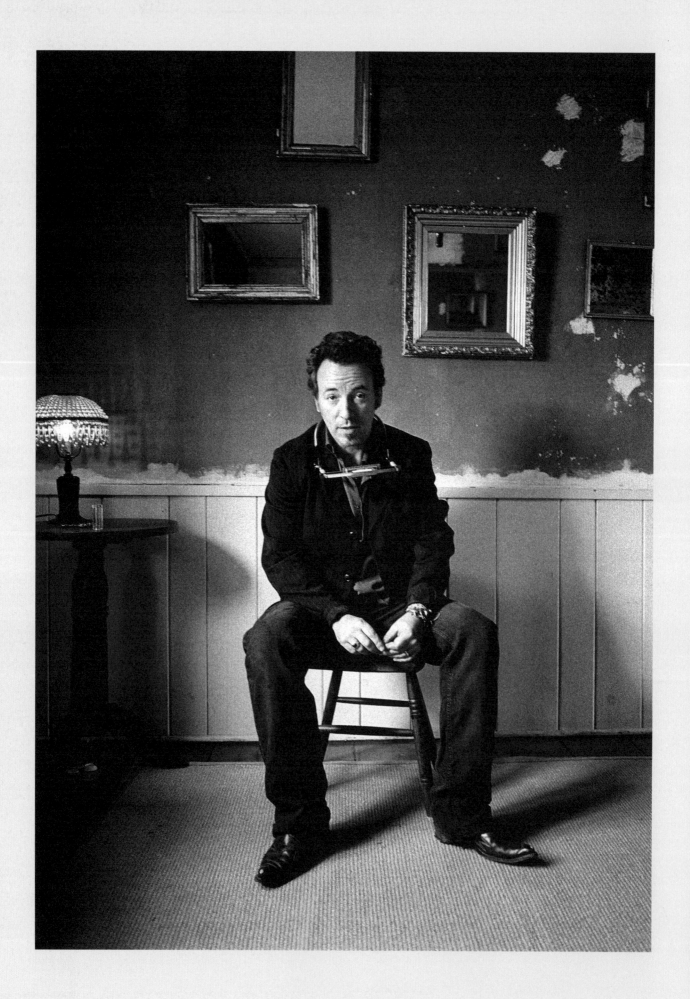

BRUCE SPRINGSTEEN